Fugitive Images

Fugitive Images: From Photography to Video
is Volume 16 in the series

THEORIES OF CONTEMPORARY CULTURE
Center for Twentieth Century Studies
University of Wisconsin–Milwaukee

General Editor, KATHLEEN WOODWARD

Fugitive Images
From Photography to Video

edited by Patrice Petro

Indiana University Press

Bloomington and Indianapolis

The paper used in this publication meets the minimum
requirements of American National Standard for Information
Sciences—Permanence of Paper for Printed
Library Materials, ANSI Z39.48-1984.

Manufactured in the United States of America

Library of Congress Cataloging-in-Publication Data

Fugitive images : from photography to video / edited by Patrice Petro.
 p. cm. — (Theories of contemporary culture)
 Includes index.
 ISBN 0-253-34428-X (cloth).—ISBN 0-253-20890-4 (paper)
 1. Images, Photographic. 2. Cinematography. 3. Visual
 perception. I. Petro, Patrice, date. II. Series.
TR222.F78 1995
770'.1—dc20 93-46701
 1 2 3 4 5 99 98 97 96 95

Contents

Introduction

Patrice Petro

The Photograph is a certain but fugitive testimony.
—Roland Barthes

THE IMMEDIATE CONTEXT and major impetus for the essays collected in this volume was a conference that took place at the Center for Twentieth Century Studies at the University of Wisconsin-Milwaukee in April of 1992 entitled "Visual Culture: Film/Photography/History." This was the first film conference held at the Center for Twentieth Century Studies since 1982, the year Patricia Mellencamp organized a conference on independent cinema. As a participant at that earlier conference, what I remember most vividly was the sense of excitement surrounding certain questions (stemming, for the most part, from feminist film theory) and the simultaneous sense that certain issues and developments had somehow played themselves out (most notably, and perhaps ironically in that particular context, independent cinema and the avant-garde).

It is easy to see in retrospect that a shift was taking place in film studies and in debates about the image more generally. Prior to the 1970s, theorists and artists were preoccupied with formal and ontological questions regarding the relationship between film and photography and the distinct temporalities and identificatory processes involved in static and moving images. By the mid-1970s and early 1980s, however, these issues were displaced in favor of a concern with narrative and the metapsychology of viewing—no doubt as a result of feminist and psychoanalytic rereadings of culturally coded and gender-specific ways of seeing.

This shift toward the psychoanalytic subject and the narrative image undeniably established a more sophisticated understanding of sexual difference in film studies. To take but one example: Teresa de Lauretis's essay "Desire and Narrative" (included in her book *Alice Doesn't* and initially presented as a talk at the 1982 conference) challenged the rigid polarization of masculinity and femininity, looking and being-looked-at, gaze and image. In the process, de Lauretis's essay made a historical approach to questions of viewing and spectatorship at least theoretically viable by insisting on the need to understand women as subjects, and not simply as objects, of the image and the gaze.

It was in the tradition of this work and of earlier Milwaukee film conferences

that I initially conceived of the conference on Visual Culture. I nevertheless sought to shift the terms of debate once again by returning, via arguments about narrative and psychoanalysis, to earlier questions about the image, the avant-garde, and the historical subject that seemed to me too hastily, and too prematurely, dismissed. To be sure, the now classic texts of photography and film theory—ranging from Bazin, Benjamin, and Barthes to Berger, Sontag, and Foucault—are obsessed with questions of history and historical subjectivity (in which photography, rather than narrative, serves as primary referent). It is well known, moreover, that each of these theorists raises troubling questions about the image's relation to the things it seems to document or represent. Their inquiries concern the indexicality and referentiality of the image, its powerful ability to indicate or attest to what has been. In short, they explore the ontological status of the image for the viewer in ways that are deeply if unpredictably historical.

There is also an implicit, if often unspoken, concern with temporality in these texts, with what might be called a "politics of periodization" (since "historical periods" obviously do not exist in history, but only in historiography, often in the form of an explicit polemic). For instance, in an attempt to date and thereby to account historically for the various shifts in image-making and perception, theorists typically appeal to an overarching Western tradition, either via a history of form (Renaissance perspective or French impressionism), a history of philosophy (notably Greek or Cartesian thought), a history of industrial capitalism and its emerging bureaucracy (particularly in the late eighteenth and early nineteenth centuries, in the shift from the classical to the modern age), or, finally, a history of war and its technologies of mass destruction (and here World War I and the Holocaust serve as the most dramatic, and disjunctive, indicators of social and perceptual change). Of course, for many theorists of the image, these various, presumably separate, histories of looking are in many ways overlapping and interrelated. Their often polemical constructions of the past nevertheless reveal a fundamentally contested view of what constitutes historical change, and what counts as historical evidence in the first place.

In planning for the conference and, subsequently, for this volume, it seemed to me that these issues had not yet been adequately addressed or fully elaborated in film or photography theory. To borrow from a persistent theme in histories of film technology, there had been an obvious "delay" in considering different investments in the image, across cultures and across time. As I suggested earlier, the emphasis on narrative and the psychoanalytic subject, especially in film theory, tended to privilege certain questions (about pleasure, about desire, about sexual difference) and to obscure others (about referentiality, about sexual as well as racial differences, about other bodily dimensions and sensory registers, such as the acoustical and the tactile). Although the concept of "delay" seemed at first a thoroughly negative one, it nevertheless implied a temporal process, and a temporal gap, which positively enabled a rethinking of otherwise separate terms—namely, subjectivity and

history—from the vantage point of changing definitions of perception, sexual difference, and the self.

Thus, the immediate context for these essays was an academic conference that proceeded from the assumption that "history" marks the contradictory play of uneven forces (economic, political, philosophical, psychic) which involve the mutual implication of psychoanalysis and historiography, of private, personal histories and the technologies that represent and recreate public events. There was, however, another, powerful and unexpected, context for the essays collected here. During the week following the Milwaukee conference on Visual Culture, the first Rodney King verdict was handed down, and Los Angeles exploded in outrage at the injustice of the decision. As Lynne Kirby points out in her essay in this volume, "events proved that even as raw, powerful, and *vérité* images as the home video footage of King being beaten by the officers could be subject to doubt; indisputable evidence was disputed." Quoting *Los Angeles Times* correspondent Charles Hagen, Kirby further explains: "While most Americans still regard the tape as irrefutable evidence of police brutality, the jury that acquitted the indicted officers obviously saw it differently. This puzzling fact goes to the heart of the matter: that photographic images of all sorts remain essentially ambiguous, and must be anchored in a convincing narrative before they take on specific meaning. And most images can be made to fit into a number of widely disparate narratives." This point was confirmed when the jury in the second trial (on civil rights charges), aided by better technical equipment and a superior prosecution case, found the video convincing proof for convicting two of the officers.

The issues much debated and discussed at the conference—indexicality and narration, technology and death, temporal duration, racial and sexual otherness, and violence—took on an added dimension and a greater urgency following the violent events in Los Angeles, when most of the essays collected here were being rewritten and revised for publication. As is well known, the suburban jury that first acquitted the indicted officers was shown the videotape of the beating more than thirty times during the trial, projected at various speeds, played forward and backward, freeze-frame and fast-motion. The defense was thereby able to defy temporal duration, deaden the emotional impact of the tape, and shift the jury's understanding of the scene from one of excessive force and institutionalized racism to one of self-defense and standard police procedure. Yet with a further delay, the second jury read the tape and its history differently, now framed also by a video of the damning testimony one of the officers gave at the first trial and later tried to recant. The verdicts in the two King cases served to underline what John Tagg so eloquently argues in his essay "The Pencil of History" (included in this volume); namely, that the compelling weight of the photographic image is never simply—or never only—phenomenological, but always and ultimately discursive: "The status of the document and the power of its evidence [are] produced only in the field of an institutional, discursive, and political articulation."

Rather than retain the title of the conference for the title of this book, I decided instead upon *Fugitive Images: From Photography to Video* in an effort to suggest both the evidential force and the powerful indeterminacy of the image and its reception in the nineteen and twentieth centuries. This title uncannily evokes the media phenomenon of Rodney King (both the person who took flight from police and the videotape which took flight from determinate meaning); it is, however, derived from a seemingly paradoxical passage in Barthes's *Camera Lucida*, which I quote at the outset of this introduction: "The Photograph is a certain but fugitive testimony" (93).

All of the essays collected here explore the richness and ambiguity of this formulation: the image as "certain" testimony—indubitable, incontestable, irrefutable—yet not specified or named in advance; hence, its transient, fleeting, and "fugitive" quality. The essays are arranged, moreover, according to four overlapping and intersecting themes: "Anatomies of the Visible," which maps the sensation, uncanny doubleness, and disappearance of the (gendered) body in photography, film, and video; "Histories of Looking," which analyzes visual economies of tourism, colonialism, and popular culture; "Still and Moving Images," which explores the relationships among film, photography, biography, and autobiography; and "Negativity and History," which aims to forge a critical historiography by treating the image as historical and history as fundamentally imagistic. Taken together, these essays explore a wide spectrum of images (faces, portraits, erotica, apparitions, landscapes, monuments, crowds) and consider the forms of attention and range of emotions they elicit (fascination, distraction, boredom, fear, as well as the more familiar tropes of anxiety and pleasure). In the process, each essay seeks to challenge, revise, and extend Barthes's observations—regarding history, affect, indexicality, and the image—as well as those of much contemporary film and photography theory.

The essay which opens this volume and the section entitled "Anatomies of the Visible" is exemplary in this regard. Here, Linda Williams analyzes a variety of erotic and pornographic images in order to challenge the view that a greater representational realism automatically produces greater obscenity and misogynist abuse of women. Pornographic images are seductive, she claims, not because of their verisimilitude, but because they dissolve the traditional separation of spectator and scene, engaging both body and eye in diverse tactile pleasures and bodily sensations—what Williams calls a "carnal density of vision." Williams criticizes psychoanalytic models of vision (which perpetuate the notion of a voyeuristic, disembodied, and ahistorical "male gaze") for failing to address these diverse pleasures, which historically have been available to women as well as men. As Williams persuasively argues, the range of pornographic images produced in the last two centuries attests to a greater variety of visual pleasures than is usually assumed, and supports the view that "what the eye of the observer sees . . . is not simply an object of vision but vision's own subjective perceptions."

Tom Gunning's essay on spirit photography and Lynne Kirby's essay on the photographic body further complicate these issues of indexicality and subjective perception. Gunning explains, for example, that the cultural reception of photography in the nineteenth century frequently associated it with the occult and the supernatural. "The idea that people, places, and objects could somehow leave behind—in fact, cause—their own images," he writes, gave photography the status of an uncanny rather than a purely scientific phenomenon. Tracing the complex genealogy of photography as it intersected with spiritualism, magic theater, and cinema, Gunning shows how photography emerged both as the material support for a new positivism and as the basis for a popular fascination with visual illusions. Kirby continues this line of analysis in her essay on contemporary media practices (which include Gulf War coverage, the King video, Benetton ads, the controversy over Mapplethorpe and *JFK*, and the experimental video *Displayed Termination*). Challenging the assumption that the replacement of photography by video and digital technologies has diminished our faith in and acceptance of the real (the photographic signifier as link to truth), Kirby insists that what matters most in our "fluctuating multimedia landscape is not so much the medium itself as the institutions of mass media."

Edward Buscombe and Áine O'Brien extend this argument in the second section of the book, entitled "Histories of Looking." Buscombe, for instance, analyzes the development of landscape in the Hollywood Western, the cinema's most enduring popular genre. The desire on the part of audiences and studio executives for "authentic" western settings, Buscombe argues, had little, if anything, to do with realism: "If Westerns needed western scenery to be authentic," he asks, "what exactly were 'the proper scenic backgrounds' which the critics demanded and which the companies were eager to provide? What ought Western landscapes to look like? The West, after all, was a big place." Drawing upon discourses of aesthetics, landscape painting, geological survey, railroad enterprise, and tourism, Buscombe shows how western settings (in photography as well as film) were less faithful representations of the real than transcriptions of the obsessions and pictorial conventions of the institutions that produced them. O'Brien further explores this theme in a photoessay which examines the cultural logic of an Irish monument—a penal jail turned national museum, built on the archeological remains of British colonialism. Against the certitudes and naturalism of the museum's photographic exhibition, O'Brien offers counter-images that de-realize its purported reality. In the process, she exposes the fictions of nation and subject formation embedded in the museum when it is constructed as an imaginary, masculine, administrative entity—one that marginalizes women's involvement in nationalist struggle.

The essays that comprise the third section of the book, entitled "Still and Moving Images," turn from institutional, discursive, and political articulations of the image in order to explore resources of the imaginary in various constructions of the self—what Régis Durand refers to as "acts of looking and thinking which

are more powerful than the image itself." Durand's essay, which opens this section, reflects upon the differences between film and photography, but only to locate these within experiences of viewing (rather than in an ontology of the image). For Durand, duration is central to the experience of watching film, while transience defines the experience of looking at photographs. Photographic images are of the order of the index, he further explains, not because of an optical or chemical activity, but because of a psychological operation that the spectator brings to the image. "Photography introduces the radical discontinuity and heterogeneity of the visual image into the thinking process itself," Durand claims; thus, the importance of photography in generating new ways of thinking as well as other images, associations, and desires.

Philippe Dubois extends this discussion of film and photography in an analysis of a relatively marginal form of cinema—what he calls a "cinema of the self." For Dubois, this autobiographic cinema includes the work of five filmmakers who are also, and equally, photographers: Raymond Depardon, Agnès Varda, Robert Frank, Chris Marker, and Hollis Frampton. Like Durand, Dubois argues that the photograph is not so much a real image as a mental image; it is full (of meaning) yet transient, permanent yet enigmatic. Exploring various conceptual devices for the staging of autobiography in documentary and experimental cinema, Dubois ultimately questions the rigid opposition between photography and film and shows how the photograph is always at stake in cinematic fictions of the autobiographical self.

Patricia Mellencamp's and Charles Wolfe's essays further refine this analysis of autobiography and biography in contemporary avant-garde and documentary practices. Mellencamp's essay takes the form of an extended reflection on the work of two Australian independent filmmakers, Laleen Jayamanne and Tracey Moffatt. In Mellencamp's view, these women filmmakers implicitly challenge the claims of an earlier, romantic and "visionary," avant-garde by focusing less on ontological questions than on empirical and historical ones—questions regarding racial and sexual otherness, experience, emotion, and popular culture. Wolfe's contribution turns from autobiography to biography, and offers a close reading of a PBS documentary that mobilizes James Agee and Walker Evans's 1941 photo book *Let Us Now Praise Famous Men* for revisionary purposes. Wolfe shows how even a routine television documentary reveals the limits to our knowledge of any documentary subject, "however deep the seductions of the photographs and the fantasies they arouse." He nonetheless argues against the view that the evidential status of the image is necessarily diminished by the vagaries of memory and of photographic testimony; indeed, following Agee, he suggests that such vagaries also allow for new ways of conceiving both documentary forms and historical consciousness—in theory and criticism as well as in photography and film.

The fourth and final section of this book, entitled "Negativity and History," turns to broadly theoretical and historiographic concerns in an effort to address what John Tagg calls the "uncertain ground of the conditions of witness and the

politics of disputable meanings." Eduardo Cadava, for example, offers an extended analysis of Walter Benjamin's "Theses on the Philosophy of History" in order to show how Benjamin, persistently and persuasively, conceives of historiography in the language of photography. In Benjamin's writings, Cadava explains, the history of knowledge is a history of the vicissitudes of light—"a light which coincides with the conditions of possibility for clarity, reflection, speculation, and lucidity; that is, for knowledge in general." Glossing a passage from Benjamin's Arcades project, Cadava maintains that there can be no philosophy without photography, since "knowledge comes only in flashes," in moments of simultaneous illumination and blindness.

Herbert Blau similarly evokes a solar language of cognition in his essay on the powers of visuality and of critical discrimination. It is paradoxical, Blau contends, that theorists of the image persistently fault vision and the proliferation of pictures rather than the discretionary basis of sight itself. As Blau puts it, "In a visual culture whose history moves before us in the blink of an eye, we find ourselves faulting vision . . . precisely when it finds itself baffled by overdrive: eyesight fading from too much sight, and with it the difficult-to-attain, costly powers of discrimination . . . without which a politics is only a question of power." Unlike Barthes and Sontag, who long for a release from the surfeit of pictures, Blau argues, following Rodchenko, for a need to "revolutionize our visual reasoning."

John Tagg's essay on the status of evidence and my own essay on boredom and visual perception take up issues similar to those discussed by Cadava and Blau. In my contribution to this collection, I attempt to show how an aesthetics and a phenomenology of boredom (in both popular and avant-garde photographic practices) enable an awareness of looking as a temporal process bound, not to a particular object, but to ways of seeing at once historical and gender specific. Tracing an extensive (if elusive) literature on boredom as a peculiarly modern and gendered visual experience, I aim to suggest how boredom—and, indeed, historiography itself— are always bound to experiences of "sensory overload and sensory deprivation, anxieties of excess and anxieties of loss." John Tagg makes a similar point in his analysis of an archival project published in Surrey in 1916, entitled *The Camera as Historian*. For Tagg, this project reveals an anxiety about the status of the photograph as evidence and, indeed, about the evidential status of the archive itself. The accumulation of detail in this rather banal handbook of photographic record work, Tagg argues, is nonetheless haunted by a "fear of lack" which is "inseparable from a horror at what may be too much." *The Camera as Historian*, Tagg writes, testifies to the problems with "the closing of the rhetoric of historiography at the level of the fact and the closing of the meaning of the photograph at the level of its indexicality." As he explains, "For the court of appeal of history, as for photography, the status of evidence is always on the line"—it is, in short, both permanent and transient, uncertain and in dispute.

Tagg's essay provides a fitting conclusion to a book that addresses the stakes of historical memory and the politics of visual interpretation today. As he writes at

the very outset of his essay: "[B]etween the burning of Baghdad and the burning of South Los Angeles, we might have been tempted to welcome one demise of evidence and damn the other. What could be more decisive than to take a stand on the real against the imposition of power to which it is vulnerable, rather than turn to the more uncertain ground of the conditions of witness and the politics of disputable meanings?" Having said this, however, Tagg nonetheless insists that we follow the path of uncertainty if we are to do justice to the image as well as use the image to do justice. The reasons for this become apparent once the status of photographic testimony is distinguished from the fleeting moment it captures and describes. Indeed, as the fate of the Rodney King video powerfully demonstrates, photographic testimony is always (and at once) overloaded yet insubstantial—open to multiple interpretation and debate. "A photograph is always invisible," writes Barthes, "it is not it that we see" (6). The essays collected here—whether following the trace of the photograph or of its interpretation—aim to bring into view what was previously invisible in certain yet fugitive images.

I would like to thank Kathleen Woodward, Director of the Center for Twentieth Century Studies, and Carol Tennessen, Conference and Publications Coordinator, for their tireless efforts on behalf of the conference and for their intellectual contributions to this book. I am also grateful to David Crane, Nicole Cunningham, Catherine Egan, Anne FitzSimmons, Gregory Jay, Brent Keever, Paul Kosidowski, Andy Martin, Barbara Obremski, and Rob Yeo. Finally, I would like to acknowledge the stunning essays presented at the conference on Visual Culture by Connie Balides, Miriam Hansen, Griselda Pollock, Rick Rentschler, Allan Sekula, and Sally Stein. For various reasons, these essays unfortunately could not be included here.

WORKS CITED

Barthes, Roland. *Camera Lucida: Reflections on Photography*. Trans. Richard Howard. New York: Noonday, 1981.

Bazin, André. *What Is Cinema?, Vol. 1*. Trans. Hugh Gray. Berkeley: U of California P, 1971.

Benjamin, Walter. *Illuminations*. Trans. Harry Zohn. New York: Schocken, 1969.

Berger, John. *Ways of Seeing*. New York: Viking, 1973.

de Lauretis, Teresa. *Alice Doesn't: Feminism, Semiotics, Cinema*. Bloomington: Indiana UP, 1984.

Foucault, Michel. *Discipline and Punish: The Birth of the Prison*. Trans. Alan Sheridan. New York: Vintage, 1977.

Hagen, Charles. "The Power of a Video Image Depends on the Caption." *New York Times* 10 May 1992: 32.

Sontag, Susan. *On Photography*. New York: Dell, 1973.

Fugitive Images

Anatomies of the Visible

1

Corporealized Observers
Visual Pornographies and the "Carnal Density of Vision"
Linda Williams

IN THIS ESSAY I am interested in a phenomenon that has been more maligned than understood: the appearance in the nineteenth and twentieth centuries of a wide variety of erotic and pornographic images—both still and moving—produced in the era of mass-produced mechanical reproduction. Most analysts agree that along with the nineteenth-century "media explosion"—the proliferation of mass-produced, printed images (first lithographs, later photographs) pioneered in France but spread throughout Europe, England, and America—there was also an explosion of "dirty pictures" which has continued unabated in a variety of forms until the present.[1]

So far as it has been studied at all, this tradition of mass-produced pornographic images has usually been explained as the dark Freudian underside of Victorian prudery[2] and/or as the result of an unprecedentedly graphic realism made possible by new technologies of image production. Film theorists of all stripes have perpetuated this way of thinking: From André Bazin's reservations about the "obscenity" of certain extreme "truths" (in documentary images of newsreels showing executions), to Stanley Cavell's notion that the "ontological conditions of the cinema reveal it as inherently pornographic" (45), to Fredric Jameson's statement that "pornographic films are . . . only the potentiation of films in general, which ask us to stare at the world as though it were a naked body" (1), we discover the basic notion, judged and traced differently by each theorist, that a new level of obscenity occurs, as if automatically, with the invention of mass-produced photographic, and then cinematic, forms of representation.

With respect to photography, a long line of photographic critics, going back at least as far as Baudelaire, also "blames" the arrival of a new "obscenity" on the unprecedented realism of photography. Abigail Solomon-Godeau, in an excellent 1987 article on nineteenth-century erotic and pornographic photography, has continued this line of reasoning while also giving it a feminist inflection, borrowing many ideas from feminist film theory. Citing the massive numbers of erotic and/or

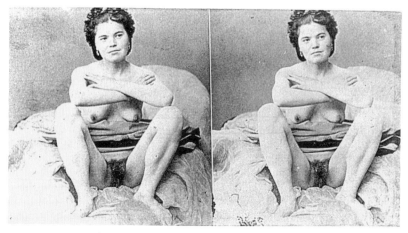

Fig. 1. Anonymous, Stereoscopic Photograph (c. 1855), Cabinet des
Estampes, Bibliothèque Nationale. From Solomon-Godeau, *Photography at the
Dock* (Minneapolis: U of Minnesota P, 1991) 231.

pornographic images that sprang up in France simultaneously with the invention
of photography, Solomon-Godeau argues that images such as this French stereo-
scopic photograph from 1855 (figure 1) were not an extension of preexisting erotic
images carried over from painting or lithography, but constituted an entirely new
genre impossible without the invention of photography and the new status of the
photographic image as the "trace of the real" (229).

 This unprecedented "trace of the real" forms the basis, in Solomon-Godeau's
schema, of a new obscenity inseparable from the carnal appeal of an excessive re-
alism. She thus argues the importance of a new "purchase on the real" offered by
the photograph: its indexical, causal relation to a naked female body which once
was really there before the camera equipped, unlike the ideal nude, with pubic hair
and vagina (233). This apparent excess of realism, which seems to sever the tradi-
tion of erotic and pornographic photography from the realm of art, was most fa-
mously condemned by Baudelaire in a passage quoted by Solomon-Godeau:

> It was not long before thousands of greedy eyes were glued to the peephole of the
> stereoscope, as though they were the skylights of the infinite. The love of obscen-
> ity, which is as vigorous a growth in the heart of natural man as self-love, could
> not let slip such a glorious satisfaction.[3]

 Solomon-Godeau argues that the love of obscenity which Baudelaire both so
vividly describes and derides was probably intended in a literal as well as a meta-
phorical sense. She understands this love of obscenity as an extreme example of
how the indexical nature of the photographic sign enhances the erotics of a "male
gaze" at the hidden recesses of the feminine. In this line of reasoning, also familiar
to psychoanalytic feminist film theory, the indexical, "motivated" nature of the

photographic image registers the ontologically real presence of the woman's "offering of the flesh" (225).

The tradition Solomon-Godeau invokes to assess the eroto-pornographic photo assumes that the visual pleasures of looking at such photos are masculine and that they objectify and fetishize the represented female bodies. Although Solomon-Godeau is very careful not to invoke simplistic antipornography claims that pornographic images "cause" the objectification of women, and is, in fact, importantly calling for a consideration of the repressed history of such images, the "male gaze" "visual pleasure" tradition she invokes assumes that an active male subject of the gaze exercises power in looking at the female object via a photographic technology (220). In both cases there is a tendency to blame "the sexual economy of looking" evident in the very rhetoric of these images on an inherently phallic vision. Though I agree with Solomon-Godeau that a phallic economy is evidenced in such images, and though I admire her careful attempts to apply concepts from feminist film theory to erotic and pornographic images, her invocation of an ahistorical Mulveyan male gaze reproduces, in the field of photography, impasses that have long been troubling to feminist film theorists.

Briefly, these impasses can be described as an overemphasis on the phallic mastery of all forms of photographic visual representations, especially those of women which supposedly leave no room for desires other than those of the centered masculine subject, and an overemphasis on a supposedly insidious reality effect—as in apparatus theorist Jean-Louis Baudry's notion that cinematic images are representations "mistaken for perceptions." Viewers of photography, and especially of cinema, are typically regarded by apparatus theorists as passive subjects of pernicious ideologies—whether of bourgeois individualism or phallocentric misogyny. The problem with such theories, Judith Mayne has recently written, is the wholesale homogenization of the spectator whose subjectivity is rendered a function of Western idealism in the case of Baudry, masculine identification in the case of Mulvey. The institutional apparatus of cinema becomes, in this model, homologous either with an ahistorical psyche or with dominant ideology (86).

There seems to me no question that male viewers have as a group historically enjoyed the pleasures of erotic gazing more than women. As the possessors of greater social power and mobility, men have been freer to exercise a power of "the look." In psychoanalytic apparatus theory, however, this power has been overgeneralized as depending upon transcendent, ahistorical functions of a homogeneous "subject" reducible to a master narrative of Oedipal desire disguising castration and "lack." This "subject" constructed by the film or photographic text has often been contrasted to real-life viewers whose diverse responses have been (sometimes dubiously) "measured" by sociological or psychological methods. My purpose here is not to criticize the apparatical theory of the subject in the name of the concrete

reality of individual viewers—a reality which is notoriously difficult to ascertain. However, my own forays into the analysis of hard-core moving images have made me wary of relying too heavily on either an ahistorical psychologism—that is, on transcendent structures reducible to the master narrative of "lack" and castration—or on a form of technological determinism—that is, the idea, as I was once all too eager to put it myself, that pornography simply follows the "invention" of photography.[4]

If we are seriously to take up the intersection of gender and technology in the study of erotic and pornographic images—let alone images in general—we need a model of vision that can encompass all forms of visual pleasure. I suggest that while the psychoanalytically derived models of vision that have dominated film theory in recent years have enabled the analysis of certain kinds of *power*—the voyeuristic, phallic power attributed to a "male gaze"—they have sometimes crippled the understanding of diverse visual *pleasures* despite the importance and prevalence of the very term *pleasure* in them. Although recent attempts to shift the alignment of pleasure from voyeuristic mastery to the masochistic pleasure of the "assaulted" or introjective gaze offer an important correction to the skewed emphasis on the active, sadistic, voyeuristic "male gaze" (see Studlar; Silverman; and, most recently, Clover), it seems to me that what we need, rather, is a model of vision that can explain pleasurable sensations that are primary to the experience of viewing images without, implicitly or explicitly, judging them as either perverse or excessive.[5]

Not the least of the advantages of Jonathan Crary's recent book, *Techniques of the Observer: On Vision and Modernity in the Nineteenth Century*, is its provocative thesis that a new model of vision began in the nineteenth century to supplant the older model of the camera obscura. Contrary to the conventional wisdom that nineteenth-century science and technology simply extended and perfected Renaissance codes of representation begun with the camera obscura, Crary sees this period as the emergence of a new science and technology that offered a profound rupture with the camera obscura's representational model.

The camera obscura is understood in this schema more as an optical principle of vision than as an image-producing apparatus. The optical principle, first discovered by the Greeks, is that light passing through a small hole into a dark chamber (camera obscura) will produce an inverted image on the wall opposite the hole. While the photographic camera realized the potential for image-making in the optical principle of the camera obscura, according to Crary the most important aspect of the camera obscura model of vision was not the nineteenth-century invention of the actual camera, but the model of vision operating from the late 1500s to the end of the 1700s offering a centered human subjectivity a view of the things of the world.

Against the familiar teleology of the birth and gradual perfection of the camera obscura in the invention of first photography and then film, Crary argues that

the camera obscura model of vision and the nineteenth-century model of vision belong to two, "fundamentally different, organizations of representation" (32). According to Crary, a "modernization" of vision took place early in the nineteenth century in precisely those scientific discourses and philosophical toys usually regarded as extending and perfecting the perspectival realism of the camera obscura. He therefore maintains that the visual nihilism, autonomy, and abstraction usually associated with modern art (and with the rupture of unitary, centered bourgeois ideology) was also the precondition for the more popular tradition of mass-produced images and philosophical toys that occurred earlier in the century. For the fragmented, subjective vision evident in modern art is like the vision facilitated by the philosophical toys—thaumatrope, phenakistoscope, stereoscope, kaleidoscope, etc.—usually associated with the triumph of the camera obscura model of vision. Both upset the stable references of the camera obscura to construct the body of the observer as a surface of inscription on which plays a "promiscuous range of effects" (93).

Crary's argument has profound implications for the conventional notion that a continuous tradition of mimetic representation leads from the discovery of techniques of perspective to cinema. It also profoundly alters the standard division of twentieth-century art into a popular, "low," realist aesthetic that perpetuated the verisimilitude of the camera obscura and an elite, avant-garde modernism that severed connection to objective reality. For Crary maintains that the "observer" within one tradition is not so different from the "observer" within the other. The loss of perspective of the camera obscura model of vision plunged both the high-modern and the low-popular observer into a *"newly corporealized"* immediacy of sensations.

The older camera obscura model of vision, on the other hand, constructed a *"decorporealized"* observer of a world whose objective truths could be rationally known. With its model of a singular, centered point of view located inside a room contemplating the projected images of an exterior world, the camera obscura, as invoked by Locke, Descartes, Diderot, and others, was an act of idealized seeing whose ideality depended upon being "sundered from the physical body of the observer" (39). As Trinh T. Minh-ha has put it, in a different context, it was a representation of a stable reality "out there" for an idealized and dematerialized self "in here" (83). In other words, in the wake of the general breakdown of the model of an idealized observer separated from the object observed, we find a new model in which the boundaries between body and world on the one hand and body and machine for viewing on the other begin to blur.

Although Crary's adaptation of Foucauldian "technologies" and disciplines of the body doesn't address erotic or pornographic images directly, and though his study is remarkably insensitive to any notion of the gender or sexuality of different observers, it may nevertheless offer the beginning of a better understanding of the bodily sensations generated by images. Crary's argument that modernist discourses

and technologies constructed "newly corporealized" bodies of "observers" with no precedent in the disembodied regime of the camera obscura jettisons the baggage of a long tradition of mind/body dualism which tends to view all bodily sensations provoked by images as suspect. Without this baggage it becomes possible to discuss the effects of images on bodies without invoking the judgment that has been in effect since Plato in apparatus theory and feminist film theory: that the senses are duped by images; that the image is a lure whose seductive resemblances to reality must be countered by exposing the reality effect that deceives the body. This judgment is as powerfully embedded, for example, in Laura Mulvey's rousing conclusion to "Visual Pleasure and Narrative Cinema" calling for the destruction of visual pleasure and the accompanying reality effect as the solution to the problem of patriarchal ideology, as it is in Jean-Louis Baudry's "The Apparatus."[6]

A first step in this reassessment of the nineteenth-century viewers' relation to images might be to question the very term *spectator* and its built-in associations with the camera obscura notion of spectacle as theatrical scene. Crary prefers the term *observer* (from the Latin *observare*) to the term *spectator*, which has dominated film and photographic criticism, because it does not connote the passivity of onlooking but rather the *disciplined* activity of *observing* codes of vision, of conforming to a prescribed set of possibilities and conventions (6). While this notion of observer would seem to introduce the possibility of diverse observers, formed by the observation of different codes, Crary's strangely neuter conception of the observer, with no apparent gender or sexuality, fails to explore these differences.[7] He thus jettisons many potentially valuable lessons of the way power and pleasure have been differently coded in "the look" of different observers. Nevertheless, Crary's concept of this observer as an embodied presence on whom plays a promiscuous range of effects might be developed to understand what, in a spirit of compromise between the spectator-subject tradition and Crary's Foucauldian observer of techniques, might be called the *erotics of spectator-observers*. This erotics would be neither the result of the verisimilitude of the objects represented nor a response to a fundamental "absence" and "lack" in either subject or object. It would be seen to result, rather, from the many discourses and practices constructing the bodies of spectator-observers as an amalgam of disparate and decentered perceptions. In thus partially adopting Crary's term *observer* I do not intend to join him in degendering and homogenizing these observers but in breaking away from the centered, unitary, and disembodied model of vision that has reigned in both apparatus theory and its feminist critique.

Crary stresses that modernist vision exists both in the tendency to "visionary abstraction" exemplified in modern art *and* in the optical gadgets, such as the stereoscope, that Baudelaire derides. For once it was proven that the observer's experience of light had no necessary connection with an objectively existing actual light—that is, once it was proven that the observer's own senses could produce the perception, rather than register the phenomenon, of light—the representational

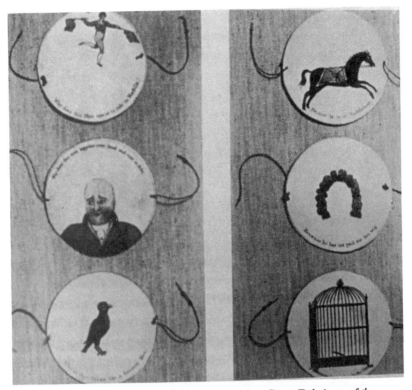

Fig. 2. Thaumatropes (c. 1825). From Jonathan Crary, *Techniques of the
Observer: On Vision and Modernity in the Nineteenth Century* (Cambridge:
MIT P, 1990) 105.

system symbolized by the camera obscura began to dissolve. Crary may go too far
when he implies that it disappeared altogether. It seems more likely that this model
survives as a rival system. However, the appearance of a model of vision in which
corporealized spectator-observers equipped with the capacity for being affected by
sensations that have no necessary link to a referent needs to be seriously explored
as a newly legitimized "way of seeing" and source of pleasure. In this new way of
seeing, both the scientific toys and modernist high art were significantly more
about the body's vulnerability to sensations than they were about the reality of the
referents causing these sensations.

Take, for example, the simple thaumatrope, literally "wonder turner" (figure 2).
Popularized in 1825, it was, according to Crary, the first scientific illustration of the
rupture between perception and its object to be sold as a toy. A twirling disc with,
say, a bird painted on one side and a cage on the other could, when spun, produce
an illusion of the bird in the cage. The experimental study of afterimages had dis-
covered that some form of retinal fusion occurred when sensations were perceived

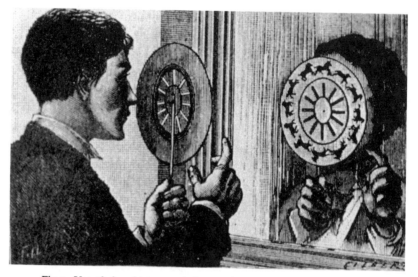

Fig. 3. Use of phenakistoscope before a mirror. From Jonathan Crary,
Techniques of the Observer: On Vision and Modernity in the Nineteenth Century
(Cambridge: MIT P, 1990) 107.

in quick succession. Thus the thaumatrope did not represent an object. It offered, rather, a hallucinatory fabrication of an image produced in the retina of the observer; only when the thaumatrope turns do we see the two elements combined. A similar, though not identical, rupture between perception and object occurred in the illusion of depth of the stereoscope (discussed below), as well as the many ways of exploiting persistence of vision to give the illusion of movement. One of the first of these was Plateau's phenakistoscope of the early 1830s (figure 3), which exploited retinal persistence to achieve an illusion of continuous motion. Though these effects were different, in each case the body of the observer produced subjective forms of vision. External objects were not observed; rather, the bodies of spectator-observers produced illusions of depth or movement.

Crary argues that a similar production of vision in the body is the very subject of J. M. W. Turner's great painting of 1843 anticipating the impressionism of vision in modern art, *Light and Color (Goethe's Theory): The Morning after the Deluge.* While on one level a painting "of" the sun, it can also be construed as a visual "fusion of eye and sun" (139). The vision of the sun, like the composite image of the bird in the cage of the thaumatrope, is not simply the eye's vision of an object "out there" but also an afterimage produced on the retina. The circular shape in the painting corresponds not simply to the referent of the sun but to the "pupil of the eye and the retinal field on which the temporal experience of an afterimage unfolds" (139–40). Though very different kinds of images, both the philosophical

toy's production of retinal persistence and Turner's vision of the sun as eye partici-pate in what Crary calls a "visionary" capacity of the body to produce sensations divorced from referents. What the eye of the observer sees, in both cases, is not simply an object but vision's own subjective perceptions.

In a sense, then, nineteenth-century technologies of vision do not simply en-courage the eye to see a referent "out there"; what the eye begins to "see" is that vision occurs from within a body and is therefore also of and in the body. The body, which had been a neutral or invisible term in the camera obscura model of vision, became a new "thickness" worthy of observation itself and producing its own kind of knowledge. This "carnal density of vision" (149) was as apparent, in a negative way, in Baudelaire's understanding of the stereoscope as it was, in a positive way, in Turner's impression of sunlight searing into the body.

Thus the sensations which we have seen Baudelaire so roundly condemn were not simply extreme examples of photography's capture of a debased, excessive reality, but a more telling seduction and capture of an exhilarated and ecstatic spectator-observer produced by new techniques of vision in a variety of ways throughout the nineteenth century. I would therefore argue that, though different in content and form from Turner's visionary abstraction, even—and perhaps espe-cially—the popular, mass-produced media explosion of "dirty pictures" should be considered as part of the same "modernized" vision.

We have already seen, for example, that even Baudelaire's condemnation of the stereograph was not directed at the stereographic images but at the spectacle of the body of a spectator-observer in thrall to this particular machinery of looking. Those "greedy eyes . . . glued to the peephole of the stereoscope" through which the body received a "glorious satisfaction" associated with the onanism of "self love" already suggest that a new masturbatory "carnal density of vision" was not simply a result of the realist form and content of the image. It was also an effect on the bodies of observers in thrall to the haptic immediacies of visual perceptions made possible by the combined phenomenon of the prevalence of mass-produced images linked with the body's new relation to the image.

Neither a passive form of submission to the power of the image nor a voyeur-istic mastery, this erotics of spectator-observers represents a new level of corpore-alized presence within the machinery of observation that breaks, perhaps not as thoroughly as Crary argues, but significantly nevertheless, with the camera ob-scura's decorporealized model. If it is possible to speak of a historically new cor-poreality of spectator-observers, then it should be possible to specify the particular nature of this corporeality as it functions in the media explosion of obscenity so often remarked upon by nineteenth-century historians. Yet it is here, precisely, that the phobic reaction to pleasures deemed either too physical, too masculine, or too photographically "explicit" come into play. In place of understanding we get blame: blame cast on photography's inherent obscenity; blame cast on the "male gaze" at a perennial "lack" which reduces to the sexual bodies of female objects; and finally

blame cast on the pornographic images themselves, which are quarantined from the general history of photography or film and only rarely included in any archive.

How, then, might we regard the form, content, and generic function of the kinds of images Baudelaire so disparaged but coyly disdained to describe? And how can we understand these images without "blaming" either a voyeuristic, fetishizing masterful "male gaze" or a photographic reality effect whose excess leads inexorably to an always unacceptable obscenity? How, in other words, can we invoke the volatile term *obscenity* without making it a special case, without bracketing it as the excessive extreme of realism or the excessive perversion of a normal sexuality? Perhaps the first step would be to characterize this new obscenity as part of a larger phenomenon in which images of all sorts have begun to seduce and excite a wide variety of viewers belonging to different classes, genders, and sexual orientations in the direct, multiple, and sensory ways suggested by Crary.

We might take as a starting point and example of this excitation Crary's discussion of the same stereoscopes that Baudelaire abhorred. This discussion is the culmination of his chapter on the various optical devices constructed to illustrate principles of optical perception. Perhaps surprisingly for the cinema-centric reader expecting a focus on the devices that bring us closest to the "invention" of moving pictures, Crary focuses his attention not on the temporal machines producing the illusion of motion but on the spatial machine producing the illusion of depth—the stereoscope. He asserts that, with the exception of photography, the stereoscope was the most significant form of visual imagery in the nineteenth century.

These viewing devices, found in a great many Victorian parlors, achieved the illusion of three dimensionality by superimposing two slightly discrepant images of the same object in an approximation of binocular vision (figure 4). The binocular vision of the stereoscope, usually understood as a further perfection of the realist camera obscura, actually, according to Crary, plunges the observer into a disunified field of different subjective intensities. It is impossible to reproduce here the stereoscopic effect; three-dimensional stereoscopic effects are today available only in plastic "View-Masters"—children's toys which limit the effect to three-dimensional views of subjects like Big Bird and Mickey Mouse. But if you have had occasion to look into one of these devices recently, I suggest you remember the effect, which is of the receding yet flattened planes Crary describes, but then imagine the image of figure 1 in the place of Big Bird.

Crary argues that depth is rendered in the stereoscope as a series of planes in which objects are separated into strangely flattened layers, creating an insistent sense of the "in front of" and the "in back of." Individual elements appear not as round volumes but as cutout forms arranged in receding planes. In contrast to the camera obscura's centered illusion of depth, the stereoscope offers a derangement of conventional optical cues that challenges the unified, homogeneous space of the camera obscura (125).

The eerie paradox of tangibility, the illusion of an accessibility to touch, the

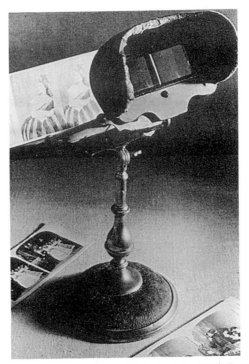

Fig. 4. Pedestal stereoscope, with photographs (1895). From C. W.
Ceram, *Archaeology of the Cinema* (New York: Harcourt, n.d.) 111.

sense of the proximity of object to viewer, are the most important illusions of the
stereoscope. The most pronounced stereoscopic effects were of objects in the near
or middle ground as is the case in figure 1 (124). The object's—or more precisely
in terms of the obscene stereoscopes that concern us, the organ's—tantalizing
closeness yet inaccessibility to touch gave the stereoscopes what most observers,
from Baudelaire to Crary, would agree is their peculiar obscenity. But what do we
really mean by this term?

 Although Crary's discussion of stereoscopes addresses the idea of obscenity,
and though it circles, somewhat coyly, around the understanding that many stereo-
scopes included contents that could be labeled obscene, he is interested in only the
most literal sense of the term: obscene as "off"-scene. His (entirely formal) argu-
ment is that the stereoscope shattered the *scenic* theatrical relationship between
viewer and object that reigned in the camera obscura by collapsing the separation
of the interiorized viewer from the exterior *scene* of representation into a paradoxi-
cal form of "*ocular possession*" (127). But it is precisely here that we need to shift
Crary's formal discussion of the stereoscopic image to one that includes content
as well.

If we do this we discover that the notion of ocular possession is entirely meta-phorical. Nothing is ever physically possessed in this erotic image of the woman who spreads her legs for the camera. The seemingly simple question, then, is how to define the pleasures of looking at such an image? Crary does not address this problem. As we have seen above, psychoanalytic apparatus theory has addressed it but only to repeat the idea that ocular possession is founded on the basic paradox of the nothing, or "lack," located in the body of the woman or in the system on which symbolization is based. Christian Metz, for example, has described the basic cinematic signifier as an absence that evokes an impossible presence. Cinematic theories of the apparatus speak eloquently of absence, lack, holes, and impossible wholes, but rarely of the bodily sensations produced by the image-machinery.

According to these theories what is absent or "lacking" in the case of erotic and pornographic images is the erotic object itself whose "real" material sexual pleasure and use entails touch. Yet I would argue that physical touch, and not its ocular substitute, *is* a very tangible sensation produced by these images. However, this touch should be conceived not as the impossible, metaphorical touch of the absent object by the spectator but literally as the real touch of spectator-observers' bodies with both the machinery of vision and themselves. Let me try to explain.

In her discussion of the stereoscope, Solomon-Godeau borrows from the French art critic Jean Clair, who writes: "the gaze is an erection of the eye" (229). We can notice in a figure of this sort an attempt to metaphorically endow vision with something of Crary's "carnal density"—to, in effect, give the nerve endings of the ocular organ something of the tumescent sensation of the most powerful locus of touch in the male body. But in Solomon-Godeau's formulation the "erect" gaze sees only the "hidden recesses of the feminine"; these stereoscopes are, for her, primarily "about the revelation of the woman's genitals" and primarily for the arousal of male genitals via "ocular possession." The problem with this formulation is that, while it applies well enough to the conventional erotic photo where women's genitals, whether visible or occulted, are what the image is most importantly about (as in figure 1), it does not so readily apply to all examples of still- or moving-image pornography (as in most of the rest of the images to be discussed below). More significantly, as a model of vision, this notion of the erection of the eye reproduces, for all its metaphorical allusion to embodied sensations, the phallic, centered, and disembodied perspective of the camera obscura model of vision. Seeing and feeling from the point of view of the phallus becomes, in this model, the only form of vision and sensation.

Such has been the great "phallacy" of gaze theory. If we only think of erotic and/or pornographic still or moving images as tantalizing offerings of a flesh that isn't there, then such images must always, as Solomon-Godeau puts it, fail to "deliver the goods" (231). Yet one of the paradoxes of erotic and pornographic images is that, despite the many protestations to the contrary by observers who describe the imagery as repetitive and/or boring, such images do "deliver the goods" of

bodily sexual arousal and may, at their limit, indeed culminate in Baudelaire's masturbatory "glorious satisfaction." Touch, in this case, is activated by but not aimed at, so to speak, the absent referent. Though quite material and palpable, it is not a matter of feeling the absent object represented but of the spectator-observer feeling his or her own body. It is also possible that this arousal and satisfaction may consist of much more than penile erection and ejaculation aimed at intangible, hidden recesses of the imaged female body; it may consist, as I hope to show below, in sensations registered in many different bodies and organs at the sight of many other, different, bodies and organs.

The problem is that our thinking about these erotic and pornographic pleasures has been limited by the lingering Cartesianism of the camera obscura model of vision which continues to deride sensations attached to the body and to oppose them to a putatively more "pure" spirit or thought. Despite its focus on the visual pleasures of cinema, psychoanalytic film theory's preoccupation with the visual "senses at a distance" has perpetuated this mind/body dualism by privileging the disembodied, centered gaze at an absent object over the embodied, decentered sensations of present observers.

However, if modernist vision in both popular- and high-art forms has, as Crary argues, already been breaking down this "mastering" distance at all levels, and if commodified images and high art both seduce and excite the body—though in different ways—perhaps we should abandon metaphors such as "erection of the eye" in favor of more literal statements of bodily sensation. Rather than dismiss this sensation as too crude or obvious or as too phallic to merit female consideration, we might view it as exemplary of the "carnal density" of one kind of modernist and postmodernist vision: an ecstasy that is in the body but produced in relation to the image. The question we need to ask is therefore not how to prevent such excitation but, since it is one limit case of the erotics of one kind of spectator-observer, (1) whether the excited penis should be equated, as it has been, with the phallus; and (2) whether this excited penis is the dominant sensation elicited by pornography?

It is something of a truism that the proliferating images that mark modernist vision tend to shift the observer from a connection with tangible objects located in space and time to a connection with images whose spatial and temporal mobility depends upon their immateriality. Crary himself calls this the "dissociation of touch from sight," an "unloosening of the eye" from references to tactility and thus from a cognitively unified field. I would stress, however, that while this mobile eye dissociates itself from the stable frame of references offered by the camera obscura and thus from the centering of the observer's body as unified perspective on a scene "out there," this mobile body of modernist (and certainly postmodernist) vision is not disembodied; touch is not dissociated from sight; sight engages carnal density and tactility, as well as gender and sexuality, precisely because it is decentered and "unloosened" from a unified field.

Tactility is engaged in a number of ways usually not mentioned in accounts of

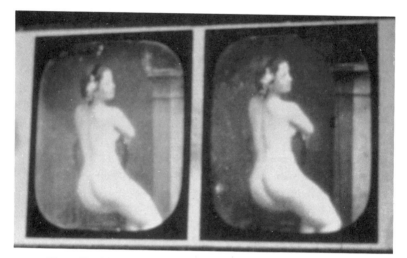

Fig. 5. Hand holds stereograph. Frame enlargement from *Film before Film, or What Really Happened between the Images*. Dir. Werner Nekes. Germany, 1985.

Fig. 6. Hand holds flipbook. Frame enlargement from *Film before Film, or What Really Happened between the Images*. Dir. Werner Nekes. Germany, 1985.

Fig. 7. Fingers form legs of picture puzzle. Frame enlargement
from *Film before Film, or What Really Happened between the
Images*. Dir. Werner Nekes. Germany, 1985.

visual pleasure. First of all there is the new tactility of the image itself: the mass-
produced image, whether lithograph, photograph, or stereograph (figure 5), is ac-
cessible to handling in a way that painting, for example, is not. It is passed around
from hand to hand, pinned up, and, in the case of erotic and pornographic images,
often physically present as incitement to masturbation and other sexual acts. Sec-
ond, there is the tactility of the body's engagement with the particular apparatus
of vision. Almost all of the philosophical toys Crary discusses have an important
dimension of manual play. This is true of the thaumatrope (figure 2) and the phen-
akistoscope (figure 3), as well as the basic flip book (figure 6), or the many picture
puzzles, such as that illustrated in figure 7, in which the hand actually becomes part
of the picture. In a more heavy-duty mechanical mode there is also the hand-crank
of Muybridge's zoopraxiscope or Edison's mutoscope (figure 8).

The mutoscope deserves a special note since it exists to this day in some ar-
cades and museums as a perfectly functioning erotic toy. (I recently cranked one
in the Museum of the Moving Image in London with images that appeared to be
from the fifties showing a scantily clad woman climbing a ladder). The device is an
elaborate flip book made up of cards which, when turned by the viewer, give the
illusion of motion. Although frequently discussed as a stage in the development of
the cinema proper, the flip book system of the mutoscope was actually developed

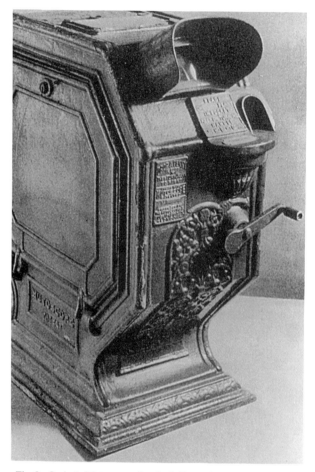

Fig. 8. Casler's Mutoscope (c. 1890). From C. W. Ceram, *Archaeology of the Cinema* (New York: Harcourt, n.d.) 135.

after the more advanced electrically driven kinetoscope containing loops of film. It offered, in other words, an alternative pleasure to the kinetoscope consisting, I would argue, in the manual pleasure of its functioning. Like today's videotape and laser disc the observer can control the speed and direction of the repetition of segments of action.

We might better appreciate the manual nature of these repeatable pleasures by looking at a few images from a 1920s stag film whose narrative depicts a mutoscope in use. In this film (*A Country Stud Horse* U.S., circa 1920) a man peers into a mutoscope (figure 9).[8] The next shot shows what he sees: a woman stripping and wiggling in erotic poses that are not unlike the still poses of the erotic stereographs (figure 10). The next shot shows the man beginning to masturbate with one hand

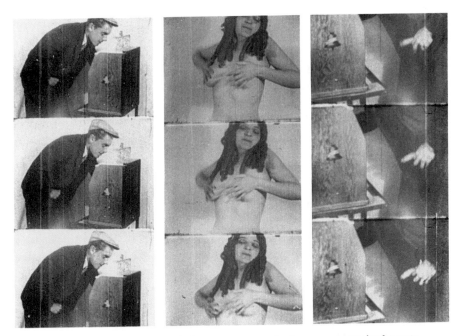

Figs. 9, 10, and 11. Man looks into mutoscope; naked woman as seen in the muto-
scope; man masturbates while looking into mutoscope. Frame enlargements from *A
Country Stud Horse* (c. 1920). Courtesy The Kinsey Institute for Research in Sex,
Gender, and Reproduction, Bloomington, IN.

while cranking with the other (figure 11). The rest of the film shows the man inter-
rupted in his viewing by a real woman and the sexual action that ensues apart from
the machine (except of course that it is the machinery of cinema that makes this
activity visible too).

Let's pause, for a moment, as teleological and technologically determined pre-
histories of cinema have not paused, on this image of the manual, tactile pleasure
of this male observer with his eyes "glued to the peepholes," one hand cranking
the machine and the other "cranking" himself. For, despite the difference in ma-
chines, it was an "observer" very much like this that Baudelaire described. And it
is the idea of a male observer very much like this that today's feminist antipornog-
raphers so abhor: a man presumably using the pornographic machine to "possess"
a woman.[9] My point, however, is that such a scene is not about possession but about
a very real stimulation of the (male) body via the image-machine. It is entirely
possible, like Baudelaire, to deride such stimulation; it seems so . . . mechanical. But
sexual activities have an element of the mechanical, of the body as machine, that is
always easy to dismiss, unless, of course, one is caught up in those motions, and
emotions, oneself.

Crary touches all too lightly upon this mechanical tactile pleasure when he

writes of the observer's engagement with the stereoscope. "The content of the images is far less important than the inexhaustible routine of moving from one card to the next and producing the same effect, repeatedly, mechanically" (132). Crary's tone betrays a dismissal of the "low" contents of such images as beneath mention; he is also unwilling to consider the actual uses of, as opposed to the scientific discourses that explained, these devices. Yet in this mechanical, tactile pleasure we encounter another form of the breakdown of the camera obscura's distanced, theatrical perspective on the object. The spectator-observer plays with the machinery and produces the particular illusion that gives pleasure. Just as modernist vision in general entails a new awareness of the body's own production of perceptions, so in the flipping, cranking, and manipulation of cards the body itself becomes a machine producing views. This body moves, and is in turn moved by, the machine.

How, then, does gender affect this movement? It is obvious that gender and sexuality matter in vision infinitely more than Crary cares to discuss. In chapter 1 of her excellent new book on postmodernism and film Anne Friedberg argues that in the nineteenth century new technologies of vision made it possible to *move* observers to a different time and place without literally moving them from their seats. One of Friedberg's important points is that a "proto-postmodernist" virtual movement of the body in space and time made possible by a new culture of the image permitted a female "*flânerie*" that had been forbidden women in the public streets. This *flânerie* of the "*flâneuse*," as Friedberg calls her, was practiced in real space and time as window shopping but also as the virtual movement through space and time offered by the diorama, panorama, stereoscope, photograph, mutoscope, etc. The paradoxical immateriality of the new image commodity made it possible for women to be seduced by images in a way they had not been seduced by objects. In other words, the image culture of nineteenth-century modernity involved a shift from the commodity as object to the commodity as a form of visual experience. While Friedberg's emphasis is on this virtual nature of the movement in space and time, I would like to stress the more literal movement of women's bodies engaged with sensational images.

Oddly enough it is Baudelaire, that original male *flâneur*, who may be one of the first to have told us about this "moved" woman. If we read on in the passage quoted earlier—Baudelaire's condemnation of "natural man's" love of obscenity illustrated by enthrallment to the stereoscope—we begin to see that what offended Baudelaire more than the spectacle of a man with "greedy eyes" glued to peepholes was a much more outrageous spectacle of an unnatural woman similarly glued:

> I once heard a smart woman, a society woman, not of my society, say to her friends, who were discreetly trying to hide such pictures from her, thus taking it upon themselves to have some modesty on her behalf: "Let me see; nothing shocks me." That is what she said, I swear it, I heard it with my own ears; but who will believe me? (87)

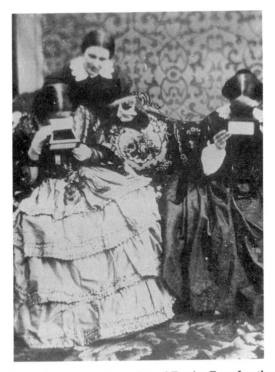

Fig. 12. Stereoscopes in use. Second Empire. From Jonathan
Crary, *Techniques of the Observer: On Vision and Modernity in the
Nineteenth Century* (Cambridge: MIT P, 1990) 123.

While earlier in the essay Baudelaire was offended by the notion that a man
might be capable of "deriving ecstasy" from images that are "unworthy" of the
"natural means of true art" (86), here he is truly scandalized by the possibility
that a woman might do the same. Yet I think we need to take Baudelaire at his
word and consider the possibility that an ecstasy provoked by images did indeed
take place in the bodies of some women. Indeed, we need to give some thought to
why it is that such seduction by images seems so shocking that many of the most
strenuous effects of censorship were performed in order to protect women from
seeing such images. Yet the Victorian or Second Empire parlor stuffed with plush
furniture, magic lantern, and stereoscope was a private place where upper-class
women—as in this picture (figure 12) from Crary's text—might very well have en-
gaged in both the virtual movement *of* the body and the physical movement *in* the
body.

It is remarkable how little these women spectator-observers have been consid-
ered given how much censorship has taken place in their name (see, for example,

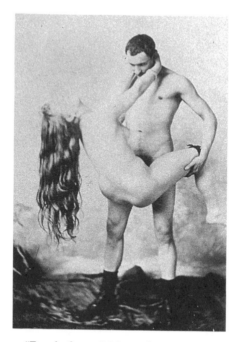

Fig. 13. "French 1890–95": Man and woman copulate in
standing position. Courtesy The Kinsey Institute for Research in
Sex, Gender, and Reproduction, Bloomington, IN.

Kendrick and de Grazia). I have been suggesting that one contemporary reason for
this omission may have to do with the dominance of a model of a disembodied and
distanced "male gaze" that phallically masters the objects represented, rather than
a plurality of differently disciplined spectator-observers seduced in different ways
by a range of eroto-pornographic images. This male gaze model has given rise to
the assumption that all visual eroticism and pornography is *for* men and *about*
women. There is of course very little documentation—and a great deal of vilifying
assumption—about who consumes this once entirely underground material. Gross
generalizations about the masculine, infantile, adolescent, or sadistic nature of the
material usually substitute for fine distinctions about form, content, or diverse
pleasures proffered.

However, even a cursory look at the full range of erotic and pornographic im-
ages produced in the nineteenth century and into the twentieth century—whether
drawings, photographs, stereographs, or moving images—suggests the existence of
a greater variety of spectator-observers than is usually assumed. For example, while
it may be safe to assume that the *erotic* images depicting women are predominantly
for heterosexual men—though what is to keep a female observer from finding

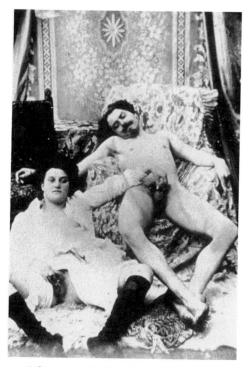

Fig. 14. "1890–1900": Erotic pose of naked man and semi-clothed woman. Courtesy The Kinsey Institute for Research in Sex, Gender, and Reproduction, Bloomington, IN.

pleasure in them?—there is a gigantic category of what might be called *heterosexual hard-core* images—whether still, animated by hand, or moving through a projector—which depict the sexual acts of heterosexual couples. These images are not only about women nor should they be presumed to be only for men. They comprise a vast selection of male and female figures engaged in all kinds of sexual activity (figure 13) or, more rarely, passively posing together (figure 14). This vast tradition of still photography and stereographs, and including motion pictures discussed below, is usually overlooked in favor of the more artistically acceptable photographic pose of the woman alone. Yet it is in this more readily censored tradition, more than in the quasi-academic erotic poses of nude or seminude women, that it becomes easier to imagine a woman spectator-observer fascinated and aroused by what she sees. The important difference lies in the fact that the erotic pose is passive while the hard-core sexual acts are, by definition, active.

There is also a considerable tradition of male homosexual erotic and hard-core imagery (figure 15) which is not at all about women, though presumably not for them either. This tradition, too, cannot be subsumed under a hegemonic heterosexual "male gaze." In these images the total absence of gender difference among per-

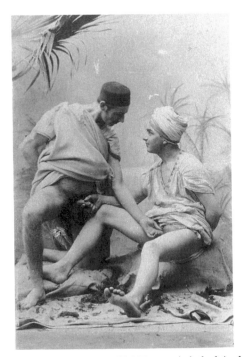

Fig. 15. "French c. 1923–25 (?)": Two semi-clothed Arab males
fondle one another. Courtesy The Kinsey Institute for Research in
Sex, Gender, and Reproduction, Bloomington, IN.

formers, as well as between performers and spectator-observers, challenges many
common assumptions about the active, powerful phallus. As Tom Waugh has ar-
gued in an article on the gay films and photos of the Kinsey Institute, "in gay porn,
power roles are not preassigned and thus tend to be in flux—interchangeable, am-
biguous, spontaneous, multivalent and egalitarian" ("Pornography as History" 32).
Gay porn, as Waugh was one of the first to point out, automatically threatens con-
ventional hierarchies by violating patriarchal taboos. Those critics who have simply
substituted active/passive for a male/female gender divide, arguing that the man
who is penetrated is treated like the woman, grossly oversimplify the sexual (as
opposed to the gender) dynamics of such exchanges.[10] Finally, there is another
lively tradition of discipline and bondage (figure 16) whose sexual and gender dy-
namics cannot easily be equated with any of the above traditions.[11]

 This is not to say that women have not been systematically excluded as spec-
tator-observers of many of these kinds of images. Such exclusion appears to have
taken place with moving-image pornography in the era of the illegal stag films,
when film exhibitions were confined to exclusively male clubs or brothels, where
women, if present, were workers and not pleasure-seeking customers.[12] We should

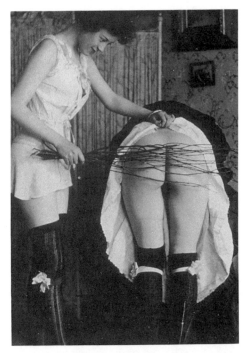

Fig. 16. "C. 1895–98": Woman birches another woman.
Courtesy The Kinsey Institute for Research in Sex, Gender, and
Reproduction, Bloomington, IN.

beware, however, of assuming that all women of all classes have always been ex-
cluded as spectator-observers. Baudelaire suggests that in the mid-nineteenth cen-
tury a certain kind of upper-class woman may very well have been in a position to
observe erotic and pornographic images. And as the technologies producing these
images became cheaper later in the century and erotic and pornographic images
circulated widely though most often illicitly, it seems quite likely that a wider range
of classes of both sexes had an opportunity to observe such images.[13]

Consider, for example, the French image from 1895 (figure 17), which bears the
mark of a cheap studio-painted backdrop with its painted-in joke of the reverse-an-
gle view afforded the male observer in the surf. I would guess, although I don't
know for sure, that such images were less expensive and thus perhaps easier to ob-
tain than the more elaborately produced examples in a series of images depicting
a wedding night (figures 18 and 19). I would also guess, although again I don't know
for sure, that some of the vast numbers of such photos were bound to find their way
into the hands of women, even if they were not explicitly marketed to women.

Looking at the wide range of this erotic and pornographic material (of which
these few images are just the tiniest fraction), we see that they tend to span a con-

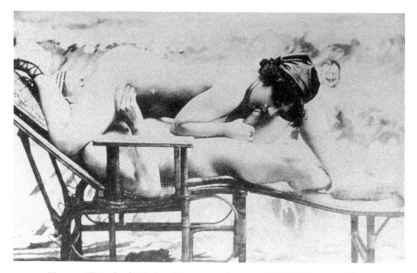

Fig. 17. "French 1895": Seaside, man and woman in "69." Courtesy The Kinsey Institute for Research in Sex, Gender, and Reproduction, Bloomington, IN.

Fig. 18. "French 1897–1900 15–1": Wedding Series 1. Courtesy The Kinsey Institute for Research in Sex, Gender, and Reproduction, Bloomington, IN.

Fig. 19. "French 1897–1900 15–2": Wedding Series 2. Courtesy
The Kinsey Institute for Research in Sex, Gender, and Reproduc-
tion, Bloomington, IN.

tinuum from what might be called *erotic show* to *hard-core event*. One pole of this
continuum (the more soft-core, erotic side) offers up an aestheticized "truth" of
the body, in the form of a posed exhibition that sometimes involves, in the case
of still photography and sometimes in the case of moving-image photography, the
look of the object back at the camera (figure 22). Solomon-Godeau, who devotes
her excellent analysis to this side of the continuum, maintains that the codes that
characterize it are governed by a shift from a conception of the sexual as an activ-
ity to a new emphasis on specularity. However, she acknowledges that sometimes
activity and spectacle converge.

I propose that this action side of the continuum is neither an exception nor an
aberration but simply the pole of eroto-pornographic imagery that, for all kinds of
reasons, has not been much examined. Whether still or moving, such images have
tended to be excluded from histories of photography and film. This more hard-core,
pornographic side of the continuum attempts to render the "truth" of sex not as
exhibitionistic pose but as act. Yet even in this hard-core tradition the aesthetic
problem is that what appears to be activity must still be staged as a sight.

For example, in the wedding sequence (circa 1897) (figures 18 and 19) we have
a photographic series which can be read, in some ways, as an anticipation of the

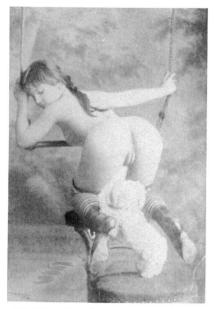

Fig. 20. "C. 1884–90": Naked woman on swing. Courtesy The
Kinsey Institute for Research in Sex, Gender, and Reproduction,
Bloomington, IN.

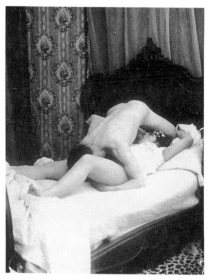

Fig. 21. "French 1897–1900 15–19": Last photo in Wedding
Series. Courtesy The Kinsey Institute for Research in Sex, Gender,
and Reproduction, Bloomington, IN.

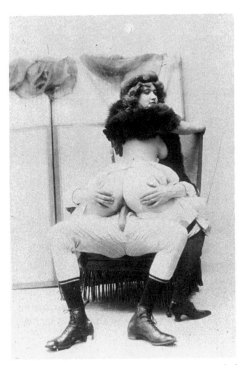

Fig. 22. "C. 1900's": Man and woman copulate on chair.
Courtesy The Kinsey Institute for Research in Sex, Gender, and
Reproduction, Bloomington, IN.

soon-to-appear stag film. Like a stag film, the photos narrate a sexual event which
might be said to conclude with the last image in the series (figure 21). However,
each individual shot is carefully composed as a still photo to show off the full bod-
ies of the performers and to center each stage of the genital or oral-genital activity
in ideally visible moments. Solomon-Godeau calls this posing for "maximum visual
access" (235).[14] Sometimes the participants ignore the camera as they engage in
this action, as they do here, and sometimes one or more of them may look at the
camera (figure 22).

 Considering the whole range of erotic and pornographic photographic images
from the first erotic daguerreotypes to the hard-core stag film, we see something
like the following general development: In the first daguerreotypes, as Solomon-
Godeau shows in her essay, figures are posed and action is technologically difficult
to render so there is an obvious favoring of the erotic nude pose. But even in such
poses hands may be posed to hint at action. Then with the development of more
"instantaneous" forms of photography and shorter exposure lengths, new codes of
action appear, as in figure 23, obviously posed yet also connoting action.

 With the arrival of moving-image photography, and the stag films that followed

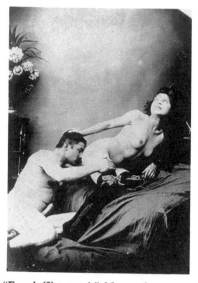

Fig. 23. "French (?) c. 1900's": Man performs cunnilingus or analingus (?) on woman. Courtesy The Kinsey Institute for Research in Sex, Gender, and Reproduction, Bloomington, IN.

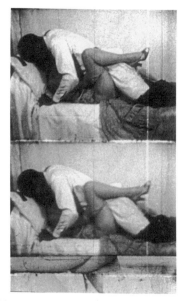

Fig. 24. Man and woman copulate on bed. Frame enlargement from *A Country Stud Horse* (c. 1920). Courtesy The Kinsey Institute for Research in Sex, Gender, and Reproduction, Bloomington, IN.

Fig. 25. "Meat Shot." Frame enlargement from *A Country
Stud Horse* (c. 1920). Courtesy The Kinsey Institute for Research in
Sex, Gender, and Reproduction, Bloomington, IN.

soon after, we find a cinematic hard core in which sexual acts no longer need to be
posed. Sexual acts could now be literally "caught in the act" whether in full shots
as in this moment from the film about the mutoscope discussed earlier (figure 24)
or in confirming, fragmented closeups that soon become a staple of the genre (fig-
ure 25, also from the same film). Though centering and visibility are still impor-
tant.[15]

If we now return to the tradition of hard-core photographic images produced
after the turn of the century we see new conventions of activity as in this mid-
twenties example of off-center movement (figure 26). Here the connotation of
action seems to derive from a photographic imitation of cinematic flux in which
bodies are not perfectly centered at every stage of an action. Another post-cine-
matic convention of still pornography (figure 27) that seems directly borrowed
from cinema is this Japanese still photo with a circular insert (an insert depicting
insertion, no less) which approximates the closeup that might follow the full shot
in a stag film. Other, more curious, codes connoting action occur in this scatologi-
cal image from the late 1890s (figure 28) where the movement of the urine into the
pot is scratched on the negative by hand, as if the action would not be sufficiently
visible without this emphasis.

In this admittedly superficial survey we can see a general tendency, over time,

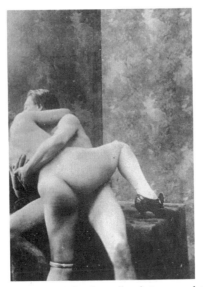

Fig. 26. "C. 1923–25": Semi-standing, hetero copulation.
Courtesy The Kinsey Institute for Research in Sex, Gender, and
Reproduction, Bloomington, IN.

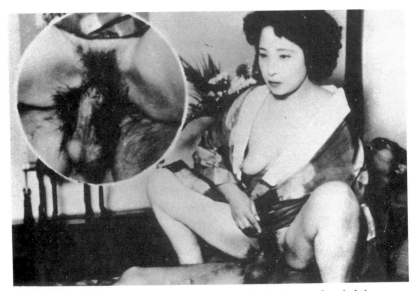

Fig. 27. "C. 1948–54" (Japan): Woman sits on man. Insert of genitals in
close-up. Courtesy The Kinsey Institute for Research in Sex, Gender, and
Reproduction, Bloomington, IN.

Fig. 28. "French c. 1885–90": Elaborately dressed women urinate into pot. Courtesy The Kinsey Institute for Research in Sex, Gender, and Reproduction, Bloomington, IN.

for codes of hard-core action, as well as a fragmentation of this action, to expand. But this does not mean that codes of action supplant codes of erotic posing. As we have seen, the pose continues to be very important in the stag film and hard-core action is frequently alluded to in the most static pose. Indeed, a tension between pose and act is an important part of the fascination and appeal of every erotic and pornographic image, plunging spectator-observers into a perpetual indeterminacy about the status of the objects observed: We ask, in effect, is sexual activity really happening? Is it staged for my vision?

In noting a general shift from pose to act we should not assume, as does the technological determinist who "blames" obscenity on the invention of photography, that the greater the representational realism the greater the obscenity and thus, automatically, the greater the misogynist abuse of women as pornographic objects. Rather, if we need to attach blame for the existence of pornography—and I am less and less sure that this is what we should be doing when we examine these images—responsibility must go to the social and psychic construction of a wide

variety of disciplined spectator-observers capable of finding pleasure in them. While the illegal, suppressed nature of these images makes it especially difficult for us to learn much about these spectator-observers, the evidence of the images themselves can at least allow us to speculate that the mid- to late nineteenth century was a period in which a new porno-erotics of corporealized observation began. This porno-erotics consisted of an unprecedented seduction of a variety of different bodies by a variety of different images. Perhaps the most important point to be stressed about this porno-erotics—whether erotic poses or the more suppressed pornographic acts—is that it is both diverse and—if the word can be neutrally invoked in Foucault's rather than Freud's sense of the word—perverse.[16] As a historically determined "implantation of perversions," this porno-erotics cannot be reduced to dominant power of the phallus. Indeed, it is a mistake to attribute to the phallus an omnipotence and mastery that it does not have in modernist vision.

Take, for example, the following instance of a hard-core stag film that seems to me to illustrate the "carnal density" of corporealized observation I have been trying to describe. As I have already suggested, illegal stag films—as opposed to the later feature-length legal pornos that have dominated since the seventies—tend to be the most misogynist of all pornographic forms precisely because female observers were socially more excluded from their reception than other forms. So I am not citing a benign example of hard-core cinematic images that might have been enjoyed by women but a film made by men, for men, primarily about women and decidedly phallic.

This 16mm, American, black-and-white, silent, thirteen-minute film from the late sixties is, in most ways, an unexceptional example of the primitive, not quite narrative stag form. Entitled *Arcade E* for no reason that I can ascertain, it consists of a series of actions whose narrative discontinuity is typical of the primitivism of stag film: a woman strips, shows her genitalia to the camera, and then engages in a slow, rather languorous number with another woman. Although this so-called lesbian number has a kind of erotic conviction and intensity that is not often seen in such numbers,[17] it still functions conventionally as "warm-up" to more phallic action; it is this action that interests me as one emblem of the erotics of heterosexual male spectator-observers posited by the film.

An erect penis appears at the bottom of the frame (figure 29). Soon the two women begin to perform fellatio upon it (figure 30). As they do so they alternate looking at the penis and, in individual closeups, looking from a very close distance into the camera, with a rather disturbing intimacy (figure 31). With a discontinuity typical of stag films, tight closeups of another woman, also performing fellatio, replace the first two women. The camera tilts down and we see what seems to be the same erect penis manipulated to ejaculation by the hand of one of the women (figure 32). Then another woman appears and engages in autoerotic activity, and so the "action" continues with no narratively definitive climax or end.

While there is no question that the vision offered here is phallic, and is certainly misogynist in its presentation of various women serially servicing an anony-

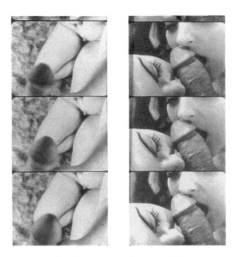

Figs. 29 and 30. Penis appears at bottom of frame; two women fellate penis. Frame enlargements from *Arcade E* (c. 1968). Courtesy The Kinsey Institute for Research in Sex, Gender, and Reproduction, Bloomington, IN.

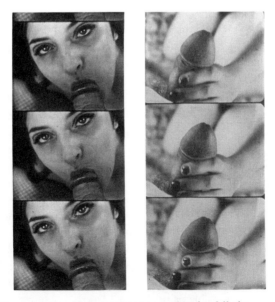

Figs. 31 and 32. Closeup of woman performing fellatio; closeup of hand on penis. Frame enlargements from *Arcade E* (c. 1968). Courtesy The Kinsey Institute for Research in Sex, Gender, and Reproduction, Bloomington, IN.

mous male organ, it does not necessarily follow that this vision offers a distanced, objectifying, and all-powerful mastery. For while everything occurs in this film for the pleasure of the disembodied phallic organ, this organ is too palpably caught up in the "carnal density" of the film's vision to be conflated with the symbolic phallus. In fact, this particular film shows the importance of seeing the penis first as a penis before attaching to it any symbolic meaning.

I think I was about halfway through what seemed to be a routine stag film when it dawned on me that the disembodied penis whose turgidity seemed so important to the women fellating it belonged to the cameraman. This explained the odd downward angle of many of the shots. The cameraman, the immediate observer of the "scene" of sexual activity, was also a participant in that scene. His "gaze," as well as the organ that was its primary object, was thus not disembodied at all; it offered, rather, a perfect illustration of the idea that what modernist vision sees is not so much the object "out there" viewed from a distanced and safe position "in here" but a kind of self-regard, the blurring of the distinction between vision in here and object out there.

Like Turner's painting of the sun that is also a painting of the eye of the observer, or like the image of the bird in the cage which exists only in the eye of the observer of the thaumatrope, *Arcade E* offers yet another variation on what Crary has identified as the rupture of the camera obscura model of vision: a fusion of the organ of vision with the mechanism of vision—in this case the camera-eye with the cameraman's eye—and the organ observed—in this case the cameraman's penis. The film offers a clearly gendered and quite literal example of the "obscenity" of which Crary speaks: the rupture of the dematerialized, decorporealized, unified centered vision of a theatrical scene and the plunging of the observer's own body into a transparent immediacy of eroticized self-presence.

Although *Arcade E* is an exceptional stag film—I have never seen any other work of silent moving-image pornography in which the body of the observer is also the body observed[18]—I would like to posit it as exemplary of the porno-erotics of an era in which the distinction between inner and outer, observer and scene, typical of the camera obscura model of vision has collapsed. What we see enacted here is a "carnal density of vision" in which the senses of the observer are not disembodied, distanced, and centered as in the camera obscura, but decentered, fragmented, vulnerable to sensation, and directly engaged. It is entirely possible to invoke terms like *phallocentrism, castration*, and *lack* to explain this erotics since the tumescent penis obviously is central to the image, but if so we must adjust the terms to the realities of a vision that no longer has the kind of idealized absence and centering that phallo*centrism* implies. Phallocentrism has an imaginary unity that depended on its never being seen. The phallus is powerful, and central within this symbolic precisely because it isn't visible as penis.

In the new corporeality of spectator-observers, of which visual pornographies such as this are prime, but not exclusive, examples, everything is visible; power and

pleasure are not centralized in an imaginary, centered gaze but dispersed over a variety of bodies and organs. Jean Baudrillard, speaking of a much later period and of another, postmodern, era of communicative technology—though one that Anne Friedberg has argued has a greater continuity with so-called modernist vision than is often assumed—has applied the term "ecstasy of communication" to our contemporary obscenity, an obscenity in which there is "no more spectacle, no more stage, no more theater, no more illusion, when everything becomes immediately transparent, visible, exposed in the raw and inexorable light of information and communication" (21–22).

Although Baudrillard writes of our contemporary immersion in electronic forms of communication, and Crary's argument is about modernist vision that was immersed in a very different technology of mechanical reproduction, both share an acute awareness that the traditional separation between scene and spectator has in both instances dissolved. In both cases images are seductive, they engage the eye *and* the body. But they do not proffer imaginary possession, and they do not remove us from the self-presence of the body. Although neither has much to say about actual erotic and pornographic images, it is important to note that the obscenities to which they both allude do not result from the unprecedented verisimilitude of the indexical photographic sign.

Erotic and pornographic images—whether picture puzzles, flip books, photographs, stereographs, or motion pictures; and whether erotic poses or hard-core actions—are important precisely in their engagement with acute bodily sensations that may be much more central to modernist vision than previously thought. For this reason it may be time to reconsider this tradition from a new direction. Instead of deriding its sensationalism as the obscene excess of the realism of the camera obscura's realist representation, and instead of bracketing it from the sublime sensations provoked by modern art, we might do better to think of the way sensation pervades nineteenth-century vision on many levels, including the sexual. Nor should these sensations be subsumed under the disembodied eye of a phallic gaze. The question worth asking, then, is not "is the gaze male," but rather, when, where, and how has there been room for the corporeal presence of other spectator-observers?

NOTES

I thank the Center for Twentieth Century Studies, its director Kathleen Woodward, and Patrice Petro, organizer of the Visual Culture conference and editor of this volume, for giving me the opportunity to learn about photography through this conference. I would also like to thank Abigail Solomon-Godeau, Anne Fried-

berg, Tom Gunning, Rick Rentschler, and Patrice Petro for generous advice and criticism on this article.

1. Beatrice Farwell discusses the early, prephotographic phases of this "media explosion" of popular mass-produced images (mostly lithographs) which, she argues, "melted into" the later photographic iconography (10). Most of the evidence of this proliferation of dirty pictures comes to us from accounts of police raids. H. Montgomery Hyde (1964) cites a raid in 1845 on a purveyor of pornography in London's Holywell Street which seized 383 books, 351 copperplates, 12,346 prints, and 188 lithographic stones. Stephen Heath cites a *London Times* report of 1874 that a police raid on a single shop seized more than 130,000 obscene photos. Peter Gay also affirms that pornography of all sorts was massively produced and, for the knowing, readily available in certain parts of Paris (around the Palais Royal) and in other major European cities (358–59). What isn't clear from the above sources, since evidence, as usual in these matters, is the simple enumeration of the quantity of items seized by police rather than any textual analysis of quality and kind, is the prospective customers for such materials. Certainly, as Gay suggests, "the invention and rapid perfection of the photograph" served to intensify the alarm of the defenders of morals. Gay suggests that it is no coincidence that 1857 saw the trials of Flaubert, Baudelaire, and Sue in France and the British introduction of the Obscene Publications Act (359). But as Walter Kendrick has suggested, the real cause for such alarm may very well have resided in the historically new phenomenon made possible by both mass-produced literature and images: the emergence of women as "observers" of both.

2. It is Stephen Marcus who made famous this "dark underside" perspective on pornography in his famous *The Other Victorians*. However, more recent historical scholarship, such as Peter Gay's comprehensive study of the entire nineteenth-century European bourgeois culture's cultivation of the senses, suggests that Marcus's picture of a generally prudish, sex-denying Victorian middle class with its sexually promiscuous "others"—almost always lower-class women and upper-class men—amounts to a caricature of the complex "education of the senses" taking place in the nineteenth century. As noted in note 1 above, Walter Kendrick points to the accumulation of concern about pornography as coinciding with the emergence of a middle-class woman reader. Foucault, too, argues against Marcus and the Freudian "repressive hypothesis" that Victorian sexuality was an effect of repression rather than discursive production.

3. Qtd. in Solomon-Godeau 222. The full essay appears in Trachtenberg.

4. In *Hard Core*, in a chapter called "Prehistory," I quote a poem called "The Origin of Porno" which beautifully leaps from the academic question about the truth of body movement posed by Muybridge's motion studies of the horse—"Is there ever a moment when all four feet leave the ground?"—to the pornographic "answer" which permits the most detailed knowledge of the body's "truth." The poem concludes, "and so we invent pornography." Today I would say, despite my fondness for this poem, that photographic realism, per se, is not sufficient explanation for the invention of visual pornography.

5. I made an initial attempt at this project, still working within a psychoanalytic paradigm, in "Film Bodies."

6. In "The Apparatus" Baudry undercut his historical excavations into cinematic "prehistory" with the notion that the basic apparatus of cinema duplicated idealist ideology: "You see why historians of cinema, in order to unearth its first ancestor, never leave off dredging a prehistory which is becoming increasingly cluttered" (307). Yet Baudry ultimately clears away the historical clutter with the proposition: "if cinema was really the answer to a desire inherent in our psychical structure, how can we date its first beginnings?" (307). For the apparatus theorist there is no real value to historical excavations of origins because the end is already in the beginning,

"the allegory of the cave is the text of a signifier of desire which haunts the invention of cinema and the history of its invention" (307). Though I must admit having once been seduced by a history of cinema that found its mythical point of origin in Plato's (repressed) desire to be chained to a movie seat, there now seems good reason to question the underlying notion that the entire prehistory of cinema from the camera obscura to the holograph represents a continuous line of the Western metaphysical ideology of the visible. Baudry and other apparatus theorists thus fundamentally agree with Plato: the image is dangerous and to be defended against—in Baudry, Comolli, and Mulvey's case—by an avant-garde attack on reality effects and pleasure.

7. Both Anne Friedberg and Jacqueline Rose (in a discussion following Crary's paper in Foster 46–47) have called Crary to task on this. In addition, as Friedberg points out, both in her book *Window Shopping* and in helpful discussions with me about this essay, Crary's use of the term *modernism* never directly addresses the much debated question of what modernism is. Is it a distinctive style of art? What are its links to the social and historical epoch of modernity linked to technology and industrialization? As Friedberg points out, Crary often slips between the two uses of these terms.

8. I discuss this film in the chapter on the stag film in *Hard Core*. In that analysis I focus on the formal attributes of the silent, one-reel stag film. Here I am interested in the relation of the body to the machine.

9. Andrea Dworkin has been one of the most ardent proponents of the notion that pornography's representation of sex acts is a form of possession in her 1979 book, *Pornography: Men Possessing Women*. In her more recent *Intercourse* Dworkin has expanded this argument to contend that heterosexual intercourse is itself an act of possession, occupation, and colonization.

10. See Tom Waugh's two essays on gay pornography in *The Body Politic*; see also Dyer.

11. See my chapter on sadomasochist film pornography in *Hard Core* and further discussion in my "Pornographies."

12. See Koch for an excellent discussion of particular modes of viewing that took place in German porn houses which also doubled as brothels. Koch's essay argues that film pornography can be viewed as an important mechanism in the restructuring of sexuality into a visual form.

13. I am not suggesting that such women looked at pornography with the same ease with which women look at videotaped pornography today, but that both technology and curiosity made such looking possible.

14. I have called a similar phenomenon in moving-image pornography the requirement of "maximum visibility." In stag films especially the bodies still pose for the ideal view, disrupting linear narrative for what I call "genital show" (*Hard Core* 58–92).

15. I discuss this phenomenon at length in chapter three of *Hard Core*.

16. I have argued elsewhere that the perversions are more "normal" to the functioning of desire than the normative account of them has led many to believe ("Pornographies"). Teresa de Lauretis argues, for example, that Freud was actually the first theorist to put quotation marks around the word "normal" and that Freud's theory of sex is actually a theory of perversion.

17. The assumption has usually been that the representation of poses or actions of "lesbian" sexuality, which are a staple of most heterosexual pornography, do not challenge the hegemony of heterosexuality the way gay male sexual poses and acts do. In other words, lesbian pornography is recuperated and institutionally framed by heterosexual desire in a way that gay male pornography isn't. While this has most likely been the case much of the time, it is an assumption that ignores the possibility of an eroto-social context of lesbian observers. The contemporary emergence of such a context gives rise to the possibility that it may have existed in the past as well. There is no guarantee, then, that lesbian poses and acts have always been recuperated by heterosexual desire.

18. There is, however, a contemporary, feature-length example of this presence of the cameraman's body in the popular "Buttman" series of heterosexual porno videos.

WORKS CITED

Baudelaire, Charles. "The Modern Public and Photography." Trachtenberg 83–89.

Baudrillard, Jean. *Simulacra and Simulations.* Trans. Paul Foss, Paul Patton, and Philip Beitchman. New York: Semio-text(e), 1983.

Baudry, Jean-Louis. "The Apparatus: Metapsychological Approaches to the Impression of Realism in the Cinema." Trans. Jean Andrews and Bertrand Augst. *Narrative, Apparatus, Ideology: A Film Theory Reader.* Ed. Philip Rosen. New York: Columbia UP, 1986. 299–318.

Bazin, André. *What Is Cinema, Vol. 2.* Trans. Hugh Gray. Berkeley: U of California P, 1971.

Cavell, Stanley. *The World Viewed.* Cambridge: Harvard UP, 1979.

Clover, Carol J. *Men, Women, and Chain Saws: Gender in the Modern Horror Film.* Princeton: Princeton UP, 1992.

Comolli, Jean-Louis. "Machines of the Visible." *The Cinematic Apparatus.* Ed. Teresa de Lauretis and Stephen Heath. New York: St. Martin's, 1980. 121–42.

Crary, Jonathan. *Techniques of the Observer: On Vision and Modernity in the Nineteenth Century.* Cambridge: MIT P, 1990.

de Grazia, Edward. *Girls Lean Back Everywhere: The Law of Obscenity and the Assault on Genius.* New York: Random, 1992.

Dworkin, Andrea. *Intercourse.* New York: Free, 1987.

———. *Pornography: Men Possessing Women.* New York: Putnam, 1981.

Dyer, Richard. "Male Gay Porn: Coming to Terms." *Jump Cut* 30 (1985): 27–29.

Farwell, Beatrice. *The Cult of Images: Baudelaire and the Nineteenth-Century Media Explosion.* Santa Barbara: UCSB Art Museum, University of California, Santa Barbara, 1977.

Foster, Hal, ed. *Vision and Visuality.* Seattle: Bay, 1988.

Foucault, Michel. *The History of Sexuality. Vol 1: An Introduction.* Trans. Robert Hurley. New York: Pantheon, 1978.

Friedberg, Anne. *Window Shopping: Cinema and Postmodernism.* Berkeley: U of California P. Forthcoming.

Gay, Peter. *Education of the Senses.* New York: Oxford UP, 1984. Vol. 1 of *The Bourgeois Experience: Victoria to Freud.* 2 vols. 1984–86.

Heath, Stephen. *The Sexual Fix.* London: Macmillan, 1982.

Hyde, H. Montgomery. *A History of Pornography.* London: Heinemann, 1964.

Jameson, Fredric. *Signatures of the Visible.* New York: Routledge, 1990.

Kendrick, Walter. *The Secret Museum: Pornography in Modern Culture.* New York: Viking, 1987.

Koch, Gertrud. "The Body's Shadow Realm." *October* 50 (1989): 2–29.

Marcus, Stephen. *The Other Victorians.* New York: Basic, 1966.

Mayne, Judith. *Cinema and Spectatorship.* New York: Routledge, 1993.

Metz, Christian. *The Imaginary Signifier: Psychoanalysis and the Cinema.* Trans. Annwyl Williams, Ben Brewster, and Alfred Guzzetti. Bloomington: Indiana UP, 1977.

Mulvey, Laura. "Visual Pleasure and Narrative Cinema." *Screen* 16.3 (1975): 6–18.

Silverman, Kaja. "Masochism and Male Subjectivity." *Camera Obscura* 17 (1988): 31–66.

Solomon-Godeau, Abigail. "Reconsidering Erotic Photography: Notes for a Project of Historical Salvage." *Photography at the Dock: Essays on Photographic History, Institutions, and Practices.* Minneapolis: U of Minnesota P, 1991.

Studlar, Gaylyn. *In the Realm of Pleasure: Von Sternberg, Dietrich, and the Masochistic Aesthetic.* Urbana: U of Illinois P, 1988.

Trachtenberg, Alan, ed. *Classic Essays on Photography.* New Haven: Leete's Island, 1980.

Trinh T. Minh-ha. "Documentary Is/Not a Name." *October* 52 (1990): 77–98.

Waugh, Tom. "A Heritage of Pornography." *The Body Politic* Jan./Feb. 1983: 29–33.

———. "Pornography as History." *The Body Politic* Mar. 1984: 29–33.

Williams, Linda. "Film Bodies: Gender, Genre, and Excess." *Film Quarterly* 44.4 (1991): 2–13.

———. *Hard Core: Power, Pleasure and "the Frenzy of the Visible."* Berkeley: U of California P, 1989.

———. "Pornographies on/scene, or 'diff'rent strokes for diff'rent folks.' " *Sex Exposed: Sexuality and the Pornography Debate.* Ed. Lynne Segal and Mary McIntosh. London: Virago, 1992. 233–65.

2

Phantom Images and Modern Manifestations

Spirit Photography, Magic Theater, Trick Films, and Photography's Uncanny

Tom Gunning

Ghosts. Cine recordings of the vivacious doings of persons long dead.
—Ken Jacobs on his film *Tom, Tom the Piper's Son*

The rest of the company, with myself, seemed not to know whether or not there is any truth in these modern manifestations.
—Susan B. Anthony, diary notation in 1854, on a discussion of Spiritualism

WHILE WESTERN CULTURE'S valorization of the visual may be rooted in a tradition which identifies the conceivable with the visible (the idea with what one sees),[1] there is no question that in the nineteenth century we enter into a new realm of visuality, and that it is the photograph that stands as its emblem.[2] The key role of the photograph as a guarantor of a new realm of visual certainty comes from a network of interrelated aspects. First, to use (as others have)[3] the vocabulary of Charles Sanders Peirce, there is the photograph's dual identity as an icon, a bearer of resemblance, and as an index, a trace left by a past event. The idea that people, places, and objects could somehow leave behind—cause, in fact—their own images gave photography a key role as evidence, in some sense apodictic. Essential to the belief system which photography engendered was the fact that the image was created by a physical process over which human craft exerted no decisive role. Photography was therefore a scientific process, free from the unreliability of human discourse. Photography could serve as both tool of discovery and means of verification in a new worldview constructed on an investigation of actual entities explored through their visible aspects.

However, if photography emerged as the material support for a new positivism, it was also experienced as an uncanny phenomenon, one which seemed to under-

mine the unique identity of objects and people, endlessly reproducing the appearances of objects, creating a parallel world of phantasmatic doubles alongside the concrete world of the senses verified by positivism. While the process of photography could be thoroughly explained by chemical and physical operations, the cultural reception of the process frequently associated it with the occult and supernatural. Balzac gives a good example of this in a digression in his novel *Cousin Pons* which states that Daguerre's invention has proved "that a man or a building is incessantly and continuously represented by a picture in the atmosphere, that all existing objects project into it a kind of *spectre* which can be captured and perceived."[4]

Balzac's description shows his ability to defamiliarize the surfaces of reality through poetic re-description. But more than that, it testifies to a widespread understanding of photography that paralleled (without necessarily contradicting) its official role as scientific record of visual reality. At the same time that the daguerreotype recorded the visual nature of material reality it also seemed to dematerialize it, to transform it into a ghostly double. However, before one sees in Balzac's conception a simple return to a Platonic idealism in which the *eidos* of every object seems to hover around it and photography becomes the proof of idealism, one must note the decentering implications of this description. Every object, place, and person is continuously radiating these images (a process that Balzac's friend the photographer Nadar remembered the writer describing to him as a constant shedding of an immaterial skin [9]). Rather than representing an ur-form of these objects, the only true reality as in Plato's idealism, these images are constantly cast off, like a sort of detritus. Photography simply retains some of them. This process of individual entities constantly broadcasting normally imperceptible signals which can be received as images exemplifies an extraordinary new mythology of modernity as it confronted technological change. Unlike official allegories which vaunted the forces of commerce and technology with desiccated images from classical mythology, this modern mythology welcomed the dissolving effects of modernity into the core of its metaphysics.

When I call this early reception of photography uncanny, I hope to summon all the resonances of this term. Thanks to Freud's English translator's decision to render his complex German term *unheimlich* by "uncanny," the specter of Freud's famous essay arises irrepressibly. Since my principal topic in this essay will be the use of photographs to document the presence of spirits, this visitation is not at all unwelcome. Among the themes that Freud relates to the experience of the uncanny is that of the double. And it is my thesis that it was the uncanny ability of photography to produce a double of its subject that gave it its unique ontology as much as its existential link with its original source. This extraordinary reproductive quality now seems so familiar that it takes the defamiliarization of initial reception such as Balzac's to restore to us an original sense of amazement.

The theme from "The Uncanny" that most inflected Freud's future writing

was that of repetition, which followed from his discussion of the double. It was the fascination with repetition, first broached in this essay, that led Freud to discover the compulsion to repeat and ultimately led him beyond the pleasure principle to a confrontation with the death drive and his late posing of the conflict between Eros and Thanatos.[5] Freud admits that the connection between repetition and the uncanny may not seem obvious at first sight. However, he adds, under certain circumstances and conditions repetition does arouse an uncanny sensation, one which recalls "the sense of helplessness experienced in some dream states." As an example he narrates an experience of his own:

> As I was walking one hot summer afternoon, through the deserted streets of a provincial town in Italy which was unknown to me, I found myself in a quarter of whose character I could not remain long in doubt. Nothing but painted women were to be seen at the windows of the small houses, and I hastened to leave the narrow street at the next turning. But after having wandered about for a time without enquiring my way, I suddenly found myself back in the same street, where my presence was now beginning to excite attention. I hurried away once more only to arrive by another *detour* at the same place yet a third time. Now, however, a feeling overcame me which I can only describe as uncanny, and I was glad enough to find myself back at the piazza I had left a short while before, without any further voyages of discovery. (237)

Freud's account brings with it a number of unexpected themes. An urban *flâneur* in an unfamiliar place, constantly seeking to avoid the seamy side of town with its temptations of the flesh, finds himself unable to follow the straight route of escape but instead traces a circular maze-like trajectory which recurringly returns him to a place where he gradually loses anonymity and courts making a spectacle of himself. At last he exits and renounces further explorations. This narrative of the return of the repressed bears an unmistakably modern urban configuration, recalling any number of haunted voyages of middle-class wanderers into those areas of the city that seem to threaten surface consciousness with repressed fears and desires.

We could compare it to an extraordinary literary work from 1875, which chronicles a similarly obsessive and uncanny urban labyrinth. In Villiers de L'Isle-Adam's short story "The Very Image," a businessman on his way to an appointment wanders somewhat accidentally into an imposing building which rises before him "like a stone apparition" but has a curiously hospitable air about it. As Villiers describes it:

> I promptly found myself before a room with a glass roof through which a ghastly light was falling.
> There were pillars on which clothes, mufflers, and hats had been hung.
> Marble tables were installed on all sides.
> Some people were there with legs outstretched, heads raised, staring eyes and matter of fact expressions, who appeared to be meditating.
> And their gaze was devoid of thought and their faces the color of the weather.

There were portfolios lying open and papers spread out beside each one of them.
And then I realized that the mistress of the house, on whose courteous welcome I had been counting, was none other than Death. (103)

The narrator had wandered into the Paris morgue, a site open to the public in the nineteenth century, where gawkers could gaze on unclaimed corpses laid out on stone tables beneath dripping water taps.

The narrator rushes to get a cab to keep his appointment. However, arriving at the arranged rendezvous, he:

promptly found myself in a room into which a ghastly light was filtered through the windows.
There were pillars on which clothes, mufflers, and hats had been hung. . . . (104)

And the text repeats with minuscule variations its previous description. The narrator returns home, resolving never again to do business, and shudders as he stresses that "the second glimpse is more sinister than the first" (105).

Several things are striking about this convergence of texts. First, Villiers had understood several decades before Freud the uncanny effect of repetition. Second, the confrontation with the repressed, here death and in Freud commercial illicit sex, comes through a sort of helpless surrender of the dream logic of urban topography. However timeless the effects of the unconscious may be, we see again how often in Freud they illuminate the new experiences of modernity. And finally and most importantly for my thesis, the effect of repetition, particularly in Villiers, inevitably recalls the possibilities of photography. Although Villiers evokes his capture in a closed circuit of time through repetition of a verbal text, this description summons up memories of film loops, of the uncanny possibilities of a photographic repetition of situations and actions.[6] And it is this effect of exact duplication, I believe, that makes the second glimpse, the double of the first, so sinister.

Although Freud does not cite the way photography evokes to the "constant recurrence of the same thing"[7] explicitly, it does haunt the margins (or at least the footnotes) of the essay. His discussion of the double proceeds from Otto Rank's classic essay on the theme, which—as Freud notes—began with a consideration of a film: the Hanns Heinz Ewers-Stellan Rye-Paul Wegener 1913 production of *The Student of Prague*. This early classic of the German uncanny cinema portrayed its unearthly double through the old photographic trick of multiple exposure (which was likewise essential to both the spirit photographers I shall discuss and the filmmaking of Georges Méliès).[8] While both Freud and Rank demonstrate that the double has a long lineage (from archaic beliefs in detachable souls to the romantic Doppelgänger) that predates photography, nonetheless photography furnished a technology which could summon up an uncanny visual experience of doubling, as much as it was capable of presenting facts in all their positivity and uniqueness.

Balzac wrote his description of photography about a decade after Daguerre's

first successful experiments. While *Cousin Pons* was being published in 1848, the United States was seized by a different sort of manifestation which led to a new worldwide metaphysical system, Spiritualism. First in the small village of Hydesville, New York, and later in the city of Rochester (coincidentally to become the industrial home of both Eastman Kodak company and Xerox), a pair of young girls, the Fox sisters, were subject to a consistent rapping noise which was eventually interpreted as a coded message from a spirit of a murdered peddler. Taken under the management of an older sister, the Fox girls soon became the center of a new movement based on communicating with the dead through séances at which rapped-out messages were received and inspired communications obtained during trances.[9] Although ideas of necromancy and other forms of intercourse with the dead are universal, the modernity of the Fox sisters and related phenomena was generally recognized and hailed by many as a new revelation. Spiritualism soon had an international following, but the sense of America as the land of the future and the home of the latest technology gave the Fox sisters' revelations an added connotation of apocalyptic modernity, and later American mediums an added authority.

The Spiritualist movement related its revelations to modern changes in technology and science, such as electricity, telegraphy, and new discoveries in chemistry and biology (Braude 9), showing the sort of merging of pseudoscience and spirituality that Robert Darnton found surrounding mesmerism in prerevolutionary France. Although this was primarily a means of endowing their new revelations with the growing authority of recent inventions (Braude 4), there are also indications that the mentality of Spiritualists and devotees of new technology had something in common. Thomas Watson, the assistant to Alexander Graham Bell in the invention of the telephone, had an interest in séances and explored the possibility that the new apparatus would be an aid in spiritual discoveries (Ronell 99). Likewise, electrical engineers delighted in creating simulacra of Spiritualist manifestations through scientific means, such as the demonstration of the power of electricity given by the Edison Company in Boston in 1887 during which "[b]ells rung, drums beat, noises natural and unnatural were heard, a cabinet revolved and flashed fire, and a row of departed skulls came into view, and varied colored lights flashed from their eyes" (Marvin 57).

In addition, this modernity manifested itself in the political positions taken by early Spiritualists which were perhaps the most radical of any group in pre-Civil War United States. Spiritualists as a rule supported abolitionism and temperance reforms, experimented with founding communistic communities, and championed a host of women's rights issues, including dress and marriage reforms, as well as suffrage. In fact, the Spiritualist support of women's sexual rights in marriage led to a frequent accusation of license and "free love."[10]

It is hardly surprising that Spiritualism would eventually intersect with photography. That photography could create a transparent wraith-like image (if the plate were double exposed or if the figure photographed moved before a full expo-

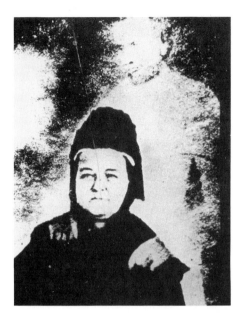

Fig. 1. Spirit photograph by William Mumler, showing the widow of President Lincoln, Mary Todd Lincoln, with the apparition of her assassinated husband.

sure was made) was realized by the first photographers. In 1856 Sir David Brewster in his book describing his new invention, the stereoscope, advised his readers that "[f]or the purposes of amusement the photographer might carry us even into the realm of the supernatural," since it was quite possible "to give a spectral appearance to one or more of his figures and to exhibit them as 'thin air' amid the solid realities of the stereoscopic picture" (*Stereoscope* 205). For Brewster, who in his 1832 work *Letters on Natural Magic* had dissolved superstitions and apparently miraculous events into scientifically explainable optical illusions, such photographic phantoms were simply "philosophical toys," amusements which first amazed but then could be used to demonstrate the principles of science. But that such images could display the iconic accuracy and recognizability of photographic likenesses and at the same time the transparency and insubstantiality of ghosts seemed to demonstrate the fundamentally uncanny quality of photography, its capture of a specter-like double.

Since Spiritualists saw their revelation as fundamentally modern, casting out the outmoded Calvinist beliefs in original sin and hellfire damnation, they welcomed evidence that their new revelation of the afterlife could be established "scientifically" (Judah 16). For Spiritualists spirit photography was more than an amusement and could expand their new forms of spiritual manifestation. Although there may well be earlier examples, the practice gained notoriety (and, when he was

Fig. 2. Photograph by medium Wyllie of mother with apparition
of dead child (c. 1880s).

tried for fraud, a legal context) with William Mumler in the early 1860s. First in
Boston, then in New York City, Mumler made a commercial business of spirit pho-
tography, producing (for prices as high as $10) portraits, strictly conventional in
pose and composition, in which sitters were portrayed in the company of ghosts,
transparent images, frequently of famous persons (Mumler's photographs included
images of Lincoln and Beethoven) usually standing behind the sitters and often
embracing them. Although each spirit photographer has a slightly different style in
the placement, size, and number of the spirit images that appeared as ghostly su-
perimpositions over the more "solid reality" of the living person, Mumler seems to
have set a basic iconography of spirit photography as an extension of portraiture.[11]

As I will show, the explanations offered for spirit photography were fluid and
changed with different periods and different influences within Spiritualism. Most
often spirit photographers (including Mumler) claimed they did not know how
their photographs happened (Gerry 11). Clearly this was in part a protective state-
ment. Since most photographs are the result of quite explainable methods of dou-
ble exposure, claiming ignorance of how the effects were produced protected pho-
tographers from accusations of fraud. However, this lack of commitment about how
the images were formed was also put forth by Spiritualists who were devoted
believers in the authenticity of spirit photography and who, not being practition-
ers, were immune to prosecution for fraud. There was a constant debate within
Spiritualist, Theosophical, and occult circles throughout the late nineteenth and

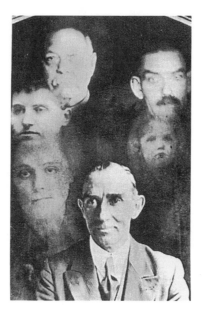

Fig. 3. Spirit photographs with "extras" (c. 1880s).

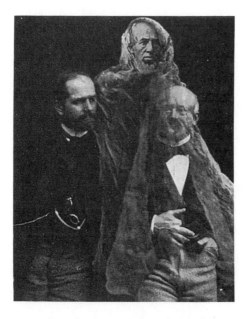

Fig. 4. French spirit photo (c. 1880s).

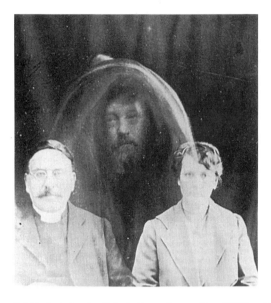

Fig. 5. Spirit photo by English photographer medium William Hope (1910s).

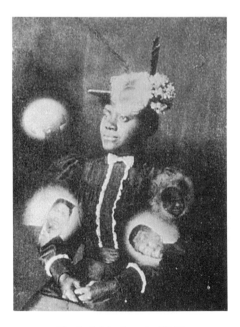

Fig. 6. Spirit photo by Wyllie.

early twentieth centuries about what supernatural forces actually produced these images. Although the supposition that the images were photographs of spirits of the dead was certainly the earliest and most prevalent, it was by no means universal. Most often commentators on the phenomenon simply claimed that the photographs were the product of *some* supernatural force, with many avowed Spiritualists supposing that the spirits of the dead may actually have had little to do with them. The images that appear in these photographs were generally described with the noncommittal, but provocative, term *extras*. They were defined as presences that had not been visible, at least to the sitters, at the time the photographs were made and whose appearance first on the negative and then on the print were a surprise to the sitters and sometimes to the photographers.

The appearance of spirit photography after the Civil War coincided with transformations within Spiritualism itself. The first heroic decade of the Spiritualist movement (which also saw its radical social agenda) based itself primarily in auditory phenomena and the transmission of messages. Although many of these messages were of a mundane personal sort, reassuring family members of the happiness of departed relatives or giving medical and financial advice, others were of a prophetic and even political nature. As Ann Braude's fascinating study of the relation between Spiritualism and the movement for women's rights reveals, the first widely attended women speakers in the United States were Spiritualist trance speakers, women who spoke in public lecture halls as the mediums for supernatural spirits, frequently delivering orations in support of the social reforms that the movement supported (84–95).

After the Civil War the emphasis in Spiritualism shifted, moving from auditory messages to visual "manifestations," either through the actual appearances of supernatural figures, the presentation of ghostly actions (floating trumpets, transported objects, disembodied hands), ectoplasmic extrusions from mediums' bodies, or other spectacular evidences of supernatural presences. As Braude indicates, this changed the role of the medium from a vatic prophetess to a producer of nonverbal displays under conditions which tended to remove the medium from the public eye and ear (177). Darkness and devices such as the spirit cabinet (introduced by medium performers such as the Davenport brothers) rendered the medium an invisible presence, while practices such as tying mediums up (as a guard against fraud) made them immobile, shifting the focus from the medium entirely to the manifestations. Spirit photographs are part of this new emphasis on visual evidence and movement away from a prophetic message. After the Civil War the social agenda of Spiritualism also began to fade, although there were still vestiges of it into the twentieth century—for instance, Virginia Woodhull, the first woman to run for U.S. president, was also the head of an American Spiritualist organization (Braude 170–73). The reasons for this are undoubtedly complex, including the loss of the central social rallying point of the abolition of slavery and the general political reaction after the Reconstruction. Further, certain political movements, such as women's

rights, began to distance themselves from Spiritualism as the apocalyptic excitement of its first appearance faded and it was looked on less as a scientific discovery than a backwash superstition.

Although I can only touch on the fascinating cultural relation between women and Spiritualism, it is important to note that the first spirit mediums were women and that the predominance of women as mediums continued throughout most of Spiritualist history. As Braude points out, the conception of the medium corresponded to cultural understandings of the feminine principle. The medium was passive, but passive in a particularly dynamic way. She was receptive, sensitive, a vehicle—a *medium*—by which manifestation appeared. All mediums, men or women, had to be, in Spiritualist parlance, feminine, or negative (borrowing again from electricity and magnetism, a technical term which also has implications for photography), in order to let the spirit world manifest itself. While one may feel the confining aspects of such gender stereotypes, it is important to stress the enormous value Spiritualism placed on this feminine negativity, and therefore on feminine leadership and feminist issues in the movement (Braude 23). While such practices as the concealing spirit cabinet and spirit photography displaced the medium from the spotlight by the growing importance of visual manifestations, the role of the medium remained crucial.

But there is no doubt that in what we could term the second generation of Spiritualists—after the Civil War—the medium becomes enframed in a sort of apparatus, and this apparatus is frequently under the control of a man. Men assumed a variety of mediatory functions, serving as business managers for women mediums (Braude 177) or show-biz masters of ceremony who mediated between audience and medium, or, as in the case of Florence Cook, the medium became a subject exposed for male investigation. In the "scientific" discourse of Spiritualism, the medium became less the voice of a new revelation than a new phenomenon demanding scrutiny. Women mediums and the phenomenon of Spiritualism increasingly became a spectacle presented for observation, whether displayed for a scientific investigation with circumscribed roles of experimental subject and probing scientist, or as a theme for popular entertainment, with female assistants put in a trance by a male stage magician.

The role of the mediating apparatus becomes literalized in spirit photography as the process of photography takes over the medium's role. Perhaps the most profound connection between photography and Spiritualist manifestation lies in the concept of the sensitive medium. Most theorists of spirit photography claimed that the presence of a medium (though in this case male mediums are more frequent than female) was necessary for an image to be formed.[12] It was claimed that all the great spirit photographers—Mumler, Wylie, Hudson, Mrs. Deane, among others—were spirit mediums. Besides this human figure the other *sine qua non* was the sensitive plate. Recognizable spirit photographs were supposedly created without using either lens or camera. Both David Daguid and Madge Donohue claimed that

Fig. 7. Photo of spirit child purportedly produced
without a camera, by female medium holding the
sensitive plate in her hand (turn of the century).

all they did was to hold the sensitive plates in their hands, and that this contact between two sensitive, receptive mediums, one spiritual, the other photographic, was sufficient to form a latent image.[13]

While Spiritualism had always had a sensational and spectacular aspect, there is no doubt that the new emphasis on manifestations led to an even greater theatricality. A second sort of spirit photography (often denied the name by some purists [Coates xi], since such photographs merely record events which are visible to anyone present rather than making use of the mediumistic properties of the sensitive plate) consisted of photographs made during manifestation séances, including images of what became known as "full materializations," full-bodied figures of spirits. Materializations became celebrated with the séances at the Eddy household in Chittendon, Vermont, in the 1870s, in which the figures of the spirits John King and his daughter Katie King appeared fully visible (Braude 176–77). Katie King was a particularly lovely apparition who touched and even kissed male members of the séance. Katie King became quite peripatetic and was also materialized by the medium Florence Cook in England. Cook's materializations are of particular im-

Fig. 8. Photo of "Katie King," a full materialization of a
spirit, photographed by William Crookes (1874).

portance in the history of Spiritualism because they were investigated by William
Crookes, a distinguished British scientist, discoverer of the new element thallium
(essential to the later development of the cathode ray tube), and eventually presi-
dent of the British Royal Society. Although Crookes's account of his investigation
of Cook's materialization during 1874 doesn't exactly demonstrate a scientific scru-
tiny of the phenomenon, he was willing to place his considerable reputation behind
the authenticity of these manifestations.[14]

The primary evidence that Crookes produced were some forty-four photo-
graphs taken during the materialization of Katie King. Crookes in later life re-
fused to publish these photos and the negatives were apparently destroyed by heirs
who wished this aspect of the scientist's career forgotten. However, a few were pub-
lished at the time and a few others discovered in the 1930s. As evidence for the
authenticity of the phenomenon they seem to controvert Crooke's claims that Ka-
tie King had no resemblance to her medium, Florence Cook. Comparisons of pho-
tographs of Cook and King show nearly identical features, a point which had been
observed at the time by other people who attended these materializations. While

Fig. 9. "Katie King" materialized by medium Florence Cook, photographed by William Crookes (1874).

Fig. 10. "Katie King" (1874).

Katie appeared and walked around the room, Cook was supposedly collapsed in a deep trance within the spirit cabinet. Breaking tradition, Crookes in his investigation was allowed into the cabinet and claimed both to have seen Cook's slumped-over figure (her face bundled in a scarf) and to have minutely examined the physicality of King: "I could look closely into her face, examine the features and hair, touch her hands and might even touch and examine her ears closely, which were not pierced for earrings" (Gettings 126). While Katie King's resemblance to Florence Cook may well provide evidence of fraud (and certainly calls into question Crookes's objective observational powers), it doesn't undermine the uncanny quality of these photographs. Although such images of a full materialization do not involve spirit aid in the photography itself (it simply records a supposedly supernatural event faithfully, hence its purported scientific value), the process of materialization mimes a photographic process. The woman medium retires into a dark chamber (camera obscura) and produces a double of herself which emerges into the light. The harsh glare of Crookes's magnesium-flare lighting and the exotic gown and headdress of King, as well as her somnolent eyes, give these photographs an extraordinary erotic charge, just as Crookes's record of his scrutiny of her physical features exhibits an eroticized fascination underpinning the unwavering gaze justified by his scientific stance and the purported uniqueness of the phenomenon. Crookes himself indicated that the physical beauty he found in the subject of his investigation overran the ability of photography to capture it:

> Photography is as inadequate to depict the perfect beauty of Katie's face, as words are powerless to describe her charms of manner. Photography may indeed give a map of her countenance; but how can it reproduce the brilliant purity of her complexion, or the ever varying expression of her most mobile features. (Qtd. in Hall 86)

Enraptured (and perhaps, as some claimed, duped) as Crookes may have been, we also see here how much the spiritual medium has become subjected to the male gaze as the source of both authentication and aesthetic approval. Florence Cook may undergo a sort of primal photographic process in emanating her double, but it is Crookes, the man of science, who fixes the image and lends it his authority while Florence remains enframed within her spirit cabinet.

While full-bodied materialization continued to play a role in mediumistic séances, séances that were photographed in the late nineteenth and early twentieth centuries placed particular emphasis on the somewhat less spectacular but possibly more uncanny ectoplasmic manifestations. *Ectoplasm* was a term given by French occultist Dr. Richet to a whitish, malleable substance that oozed from the orifices of mediums.[15] The appearance of this mucous-like substance gave séances an oddly physiological turn, as normally taboo processes—bodily orifices extruding liquidy masses—were accepted as evidence of spiritual forces. Such ectoplasmic masses were considered supernatural phenomenon and also supplied the malleable stuff

Fig. 11. Ectoplasm oozing from the nipples of medium "Eva C." (1913).

Fig. 12. Ectoplasm extruding from between legs of English medium
(c. 1930).

Fig. 13. "Eva C." with two-dimensional materialization (1913).

from which figure manifestations such as Katie King were formed (Mrs. Marryat, a witness of Cook's séances, described Katie as disappearing like "melting wax") (Hall 66). Ectoplasm was a sort of *prima materia* which was molded by spirit forces to create manifestations. Mediums such as Eva C. claimed that the patently two-dimensional nature of some of her manifestations, rather than indicating fraud, simply showed the manifestation process in an incomplete stage, moving from two-dimensional images to fully manifested third-dimensional figures (Gettings 121–23).

Perhaps most uncanny are instances of ectoplasmic extrusions bearing images within them. There are several instances, primarily in the twentieth century, in which mediums produce from their orifices spirit images or photographs. Such instances led Dr. Richet to theorize that ectoplasm "may be merely an image, and not a living being" (Gettings 123). This phenomenon clarifies the role images play in Spiritualist manifestations, not only as representations of something otherwise unseen, but supplying a sort of pictographic code between the visible world and the realms of the invisible. Spirits are not simply captured in pictures; they communicate by a sort of picture language.[16] The medium herself became a sort of camera, her spiritual negativity bodying forth a positive image, as the human body behaves like an uncanny photomat, dispensing images from its orifices.[17]

Fig. 14. Ectoplasmic manifestation from nose of Canadian medium "Mary M." (1928), bearing images, including one of Arthur Conan Doyle.

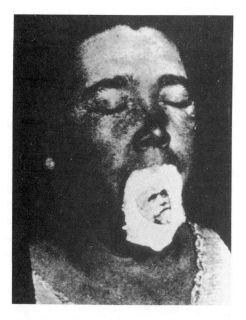

Fig. 15. Same medium with ectoplasmic manifestation from mouth bearing image.

While photographing materializations played the more conventionally scientific role of capturing in a hopefully incontrovertible manner the evidences of the senses, the increasingly spectacular nature of Spiritualism mined a deep fascination in visual events that amazed spectators by defying conventional belief. The potential entertainment value of such visual attractions was immediately recognized. The Davenport brothers, for instance, toured Europe and the United States with a spirit cabinet show which produced phantom hands, levitating objects, musical instruments which appeared to play themselves, and other supernatural manifestations while the brothers themselves were apparently securely tied within the cabinet. During their European tour in the 1860s the brothers exploited their attraction as a theatrical event, gaining support and appreciation particularly from such masters of the nineteenth-century spectacular stage as Dion Boucicault and Henry Irving. When skeptical onlookers objected to the darkness in which these performances were held, Irving leapt to the brothers' defense by citing photography: "Isn't a dark chamber essential in the process of photography?" he queried. Irving wondered how satisfying the results would be if photographers were asked to produce images outside of their camera obscuras.[18]

Inevitably, spectacular Spiritualism encountered the nineteenth-century magic show and had a role in transforming it into an intensely visual theater of illusion.[19] Attending an exhibition given by the Davenport brothers, John Neville Maskelyne, a young apprentice watchmaker whose fascination with mechanical devices had led him to stage magic, recognized the possibilities of such shows when liberated from metaphysical claims. When an obscuring shade slipped for a moment during the Davenports' performance, piercing the darkness essential to their "manifestations," Maskelyne exercised the gaze of an intrigued craftsman rather than an enraptured scientist. He perceived one of the brothers, having liberated himself from his bonds, emerge from the cabinet, manipulate some object, and then reassume his position and retie his ropes. Maskelyne and his magician partner Cook undertook to figure out and reproduce the various effects the Davenports had created, and announced a spectacle that would recreate the séance "without the aid of spirits" (Maskelyne 21–28).

Maskelyne made the recreation of séances one of the mainstays of his extremely successful career as a stage illusionist. A poster for Maskelyne and Cook circa 1877 announced an "exposition of Spiritualism so-called. Light and Dark Séance Extraordinary including the appearance of the spirit form of John King."[20] While Maskelyne was intent on exposing Spiritualists (and even testified at the fraud trial of Spiritualist slate writer Dr. Slade to explain how his phenomenon could be managed [Maskelyne 54]), he also professed admiration for the dexterity of the Davenport brothers.[21] Spiritualists, he seemed to indicate, put on a good show, one that was so enthralling visually that it could be presented without serving as evidence for supernatural events.

Maskelyne occupies a key position in the development of modern magic.

While magical illusions, even elaborate ones, are as old as stagecraft, the new tech-nology of the nineteenth century made illusions both easier to manage and more spectacular. Advances in electricity, mechanics, and lighting ushered in a golden age of magical theater, which also fed off the nineteenth-century passion for visual amusements. Eugène Robert-Houdin, another former clockmaker turned conjurer, is often seen as the founder of modern magic and one of the first to use electricity for magical effects (Hopkins 11–19). Robert-Houdin had also made the exposure of Spiritualist phenomena part of his magical stock-in-trade and had presented his own re-creation of the Davenports' séances after the brothers' European tour reached Paris (Houdini 257). Robert-Houdin's technologically modern versions of supernatural phenomena also played a role in imperial France's expanding colonial policy. Napoleon III sent the conjurer to cow the Marabouts, a group of Alge-rian wonder-workers leading local resistance. Robert-Houdin's magic shows in-cluded feats of prestidigitation, the creation of automata, and full-blown theatrical spectacles using stagecraft to produce elaborate optical illusions. Maskelyne, particularly after he and Cook installed themselves in a permanent theater, the Egyptian Hall in London (former site of curiosities and freak shows), developed Robert-Houdin's brand of magic spectacle even further. He created a number of spectacular turns (along with the more traditional feats of prestidigitation and the display of automata that he also delighted in) frequently patterned on Spiritualist phenomena. The fascination in visual entertainments and modern technology also made the Egyptian Hall a natural place for some of the first permanent English film programs, as Maskelyne added motion pictures to the bill immediately after the Lumière brothers' premier in London (Barnouw 56–57).

The Houdin-Maskelyne tradition of magical performance can be seen as hav-ing two direct heirs. One was Harry Houdini, the American magician and escape artist born Ehrich Weiss, who named himself after the famous French conjurer. Al-though Houdini's escape routines basically took a different direction from the op-tical magic of his predecessors, he continued and extended Maskelyne's debunking of Spiritualists. With Houdini the investigation of Spiritualists became a personal obsession, involving his own doubts and desires concerning life after death, rather than Maskelyne's appreciation of a good show. In 1909 he did track down the sur-viving Davenport brother who recognized Houdini as a fellow illusionist and re-vealed to him many of the tricks of their trade, including the rope tricks by which they freed themselves of their bonds and the special design of their spirit cabinet (Houdini 36).[22]

The other branch of the Houdin-Maskelyne legacy forks into a new techno-logical medium. Georges Méliès, youngest son of a successful boot manufacturer, after being enraptured by his visits to Egyptian Hall during a stay in London, bought the nearly defunct Théâtre Robert-Houdin (including Robert-Houdin's original automata) and turned it into a thoroughly updated theater of magical il-lusions. Méliès's successful original illusions at the Théâtre Robert-Houdin in-

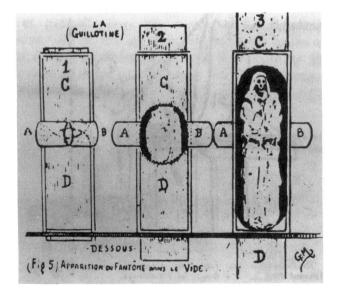

Fig. 16. Sketch by Méliès showing the shutter mechanism which, combined with lighting effects, produced the illusion of a dematerializing spirit for his stage illusion, "les phénomènes du spiritisme."

cluded newly designed Spiritualist numbers, in which devices of lighting, careful control of point of view, and an elaborate optical shutter derived from photography recreated the effects of a materialization séance.[23]

But, of course, Méliès's main claim to fame comes from grafting the nineteenth-century tradition of magic theater onto the nascent apparatus of motion pictures. First fascinated simply with the newest technological marvel in visual illusions (he is reported to have exclaimed at the preview of the Lumière brothers' invention, "That's for me, what a great trick"),[24] Méliès's first films were simple actualities. However, he soon discovered the possibilities of using the cinema's control over point of view and ability to overcome time through shooting and splicing to create magical performances which were not only endlessly repeatable but also reproducible, so that the illusions of the Théâtre Robert-Houdin could be seen across France and around the world.[25] A number of his magic films included routines inspired by Spiritualism, including the film *L'Armoire des Frères Davenport* (1902), which may be based on the original Robert-Houdin version of the brothers' séance—a film which (unfortunately like most of Méliès's work) has not survived.[26]

In the spring of 1903, a few months after completing his most famous film *A Trip to the Moon*, Méliès produced the short film *The Spiritualist Photographer*, of which a paper print deposited at the Library of Congress for copyright purposes

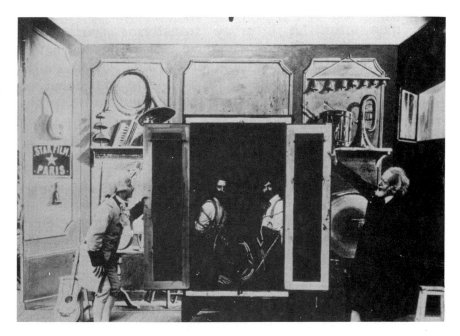

Fig. 17. Still from lost Méliès 1902 film, *L'Armoire des Frères Davenport* showing the brothers tied up in the "spirit cabinet."

has survived. It shows many of the aspects common to the essentially nonnarrative magic films that made up the bulk of Méliès's work. As a strong example of what I have termed the cinema of attractions, the film addresses an acknowledged spectator rather than creating a fictional universe. This sort of direct solicitation of the spectator through a punctual succession of magical or curious "attractions" typified much of early cinema before 1906 or so. For Méliès and other early filmmakers the purpose of a film lay more in astonishing a viewer than in creating a narrative structure based on cause and effect and character development.

The Spiritualist Photographer begins with a message addressed directly to the audience. As a magician's assistant enters, he places two inscribed placards, one in French and one in English, in the front of the set. The English text (a translation of the French) reads: "Spiritualistic photo. Dissolving effect obtained without black background. Great novelty." Through this written legend, Méliès not only directly addresses the spectator but defines his film as a technical trick, pointing out its novel aspect (the lack of a black background which was generally necessary for a solid superimposition in trick films). Although the announcement declares the effect to be a "spiritualistic photo," any claim that the effect is supernatural is undercut. Méliès invites technical amazement at a new trick rather than awe at a mystery.[27]

The magician, played by Méliès himself, enters the set, acknowledging the spectator with a wave of his hand. After placing an ornate frame on a platform and unrolling a large blank piece of paper within the frame, he brings onto the set a young woman dressed as a sailor. He places the woman in front of the paper and conjures up a mystical flame in front of her. As the flame grows, the woman seems to fade away and the paper behind her becomes imprinted with her image. After rolling the life-sized photo into a cone, the magician then unfurls it, producing from within the woman restored to life and the paper now blank.

The series of transformations that take place involve very much the sort of masculine manipulation of the female body and image that Lucy Fischer discusses in her essay "The Vanishing Lady."[28] The woman stands passively, often needing to be physically rearranged by the male magician's hands, and his theatrical passes and active pacing around the set clearly indicate that he is the source of demiurgic power. But the visual fascination of the trick comes exactly from the play between an apparently three-dimensional mobile woman figure and her static figure transferred to paper and initially ornately framed. While the magician directs the living model with a courtly extended hand, he can directly touch and pat her two-dimensional image.

Like the most radical spirit photographs, the magician played by Méliès obtains the woman's image without a camera. But the supernatural effect here comes from the fact that the model merges with her image, the image itself replacing her. And in the usual logic of reversible magic procedures, the image itself can also give birth to the live entity. Here is a photograph in which the living body not only emanates its light-bearing specter but becomes replaced by it, as body melds with paper. Image and model have an interchangeable ontology here, not simply through an indexical process of tracing an image but via a mysterious process in which image replaces body and vice versa. For Méliès, spirit photography results less in communication with the dead than in an exchange of identities between image and model.

A film like Méliès's *The Spiritualist Photographer* traces a complex genealogy between the new technology of photography, a new spiritual revelation, a development of a theatrical spectacle, and then a further development of the technology of photography into motion pictures. Although the configuration of these complex intersections within visual culture is fascinating in itself, I believe that it also carries implications for our modern understanding of visual images and allows us to reexamine what meaning photography has within visual culture. In her insightful essay on Nadar, Rosalind Krauss relates photography to Spiritualist and Swendenborgian phenomena through the concept of the photograph as index, as trace. Certainly all claims of spirit photography as evidence of an afterlife rest on this indexical claim: that ghosts invisible to the human eye are nonetheless picked up by the more sensitive capacity of the photograph.

However, the claims made for spirit photography, particularly as it moved into

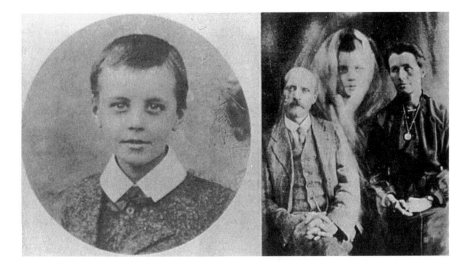

Fig. 18. Spirit photo paired with life photo of child. This comparison was made by spiritualists to authenticate the spirit photo.

the twentieth century, were generally more complicated than this. Much of this complexity was undoubtedly the product of base rationalizations trying to cover up clear examples of fraud. Nonetheless, the attitudes such explanations reveal toward photography are as ideologically revealing as they are rationally unconvincing. It was pointed out by unconvinced investigators of spirit photography that the "extras" that appeared in such photographs were often exact duplications of existing photographs or even of other art works.[29] While this fact all too clearly indicates the method by which most spirit photographs were made—the rephotographing of existing photographs—Spiritualist apologists, unable to deny the fact of duplication, claimed that such phenomenon did not rule out supernatural occurrences.[30]

The explanation of spirit photography that became current in the early twentieth century held that the photographs were not simple records of the appearance of invisible spirits. Rather, spirit photographs were the products of unknown spiritual forces who used the images of the dead as a way of communicating their existence to the living. Paul Coates, author of the early classic work on spirit photography, *Photographing the Invisible*, indicated that these spirit forces may actually need to consult existing photographs in order to create these images. After all, Spiritualist doctrine indicated that spirits transformed radically after death, and existing photographs taken during a lifetime might provide the necessary model for them to "refresh their memory" and recreate their previous appearance in a spirit portrait.[31] We see here that a photograph, rather than providing indexical evidence of the appearance of a spirit, becomes a model for reduplication and the

basis of recognition. A Spiritualist leader, Dr. Alfred Russell Wallace, declared the spirit photograph was a creation by spiritual forces rather than a record of their appearance: "It does not follow that the form produced is the actual image of the spiritual form. It may be but a reproduction of the former mortal form with its terrestrial accompaniments *for the purpose of recognition*" (qtd. in Glendinning 126). Coates gives spirit testimony through mediums that the process of spirit photography was a complicated procedure which marshaled the efforts of spirit chemists and spirit photographers on the "other side" (199). Instead of images of spirits, spirit photography becomes understood as a joint effort, nearly an industry, which multiplies images and sees to their distribution in order to announce the existence of spiritual forces. Photography becomes independent of its ordinary indexical references, since supernatural forces use it primarily as a process of reproduction and communication.[32]

At least one form of spirit photography dispensed with any indexical claim of spirit agency altogether, returning to Brewster's suggestions for the deliberate (and natural) production of phantom images, but using the iconographic effects of transparent phantoms for other emotional effects than entertainment. Although I have not established how widespread the practice was, spirit photographs were produced as mourning images in the nineteenth century. Photographs of dead relatives were knowingly superimposed over photographs of their surviving loved ones, often in watchful and protective stances.[33] Rather than claiming evidence for survival after death, such images used photography's reproductive possibility to create a convincing (or consoling) image of mourning and faith. If there is a belief embodied in these images, it would have to be translated by the acknowledgment that the subjects of photographic portraits may die, but their images are eternally reproducible. Although of a very different mood than Maskelyne and Méliès's entertainments, such images share with them a fascination with visual illusions, a fascination which may be multiplied rather than diminished when separated from claims of recording an indexical reality.

I return, then, to the aspect of photography that seemed so occult to Balzac, not simply that it captured the trace of something, but that it involved a nearly endless series of images that all objects constantly radiate. The process of mechanical reproduction does more than dissolve the aura of uniqueness that seemed to guarantee individual identity; it replaces the unique with a mirror play of semblances. The undermining of traditional modes of authenticity and truth that thinkers from Benjamin to Baudrillard have associated with modern image-making processes depends on this proliferation of images. As Jonathan Crary has indicated, the potentially endless mechanical reproduction that photography makes available aids the system of exchange and circulation on which modern capitalism and industrialization is founded. Photography is, in this sense, the standardization of imagery. The essential aspect of photography, its truly modern and destabilizing role, may work at cross-purpose to its identity as an index which can be traced back to

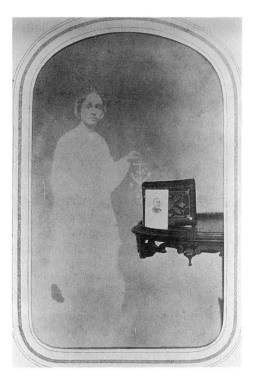

Fig. 19. Photo showing apparition over displayed photographs, possible as a mourning image rather than as a purported spirit image (c. 1870). Courtesy George Eastman House.

a unique original. Photography as mechanical reproduction may undermine identity through its iconic power to create doubles of an unaltering similarity (identity?). For Balzac, the photograph simply confirmed an occult belief that objects radiate images. Similarly for the Spiritualists, photography seemed to give evidence of a metaphysical belief, but only because the belief itself could be adapted to a system of infinite multiplication.

The Spiritualist encounter with photography reveals the uncanny aspect of this technological process, as one is confronted with doubles that can be endlessly scrutinized for their recognizable features, but whose origins remain obscure. Although mere images, photographs remain endlessly reproducible, able to survive the physical death of their originals. While serving, on the one hand, as evidence of a supernatural metaphysical existence, spirit photographs also present a uniquely modern conception of the spirit world as caught up in the endless play of image making and reproduction and the creation of simulacra. What is haunting about these images is perhaps their very lack of tangible reference, serving even within Spiritualist metaphysics simply as a nostalgic reminder of how things once

appeared, a *symbolon* passed between the living and the dead as a token of recognition.

In spirit photography we find an extraordinary conjunction of uncanny themes, the visual double, the "constant recurrence of the same thing," and the fascination with death and its overcoming through the technical device of mechanical reproduction. As revelatory images, evidence of an afterlife, such photographs led to byzantine conceptions of the spirit realm as engaged in the manufacture and reproduction of image doubles. As visual spectacles and entertainment, such manifestations opened the way for the enjoyment of appearances whose very fascination came from their apparent impossibility, their apparent severance from the laws of nature. Instead of a discourse of visuality that underwrites a new worldview of material certainty with apodictic clarity, we uncover a proliferating spiral of exchanges and productions of images, founded in a process of reproduction for which no original may ever be produced. Spooky, isn't it?

NOTES

1. For the original visual meaning of the terms *idea* and *eidos* see Friedlander (13–16) and Peters (46).

2. Perhaps the most detailed and insightful of the recent investigations of the change in visual perception in the nineteenth century is Crary's *Techniques of the Observer*.

3. Among the critics who have discussed the indexical aspects of photography are Wollen (120–26) and Krauss (34). Krauss's essay, which also involves a discussion of spirit photography, was a strong influence on my essay.

4. 131. A similar sense of photography as an occult activity is given in Nathaniel Hawthorne's nearly contemporaneous *The House of the Seven Gables* from 1851 in which the daguerreotypist Holgrave attributes visionary properties to his "sun-portraits" and is also a mesmerist.

5. The further development of the compulsion to repeat comes in *Beyond the Pleasure Principle*.

6. Followers of recent horror films may recall a brilliant use of this sort of repetition in *Nightmare on Elm Street Part 4*.

7. 234. The use of this phrase of Nietzsche's seems to be a conscious citation on Freud's part, as his editors indicate (234n).

8. A thorough examination of the Ewers-Rye-Wegener film is offered by Schülpmann. Kristin Thompson supplies a valuable discussion of Wegener's ideas about film around the time of *Student of Prague* in her essay *"In Anfang War,"* in which she quotes Wegener as indicating that he entered cinema in order to do something only film could do—create the Doppelgänger effect, through double exposure (142).

9. Perceptive histories of Spiritualism can be found in both Braude and Judah.

10. See Braude for a fascinating discussion of the social and political positions of early Spiritualism.

11. All accounts of spirit photography I have examined begin with Mumler. See Coates (1–21); Gettings (25–27); Permutt (12–16); and Gerry.

12. Paul Coates describes each spirit photographer he treats in his book as a medium.

13. Coates describes Duguid's process (65–89). Likewise Madge Donahue claimed to achieve her "skotographs" by holding photographic plates in her hand until a series of taps "tell me that the spirit photographers wish to speak to me" (n.pag.).

14. The most thorough—and skeptical—account of the Crookes-Cook affair can be found in Hall.

15. For a discussion of ectoplasm, see Gettings (115–28).

16. Donahue's "skotographs" include messages in a strange sort of spirit writing made of patterns of dots which she decoded.

17. Besides the images reproduced in Gettings and Permutt, the *Proceedings for the Society for Psychic Research* July 1922 includes some extraordinary photos of Eva C. with images coming out of her mouth.

18. Houdini 272. Accounts of the Davenport brothers' career can be found in Houdini (20–35).

19. The theater of magical illusions is described in Hopkins. Of course, illusionary spectacles involving ghosts and spirit manifestations preceded the modern Spiritualist movement, with the most spectacular example being Robertson's Fantasmagoria of the end of the eighteenth and early nineteenth centuries. On Robertson, see Levie, and Barnouw (19–27), and for exhibition of phantasmagorias in nineteenth-century America, see Barber.

20. Reproduction of poster in file at Billy Rose Theater Collection, Library of Performing Arts, Lincoln Center, New York.

21. Maskelyne states this in an undated clipping from *The Playgoer* in a file under his name, Billy Rose Theater Collection, Library of Performing Arts, Lincoln Center, New York.

22. Famous magician Harry Kellar actually began as an assistant to the Davenport brothers (see Hopkins 24).

23. Paul Hammond gives a particularly good account of Méliès's relation to the tradition of magic theater (14–26). Pierre Jenn reprints a complete description by Méliès of his "Les phénomènes du spiritisme, Un grand succès du Théâtre Robert-Houdin par Geo. Méliès" (153–68).

24. This comment is quoted from a recorded interview in Quévrain and Charconnet-Méliès (235). This essay also draws provocative associations between Spiritualism, hypnotism, hysteria, psychoanalysis, and the work of Méliès.

25. I have explored Méliès's relation to magical illusions and emerging film technique in " 'Primitive Cinema.' "

26. *158 Scénarios de Films Disparus de Georges Méliès* reprints the original description of Méliès's *L'Armoire des Frères Davenport* 1902 (46–47).

27. A detailed description of this film can be found in *Essai de Reconstitution* (134–35).

28. Perhaps even more relevant is Linda Williams's essay "Film Body" which deals with both Méliès and Muybridge in terms of a subjection of the woman's body to the nascent cinematic apparatus. Williams's thesis may be extended to the general transformation of Spiritualism after the Civil War in which the original feminine spiritual negativity seemed to be increasingly subjected to a male-operated apparatus. However, one should resist making this scenario too Manichaean. Early Spiritualism still worked within certain patriarchal assumptions, and the importance of female mediums (including spirit photographers like Mrs. Dean and Madge Donahue) continued into the twentieth century. One could similarly see Méliès's films as presenting scenarios of the evasion of control as much as domination.

29. One such case of reproduction fraud is discussed in Hopkins (435–38). The discussion of spirit photography in Hopkins's compilation is taken from Woodbury.

30. See Coates's discussion of the "Cyprian Priestess" (84–89) and of the portrait of Empress Elizabeth of Austria (103–107). Maskelyne exposed one such reproduction in 1909, although Coates again feels the "materialist" magician has misunderstood how spirit photography really functions (109–15).

31. Coates quotes a Mr. Blackwell who theorizes this process (160).

32. Gettings indicates spirit communications often directed photographers on the length of exposure for the photograph (106).

33. I am indebted to a conversation with David Francis of the Division of Motion Picture and Recorded Sound at the Library of Congress for this insight. I have found what appears to be a clear example at the George Eastman House archive, in which a phantom image is superimposed over a mantle piece bearing family photographs.

WORKS CITED

Balzac, Honoré de. *Cousin Pons.* Trans. Herbert J. Hung. London: Penguin, 1978.

Barber, X. Theodore. "Phantasmagorical Wonders: The Magic Lantern Ghost Show in Nineteenth Century America." *Film History* 3.3 (1989): 73–86.

Barnouw, Erik. *The Magician and the Cinema.* New York: Oxford UP, 1981.

Braude, Anne. *Radical Spirits: Spiritualism and Women's Rights in Nineteenth-Century America.* Boston: Beacon, 1983.

Brewster, David. *Letters on Natural Magic.* New York: Harper, 1832.

——. *The Stereoscope, Its History, Theory and Construction.* London: Murray, 1856.

Coates, Paul. *Photographing the Invisible.* 1911. New York: Arno, 1973.

Crary, Jonathan. *Techniques of the Observer: On Vision and Modernity in the Nineteenth Century.* Cambridge: MIT P, 1990.

Darnton, Robert. *Mesmerism and the End of the Enlightenment in France.* New York: Schocken, 1970.

Donahue, Madge. Scrapbook of spirit photographs by Madge Donahue c. 1929–35 with notes by Ms. Donahue, preserved at Visual Studies Workshop Archive, Rochester, New York.

Essai de Reconstitution du Catalogue Français de la Star-Film, suivi d'une Analyse catalographique des films de Georges Méliès Recensés en France. Paris: Centre National de la Cinématographie, 1981.

Fischer, Lucy. "The Vanishing Lady: Women, Magic and the Movies." *Film before Griffith.* Ed. John Fell. Berkeley: U of California P, 1983. 339–54.

Freud, Sigmund. "Beyond the Pleasure Principle." 1920. *SE* 18:1–64.

——. *The Standard Edition of the Complete Psychological Works of Sigmund Freud.* Trans. and ed. James Strachey. 24 vols. London: Hogarth, 1953–74.

——. "The 'Uncanny.'" 1919. *SE* 17: 217–52.

Friedlander, Paul. *Plato: An Introduction.* Trans. Hans Meyerhoff. New York: Harper, 1958.

Gerry, Eldrige Thomas. "Argument of Eldrige Thomas Gerry, Counsel for the People in the Case of William H. Humler." Pamphlet on file at George Eastman House, n.d.

Gettings, Fred. *Ghosts in Photographs: The Extraordinary Story of Spirit Photography.* New York: Harmony, 1978.

Glendinning, Andrew, ed. *The Veil Lifted: Modern Developments of Spirit Photography.* Whitaker and Co., 1894.

Gunning, Tom. "The Cinema of Attractions: Early Cinema, Its Spectator and the Avant-Garde." *Early Cinema: Space Frame Narrative.* Ed. Thomas Elsaesser. London: BFI, 1990. 56–62.

——. "'Primitive Cinema'—a Frame-up? or The Trick's on Us." *Cinema Journal* 28.2 (1989): 3–12.

Hall, Trevor N. *The Medium and the Scientist: The Story of Florence Cook and William Crookes.* Buffalo: Prometheus, 1984.

Hammond, Paul. *Marvelous Méliès.* London: Fraser, 1974.

Hopkins, Albert A., ed. *Magic: Stage Illusions, Special Effects and Trick Photography.* 1898. New York: Dover, 1976.

Houdini, Harry. *A Magician among the Spirits.* New York: Harpers, 1924.

Jenn, Pierre. *Georges Méliès, Cinéaste.* Paris: Albatross, 1984.

Judah, J. Stilson. *The History and Philosophy of the Metaphysical Movements in America.* Philadelphia: Westminster, 1967.

Krauss, Rosalind. "Tracing Nadar." *October* 5 (1978): 29–47.

Levie, François. *Etienne-Gaspard Robertson, La vie d'un fantasmagore.* Québec: Préamble, 1990.

Marvin, Carolyn. *When Old Technologies Were New: Thinking about Electric Communication in the Late Nineteenth Century.* New York: Oxford UP, 1988.

Maskelyne, Jasper. *White Magic: The Story of the Maskelynes.* London: Paul, 1936.

Nadar. "My Life as a Photographer." Trans. Thomas Repensek. *October* 5 (1978): 7–28.

Permutt, Cyril. *Photographing the Spirit World: Images from Beyond the Spectrum.* London: Aquarian, 1988.

Peters, F. E. *Greek Philosophical Terms: A Historical Lexicon.* New York: New York UP, 1967.

Quévrain, Anne-Marie, and Marie-George Charconnet-Méliès. "Méliès et Freud: Un avenir pour les marchands d'illusions?" *Méliès et la naissance du spectacle cinématographique.* Ed. Madeleine Maltête-Méliès. Paris: Klincksieck, 1984. 221–39.

Rank, Otto. *The Double: A Psychoanalytical Study.* Trans. and ed. Harry Tucker Jr. New York: New American Library, 1979.

Ronell, Avital. *The Telephone Book: Technology—Schizophrenia—Electric Speech.* Lincoln: U of Nebraska P, 1989.

158 Scénarios de Films Disparus de Georges Méliès. Paris: Association "Les Amis de Georges Méliès," 1986.

Schülpmann, Heide. "The First German Art Film: Rye's *The Student of Prague.*" *German Film and Literature: Adaptations and Transformations.* Ed. Eric Rentschler. New York: Methuen, 1986. 9–24.

Thompson, Kristin. "*In Anfang War . . .* Some Links between German Fantasy Films from the Teens and Twenties." *Before Caligari: German Cinema 1895–1920.* Ed. Paolo Cherchi Usai and Lorenzo Codelli. Pordenone: Edizzioni Biblioteca dell'Immagine, 1990. 138–62.

Villiers de L'Isle-Adam. "The Very Image." *Cruel Tales.* Trans. Robert Baldrick. Oxford: Oxford UP, 1985. 102–105.

Williams, Linda. "Film Body: An Implantation of Perversions." *Narrative, Apparatus, Ideology: A Film Theory Reader.* Ed. Philip Rosen. New York: Columbia UP, 1986. 507–34.

Wollen, Peter. *Signs and Meaning in the Cinema.* Bloomington: Indiana UP, 1969.

Woodbury, Walter E. *Photographic Amusements.* New York: Scovil and Adams, 1896.

3

Death and the Photographic Body

Lynne Kirby

MUCH HAS BEEN made recently of the disappearance of photography and its replacement by video and digital technologies. A 1991 British exhibition entitled "PhotoVideo" took as its guiding concept that photography as we have known it—a medium in which an "image is fixed onto light-sensitive paper by the use of a camera," and a medium, above all, of evidence—is in the process of being transformed and ultimately replaced by video and computer technologies (Wombell, *PhotoVideo*). Photography historian Fred Ritchin is a major champion of traditional photography and also its prophet of doom, spreading the gloomy news about the decline of "fact-based, mechanistic qualities" in the age of electronic reproduction (8).

Photo scholar Anne-Marie Willis echoes the lament, claiming that "Notions of the primacy of the material world over the world of images (real versus representation) which have been challenged by postmodern theory are thus being undermined by technological developments themselves," adding that "The image versus the real distinction has had its day; a more workable distinction now might be between the immaterial and the material . . . " (203). Willis would like to dispense with the Real yet keep it, too, honoring the indexicality of the photographic signifier as link to truth. But the conclusion is the same: the emergence and increasing acceptance of video still cameras over conventional, mechanical cameras, along with the ability of digital processing techniques to alter any image originating in any medium, period, are ominous signs of the erosion of our faith in and acceptance of photography—and, by extension, the image.[1]

As an example, Ritchin and others point to how the press is abandoning the traditional photograph for the electronic one. Beginning with the famous photograph of the lone Chinese man bravely facing down a column of tanks in Tiananmen Square (a photo that appeared in the press thanks to a scanning process that allowed it to be transmitted over telephone lines), newspapers have begun to rely more and more on electronic images, grabbed video frames, or rescanned photographs as privileged images of truth and "news."[2] Ritchin and others recite a litany of examples of photography's decreasing presence in our media, including the invention of newspaper photos from scratch using computer imagery, the retouching

of magazine images, the acceptance and use of the Rodney King video (itself subject to the kinds of challenges photographs invite), and the imagery of the Gulf War.[3]

The Gulf War is the best-known and most profoundly disturbing instance of the triumph of video and computer imagery in the popular media. As everyone knows, this was a war whose most lasting image is that of the smart bomb's point of view as represented on a low-resolution black-and-white video screen.[4] During the war, our television screens were dominated by simulated imagery of video-game-like battles, computer-generated strategic maps, and, of course, CNN video reports. And to all appearances they will continue to be: The army's newest computer simulation war game is a "Desert Storm" tank battle recreated by computer from actual footage shot during the war, such that the real battle functions retroactively as the test for the simulated imagery.[5] In a sense, television during the war cloaked itself in modernism, turning its own technological base (and stepchildren in computer-related imaging) inward and spurning the photochemical image. Thus, as Ritchin points out, unlike during the Vietnam War, photo-based media had almost no role in defining the imagery and attitudes of the Gulf War (10).

But the elevation of military video and computer imagery to this new journalistic status in our culture implies for Ritchin other things for war imagery and for photojournalism. Not only did we enjoy far fewer photographs during the Gulf War, we also were presented with far fewer bodies or images of bodies (Ritchin 10; Kahn 45–56; Lee and Solomon xvii–xx). As we know, during the Vietnam War, photography and film played a major role in "bringing the war home" with images of American barbarism reported in excruciating close-up. It's hard to imagine a war in which photography or photography-based media occupied a more central place in sculpting public consciousness about the war. The paramount importance of television in disseminating images notwithstanding, Vietnam was essentially a photographer's war. And the consciousness it inculcated was for the most part consciousness of bodies, as well as body bags.[6] In line with representation of previous wars, war photography has always affirmed the body as casualty, as death, as corpse.

It is the absence of bodies—a focus on cause at the expense of effect, we might say—that is perhaps for Ritchin the most important effect of the absence of photography (Ritchin 10–11, 15). If, as has been argued, photography and film both always bear the work of death, the pausing to freeze, mummify, "corpse-ify" whatever body they capture or pose, the repression of photography in this case is the repression of death.[7] It is also the repression of memory—of *memento mori*. This is where the technological argument seems to hold water: Photography traffics in fixed, stable images; electronics in highly unstable ones. Photography gives the viewer a material trace to scrutinize at length, rip out of the newspaper, pause to examine and return to. Video, as television image, is ephemeral, unlasting, and inscrutable, except in the utterly exceptional repetition of the Rodney King footage, which, ironically and tragically, did not sustain the extended gaze of analysis.

(Meanwhile, it has been justly argued that Rodney King satisfied the voyeuristic thirst for bodily aggression denied during the Gulf War.)[8] Memory has an uncertain status on television, in part because of TV's addiction to instability and ephemera, in part because of the sound-bite conventions of news reporting and the relative absence of any archival function on television. We hardly ever return to the past outside television, only to unending reruns.

But even if we grant that photography played a diminished role in the reporting of the Gulf War, and that it plays a reduced role in news reporting, we must recognize nonetheless our culture's continuing fascination with the medium. If photography has been routed from war coverage, it has resurfaced like the tip of a squeezed balloon at the other end of culture, in art, advertising, and film, places where photography of every genre has existed for decades. Ritchin speaks somewhat naively of contemporary photographers as "today's poet-artists, acknowledged for their articulate subjectivity, and, for the same reason, less convincing with their photographic evidence to the general public" (10). He basically sees art as a tiny pasture for a retired and sadly irrelevant war horse. But even photographs from galleries, small-press books, and museums have mass-media power, as in the cases of Mapplethorpe and Serrano, which were powerful in part because their images were *too* believable, too realistic, not nearly as fantastic and incredible as repulsed moralists wished them to be. And photographs arouse historical, aesthetic, and journalistic interest as artifacts in the popular movie *JFK*, a flamboyant entry of the photograph as obsessional object into contemporary American culture that has stimulated an entire industry of photo-scrutiny and reflection on the veracity of the image at the mass level. Both *JFK* and Mapplethorpe are also about the body, its place as image in our culture, its presence/absence—too present in the case of Mapplethorpe, too absent in that of *JFK*, with the missing corpse, the lost brain, the autopsy on photography standing in for the autopsy on the president.

The search for the photographic body also leads us to the recent Benetton ads that have sparked so much controversy for their bald recycling of startling news photographs for commercial purposes. Their *"agence presse"* quality (some are clearly press photos, like the photograph of Albanian boat refugees), along with their painterly retouching of images in some cases, establishes photojournalism-as-art in a new way by fetishizing the shock value of "candid," *vérité* photography. The photo of the pieta-like AIDS victim and his weeping family, which is the image that has raised the greatest debate, shows us another mass-mediated receptacle for the contemplation and consumption of repackaged death that was denied as raw image during the war.[9] This, as much as photojournalism's demise, is what should trouble Ritchin.

Perhaps, then, what matters in this fluctuating multimedia landscape is not so much the medium itself as the institutions of mass media. The battle over technology is also a battle over the repression of information, as we are becoming more and more aware, with the recent reports of gross inflation of the performance rec-

ord of the military, from cruise missiles to Patriots, and the continuing flow of information out of Iraq regarding the devastation of the country and its populace (Cushman 4). Clearly there was video footage of death that was repressed as much as photographic evidence, or the mere presence of photographers. With limited access to the front, and even with access to Iraq's devastation, reporters of all media faced frustration in the reporting of casualties (Lee and Solomon xviii–xxii; Kahn 45–46). Not only were attempts to repress death imagery spun out of control by the military and the media, but the very evocation of mutilated corpses also became subject to self-censorship. A friend tells of someone she knows, a reporter for a major news daily, whose article on the refusal of a network to run video imagery of charred Iraqi victims by one of its reporters was itself refused print—an article, not even an image. And Jon Alpert, an independent video producer shooting inside Iraq, ended his twenty-year relationship with NBC over their refusal to air any of his footage.

We also need to remember that the so-called uncensored war that Vietnam is now thought to have been was actually represented by the media largely from the establishment viewpoint until attitudes in the American public began to shift just prior to the Tet offensive. As Daniel Hallin shows us, the misremembered obsession with bodies obscures the actual focus—and not a very strong one—on American, not Vietnamese, deaths (129–34; 144–64; 168–76).

In the zeal to indict the technology—even admitting its inherent tendency to unstable images and speed—the question of control over all images becomes focused more on the technology than the user. Even when it is acknowledged that the issue might be one of power, photography is waved as a banner of objectivity that, in the old days, was capable of challenging power effectively (Ritchin 15; Willis 206). But we know that censorship, whether official and organized (the Pentagon, the government) or unofficial and self-imposed (television, the press, the media), privileges no medium. (And even the camcorder's claim to objectivity as successor to the photographic camera has been thrown into doubt by the Rodney King verdict, leaving the question of technology as open as ever.)

While clearly supporting the need for more images, especially repressed images, to pierce the multiple veils of censorship obscuring the operations of power at home and abroad, I worry that photography as journalism is being elevated in the eyes of Ritchin, Willis, and others as a sacred cow of truth, and that new technologies of representation are being a priori framed as instruments of repression. It is true that today's technology can alter images so skillfully that no trace of alteration remains, and that the potential for suspension of disbelief is unprecedented (see Ritchin 12–13; Willis 204–207; and Holusha 6). But the crudeness of cut-and-paste methods of tabloid-type photo-fiction has never stopped "official" historians from doing it, or the public from believing it—if *JFK*'s assertions about the faked Oswald-holding-rifle photograph are to be believed (and even if they are not). It just makes the case for alternative images, and for alternative contexts for

images, that much stronger since, as the King video reminds us all too painfully, no picture really speaks for itself. It is to such a case that I now wish to turn.

Instead of looking at photography and video as adversaries in a battle for truth, I would like to focus here on how they might be seen together, not as digitally merged media but as modes of inquiry, to talk about war, death, violence, bodies, memory, and repression in alternative ways. Beyond television's faddish infatuation with home video as raw reportage, some video artists have taken up the photographic mode in a way that gives video the status of photography, as preserve of memory, as literal image, and as investigative eye. This is where video has been able to perform some of the functions of photojournalism—providing images to interrogate, comment on, illustrate, or investigate, graphic images that don't speak for themselves and that require contextualization.

The relationship between video and photography is long-standing. Video artists have been fascinated and informed in their practice by photography since the beginning of video as an art form. William Wegman, Bill Viola, and many others have merged the media in approach if not in form. And the work of Philippe Dubois shows us how often in Godard's work, especially in Godard's *Histoire(s) du cinéma*, video has been used to support or do the work of photography through manipulation of still imagery, freeze-frame, and processing techniques.

Video artists have also been concerned with representation of war. Looking back on video art since Vietnam, there are examples of video's rendering of bodies in graphic and photographic ways that loudly assert the existence of an unjust war at a very primal, emotional level: The work of Dan Reeves and Jon Hilton comes to mind (*Smothering Dreams* and *Body Count*). *Smothering Dreams* in particular, produced in 1981, should be read against the PBS official history of the Vietnam War, the thirteen-part series that aired in 1983 and that managed, despite abundant documentary footage of atrocities, to retreat from judgments those images suggested.[10]

But there is other video artwork that creates a critical window on war, and that sculpts a place for the body, photographically and in other ways, without literally showing us corpses. I want to look at what else might be said about the photographic body, and about the corpse in particular, either as a present or absent feature of representation—and whether its presence is necessary to a critical understanding of official war history *and* death. A recent work I wish to focus on, *Displayed Termination: The Interval between Deaths* (1988) by photographer/videographer Erika Suderburg, allows us to look at how the spirit of photography infuses an inquiry into the image that is critical, but not literal, and that uses that spirit to question the veracity of images and the truth of official histories. In this work sound is the crucial device guiding that spirit and turning a contemplative and critical gaze on the construction of history.

Displayed Termination: The Interval between Deaths is a twenty-five-minute experimental documentary that combines found—or we might say sampled—footage

Fig. 1. Erika Suderburg. *Displayed Termination: The Interval between Deaths* (1988).

and radio reports with original video imagery to create a critical collage about war.[11] The conflicts that feed this critique are the Vietnam War, the Philippines at the time of Marcos, and, to a lesser extent, World War II, as well as random examples of modern conflict that are less easily identifiable. (In retrospect, we can also see the tape as uncannily pointing forward to the Gulf War, in its obsession with desert imagery [as American military preserve], its use of Algerian Rai protest music, images of the air force, and the title itself, which evokes the video screen "interval" between smart-bomb deaths.)

The tape's primary techniques are repetition and juxtaposition: In the time-honored nonlinear fashion of experimental documentary film, it plucks sounds and voices from various contexts and hinges them to images from other contexts, avoiding almost entirely the use of synchronized sound. The tape also returns obsessively to certain images and sounds as mnemonic devices and intermittently drops chyron textual fragments over the images.

The result is to invest appropriated photographic and film footage and video images with highly charged sounds and voices that collide with each other, and the image, to spark unexpected and complex feelings about what the spectator is hear-

Fig. 2. Erika Suderburg. *Displayed Termination: The Interval between Deaths* (1988).

ing and seeing. Basically, we are meant to listen to some extremely powerful voices, witnesses to different kinds of war experiences, some distant, some close, and to reflect on chilling commentary by American soldiers in Vietnam as we contemplate the image.

The tape begins from a *mise-en-abîme* of its own representational strategy, interweaving indecipherable code signals; sounds of children playing; the voices, musical fragments, and static of a radio dial flip; and sounds of someone writing furiously with slow pans across empty rooms, shots of the American desert, and tableau images of women reading and writing. It starts as a search for meaning, straining to look and listen for sense and setting up the women as interpreters, archivists, historians. At one point we hear a German man speak of his relation to his father in terms of repression, describing an image of a pot boiling over and trying to keep the lid on—by which he means the lid on anger, resentment, and the history his father represents. This image of uncontainability moves the tape into a long sequence of various images defined by one soundtrack: a gripping description by an American reporter of Marcos thugs terrorizing ballot collectors during the election that brought Aquino to power. We hear doors being beaten down, chairs being thrown, frightened women clinging to ballot boxes and running hurriedly down hallways. The urgency of the acoustic effect is very much like the effects of Edward R. Murrow's reports during the bombing of London. Meanwhile, we see a montage of unrelated images: a slow pan of an anonymous woman laying sticks across a clay or wax box, tracking shots of the California desert, found video footage of police beating a man, and other documentary film footage from Vietnam (an American pilot, a military convoy, Vietnamese girls).

After this, the tape shifts to a sequence organized principally by voices of Germans, mostly women, who grew up with Nazi parents. The basic thrust of their accounts is that the fathers have lied, and the fathers are not dead, but survive as "Good Western Democrats" in contemporary Germany and Austria. We hear Marlene Dietrich sing "*Das Lied ist Aus*" and see images of Germans in photographs that the camera pans twice in an attempt to make sense of the images which do not illustrate what the voices describe. The voices and song continue over an image of a very young Vietnamese woman holding a baby, a long take of a partially obscured woman sewing up a tear in a pouch-like sheet, and various other images related to war.

The tape concludes with sound and imagery built largely around the U.S. withdrawal from South Vietnam. A British reporter describes having witnessed a South Vietnamese colonel driving a pink Cadillac go mad in public, which the tape recreates in artificial tableaux, slow pans, and closeups of the dead colonel's hair rustling in the breeze. American soldiers speak ashamedly of their hasty departure from the country. Finally, in one of two synchronized sound passages in the tape, we watch an American bomber pilot (whose image has appeared in brief snippets throughout the tape) describe with glee the details of a successful bombing mission

he has just completed. This image is interrupted by the woman sewing the pouch in a sheet, and the voice of a South Vietnamese woman who painfully describes her departure from Saigon.

The tape thus presents us with a very complex skein of images and sounds arranged according to a logic of association. But despite the title (*Displayed Termination*), very little in the way of termination, or the terminated—that is, bodies—is actually displayed. There are two brief images of torture: black-and-white footage of a captured North Vietnamese man subjected to water torture by American and South Vietnamese soldiers and found video footage of an unidentified man being dragged violently from a house as American policemen and SWAT-team types surround him. But for the most part, bodies are visible but inscrutable; text that appears over the man being dragged says "We couldn't see what was happening," repeating what the reporter says about the ballot-box scene. This might be considered a key trope of the piece, as we and the camera are constantly struggling to see something in the image, some clue as to "what's happening."

The body, in short, is elusive as an image, an idea that the tape links to the elusiveness of history. Indeed, one of the most repeated images in the tape is that of the anonymous woman, shot in video, whose face we never see but whose arms and hands are busy sewing up what looks like a pouch in a white sheet. At one point, the text over this image reads "Constructing the Corpse." From its juxtaposition with other images and voices, we understand this to be both specific corpses hidden from sight and the larger corpse of history. This image shows us a body trace, or more properly a body bag, that draws a circle around the historical corpses that litter the negative space of the tape.

But if we are denied bodies as images, even and especially when the tape focuses on pro-filmic photographs, we are offered bodies as sound: pained voices, descriptions of suffering, sounds of running, hitting, crying. The dense web of sound from which voices emerge is our access to historical and personal memory—memory as radio with a thousand channels, an archive of voices and images marked by war. By the same token, the tape constructs in individual images a photographic space of contemplation, empty rooms and desert landscapes panned slowly to be filled by new meanings, captions provided by the soundtrack and the juxtaposition with other images. These metaphorical "exquisite corpses" allow the point of view, the commentary of the tape, to emerge in the juxtaposition. As such we get a Tokyo Rose/Hanoi Hannah corpse, a Marcos/U.S. Army corpse, a German woman/Vietnamese woman corpse, and so on.

Often the image is quite beautiful, especially the most tableau, photo-like images of the woman with the box and the corpse-bag. But their beauty is not permitted to absorb the gaze; sound intrudes on the image constantly. The tape insists more on looking at beauty and listening to terror—laying bare an essential duality of Western culture—than on contemplating images of death, suffering, decay, which are evoked nonetheless in the sound/image gap. This gap is the very obvious

means by which the tape questions the various "voices of authority" floating in and out of the text. By mixing discrepant material, the tape works against the convention of a unified voice and instead allows the fragments to read each other in uncomfortable proximity.

Take, for example, a sequence in which a German woman tells of her childhood experience during the fall of Berlin, when American soldiers came into her mother's home. The mother, fearful that the Americans were going to rape her and her three daughters, challenged the soldiers in English, saying "Think of your mother!" The voice-over, which is heard above the Dietrich song, begins over a pan of photographs of German women and then continues over a cut to black-and-white footage of a Vietnamese girl holding a baby. It is over this image that we hear the mother's remark, "Think of your mother!" The voice continues the story over the next image of the woman sewing the corpse-bag and tells us that although they weren't violated, the soldiers did take their things. The stretching of the anecdote and the Dietrich song across these three images takes us from a nostalgic, poignant space of German history to an abrupt comparison with Vietnam, linked by the threat of American soldiers, and then to a more abstract space that pulls the story into the register of the "Corpse." The effect is to link in a visceral way the pain of victims on various sides of a conflict, temporarily at least disallowing a hierarchy of victims.

This essentially poetic technique works in other sequences to intensify the defamiliarization of the historical fragments and reclaim them for other purposes. In the very last sequence of the piece, an American bomber pilot has just finished discharging several bombs over the Vietnamese countryside and describes enthusiastically how he has hit his human targets and the effects the bombing will have on those who escaped death: "The napalm breaks their eardrums and makes them senseless. . . . By Jove, that's great fun, I really like to do that." The American pilot has been seen intermittently from the beginning of the tape, always without synchronized sound, and has functioned as a kind of agency driving the violence at a visceral level. At the end, we see him as he speaks: the synchronous marriage of sound and image is a culmination of previous drives in the text. But the marriage is spoiled by the intrusion of other images, other sounds. While the pilot is in the midst of describing his bombing, the image of the woman sewing the bag intervenes to reference not only the offscreen bodies the pilot has killed but the other corpses sewn into the image earlier. It also works as ironic counterpoint—her work versus his—and serves to heighten the shock effect of his discourse.

The final image of the tape—the pilot frozen as a photograph—is re-framed by a South Vietnamese woman's emotional voice-over describing the fall of Saigon, a voice that continues in the video black following the last image of the pilot. The woman tells a wrenching story of desperation and abandonment as she struggled to get out while the war continued to rage around her. The work of displacement here is complex; in theory she would not count as a victim of the pilot, but the

effect of the juxtaposition is to reposition the pilot as her aggressor: "How can men do this?" While still pointing strongly to American responsibility for the war, it widens the question of agency to men in general: Throughout the tape there is an insistence on men as perpetrators of war, represented obliquely as rape, and women as restorers of the body, the ones who pick up the pieces, literally, and put them back together. (It must be said, however, that the work of the tape is more sophisticated than this implies: Gender blame is not absolute in the tape, as some men are heard as victims and heroes at various points in the piece.)

As a critical strategy, the use of sound, and voice in particular, to inflect otherwise unreadable images in a visceral and critical way leads us back to the Gulf War coverage. *Displayed Termination* reminds us that the first several hours of the war were reported with a paucity of images and basically as sound: the voices of CNN correspondents Bernard Shaw, Peter Arnett, and John Holliman heard over maps of the Middle East, as well as over their own photographs and low-resolution images of bombs exploding over Baghdad. I vividly remember the sense of sheer fright with which the reporters cautiously described what they could see and what we could not—and the sense that "our" bombs might fall on them. To me this was critical reportage as personal essay: The whole scenario was one of reporting from the front, not from within enemy territory; it was one of slight shock that this was happening at all. The patriotic rhetoric, in other words, had not yet taken hold, and Peter Arnett had not yet been tarred with the "traitor" brush. And there wasn't even one body in sight.

NOTES

1. See Willis (200); Ritchin (9–15); Bode and Wombell; Becker; Robins; and Welsh. See also Holusha, "American Snapshot, the Next Generation," which profiles current and imminent technologies in consumer and industrial-grade video still cameras.

I need to say here too that though I believe skepticism of images is to be welcomed, I am not primarily concerned in this paper with ontology in the sense of the presumed reality outside the image. But I am concerned insofar as a greater truth status may be accorded one medium of representation over another, regardless of context, a tenet with which I clearly disagree.

2. Ritchin 9–10; Bode and Wombell 2–3; Becker 23–78. An emblematic example can be found in a front-page color video/photo in the March 28, 1992, Minneapolis *Star Tribune*. The image shows Bill Clinton and Jerry Brown locked in televised debate, with Clinton on a television screen within the image pointing at Brown who, from a TV studio, points back at Clinton with an electronic Sistine Chapel-like rapprochement.

3. Ritchin 10–13; Bode and Wombell 2–3; Becker 25–31; Willis 202–207; and Paul Wombell, "Screen War."

4. See Peters, in particular the article by Kahn. See also Lee and Solomon (xviii); Ritchin (11); Welsh (81); and Wombell, "Screen War."

5. The story was reported on CNN's *Headline News Network*, 25 March 1992.

6. Criticizing the attempts of the peace movement to equate the Gulf War with Vietnam, Nabil Al-Hadithy notes: "The favorite cliché was *body bags*. It really angered me.... This happened time and again. People I spoke to in leadership positions in the peace movement understood that there was something wrong with the Vietnam analogy too, but they were too attached to this image of American kids dying. They thought the only way to scare the American public away from supporting Bush's war was to talk of body bags. It didn't work. It backfired very badly. ... But it was a conscious effort to use this technique against all advice from Iraqis, and there *are* Iraqis in the Bay Area ... " (60–61).

7. The work of Susan Sontag and Roland Barthes is well known, but see also the illuminating articles by Stewart, and Creekmur. See also John Muse's reference to the Gulf War as "[a] war killing death itself" (56).

8. Kahn 46. It must be noted that the paper my article is based on was delivered a few days before the Rodney King verdict was handed down and Los Angeles erupted tragically in outrage at the clear injustice of the decision. Needless to say, events proved that even as raw, powerful, and *vérité* images as the home video footage of King being beaten by the officers could be subject to doubt; indisputable evidence was disputed. As a petition signed by members of the Society for Cinema Studies the week of the riots reads, "This demonstrates how close readings can incur misreadings" (qtd. in *The Chronicle of Higher Education*). Anne Friedberg drew a timely comparison to *JFK*, remarking "Part of what is so disturbing and upsetting about the verdict and the reaction for those who couldn't believe the arguments of the officers was that it must seem in South Central L.A. that the police were caught red-handed by the visual evidence. The fact that it didn't make any difference, in my reading, made the evidence seethingly more contributory to the rioting. It makes me think back to the Zapruder film, about the rearrangement of the visual evidence" (qtd. in McBride).

Also writing a few days after the riots began, Charles Hagen noted the incredible power the video footage of King held, which he felt could not be matched by a photograph, no matter how compelling it might be, in part because of the sheer duration of the tape. He summed up the irony of its troubling fate as follows: "While most Americans still regard the tape as irrefutable evidence of police brutality, the jury that acquitted the indicted officers obviously saw it differently. This puzzling fact goes to the heart of the matter: that photographic images of all sorts remain essentially ambiguous, and must be anchored in a convincing narrative before they take on a specific meaning. And most images can be made to fit into a number of widely disparate narratives" (32).

9. As Vicki Goldberg puts it: "No one fumed when the AIDS photograph was published in an article in *Life* a year and a half ago; the shock came when Benetton claimed ownership of today's most desperate news by branding it with the company name.... [H]owever pure or impure its motives (and though advertising keeps capitalism perking along, it has seldom been accused of purity), Benetton has given us what we should have expected and probably deserve: images of catastrophe as corporate ballyhoo" (33).

10. See the accompanying book by Stanley Karnow, *Vietnam: A History*.

11. *Displayed Termination* can be obtained through Video Data Bank in Chicago, Illinois.

WORKS CITED

Al-Hadithy, Nabil. "The Education of American Consciousness." Peters 59–61.

Becker, Karin. "To Control Our Image: Photojournalists Meeting New Technology." Wombell, *PhotoVideo* 16–31.

Bode, Steven, and Paul Wombell. "In a New Light." Wombell 1–7.

Body Count. Dir. John Hilton and Dan Reeves. Electronic Arts Intermix, 1981.

The Chronicle of Higher Education 13 May 1992.

Creekmur, Corey. "The Cinematic Photograph and the Possibility of Mourning." *Wide Angle* 9.1 (1987): 41–49.

Cushman, John, Jr. "Pentagon Report on Persian Gulf War: A Few Surprises and Some Silences." *New York Times* 11 Apr. 1992.

Displayed Termination: The Interval between Deaths. Dir. Erika Suderburg. Video Data Bank, 1988.

Dubois, Philippe. "Video Thinks What Cinema Creates." *Jean-Luc Godard: Son + Image.* Ed. Raymond Bellour with Mary Lea Bandy. New York: Museum of Modern Art, 1992. 169–85.

Goldberg, Vicki. "Images of Catastrophe as Corporate Ballyhoo." *New York Times* 3 May 1992: H33.

Hagen, Charles. "The Power of a Video Image Depends on the Caption." *New York Times* 10 May 1992: 32.

Hallin, Daniel C. *The "Uncensored" War: The Media and Vietnam.* New York: Oxford, 1986.

Holusha, John. "American Snapshot, the Next Generation." *New York Times* 7 June 1992: 6.

Kahn, Douglas. "Body Lags." Peters 43–46.

Karnow, Stanley. *Vietnam: A History.* New York: Penguin, 1983.

Lee, Martin A., and Norman Solomon. *Unreliable Sources: A Guide to Detecting Bias in News Media.* New York: Carol, 1991.

McBride, Joseph. "Visual Evidence Not the Whole Story for King or *JFK.*" *Variety* 14 May 1992.

Muse, John. "War on War." Peters 55–57.

Peters, Nancy J., ed. *War after War.* Spec. issue of *City Lights Review* 5 (1992): 1–273.

Ritchin, Fred. "The End of Photography as We Have Known It." Wombell, *PhotoVideo* 8–15.

Robins, Kevin. "Into the Image: Visual Technologies and Vision Culture." Wombell, *PhotoVideo* 52–77.

Smothering Dreams. Dir. John Hilton and Dan Reeves.

Stewart, Garrett. "Photo-gravure: Death, Photography and Film Narrative." *Wide Angle* 9.1 (1987): 11–31.

Welsh, Jeremy. "Mechanical Reproduction to Endless Replication." Wombell, *PhotoVideo* 78–91.

Willis, Anne-Marie. "Digitalisation and the Living Death of Photography." *Culture, Technology and Creativity.* Ed. Philip Hayward. London: Libbey, 1991. 197–208.

Wombell, Paul, ed. *PhotoVideo: Photography in the Age of the Computer.* London: Rivers Oram, 1991.

Wombell, Paul. "Screen War." Wombell 92–103.

Histories of Looking

4

Inventing Monument Valley
Nineteenth-Century Landscape Photography and the Western Film
Edward Buscombe

> This mesa plain had an appearance of great antiquity, and of incompleteness; as if, with all the materials for world-making assembled, the Creator had desisted, gone away and left everything on the point of being brought together, on the eve of being arranged into mountain, plain, plateau. The country was still waiting to be made into a landscape.
>
> —Willa Cather

I

"COWBOYS, INDIANS AND Mexicans must be seen in proper scenic backgrounds to convey any impression of reality." So wrote a critic in the *New York Dramatic Mirror* on 5 June 1909 (Robert Anderson 24). Conventional film history, including my own, has generally dated the Western from the appearance of *The Great Train Robbery* in 1903. But recently, scholars have doubted whether this film may properly be called a Western at all (Neale 52). Certainly it was not made in the West, the location sequences being shot on the Delaware and Lackawanna Railroad in New Jersey. The first recognizably Western films to be shot in a recognizably western landscape did not appear until 1907, when the Selig company ventured to Colorado. The company went out of its way to publicize the "magnificent scenic effects" of its productions. *Western Justice* was advertised in *Moving Picture World* as set "in the wildest and most beautiful scenery of the Western country" (Robert Anderson 23).

The next year, 1908, Selig was followed to Colorado by Essanay. So successful were the resulting films that many of the established film companies such as Biograph, Edison, Lubin, Vitagraph, and Kalem attempted to exploit the popularity of the emergent genre by producing their own Westerns back east. But these eastern Westerns could not compare in authenticity with the productions of Selig and Essanay. The critics roundly condemned their lack of true local color. In a mere two years, as the response of the *New York Dramatic Mirror* makes clear, western loca-

tions had gone from being a novelty to a necessity. By 1911, D. W. Griffith and the Biograph company had followed suit and gone west. Griffith's *The Heart of a Savage* was advertised in the *New York Dramatic Mirror* as featuring "the most beautiful Californian mountain scenery ever photographed" (Robert Anderson 26).

Robert Anderson, who has traced these developments in the formation of the Western genre, argues that its rapid rise to popularity—by 1910 20 percent of American pictures were Westerns—was a major factor in the successful battle of American producers against foreign imports. Attempts at this time by European companies to make their own Westerns in France, England, Denmark, and elsewhere testified to the box office success of this type of film, but the results appeared only to confirm that the appeal depended crucially on an authentically western look. American producers had found a type of film they could call their own, a truly national genre which proved a continuing hit with the public and for which foreign imports could not substitute. Not for another fifty years, until the rise of the Italian Western in the 1960s, were American producers challenged in their monopoly of the cinema's most popular genre.

But if Westerns needed western scenery to be authentic, what exactly were "the proper scenic backgrounds" which the critics demanded and which the companies were eager to provide? What ought Western landscapes to look like? The West, after all, was a big place. It offered a wide variety of potential locations for the filmmaker. Which was the most apt for Western subjects? And if there was an accepted type of landscape, how had the canon of taste been formed?

Visual representations of landscapes west of the Mississippi begin to appear in the 1830s, when professional artists first journeyed west to see for themselves. Though there are pictures of the Great Plains dating from this era, it was the Rocky Mountains which first captured the imagination both of painters trained in the European traditions of high art and of those working in a more popular idiom. By the 1860s, mountains in general and the Rockies in particular had become established as what western landscape was all about. A popular chromolithograph by Fanny Palmer issued by the Currier and Ives company in 1866 is entitled *The Rocky Mountains/Emigrants Crossing the Plains*. It depicts a wagon train making progress through a vista of verdant meadows which Constable would not have disdained. In the background, white-capped mountains rise to dizzying heights. The scene owes everything to European models, mixing the pastoral and the romantic in equal parts.

The foremost painter of western landscapes at this time, Albert Bierstadt, had trained in Düsseldorf, home of German romanticism. He found the Rockies "very fine. As seen from the plains they resemble very much the Bernese Alps; they are of granite formation, the same as the Swiss mountains . . . the colours are like those of Italy" (Goetzmann 225). He proceeded to paint them so, dramatizing his pictures with thrilling effects of light and cloud. The pictures were themselves on a physical scale to match their subjects—six feet by ten feet. They were wildly suc-

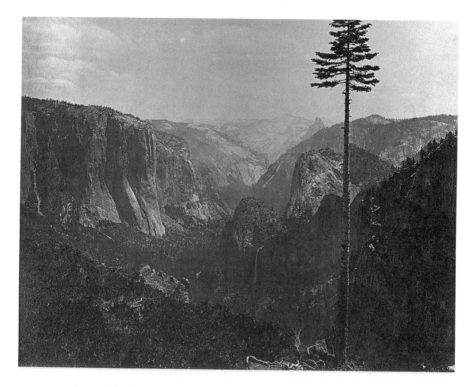

Fig. 1. Carleton E. Watkins, "Yosemite Valley" (1886). From the American Geographical Society Collection, University of Wisconsin–Milwaukee Library.

cessful with the public and, despite Bierstadt's European training, were hailed as representative of a genuinely American art. The critic Henry T. Tuckerman, writing in 1870, thought Bierstadt's *The Rocky Mountains* "eminently national . . . a grand and gracious epitome and reflection of nature on this Continent" (qtd. in Baigell 11).

Bierstadt's pictures of the California Sierras were equally spectacular. The pearl of the Sierras was the valley of Yosemite. From the beginning of the 1860s it had attracted the attention of both painters and photographers, whose images were influential in the decision by President Lincoln in 1864 to decree Yosemite a natural preserve. The San Francisco photographers Carleton Watkins and Eadweard Muybridge vied with each other in producing ever more sumptuous views of the Yosemite landscape on the huge (18" x 22") glass plates of their specially constructed cameras. The principles of composition which the photographers adopted were drawn directly from the traditions of landscape painting. The rules governing the respective proportions of landscape and sky, the framing of a distant view by foliage artfully arranged in the foreground, the frequent use of an expanse of water to reflect and so enhance the beauty of the view, all are transposed directly into the

new medium of photography—and back again, for Bierstadt in turn used the photographs of Watkins and Muybridge to assist him in his painting of Yosemite (Baigell 13).

The growth in production of photographs of beauty spots such as Yosemite was both the cause and the effect of tourism. Photography increased the visibility of such places, stimulating the desire to travel to them, and it provided a means whereby the landscape could be rendered into a consumable form and carried away at an affordable price. This kind of art photography, with its painterly qualities, based on the representation of landscapes validated by a European tradition and reflecting the taste of the comfortable middle classes who consumed it, passed easily into the cinema. From the earliest Westerns located in the Rockies of Colorado to the classics of the 1950s and 1960s, mountain scenery has been used to authenticate "Westernness." André Bazin identified what he called the "sur-Western," the Western "that would be ashamed to be just itself, and looks for some additional interest to justify its existence—an aesthetic, sociological, moral, psychological, political or erotic interest, in short some quality extrinsic to the genre and which is supposed to enrich it" (151). The opening sequence of *Shane*, a self-conscious attempt to create a summation of the genre, an instant "classic," is indeed "enriched" by the combination of distant mountains, framing foliage and reflecting water as the young Joey observes from behind the trees the approach of Shane. The director George Stevens's use of landscape derives from the tradition which Bierstadt was instrumental in creating. And one may even suspect a more direct borrowing from one painting in particular, for in the opening sequence is there not in the watchful deer posed against the backdrop of the Tetons an echo of Bierstadt's painting *Estes Park, Colorado: Whyte's Lake*?

Landscape in this tradition is an aesthetic object. Its function is to be gazed at, in an act of reverential contemplation. Roderick Nash has placed the sources of this attitude to landscape within the romantic movement: "The concept of the sublime and picturesque led the way by enlisting aesthetics in wild country's behalf while deism associated nature and religion. Combined with the primitivistic idealization of a life close to nature, these ideas fed the Romantic movement which had far-reaching implications for wilderness" (Nash 44). Nature is conceived of as essentially unspoiled. Human beings appear in these pictures only rarely. Indians are allowable because they are assumed to be part of the natural world, and humans may also function as markers of scale, serving to play up the vastness of the panoramas displayed. Besides conforming to the aesthetic rules of landscape art, photographers of western scenes also followed the practice of painters by including the viewing subject in the scene, inscribing into the image the correct way of reading it. The spectator within the frame, in a position of static, usually sedentary relaxation, gazes in awe at the wonders in the distance. Mountain scenery in this tradition seems inescapably bound to a kind of spiritual uplift, as if the verticality of the

mountains were in some way a metaphor of their effect upon the observer. In Hollywood cinema, and in the Western in particular, mountain scenery could be said to function as a substitute for religion, a way of introducing a secular spiritual dimension.

II

Yet today when we think of the West and Westerns, it's not mountains, trees, and lakes that first come to mind, but more often the deserts and canyon lands of Arizona and Utah. Since the 1860s the center of gravity of the Western landscape has moved southwest. As we have seen in the case of *Shane*, deserts and canyons never managed a monopoly of Western scenery. But they did achieve a certain domination, such that Anthony Mann, famed for his use of mountain scenery, was moved to protest: "I have never understood why people make almost all Westerns in desert country. John Ford, for example, adores Monument Valley, but Monument Valley, which I know well, is not the whole of the west. In fact the desert represents only a part of the American west" (qtd. in Mauduy and Henriet 69). In *Géographies du Western*, a map shows that for a total of 411 films surveyed the setting of the diegesis was heavily weighted toward the Southwest, including New Mexico and Texas. A second map shows the actual locations in which films were shot. Here, for a total of 191 films surveyed, the preponderance of southwest setting is even more pronounced (Mauduy and Henriet 23). Particularly striking is the fact that despite the large number of films set in New Mexico and Texas, very few were actually shot there. In many cases Utah and Arizona are doubling for these two states, presumably on the grounds that they correspond more to what Texas and New Mexico "ought" to look like. John Ford's *The Searchers*, set in Texas but largely shot in Monument Valley in Arizona, is a notable example.

Over the past hundred years or so, two topographical features of the Southwest landscape have achieved special status, though via somewhat different routes. The Grand Canyon and Monument Valley have come to signify, in contemporary usage, not just the Western, but America itself. In a recent British Airways commercial, the Grand Canyon stands as a symbol of the access to the exciting places in the world which the airline claims to provide, even though there are no scheduled British Airways services to the Grand Canyon itself. In the last few years, the silhouette of Monument Valley has become an even more readily identifiable icon of the West of America, and of the West *as* America. In a Burger King commercial, a couple of Indiana Jones-type flyers in a World War II Dakota touch down in the valley for fast food. In a recent campaign for Rebel Yell bourbon, Monument Valley appears in a bizarre collage of icons—a bucking bronco, the Confederate flag on a guitar, the Statue of Liberty—designed to communicate the essence of America.

Monument Valley was placed on the cultural map by John Ford, who first went

Fig. 2. Diagrams from J. Mauduy and G. Henriet, *Géographies du Western*.

there in 1938 to make *Stagecoach* and subsequently shot seven more Westerns there. Over a period of about ten or fifteen years that one location became almost exclusively identified with Ford's films. Other filmmakers have on occasion ventured to the same spot, but they have been very few, and often, as in the case of Sergio Leone's *Once Upon a Time in the West*, a deliberate reference to Ford has been intended. As a result of this close identification between Ford, the Western, and southwestern scenery, critics sometimes assume that any film showing canyons and desert must have been shot in Monument Valley. In *The BFI Companion to the Western*, Paul Willemen's entry on Raoul Walsh's *Pursued* mistakenly refers to "the towering rocks of Monument Valley" (Buscombe 290). I myself, in an entry on Monu-

ment Valley, mistakenly claim that Ford's *Wagon Master* and *3 Godfathers* were shot there (Buscombe 191). More recently, Leo Braudy writes in a review of *Thelma and Louise*:

> As they escape, when the film truly hits the road, the promise of space and free-dom lures them on. But the camera still continues to stress the choking inevita-bility of the world they are trying to escape, not just the massive machinery, oil drilling equipment, and trucks that constantly threaten to squeeze them out of our vision, but even the seemingly more benevolent spaces and spires of John Ford's Monument Valley. (28)

As the closing credits to the film tell us, the western scenes of *Thelma and Louise* were actually shot in Arches and Canyonlands National Parks. But Monument Valley has now come to signify Ford, Ford has come to be synonymous with the Western, the Western signifies Hollywood cinema, and Hollywood stands for America. Thus, through a kind of metonymic chain, Monument Valley has come to represent America itself.

Ford's genius for framing and camera placement drew from this one location an astonishingly rich and evocative variety of meanings. But before he could ex-ploit its resources, the landscape had first to be invested with meaning. The process whereby its unique arrangements of rock and space accreted aesthetic value had taken place much earlier, in the last part of the nineteenth century when the shift in public taste occurred through which deserts and canyons replaced mountains as the most beautiful and authentic American landscape.

As we have seen in the case of Bierstadt, the celebration of America's natural wonders was held to be an eminently patriotic activity. But inevitably there was something imitative about the depiction of the Rockies and Sierras. Other coun-tries too had beautiful mountains; had, in a sense, had them for longer than Amer-ica. What was needed was something different, something unique. That something was first revealed during the 1870s as the Southwest of the United States was opened up by systematic exploration and a new kind of landscape was discovered, one which could not easily be understood within the categories of the sublime or the picturesque which had previously valorized the mountains.

The largest feature in the landscape of the Southwest was of course the Grand Canyon. The first white men to see it were part of the Coronado expedition of 1540, but, strange though it now seems, it made little impression on them. It was as if they literally could not see it, because they could not fit it into the visual framework of the time. The first proper exploration came with the Ives expedition by the Army Corps of Topographical Engineers in 1858, whose report was published in 1861. Ten years later, at the beginning of the 1870s, two separate government expeditions brought back the first photographs of the canyon. Under the sponsorship of the Smithsonian Institution, Major John Wesley Powell, a one-armed Civil War vet-eran, made an extensive survey of the entire canyon by boat. Powell had made a previous river passage in 1869; this time he had a photographer, Jack Hillers.

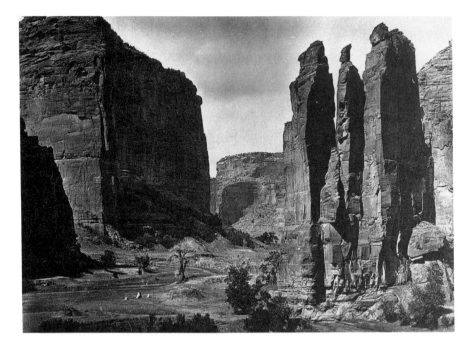

Fig. 3. Timothy O'Sullivan, "Canyon de Chelly" (1873). Library of Congress, Washington, DC.

Also exploring the Grand Canyon area in 1871 was an army expedition led by Lieutenant George Wheeler. The photographer with Wheeler's party was Timothy O'Sullivan, who had learned his trade while a member of Matthew Brady's Photographic Corps in the Civil War. In 1873 O'Sullivan returned to the Southwest with Clarence King's geological survey, making pictures of the Canyon de Chelly and elsewhere in Arizona. Many of his photographs were destroyed when a reporter carrying them back east was killed by Apaches in the Wickenberg Stagecoach Massacre of 1873—a case perhaps of nature imitating art—but fortunately some survive.

The landscape that confronted Hillers and O'Sullivan resisted accommodation to the canons of European landscape painting. Here were no uplifting, elegantly pointed mountains, but rather canyons of dizzying depth and outcrops of rocks twisted into bizarre shapes by volcanic and erosional activity. There were scarcely any trees to provide a harmonious frame, nor many lakes of quiet water to offer a pleasingly symmetrical reflection. Unlike Muybridge and Watkins, Hillers and O'Sullivan were not primarily motivated by the desire to please the paying public. They were not obliged to take popular taste or artistic convention into account, since the chief purpose of their pictures was scientific. Powell had a promiscuous interest in many of the emergent branches of science at the time. In 1879 he

created the Bureau of Ethnology at the Smithsonian Institution, and Hillers made many photographs of Indians while employed on Powell's expeditions. But in the 1870s the queen of sciences was geology, and Powell's main purpose was to inquire into the geological structure and history of the Colorado valley. Wheeler's brief from the army on his tour through California, Nevada, and Arizona, though primarily a practical one, also encompassed a scientific purpose:

> "The main object of this exploration will be to obtain topographical knowledge of the country traversed by your parties, and to prepare accurate maps of that section. . . . It is at the same time intended that you ascertain as far as practicable everything relating to the physical features of the country, the numbers, habits and disposition of the Indians who may live in this section, the selection of such sites as may be of use for future military operations or occupation, and the facilities offered for making rail or common roads, to meet the wants of those who at some future period may occupy or traverse this part of our territory." In his spare time [!] he was to survey the mineral resources of the country, the geological formations, the vegetation, its suitability for agriculture, the weather, and establish a number of astronomically observed points of latitude and longitude. (Goetzmann 469)

The pictures which Hillers and O'Sullivan took were not primarily intended as aesthetic objects but as scientific evidence to support the speculations of the geologists on the forces that had shaped the landscapes they explored. The first person to appreciate the scientific significance of the Grand Canyon was John Strong Newberry, the geologist of the Ives expedition, who produced a description of the different rock strata which the canyon revealed. Newberry called it "the most splendid exposure of stratified rocks that there is in the world." In his view, "the Colorado Plateau is to the geologist a paradise" (qtd. in Pyne 21).

The philosophical impact of the scientific speculations set in motion by geological explorations can scarcely be overestimated. In 1849 the discovery in Dakota territory of fossils within successive layers of rock had suggested that, if evolution theory was correct, immense expanses of time must have elapsed since such primitive life forms existed. Before turning to the Grand Canyon, American geologists had already identified Precambrian strata among the exposed cliffs along the Green River in Wyoming, taking the history of the earth well back beyond the formation of living creatures. But the Grand Canyon was by far the most visually spectacular demonstration of the revolution that geology demanded in the conception of historical time. If, as geologists argued, the gorge of the Colorado had been caused by fluvial erosion, then vast eons must have elapsed while the river cut its way deep into the earth. "The growing realization, confirmed by Darwin's success, that the earth was not merely older than previously thought but immensely and indescribably older found expression in the erosional forms of the Colorado Plateau" (Pyne 21). The photographs brought back by Hillers and O'Sullivan provided stunning views of the canyon's wonders. The visual evidence they provided of the almost unimaginable antiquity of the earth surely endowed the pictures with an

added dimension, a philosophical frisson. Just as the astronomical revelations of Galileo removed the earth from its presumed position at the center of the universe, so geology decentered humanity from its position of occupying the whole of history. Human beings were now seen to be late arrivals on a planet whose physical shape had been carved out over periods of time virtually "measureless to man." If the sight of mountains aroused the spectator to a quasi-religious awe, raised him or her up, almost literally, to a contemplation of what was most noble in human nature, the vision down into the earth, peering back into countless millions of years, produced a no less awesome sense of humility in the face of the immensity of time.

The Grand Canyon was by no means the only area of the West to excite the geologist's imagination. At the same time that Powell was exploring the Colorado, Ferdinand V. Hayden mounted an expedition to the Yellowstone area of Wyoming. Hayden was working for the United States Geological Survey, an agency of the Department of the Interior, and had distinguished himself in scientific explorations of the West—he had been active in the discovery of fossils in the Dakotas. He was fortunate to have with him on his trip to Yellowstone William H. Jackson, perhaps the greatest landscape photographer of the West during the nineteenth century. Hayden was alert to the value of photography in providing visual evidence of the marvels which the explorer uncovered, and in thus helping to secure funds for future expeditions. In 1870 he published *Sun Pictures of Rocky Mountain Scenery*, a popularization of earlier Survey reports which contained thirty photographs by the noted railroad photographer Andrew J. Russell. In this book, Hayden created what Peter Hales has called a "poetics of geology and one of landscape as well" (69). Hayden wrote:

> We shall also delay now and then, to study the rocks and unearth their fossil contents; and in many a locality we shall find the poet's utterance no fiction, that there are "sermons in stones" etc. Scenes more wonderful than any related in the far-famed Arabian Nights Entertainments have been performed on these apparently lifeless, monotonous plains. (Hales 70)

Landscape, then, was a text to be read by science, but its ultimate significance required a philosophical interpretation. What the rocks revealed was that "life is infinitely short, and human achievement utterly insignificant" (Hales 70). Photography, which was also underpinned by science, revealed as nothing else could the immense scale of the landscape, the smallness of humans within its space, its vast age and its sobering effect on human self-importance.

Like the canyon lands of the Southwest, Yellowstone could not easily be assimilated into the European landscape aesthetic. An example of how this newly discovered region conflicted with the preconceptions of artists can be found in the first attempts of the painter Thomas Moran to portray Yellowstone. Moran, born in England and an admirer of J. M. W. Turner, was making his first trip west as a guest of Hayden's expedition. His sketch of the Grand Canyon of the Yellowstone, done

for *Scribner's Monthly* in 1871, owes little to the scene itself and everything to a romantic European tradition. But Moran and Jackson struck up a friendship, and the painter was able to learn much from the images which Jackson produced. The debt which Moran's eventual painting of the Yellowstone, executed on a heroic scale (84" x 144"), owes to Jackson's photography is considerable. Another Jackson picture, a stereograph, shows Moran in the process of investigating the landscape at close quarters. Moran, conscious of the scientific value of what he painted, claimed that he painted rocks so exactly that "a geologist could determine their precise nature" (Goetzmann and Goetzmann 176).

In 1873 Moran was invited by Powell to join his continuing explorations of the Grand Canyon area. His subsequent painting, *The Chasm of the Colorado*, on a similar scale to his painting of the Yellowstone, again owed much to photography. Moran and Hillers worked closely together. But the Grand Canyon posed a problem for both painters and photographers. As anyone who has ever tried to photograph it will know, its sheer size resists being captured within the frame, however large.[1] Despite his claim of geological exactitude, Moran succumbed to the romantic allure of clouds and sky, suggesting the vast distances of the scene by obscuring the detail in haze. The distances also tended to defeat the attempt of photographers at accurate representation, since, inevitably, the furthest parts of the view became diffused. Perhaps the most telling photographic view of the canyon is one by Jackson, dating from considerably later and made in 1892, which surrenders to the inevitable blurring of distance and makes the focus of the picture the observers' sense of wonder.

The most accurate and the most exciting pictures of the canyon were produced neither by photographers nor by painters but by William Henry Holmes, a scientific illustrator who provided pictures for the classic work on the canyon's geology, Clarence Dutton's *Tertiary History of the Grand Canyon District* (1882). Holmes managed to combine the most painstaking representation of the layers of rock formations down through the canyon walls with a vertiginous sense of depth. But Holmes's pictures were buried in a single government report. Jack Hillers's photographs, which in the form of heliographs were also included in Dutton's work, achieved much wider currency through other means.[2] It would be hard to overestimate the influence of Hillers and his peers on the popular taste in landscape pictures:

> Because he worked solely for organizations dedicated to conveying information to various publics, Hillers's works probably were more widely disseminated, and seen by more people in the nineteenth century and since, than any of his peers'. First, his photographs were used as the basis for engravings or woodcut illustrations, and later (as printing technology improved) for half tones, in many publications of the Bureau of American Ethnology and the Geological Survey. No actual count has been made of the number of Hillers's images used in those publications during his active career, but it would likely run to over four hundred examples. Bureau of Ethnology and Geological Survey publications were widely

> distributed. Often as many as 10,000 copies were ordered printed. . . . Thousands
> of copies of the stereographs that Hillers made from 1872 through at least 1879
> were duplicated by the Jarvis Company of Washington D.C. . . . Finally, Hillers's
> prints and transparencies were shown at several international expositions from
> 1876 to 1904. (Fowler 155)

The demand in the later part of the nineteenth century for landscape photography,
for pictures of mountains and canyons alike, was immense. In 1902, its peak year, the
Detroit Photographic Company, which had eventually purchased most of Jackson's
negatives, sold over 7 million photographs, a large number of them landscapes, rang-
ing from postcards and stereographs to panoramas 20" x 150". Stereographs were es-
pecially popular. They had created a sensation when shown at the Crystal Palace
Exhibition in London in 1851. All the important photographers of the West, including
Muybridge, Watkins, Jackson, and O'Sullivan, made stereographs for sale to the pub-
lic. From the Powell survey, about 650 different stereographs were made by Hillers
and others for commercial sale.

The strange landscapes of the Southwest met with some resistance from those
still loyal to the European tradition. Moran's 1873 painting of the Grand Canyon
had not found universal approval. *Scribner's* disliked "an oppressive wildness that
weighs down the senses" and *Atlantic Monthly* considered the picture "wanting al-
most entirely in the beauty that distinguished earlier work" (Goetzmann and
Goetzmann 185). Yet the immense outpouring of both paintings and photographs
of southwestern scenery, fueled by the growth in informational and educational
publications, assisted by developments in printing technology, and buoyed by a
public which found entertainment in scientific novelty, is evidence that a distinctive
shift in taste was under way.

III

As we have seen in the case of the tourist appeal of Yosemite, not all the pic-
tures of the West were made for scientific purposes. In the 1870s and afterward,
large numbers of photographs were commissioned by the railroad companies. The
railroads had a direct interest in the development of tourism, and the more the
western landscape could be promoted as an unspoiled wilderness, the more busi-
ness they did, even if paradoxically the more tourists arrived the less unspoiled it
became. The railroads needed both to portray to its fullest extent the wildness of
the country, thereby elevating their own achievements in traversing it, and at the
same time to demonstrate that while the landscape had lost nothing of its splendor,
it had now been rendered safe and comfortable for travel. They therefore lavishly
commissioned photographs which showed off their spectacular achievements in
throwing railroads across the West's most intractable terrain.

No canyon was too deep, no mountain pass too high, no river too wide for the

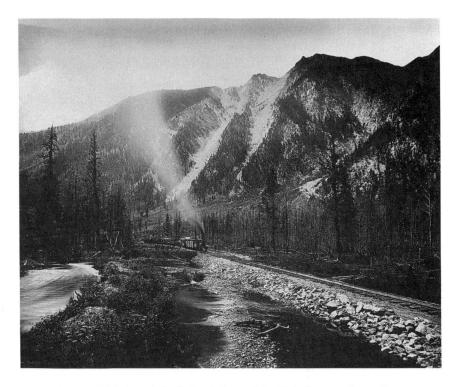

Fig. 4. W. H. Jackson, "Chalk Creek Canyon" (c. 1887). Courtesy Amon Carter Museum, Fort Worth, Texas.

engineers to span. There was even at one point a plan to run a railroad down the Grand Canyon itself. Though the railroads as a whole did not especially favor the Southwest over other regions—each company was concerned to promote its own field of operations—their emphasis on landscape as an obstacle to be surmounted as well as an object of aesthetic contemplation was consonant with the shift in taste produced by the geologists. For the railroads, aesthetically harmonious views came to be less prized than pictures which accentuated landscape's resistance to conquest.

The railroads and their photographers had a different perspective on Time from the geologists. In trumpeting forth their engineering achievements, they evoked not a past of unimaginable duration but a future of limitless progress which would be delivered by the unstoppable combination of technology and capitalism. Landscape was no longer solely an object of contemplation but a barrier to be overcome. In taming its awesome proportions it could be possessed, made manageable, even domesticated, and turned into a source of profit.

The railroads financed not just photographers but painters too, especially in

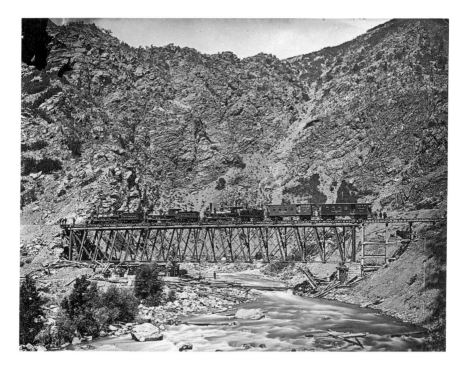

Fig. 5. Andrew J. Russell, "Iron trussed span, Weber Canyon, Utah" (1869). Courtesy of The Oakland Museum History Department.

the Southwest. Thomas Moran had been funded on his trip to Yellowstone by Jay Cooke, who financed the construction of the Northern Pacific Railroad. But:

> The most profitable of Moran's corporate relationships was undoubtedly that with the Atchison, Topeka and Santa Fe Railroad, which began late in the 1870s but came to fruition in 1901, when the line was extended to the Grand Canyon. In a cooperative arrangement involving the exchange of pictures for travel and lodging, Moran's paintings of the canyon were placed in parlor cars, hotels, and corporate offices. More important, however, were the images that appeared in guidebooks, on posters and calendars, and as chromolithographs. These were distributed widely during various promotional campaigns for the railroad, but they also served to promote the work of Moran. Neither the artist nor the picture-buying public seemed to tire of his Grand Canyon paintings. Following the completion of the railroad spur to the canyon in 1901, Moran returned to the area annually till his death in 1926. During that period he produced hundreds of Grand Canyon paintings for a market that owed at least part of its strength to the tireless promotional efforts of the Atchison, Topeka and Santa Fe. (Nancy Anderson 255)

In 1875 Powell published his own book, *The Exploration of the Colorado River of the West*. It was immediately popular and was influential in attracting visitors to the area.

By the turn of the century, tourism to the Grand Canyon was in full swing, so much so that it became itself the actual subject of the picture in Oscar Berninghaus's 1915 painting *A Showery Day, Grand Canyon*, which depicts visitors enjoying the view. The 1899 edition of Baedecker's guide to the United States included a map and instructions on how to reach it by stagecoach. When the Santa Fe Railroad built its spur to the south rim, the Fred Harvey company put up the El Tovar hotel at the terminus. In 1903 Teddy Roosevelt, that great booster of the West, came and pronounced: "In the Grand Canyon Arizona has a natural wonder which, as far as I know, is in kind absolutely unparalleled throughout the rest of the world. . . . You cannot improve on it. The ages have been at work on it, and man can only mar it. . . . Keep it for your children, your children's children, and for all who come after you, as the one great sight which every American . . . should see" (qtd. in Pyne 29).

Once the Southwest had been opened to the traveling public there was a concerted attempt to populate the landscape and to recreate Indian life specifically for the purposes of tourism. In 1903 the Santa Fe published *Indians of the Southwest* by George Dorsey with illustrations by the great photographer Edward Curtis. In 1904 Fred Harvey, who had made a fortune out of the restaurant concession on the Santa Fe, commissioned the Detroit Photographic Company to produce a large number of views of the country through which the railroad traveled, for sale at his restaurants and hotels:

> At a time when the Southwest remained one of the few regions tourists still insisted they'd rather travel through at night than during the daytime, Harvey's decision to use the Detroit Photographic Company and the postcard medium as a means of generating a new and more positive image, was brilliant. . . . Harvey's commissions presented the Southwest as a place of romance rather than Romanticism. Focusing first on the most obvious points of tourist interest, the earlier sets "worked up" the Grand Canyon, revitalized the Indian as a creature of interest to visitors, and began to market a new Western sublime of the desert. . . . Harvey's set showed Kit Carson's house, Navajo medicine men, an "Apache War Party," Indians on horseback, Indians in ceremonial garb, Indians in all possible poses designed to suggest to the viewer the possibility of reenacting a mythological Western past without danger to self or property. And this presentation dovetailed with the campaign to present the dry Southwest as a place with an exciting past and a picturesque present. (Hales 266)[3]

Besides Harvey's postcards, the Santa Fe produced hundreds of lantern slides which were exhibited in Lecture Lounges in Harvey hotels during illustrated talks for tourists, as well as in schools and places of business.[4] Each year the Santa Fe published a calendar featuring paintings of Indian life by such well-known artists as E. Irving Couse, a founder of the Taos School. The railroad named cars on its famous *Super Chief* train after famous Indians such as Satanta and Geronimo (McLuhan 194). On the way from Chicago to Los Angeles passengers could take an Indian Detour at Albuquerque, where they would embark on a luxury motor bus and visit Indian pueblos

Fig. 6. "A Hopi Basket Weaver." Fred Harvey Co. postcard, produced by the Detroit Publishing Co.

and the Canyon de Chelly. Famous detourists included European royalty and Albert Einstein.

This safely romanticized and humanized version of the Southwest finds appropriate and accurate cinematic expression in *The Harvey Girls*, MGM's musical tribute to the Harvey restaurant chain. The film opens with Judy Garland singing from the back of a Santa Fe car as it speeds through Monument Valley on its way to the town where Judy will be employed in a Harvey's restaurant and will thus play a full part in the civilizing of the West. The sequence calls attention to the role of the railroad in the aestheticization of the desert and in making it available for mass consumption. In the course of her song, Judy retires into the interior of the car, from where the landscape can be seen rolling past the windows, thus giving us a taste of the effect of Hale's Tours, that curious contraption from the early years of cinema in which a paying audience was accommodated in a mock-up of a railway car while filmed travel scenes were projected outside. The relation between the railroad, tourism, the aesthetics of landscape, and the cinema could not be more concisely communicated.

IV

How far can we see in the films of John Ford traces of these historical discourses which produced such a shift in the aesthetics of the western landscape?

Fig. 7. Judy Garland in *The Harvey Girls* (MGM, 1945).

Despite the attentions of Ford and other filmmakers, Monument Valley has never become a tourist mecca like the Grand Canyon. It was, when John Ford first went there, the furthest point in the continental United States from a railroad—180 miles, in fact. Even today tourism is little developed. The valley lies in an empty quarter on the way to nowhere in particular, and few visitors make the detour. It has, unlike the Grand Canyon, essentially no existence in the popular mind except as a movie set. Its later iconographic status seems entirely due to the influence of Ford's work. Nevertheless, what Ford manages to make the landscape mean owes much to what artistic and photographic discourses had previously inscribed upon it. First, Ford's framing of the landscape to exert the maximum contrast between its vast distances and the smallness of the figures that populate it is a clear echo of nineteenth-century photographic practice. Just as the photographers of that time played on the vastness of both space and time, so in looking at the vistas which Ford puts before us it is impossible not to register the relative puniness of humanity measured against his towering mesas. And just as the Grand Canyon excited the imaginations of nineteenth-century geologists, dramatizing the huge forces and vast eons that had carved such a chasm, so the thousand-feet-high outcrops of de Chelly sandstone rising starkly from the valley floor of Monument Valley surely

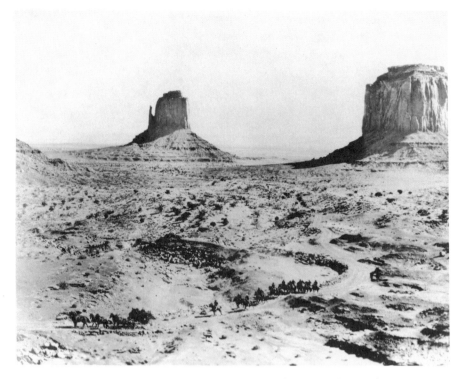

Fig. 8. Monument Valley in *Stagecoach* (United Artists, 1939).

call to mind an equally awesome sense of time etched into the rock by millions of years of erosion.

However, landscape in the cinema is never, or never for long, an object merely of contemplation. Narrative is all. In a film, landscape becomes scenery in another, theatrical sense, a backdrop against which the action is played. In the Western, that action frequently takes the form of a journey; landscape then becomes an obstacle which has to be overcome. Its beauty is incidental to its function as a test of the protagonists' characters. At the end of *Wagon Master* the emigrants gird themselves for one last haul up the jagged cliff face. When finally the journey is successfully achieved, and the terrain, with its physical obstacles, has been traversed, then the sense of accomplishment is akin to that in the railroad photographs of chasms bridged and mountains tunneled. The conquest of the terrain is emblematic of the achievement of the individual in overcoming personal trials and is analogous to the wider victory of capital in subjugating nature. Ford's epic Western of the 1920s, *The Iron Horse*, celebrates just such a personal and social conquest of the mountains in the construction of the first transcontinental railroad.

V

The vision of a picturesque Southwest constructed in the promotional publications of the Santa Fe railroad and Fred Harvey appears to have jumped straight off the page and into MGM's movie about Harvey's business venture. When the train arrives in the town there is a lavish musical number ("The Atchison, Topeka and the Santa Fe") in which colorfully dressed cowboys join with Indians in southwest-style garb in an exuberant celebration of a tourist paradise. There are moments in Ford's Westerns when the mannered way in which Indians are posed against a landscape seems designed to trigger a not dissimilar response, as for example toward the end of *She Wore a Yellow Ribbon*, when John Wayne as Captain Brittles rides into the Indian camp to meet his friend Chief Big Tree, and in a series of shots warriors are positioned picturesquely against the skyline. Usually, however, the view of the Southwest which found its way into Ford's films was a trifle more robust, more "manly" than the feminized world of the MGM musical. Though visually it undoubtedly owed something to tourist postcards, it was also refracted through other media of popular culture, most notably the stories of Zane Grey. In 1907 Grey, by profession a dentist and an aspiring but as yet unsuccessful writer, was taken on a trip to Flagstaff, Arizona, and then by horseback to the Grand Canyon. The effect on him of the desert scenery was momentous. His first bestseller, *The Heritage of the Desert*, was written under its spell. Not only was Grey the most popular Western novelist of the time, but his tales were to become the most filmed. The first film made from a Grey novel, *The Last Trail*, was produced by Fox in 1918; over the next thirty years scores of others followed, many with a southwest setting and with titles such as *Call of the Canyon, Wanderer of the Wasteland, Drums of the Desert, Under the Tonto Rim*. In 1913 Grey had visited Monument Valley and written about it in *Tales of Lonely Trails* (Gaberscek 144). Paramount's film version of Grey's novel *The Vanishing American* (1925) has some of its initial scenes set in Monument Valley. In his most famous work, *Riders of the Purple Sage* (1912), there is a description of canyon country:

> All about him was ridgy roll of wind-smoothed, rain-washed rock. Not a tuft of grass or a bunch of sage colored the dull rust-yellow. He saw where, to the right, this uneven flow of stone ended in a blunt wall. Leftward, from the hollow that lay at his feet, mounted a gradual slow-swelling slope to a great height topped by leaning, cracked, and ruined crags. Not for some time did he grasp the wonder of that acclivity. It was no less than a mountain-side, glistening in the sun like polished granite, with cedar-trees springing as if by magic out of the denuded surface. Wind had swept it clear of weathered shale, and rain had washed it free of dust. Far up the curved slope its beautiful lines broke to meet the vertical rim-wall, to lose its grace in a different order and color of rock, a stained yellow cliff of cracks and caves and seamed crags. . . . The canyon opened fan-shaped into a

Fig. 9. Edward S. Curtis, "Saguaro Gatherers" (1907). Library of Congress, Washington, DC.

Fig. 10. *My Darling Clementine* (Twentieth Century Fox, 1946).

great oval of green and gray growths. It was the hub of an oblong wheel, and from it, at regular distances, like spokes, ran the outgoing canyons. Here a dull red color predominated over the fading yellow. The corners of wall bluntly rose, scarred and scrawled, to taper into towers and serrated peaks and pinnacled domes. (Grey 44–45)

Unlike *The Harvey Girls*, the trajectory of *Riders of the Purple Sage* is one of retreat from the softness of civilization into the stoicism of the wilderness. At the end, the hero takes the heroine into a remote and secret canyon guarded by a huge stone. He then rolls the stone across the entrance to keep them immured forever. Ironically, though, that very celebration of the distance of the Southwest from civilization which Grey's novels achieved was already bringing civilization, in the form of tourists, into the region.

VI

In case there should be any doubt that Ford's Monument Valley is a constructed, not a found, landscape, consider finally the question of the cactus. At some point in the process of popularizing the scenery of the desert, cactus became a key iconographical feature. So recognizable did one distinctive species, the organ-pipe or saguaro cactus, become that it virtually came in itself to signify the West. It appears in a photograph by Edward Curtis in 1907; by the middle of the century it had achieved synecdochic status, a commonplace in advertising of all kinds, on the label for a tape of songs by the Sons of the Pioneers (a group Ford used in his films), on the covers of countless paperback novels, and of course in the movies. We may choose to read Ford's landscape as the expression of his personal sensibility, but it is formed of just such popular elements. The saguaro cactus is not, one would hazard, native to Monument Valley itself. But as Henry Fonda leans lazily back in his chair while surveying the main street of Tombstone in *My Darling Clementine*, what do we see in the distance, along with those familiar mesas, but cactus?

NOTES

1. At the end of Lawrence Kasdan's film *Grand Canyon*, the chief characters are assembled at the rim of the canyon in an intended epiphany in which the glory of the canyon will reveal to them the true meaning of life. Unfortunately, because a photograph of the canyon never comes up to expectations, what the audience sees on the screen is but a shadow of the real experience the characters are supposed to be undergoing, and thus the moment falls short of what the filmmaker intended.

2. At this period, the half-tone printing process, which allowed for the mass reproduction of photographs in magazines and books, had not yet been introduced. Before the early 1890s, photographs had first to be copied by engravers if they were to appear in mass-circulation publications.

For limited editions of books, however, photographs could be laboriously copied one by one (as "heliographs," in effect contact prints—enlargements were not yet possible) and pasted into each copy of the book.

 3. I have collected some of these postcards. They mostly show Hopi or Navajo engaged in everyday tasks such as carrying water or weaving baskets. However, one shows a white lady in a flowered hat and carrying a parasol sitting overlooking a canyon through which a train is rushing. The legend reads: "Crozier Canyon is but one of the many picturesque gorges, out in Arizona, penetrated by Santa Fe rails, en route to California. It is several miles long and lies between Peach Springs and Hackberry stations. In this canyon is a U.S. Government Indian school, where the Hualapai and Havasupai Indians are made over into educated citizens. The scenery here is typical of western Arizona—bare red rock, sand and cactus, with sparse vegetation; the coloring is beautiful."

 4. Many of these slides are reproduced in *Dream Tracks: The Railroad and the American Indian 1890–1930* by T. C. McLuhan.

WORKS CITED

Anderson, Nancy K. "The Kiss of Enterprise." *The West as America: Reinterpreting Images of the Frontier 1820–1920*. Ed. William Truettner. Washington: Smithsonian Institution, 1991. 237–83.

Anderson, Robert. "The Role of the Western Film Genre in Industry Competition 1907–1911." *Journal of the University Film Association* 31.2 (1979): 19–27.

Baigell, Matthew. *Albert Bierstadt*. New York: Watson-Guptill, 1981.

Bazin, André. "The Evolution of the Western." *What Is Cinema?* Vol. 2. Trans. Hugh Gray. Berkeley: U of California P, 1971.

Braudy, Leo. "Thelma and Louise." *Film Quarterly* 45.2 (1991–92): 28–29.

Buscombe, Edward. *The BFI Companion to the Western*. London: Deutsch, 1988.

Fowler, Don D. *Myself in the Water: The Western Photographs of John K. Hillers*. Washington: Smithsonian Institution, 1989.

Gaberscek, Carlo. "*The Vanishing American*: In Monument Valley before Ford." *Griffithiana* 35–36 (1989): 127–49.

Goetzmann, William H. *Exploration and Empire*. New York: Vintage, 1972.

Goetzmann, William H., and William N. Goetzmann. *The West of the Imagination*. New York: Norton, 1986.

Grey, Zane. *Riders of the Purple Sage*. New York: Pocket, 1980.

Hales, Peter B. *William Henry Jackson and the Transformation of the American Landscape*. Philadelphia: Temple UP, 1988.

McLuhan, Teri C. *Dream Tracks: The Railroad and the American Indian 1890–1930*. New York: Abrams, 1985.

Mauduy, Jacques, and Gérard Henriet. *Géographies du Western*. Paris: Nathan, 1989.

Nash, Roderick. *Wilderness and the American Mind*. 3rd ed. New Haven: Yale UP, 1982.

Neale, Steve. "Questions of Genre." *Screen* 31.1 (1990): 45–66.

Pyne, Stephen J. *Dutton's Point: An Intellectual History of the Grand Canyon*. Grand Canyon Natural History Association, 1982.

5

Derelict Histories
A Politics of Scale Revised
Áine O'Brien

document 1

a supplementary space

document 2

DERELICT HISTORIES:
a politics of scale revised...[1]

marker memorial

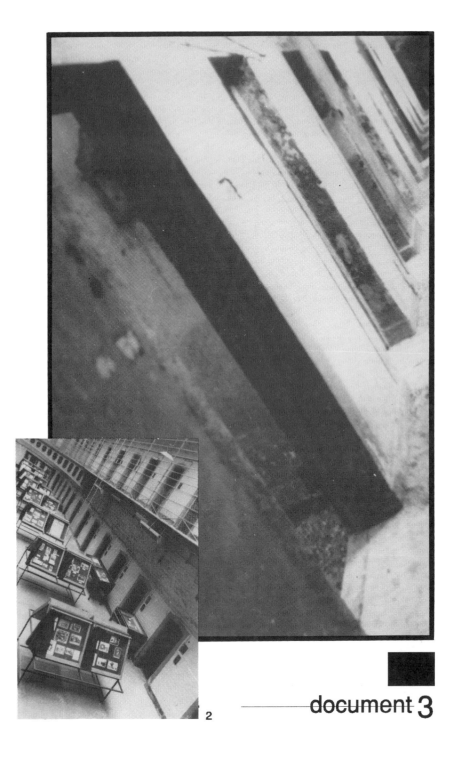

2

document 3

form of surveillance

discrete

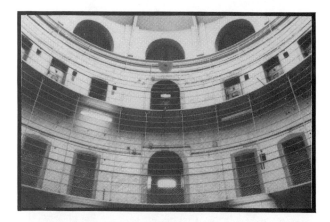

an ideal

series$_3$

and dereliction _____ document 4

in the "decisive moment" the event surfaces ■ ■ ■ 4

while on :::the tour

a story is retrieved from oblivion.₅

A

point of origin ■

fantasy

particular ₆

perspective

purely

photographic

in

space

depth

and

plenitude 7

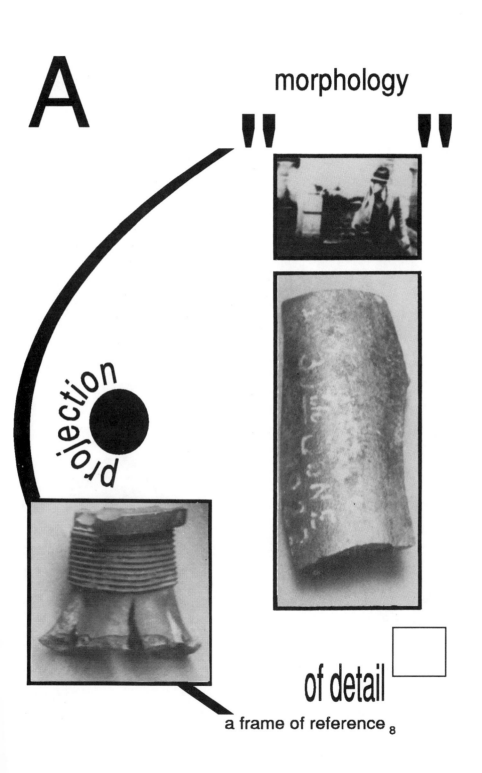

A

morphology

projection

of detail

a frame of reference $_8$

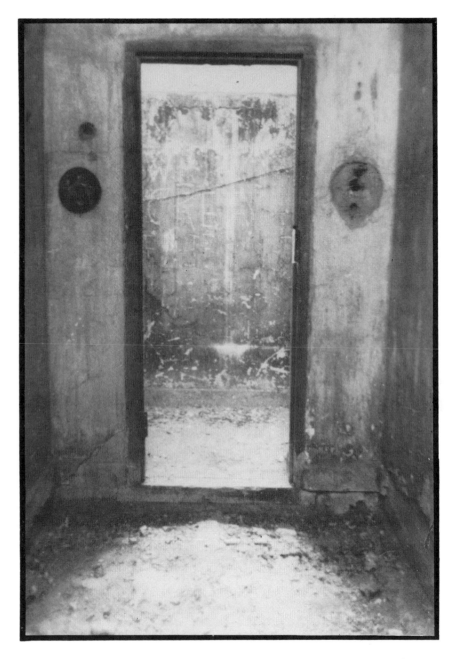

redundant in the interval

document 5

translate

"

, a part , object ,,

frame

manoeuvre

retroactive

event

empty$_{10}$

document 6

a point

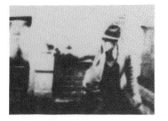

restoration

of focus

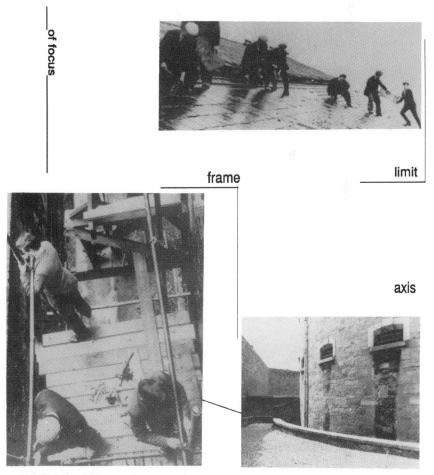

frame

limit

axis

construction

index₁₁

and dereliction

document 7

frame

time/space

edifice

revolution

scene

passage

consume12

perspective of an imaginary origin ▮

———————————————document 8

an optical
exercise in
history as

fiction

dispossession

possession

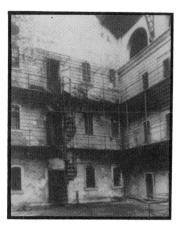

property

13

artifice₁₄

while over and over
a story is retrieved
from oblivion...[15]

NOTES

1. My focus is a penal jail, turned national monument, turned nationalist museum. Kilmainham Gaol, popularly referred to as Ireland's Bastille, is hailed in tourist literature as the "most important national monument of the modern period." It is in every sense of the word a national monument built on the archaeological remains of colonialism. At present, the museum functions as a leisure space where people consume the nation. It is both metonym and symptom of a larger cultural phenomenon which intersects with an ideology of heritage, tourism, and popular culture. Kilmainham is not so much a representative place symbolizing the arch production of nation but rather a space more intricately linked to a more "productive" public discourse about planning, development, architecture, and the cultural industry of tourism.

The discourse of individualism, so central to the idea of a republic and to the principle of a nation-state, is, perhaps, Kilmainham's most apparent and traditional operative mechanism. The museum depicts, in Raymond Williams's words, "a selective version of a living tradition" in the myth of republican individualism (117). Hence, the building suspiciously facilitates access to the continuity of "community"; but perhaps more aptly, and to borrow a phrase from Benedict Anderson, this monument symbolizes the "transforming [of] fatality into continuity" (18). My reading of Kilmainham—as both site and event in a quickly changing tourist economy—is related to my enquiry about the historical production of a national gaze. I am concerned with tracing the particular social organization of this gaze and with examining the manner in which this way of looking, historically produced at a very specific moment, continues to configure the contemporary discourse of heritage management.

2. An immediate problem that I encountered when I tried to make sense of this museum was the glaring absence of an account of women and nationalism. The narrative of Kilmainham fictionalizes the relationship between masculinity and nationalism and thus completely marginalizes women's involvement in the nationalist struggle. Basically, the museum portrays the relationship *between* men in nationalism. More fundamentally, the museum's archive is almost hysterically concerned with the figure of "man" and the discourse of rebellion. It traces a fictive map of the newly imagined and publicly transformed space of the emerging nation. "Woman," however, figures as a decorporealized entity on this map, for Kilmainham's central archive is predicated on the absence of "woman." When the literal figure of "woman" does appear, it is generally as "wife" or "sweetheart" in the confines of the private sphere or as "colonial victim," "innocent bystander," and "exceptional agent" in the public sphere. The only "evidence" of women at Kilmainham exists in the now derelict cells where approximately three hundred women were imprisoned during the Irish Civil War in 1923. This deserted wing does not feature in the public tour of the museum, and has never done so. Hence, part of my project involves researching and writing/imaging an archive that has heretofore been neglected. This revisioning process necessarily moves between the discourses of gender and nation in the context of a formal appraisal of the museum's representative strategies; it also highlights a related (discursive) problematic which addresses the question of gender, narrative, and a national populism in the larger cultural arena of a heritage market. Constructing a nationalist feminist archive on the margins of the central exhibit and on the critical margins of a rhetoric of progress introduces the fractious temporal register of a discordant history, hidden from what Michel Foucault might call the "evolutive" time of the nation (161). To bring this discordant history "out" to the consumer/spectator means putting Kilmainham Museum itself under partial erasure.

3. Built in 1796, Kilmainham Gaol was designed according to eighteenth-century utilitarian notions of discipline and punishment. The building is not strictly Benthamite in architecture, but the philosophy of Jeremy Bentham and of the prevailing prison discourse of the eighteenth century inspires the overall disciplinary design of this former colonial institution. As one critic writes: "Kilmainham Gaol is linked in the national consciousness to Robert Emmet, the Fenians,

Parnell and the executions of the leaders of the 1916 rising. . . . What may not be equally recognized is the fact that Kilmainham Gaol was the prison for the County of Dublin where 'ordinary' law breakers were confined" (Field viii).

Kilmainham was thus built as the county jail for Dublin to take care of both criminal and political prisoners. The east wing of the prison, extended in 1867, more closely resembles the panopticon shape familiar in such buildings from the 1830s onward. The semicircular structure with its discrete cells and its central inspection hall clearly demonstrates the way in which architecture was, in Foucault's words, made "transparent to the administration of power" (249). The central museum exhibit is housed in this wing of the jail; thus, the carceral space becomes part of the textual system of the museum and determines the exhibit. In opposition to the controlled (implosive) space of the prison interior, the exhibit's displays and images project a social space constituted by an emerging nationalist consciousness.

4. The production of this coherent national drama is implicated with an ideology of visual reproduction dependent on the codes of realism—codes portraying an ideology of change rather than of "consciousness" or culture (see Guha). History is written and re-presented by signifying a perspective of depth, verticality, and continuity. The time of the nation is thus narrated in the form of an "imaginary plenitude." Kilmainham's museum literature describes the jail's peculiar specular quality; the double-mirror structure so often cited in theories of interpellation is perceived as one of its "natural" pedagogical characteristics. Photography, in particular, so crucial to the carceral system of realism and surveillance, provides the specific means of imaging the aesthetics of nation formation. The indexical quality of the photographic print sustains the imagined sense of community as continuity—of a time immemorial. While not all the photographs portray the notorious subject—often the anonymous figure is imaged—the cult of the individual governs the narration by emphasizing moments of military maneuver. The relationship between the decisive moment of maneuver and the trope of the decisive moment in photographic discourse overlap.

5. The spectator/tourist is directed around the museum by means of a number of interpretive vehicles: the introductory film, the narrated tour of the prison, the central exhibit hall, the sale of related materials that include souvenirs as well as teaching texts for school children. The communicative capacity of the museum is tapped so as to encourage a level of "active," albeit minimal, participation. Making the museum "popular" plays a major part in this restructuring of communicative methods. Creating an "image" for the museum establishes its location in tourism and also helps generate profits to pay for the museum operation. Besides the overtly didactic method of educating the spectator by means of a panoply of selected objects, a limited attempt is also made to encourage a more active consumption of the museum's historical potential.

But the "ideology of preservation," as Umberto Eco calls it, facilitates an often paradoxical reconstruction of the past. At Kilmainham, the desire for perfect illusion is constantly marred by the imperfections of the display, the tour, the building (left as it is, the authentic site/object is not re-visioned by any major restoration). There is no attempt to connect, or even distinguish, the genuine from the fake. There is no attempt to fill every space. In fact, Kilmainham appears content to celebrate a "horror vacui"; it thus allows the spectator to fill in the gaps, to speculate on details and incidents, or to imagine meta-narratives (see Eco 23).

6. Stylistically, the display takes after the classic nineteenth-century museum exhibit wherein miscellaneous bric-a-brac are arranged according to a specific narrative logic. For example, paraphernalia is collected and "preserved" as "national heritage" (see Glusberg 61). Michel de Certeau refers to this as the strategic "establishment of a place" against the constraints of time (34). The need to occupy space, as a symbolic site, is part of an overall strategy of cultural conservation.

The criteria of historical selection in this fortified place, however, are quite arbitrary. Like many museum interiors, the display operates successfully only when it is sustained by a fiction in which the objects, fragments, shreds, and shards of a self-selected culture constitute a wider and

more coherent narrative—that is, when the selected objects metonymically project a more total history. Assuming a level of moral authority, the authentic or "real" object impedes a more inclusive and critical account. In this respect, the display indulges in a cult of the original, and yet the substance of originality is often specious, if not ironic. The museum's intertextual shaping, then, is more complex than that which first meets the eye.

7. The photograph functions as a discursive thread that illustrates what Roland Barthes calls the "intractable" force of the past (77). The relationship of photography, history, and death is, for Barthes, an integral one. Arguing the ontological essence of the photograph, he writes: "What I see has been here, in this place which extends between infinity and the subject (operator and spectator); it has been here, and yet immediately separated" (77). The photograph's power lies in its ability to defeat time, and the historical photograph suspends the progress of time yet tells of a death in the future. The spectator caught in the in-between space of the photo-text, then, "shudders over a catastrophe which has already occurred" (96).

Barthes's rather essentialized reading parallels the logic of the museum exhibit's use of photography. The photograph functions to convince the spectator that these dramatic incidents were indeed monolithic and tragic; it thus certifies a nationalist history in the making. Here, certitude is meant to compensate for the lack of a critical and inclusive interrogation. The aura of the immobilized pose blocks meaning and privileges the pedagogical document over a more inclusive and overdetermined performative historical scene. To borrow from Barthes: The historical photograph "[attests] that what I see has indeed existed" (82).

8. In nowhere else but the museum does the artificiality of the impulse to semanticize objects seem more obvious. For example, in one display, simply labeled "The Debris of Battle 1916–1923," spent bullets, empty mortar shells, and fragments of ammunition lie in state. Supposedly expressing a more intricate connotation of rebellion, the display invites the spectator, without any other motivating factor, to take the imaginative leap into the past and to rest content with such evidential truths from the scene of counter-colonial battle. The projected past is one of "ruin" and social disorder, but the remnants convey the triumph of failure and the equally triumphant discourse of the immortal. Images of the battle-torn city and country supplement this narrative display, and this representative landscape serves to compensate for the fragmentary objects on display.

9. A dominant aspect of the museum's content is dependent on a description of the political prisoner's objectification by the punitive codes meted out by the colonial authority (and later by the Irish Free State army). The history of subjects accused of revolutionary and nationalist crimes, however, tends to complicate Foucault's description of the disciplinary production of the docile body. It is important to link this particular history with the overall account of disciplinary discourse outlined by Foucault. If the jail is seen as part of the apparatus of knowledge and power of the nineteenth century (in which the need to punish is symptomatic of a "treatment" regime whereby the criminal is individualized and therefore socialized), then the current archive is composed of evidence excavated from the remains of this administrative practice. The subject once produced by a corrective technology is now reconstructed by a nationalist ideology dependent on the discourse of colonial surveillance for its aesthetic form. The revolutionary body is classified, labeled, and documented, and thus rendered into an object of nationalist knowledge within a nationalist narrative shaped by the earlier biographical model which wrote the case history of the "criminal." Thus, criminal "biography" serves to make national "history" persuasive.

10. Photographic prints are presented as "isolated" objects (though juxtaposed with other miscellaneous items) and thus reveal the "truth" value of the narrative. In one sense, the realistic photograph naturalizes the exhibit's message and suppresses the multiplicity of codes which make up the image. The documentary photograph cements the narrative which might otherwise splinter under the weight of the display's arbitrary form. Photography bolsters the myth of the linear development of an emerging national consciousness. However, this representative strategy, while rec-

tifying the balance between success and failure in favor of "successful manoeuvre," teeters on the edge of its own formation. In one sense, the photograph successfully transforms the performative subject of history into a pedagogical object. This is its pedagogical objective, but in order to do so it must effectively close down meaning. The extent to which it does, however, is arguable.

Randomly placed alongside other objects—found objects, medals, facsimiles, photocopies, fragments of uniform, personal items, buttons, diaries, letters—the photographs appear to restore an authority and semblance of "truth" to the more chaotic medley of objects. Supplying credibility to the "pastness" of the scene, the selected images fortify an official history and thus lend an archaic tone to the general narrative. As Barthes puts it, the historical photograph is ironically a "testimony of presence" rather than absence or loss; it therefore affirms the spectator's identity insofar as the spectator is indeed the reference of every photograph (85). Part of the logic of documentary realism is to remind the viewer of his or her place in the present and to strengthen the viewer's concept of an inherited communal identity, or the "horizontal comradeship" that Benedict Anderson writes about. But the notion of "inheritance" is precisely where the problem of spectatorship lies.

11. The jail—after its last use as a nationalist military prison—was closed in 1924. The building was purchased by the Office of Public Works in 1938.

A Kilmainham Restoration Committee was not established until 1960. This voluntary group restored the prison. Having invented and constructed the archive, the voluntary committee initiated guided tours of the jail-turned-museum. The restored building was then handed over to the state in 1986 and is currently administered by the Office of Public Works (OPW).

The OPW was first established in 1831. At that time it was answerable to the colonial government at Westminster and was an institution determined by British codes of heritage management. Like so many institutions after the transfer of power, it retained many of the structures of the colonial regime. Heritage and conservation under the Irish State authority was simply a cosmetic shift in name rather than a radical transformation of philosophy or ideology. Yet, none of the current publications issued by the OPW acknowledge this absence of an epistemological break. At present, the OPW regards itself as a modern institution attuned to the roles that the cultural tourism industry and the "cultural heritage product" play in a changing economy (see Mahoney).

12. Both Barthes in *Camera Lucida* and John Berger in *Another Way of Telling* argue (though in quite different ways) that the historical photograph offers a resistance to history and that it "[defies] the passing of time" (Berger 106). An expressive photograph, writes Berger, is capable of communicating, through the level of the particular, a more general idea. A truly "legible" photograph thus encourages a reading beyond the frame toward the universal. It is capable of quoting at length, of supplying sufficient information to the spectator so that he or she can then translate the discursive detail into a more coherent, if not ubiquitous, meaning. Following Berger's analysis, I argue that the concept of the photograph as a conveyor of a total history determines the exhibit's means of production. In its function of supplying the visitor with a particular segment of the idea of the nation, the photograph strengthens the supposed credibility of the archive and directs the visitor's assessment of the reconstructed history.

Yet, while on the one hand offering to counter the selective subjectivity of the exhibit's overall style with a more "objective" reading of the national drama, the realistic photograph also reveals itself as unreal. In a related context, Victor Burgin writes that by freezing a fragment of the spatiotemporal continuum—the decisive instant so privileged by Barthes and Berger—the photographic image acts as a fetish and thereby stands in for and compensates for the perception it commemorates. In other words, the discourse of realism as documentary evidence is undermined by the mechanics of realism, and a more discursive history is denied. As fetish object, it portrays the tale of the emerging nation, but, at the same time, by framing, by wrenching out of context, the historical moment, the photograph inscribes that moment as monolithic, exceptional, and

somehow compensatory. It thus operates to reproduce the myth of national origin by evoking the pre-photographic, and then displacing it through the discourse of the frame and the laws of geometric projection. The spectator is thereby assigned a point of view by the position of the camera, and each photograph portrays a scene as well as the gaze of the spectator—or, as Burgin puts it, "an object and a viewing subject" (146).

13. The photographs depicting the "early" stages of colonial and nationalist struggle—for example, the 1870–1880 Land Wars and the 1916 Rising—construct the national figure from the perspective of the coding authority. Photography plays a major part in representing the proof value of the imagined total history: one that extends from the early shots of the evictions during the Land Wars that depict "peasants" displaced from the land to the images portraying the work of the restoration crew in the 1960s. From dispossession to repossession, this narrative link is quite blatant. Augmented by a whole range of themes, these images familiarize the spectator with a more intimate knowledge of the national paradigm.

However, the subject depicted is posited from a point of view outside the discursive scene of the incident. The myth of the decisive moment so prevalent in theories of photography is fully controlled by the point of view of authority. Yet the agency of the frame, selecting the dramatic scene, simultaneously stages and diminishes the myth of the decisive moment. The discourse of realism, while on the one hand luring the spectator into the imagined space of a revolutionary mise-en-scène, also motivates the spectator to his or her gaze beyond the frame. The museum's installation framework attempts to compensate for the intrusion of the frame, thus stalling an awareness of how a monocular system of representation positions the reader as a sutured spectator.

14. On closer inspection, the exhibit reveals an idiosyncratic quality. The substance of its worth as verifiable evidence runs thin, often to the point of comic irony. Personal objects are used to reconstruct the imaginary male body: locks of hair, personal cards, letters, and so forth. This is a revolutionary body paradoxically feminized by the cult of the personal and the discourse of the intimate. The male body is stitched together rather haphazardly, and these "private" details contrast with the more public information narrated to the spectator on the tour. No obvious connective principle links the discordant shreds of evidence together. The narrative builds momentum intertextually, but is dependent on a more figurative discourse to catalyze its effect. The illusory completeness of the revolutionary body is thereby made "authentic" by means of the photographic print, and the fetishistic fragments on display are thus joined in an imagined, masculine, administrative entity.

15. My photographs in this essay comprise my own re-visioning of the Kilmainham texts. My thanks to the curator of the Kilmainham Museum, Pat Cook, for generously supplying me with material for this study. I am also grateful to the supervisor of the museum, John Toolan. Special thanks to Val Bogan at Micromail, Cork, for once again teaching me the possibilities of design and for her endless patience when advising and helping me with the graphic layout.

WORKS CITED

Anderson, Benedict. *Imagined Communities: Reflections on the Origin and Spread of Nationalism.* London: Verso, 1983.

Barthes, Roland. *Camera Lucida.* New York: Hill, 1981.

Berger, John. *Another Way of Telling.* New York: Pantheon, 1982.

Burgin, Victor. "Looking at Photographs." *Thinking Photography*. Ed. Victor Burgin. London: Macmillan, 1982.

de Certeau, Michel. *The Practice of Everyday Life*. Berkeley: U of California P, 1984.

Eco, Umberto. *Travels in Hyper-Reality*. London: Picador, 1986.

Field, Maureen. *Kilmainham Gaol: A Penal History*. Dublin: Office of Public Works, 1991.

Foucault, Michel. *Discipline and Punish*. New York: Vintage, 1979.

Glusberg, Jorge. *Cool Museums and Hot Museums*. Buenos Aires: Center of Art and Communication, 1977.

Guha, Ranajit. Preface. *Selected Subaltern Studies*. Oxford: Oxford UP, 1988.

Mahoney, John. "The Role of the Office of Public Works." Dublin: Office of Public Works, n.d.

Williams, Raymond. *Marxism and Literature*. Oxford: Oxford UP, 1977.

Still and Moving Images

6

How to See (Photographically)
Régis Durand

You have shown us the way, Rabbi, for we have recognized that the world as the Lord—hallowed is His name—created it, exists in time and that consequently the Creation, since it already partook of the created world, required a beginning and an end. But in order for there to be a beginning, time had already to be present, and for the segment of time before the Creation the angels were on hand, to fly through time on their wings and to sustain it. Without the angels there would not even be God's timelessness in which, according to His holy decree, time is embedded.

—Hermann Broch

JEAN LOUIS SCHEFER, in *L'Homme ordinaire du cinéma*, speaks of our place in front of the filmic image as *impermanent*, as shifting, linked as it is to the lag, "the inevitable lag that exists between ourselves and what we see" (205). This "lagging" has for a counterpart, in the experience of the cinema, what Roland Barthes calls a form of "continuous voracity":

> Do I add to the images in movies? I don't think so; I don't have time: in front of the screen, I am not free to shut my eyes; otherwise, opening them again, I would not discover the same image; I am constrained to a continuous voracity; a host of other qualities, but not *pensiveness*. (*Camera Lucida* 55)

In front of the unreeling images, the "continuum of images," I experience the anxiety of lagging behind the ongoing flow and behind the meaning. Hence the resistance expressed by Barthes in front of what he calls "the saturation of the cinema" (*"le plein du cinéma"*):

> Resistance to the cinema: the signifier itself is always, by nature, continuous here, whatever the rhetoric of frames and shots; without remission, a continuum of images. The film (our French word for it, *pellicule*, is highly appropriate: a skin without puncture or perforation) *follows*, like a garrulous ribbon: statutory impossibility of the fragment, of the haiku. Constraints of representation (analogous to the obligatory rubrics of language) make it necessary to receive everything.... (*Roland Barthes* 54)

Unless otherwise indicated, all translations are my own.

Barthes has spoken very well of the powerful imaginary charge associated with the filmic image, the one-on-one that characterizes the imaginary relation: "The image is there, in front of me, for me: coalescent (its signifier and signified melted together), analogical, global, pregnant . . . a perfect lure . . . " ("Leaving the Movie Theater" 348). However, this situation, which Barthes calls in turn hypnosis, or sideration, or fascination, tells us more about a subject's own imaginary than it does about the filmic image itself. We recognize here, for instance, Barthes's own loathing for the viscous, the clammy, for that which cannot be cut neatly. But take someone else, such as Schefer mentioned earlier: he, on the contrary, will see in it "the genesis of thought, its slow inchoation and the emergence of a visibility which is not yet a figure, not yet an action" (216).

How—if the question is not too naive—is that possible? How can the same image (or the same type of image) carry values so radically opposed: viscosity, suture, globality for the one; tremor, inchoation, fragmentation for the other? There have to be, in front of this image, acts of looking and of thinking which are more powerful than the image itself, and which submerge it completely, to the point that it becomes secondary.

The question which then arises is what happens to gazing and thinking when the image, instead of being swept away by the flow, lingers on, as it does in photography. The filmic flow turns every vision of the image into memory (even if it is the memory of something which is still in the making). Whereas the permanence of the photographic image turns it into a presence—but a presence which is fated to deceive and disappoint the reality of a "memory without images," the memory of a scene which has already taken place and now attempts to find its representation, more or less successfully.

In order to stem the flow and the "viscosity" of the film, Barthes tried several things. First of all he tried reducing the cinematic image to the frame still (*photogramme*)—thus getting asymptotically closer to the photograph, as if it were possible to ease gently from one imaginary regime to another. And indeed, once the first objections have been overcome (such as: "it's impossible, you cannot slide so easily from one to the other, a frame still is not, and never will be, a photograph," and so forth), we realize that Barthes may have effected something which is essential to the understanding of way photographs are looked at. And that he did so even as he himself did not take this further—electing, as we know, to collapse the analysis of photography into that of the temporality of loss, the loss of the beloved and the pathos of mourning.

The operation effected here is essential because it takes place at a divide, at the point where the perception and even the invention of the image are being transformed, at the edge between things and their representation, and between representation and the materials of representation. The frame still is (for Barthes) the ideal object, in the sense that it is at the same time free of the narrative or sequential imperative of film, while retaining its dynamics, the "possibility of configura-

tion," "the armature of a permutational unfolding," of what Barthes calls "the filmic"—that "third meaning," "an inarticulate meaning which neither the simple photograph nor the figurative painting can assume because they lack the diegetic horizon" ("The Third Meaning" 60). With the still, the taste for fragments joins with the call for "a genuine mutation of reading and its object, text or film," because the still asks for a vertical reading of articulations and distributions.

As he compares the still to a palimpsest, Barthes points out the ambivalence of its signifying regime: it is both *empty*, in a state of *depletion* (nothing comes to fill the signifiers which it calls up, and its existence never exceeds the fragment), and *full* (it superimposes different levels of perception and analysis, and, being a palimpsest, it never ceases to call for decipherment). That is because the still carries with it not signs but *marks* or *accents*, which designate the displacement of the center of gravity—a center of gravity of which Eisenstein says that it is transferred inside the fragment, into the elements included within the image itself.

Whether it be Eisenstein or Vertov, Barthes or Deleuze, we come up repeatedly against the same idea: that we are dealing here with the genetic element of all images, the very division where perception occurs. In the case of Barthes, it seems that the filmic remains a kind of utopia—something like *the novelistic* in connection with the novel—which makes the film bearable as a theoretical object by bringing it closer to the Text. But the still never quite crosses the line which divides it from the photograph. For Gilles Deleuze, it is the discussion of Bergson and the cinema which is central to the argument. Bergson has an ambiguous attitude to the cinema in which he sees misconception of movement, to the extent that it operates in the same way as natural perception. Deleuze:

> For Bergson, the model cannot be natural perception. . . . The model would be rather a state of things which would constantly change, a flowing matter in which no point of anchorage nor center of reference would be assignable. On the basis of this state of things it would be necessary to show how, at any point, centers can be formed which would impose fixed instantaneous views. (58–59)

Thus, in a move that reverses the phenomenological approach (which Barthes remains very close to), Deleuze (following Bergson) would see the image as movement, but a movement that can always reverse itself. For Bergson, there is no situated intentional consciousness which organizes the perceptive field. Deleuze again:

> My body is an image hence a set of actions and reactions. My eye, my brain, are images, parts of my body. How could my brain contain images since it is one image among others? External images act on me, transmit movement to me, and I return movement: how could images be in my consciousness since I am myself image, that is movement. (58)

Of course, as mentioned before, there is the possibility of temporary points of anchor or centers. These may be called *photographs*, but in Bergson's sense, they become part of an unending *modulation*: "Photography, if there is photography, is

already snapped, already shot, in the very interior of things and for all points of space" (qtd. in Deleuze 60).

The difficulty here is in trying not to be too reductive—in trying not to reduce, for example, the dynamics I am describing to a simple opposition between movement and the absence of movement. Film theory has been prone to doing this, notably in following André Bazin who, in one of his most famous essays, "Theater and Cinema," picks up the distinction between *molding* ("moulage") and *modulation* ("modulation"):

> The photographer proceeds, via the intermediary of the lens, to a point where he literally takes a luminous imprint, a cast. . . . [But] the cinema realizes the paradox of moulding itself on the time of the object and of taking the imprint of its duration as well. (Qtd. in Deleuze 24)

Yet we know, from *Camera Lucida*, how desperately Barthes tried to see in photographs a molding of the very time of the object. And we come here to another point of divide. The photograph, like the still, bears the imprint, the accent of movement and time. The difference is that the photograph is forever deprived of the diegetic combination and linearity which characterize the still. For in spite of various attempts to give it, through sequencing or assemblage, some kind of diegetic quality, the photograph is arrested, suspended. Yet to stop at this, as Bazin more or less does, would be absurd—equivalent to saying that the difference between film and photography is that the one moves while the other does not.

The *arrest* that I am talking about is a dynamic feature, one that turns the energy of the image inward, inside the frame, in a kind of implosion or condensation. And the real *pensiveness* is perhaps to be found there—not in a purely imaginary way, in the object of the photograph, as Barthes does, but in the photographic operation itself, in the *revulsion* that it effects.

How does this come about? First of all, by dissociating the gesture and the object it aims at, the energy or the movement and their destination. Speaking of the "photographic look" (by which he means the look in the eyes of whoever is being photographed, not the viewer's gaze), Barthes makes a series of distinctions which remind us of the one between the filmic and the film, or the novelistic and the novel:

> One might say the Photograph separates attention from perception, and yields up only the former, even if it is impossible without the latter; this is that aberrant thing, *noesis* without *noeme*, an action of thought without thought, an aim without a target. And yet it is this scandalous movement which produces the rarest quality of an air. (*Camera Lucida* 111)

This movement is more than just a theoretical fiction, the fantasy of pure inception, of the emergence of thought—of *thinking*, as it were, *photographically*. It is

essential, again, to point to the dividing line. Compare with Jean Louis Schefer's description of the experience of thinking in the cinema: "The act of thinking and not its object (it is not a process that can be compared or reduced to figuration that we are witnessing). . . . It is a world which trembles, which dissolves, which reforms itself because it has been looked at, in other words because the definition of the world has been endowed with movement" (217–18). With Barthes, on the other hand, it is the person in the photograph who looks at us, it is he or she who *has been* (who once was) and it is he or she who seems to withhold his or her gaze. Barthes shows signs, here in particular, of having closely read Lacan on the gaze:

> It is because the look, eliding the vision, seems held back by something interior. The poor boy who holds a newborn puppy against his cheek (Kertész, 1928), looks into the lens with his sad, jealous, fearful eyes: what pitiable, lacerating pensiveness! In fact he is looking at nothing; he *retains* within himself his love and his fear: that is the Look. (*Camera Lucida* 113)

The look, then, is the presence which the Real has laid down and inscribed within the photograph, and which addresses me without seeing me. The retentive quality (the withholding) which Barthes attributes to the object of the photograph finds its justification in the photographic apparatus: the imprint, the sampling of the real which it effects, and a consequence of which is the closure of the photograph on itself, the impossibility of an exchange of looks, the *suture* of what becomes properly speaking a *fascinum* (that which has as an effect the arrest of movement or of life, as Lacan defines it).

The gaze thus understood (and the photograph it characterizes) is a *catastrophe*. Everything collapses into it, and the living look becomes identified with the gaze itself, the deathly paralyzing gaze (the "Medusa-effect"). The only possibilities left in front of this arrested picture of Time are *hallucination* and *pity*. In both cases, we have a revulsion: something turns on or against itself. The world is not, as Schefer says, different from having been, one day, gazed at. It only comes back to tell me that it once was a witness to something intolerable, and that only the pathos of this experience can be recaptured.

But it is necessary, I think, to suspend the gesture which conflates photography with pure hallucination, and to dwell instead on the photographic "thought" *as it emerges*, in its nascent state when lines and traces are still emerging from the uncertain shades. It is necessary, then, to shift from the gaze as we have been discussing it, to what might be called *a gaze-in-use*—the gaze that the user/spectator brings to the photographs, the gaze which activates the energies they contain. To fail to do so would be to hallucinate (and Barthes, at least, went to the end of this logic, in his phenomenology of the object of the photograph, as well as in the hallucination itself, the famous "ecstasy").

But where is such a user/spectator to be found? In what position, in front of what apparatus? Contrary to the experience of viewing films, the viewing of pho-

tographs implies no definite apparatus. Even more than reading, it is infinitely particularized and atomized. No séance there but, on the contrary, varying durations and types of attention. Of course, it is possible to leave or to suspend at any time the projection of a film, to get up, leave the theater, close one's eyes, or stopframe the VCR. But it remains an exception, a transgressive or merely technical gesture. On the other hand, photography seems to call for so many different ways of viewing. It is not even clear that it exists (and how) as a medium. Is the medium the paper print, the ordinary print we use for our snapshots? Or is it the artist's print, which can be put up on the wall, matted and framed, or kept loose in a portfolio? Or is it the photograph as printed on the page of a magazine, or in a book (by far the most widespread use today)? The object itself lacks all "certainty" (to use Barthes's word), making the phenomenological reading of it problematic and plural.

Yet there is something in photographs which is the very opposite of the fascination they seem to produce at times—something which is the cause of the fact that they can only be looked at quickly, as if they had to be dropped. That something, that flight, is most of the time disavowed and controlled. Yet we know it is emblematic of something central to the experience of photography—its *transience*: something which has to do with speed, repetition, and the production of waste, and also with *a desire not to see* (to which I shall return later). And we also know that an attitude of piety (of a prolonged, respectful contemplation) is nothing but the other side of the same problem.

There is something in photographs which resists the gaze, which deflects it with the power of all disavowals. The photograph is a fetish: that which is here to allow me to believe that what is missing is present all the same, *even though I know* it is not the case. All those appeals to presence, to "having-been-there," to the referent, to the index, etc., are merely ways of stating the essential connection between photography and the lack (the "symbolic castration"). And whereas painting faces the lack itself and attempts to make it visible as such (in a rather "heroic" fashion), photography plays rather on the side of disavowal. It always (almost always) conjures up something which comes to the fore in order to fill that void—the object of representation (the referent) which, like the fetish, reveals and conceals the lack.

This is probably one of the reasons why photography fascinates and repels at the same time. Like the fetish, it fascinates because of its close (analogical) connection with the object of desire. But at the same time, it establishes itself as a substitute, a simulacrum, a worthless trinket. As we look at photographs, we cannot help going through a more or less rapid sequence of sideration and rejection, in front of the monotonous succession of images which all attest that they fill up a void, set up a diversion, a screen. There is something self-destructive (or at any rate self-denying) in the accumulation of photographs, in the recognition that they are meant to follow on one another so quickly, to file off. But on the other hand, the speed with which I pass over those images, under the pretext that it is in their very

nature, has to do with something in me, undoubtedly. The photographs confront me a little too abruptly with what I am intent on not seeing.

The relation between photographic images and identifiable objects cannot therefore be analyzed with the help of concepts such as reference or index. And if those images are indeed of the order of the index, it is not because of the photographic process itself (of its "ontology"), which is geared, more than anything else, to the production of part-objects. Nor is it because of some "realism" inherent in the same process. It is rather because photography, within a fraction of an instant, makes those objects disappear and return. Cézanne is reported to have said that a painting, too, had to be seen instantly or not at all. But with photographs, the speed of the viewing duplicates more exactly the speed of the process of taking. All the retarding operations (such as setting up the scene, framing, printing, etc.) can only attempt to conceal that *everything, in fact, has been played out in an instant*—but that the instant can never be captured or rendered without introducing some kind of artificial indirection or delay.

The only photographs we care about are the ones which seem to have a knowledge of that—of the fact that some things can only be seen by looking away or closing one's eyes. Or, to put it differently, that a direct encounter with the real subject of photography is not possible, and that we have to take the indirect path of the symbolic. Those who try to short-circuit it—either by dreaming of a direct confrontation with the real (as in reportage) or by finding shelter in intricate, imaginary games (as in staged photography)—expose themselves to violent returns of the repressed. Barthes made of one such symptom the subject of his book. But it can also be found in a great many photographers whose work merely duplicates their own fascinated gaze.

Photographic images, then, whatever their apparent subject, are images *in crisis*. Something in them is always trying to run off, to vanish. Even when staged or posed, photographs always relate to a sense of disaster, of catastrophe, to the infinitely short instant when something collapses, turns around, becomes undone, or undergoes a transformation. And there is no need for an apocalyptic or pathetic vocabulary to describe this. I am not sure either that the explanation is to be found in the technology itself. For photography is only fast in appearance. Even in its most instantaneous forms (the polaroid, for instance), it functions as a kind of *delayed action* in relation to the actual present. It is a doubling, a retentive or echoing gesture which bespeaks the failure to keep time. And the explanation is to be found in the mental operations which take place, rather than in the technology. That is why a film sequence, although it is entirely fabricated, can give us a sense of an authentic duration, whereas the sharpest, crudest photograph will always be somewhat off the mark (dreamlike, unreal, pensive, depending on the value we give to this discrepancy, this lagging), in a state of temporal imbalance.

What is it that *limps* so in a photograph? What disparity does it strive to make visible? Photographs attempt, often in a panic, to capture a thought as it tries to

materialize, to image itself, in an object or a scene. The choice of object or scene is of course not indifferent. Indeed, their presence may be so strong that it sometimes blocks the process it is intended to materialize. What matters is that, whatever the outcome, a photograph is the search for a novel imaging of a thought—it is an *image-thought* (hence its inchoative nature). Deleuze has shown that it is also the case for the cinema, and perhaps for every form of thinking which, as he puts it, "always reiterates its own inception." The closed loop—image-relation/relation-image—is that of thinking itself. But the photographic image does it in a highly specific and original manner, because of its formidable analogical power and its speed which allow a kind of immediate inscription and visualization of the process, an almost instantaneous return of the image onto the original thought.

This return (or reversal) is not continuous. Contrary to the operation of language, which is homogeneous to the process it is called upon to represent, photography introduces the radical discontinuity and heterogeneity of the visual image into the thinking process.

What is the nature of the discontinuity here? First of all, it consists of introducing a foreign body into the abstract or symbolic process of thinking. This foreign body, because of its opacity, has a considerable absorbing power, so much so that the original impetus may be arrested, like radiation by thick metal plating. The visual image captivates, and the eye is more than willing to come to a standstill, to rest in it from its unquiet mobility. Many photographs (perhaps most) ask no more of us than that we bask in the serene contemplation of the represented object, in its indisputable presence. It is even possible that those images fulfill a fundamental need in us, a need for "bound" images or for what Freud calls "cathected quiescence."

Photographs, then, because of the ease and profusion with which they are made, are an extraordinary source of quiescence. Solidly "bound" by their analogical character, they help us defend ourselves against certain aggressions from the outside and certain influxes of uncontrolled energy. A defense against external "unbinding," the photographic image is perhaps just as much and simultaneously its inverted figuration—that which, in ourselves, would unconsciously go out toward external stimuli, acting as their ready receptacle. Freud saw in this manner of accepting or soliciting external stimuli a manifestation of unconscious cathexis. In "A Note on the Mystic Writing Pad," he writes:

> My theory was that cathectic innervations are sent out and withdrawn in rapid periodic impulses from within into the completely pervious system *Pcpt-Cs.* . . . It is as though the unconscious stretches out feelers, through the medium of the system *Pcpt-Cs*, towards the external world and hastily withdraws them as soon as they have sampled the excitations coming from it.

Freud adds, "I further had the suspicion that this discontinuous method of functioning of the system *Pcpt-Cs* lies at the bottom of the origin of the concept of time" (19:231).

Images, then, would be visible forms of such unconscious "feelers"—the visible traces of unconscious "gestures." Not *illustrations* of them, but rather like a rebus, a code which, even though it is no simple translation or figuration, must have some affinity, some sense of a connection with the original impulse. There lies something, in the photograph, of unconscious desire, but hardly anything on its surface can lead back to the source—except precisely the sense of its having come from *a* source, and of the ensuing transformation and loss.

This takes us into the second phase of the process, in which the image flows back onto the original mechanism of thinking as defined earlier. The term *second phase* should not mislead us: this is not actual chronology, but the imaginary reconstruction of a process which cannot really be broken down as such. But Freud did see in it a possible version of the origins of psychical time, and I am convinced that this accounts for the importance of time in photography. Time, as understood here, has nothing to do with the temporality of the represented object—as Barthes thought, its "having-been-there"—but with the temporality of the workings of the thinking process, or *one* possible version of the thinking process (if we are willing to call "thinking" this initial encounter between an energy and the outside world).

Photography, then, echoes the unconscious process, not in its subject matters or in its affects, but in its very inchoative energy. Yet, it cannot help but draw away from this original impulse even as it draws closer to it. That is because the images produced (contrary to the unconscious "encounters" described by Freud) do not cancel themselves out. They remain in visible forms, which generate in turn other associations, other desires, and call up other images. It is like an infinite proliferation of small branching-outs, which end up covering up completely the original trace and leading the mind astray in many directions. Hence the strange paradox of photography: its incessant quest for new subjects, but at the same time always the same subjects, ending up in an infinitely complex palimpsest, a subtle layering of images.

It is in this manner that the photographic process leads back to itself rather than to the object it purports to represent. Such a mode of "thinking" is very close to the operations of the scopic drive—hence its power and its importance. In all partial drives (and in the scopic drive in particular) the same circular mechanism can be found, as Lacan has demonstrated, as if the drive looped on itself, in a "circuitous return" in which it is "the object as absence" which is aimed at.

What is *really* being looked at in the photographic operation (and what is left of it in the viewing of photographs)? It has already been pointed out that the photograph looked, as it were, *beside* its object, and that therefore what was there to be seen was not necessarily the object or the scene represented. We have seen that this could be analyzed as analogous to the workings of the fetish, which deflects the attention to a substitute of what cannot be named as such. Or that it could be compared to a composite image of a primary process by which energy encounters reality. Barthes chose to designate the site of absence as something external to the photograph, whereas I believe it is intrinsic to it. He calls it a *"hors-champ subtil"*

("a subtle beyond-the-frame," which becomes in the English translation "a subtle beyond")—"as if the image launched desire beyond what it permits us to see" (*Camera Lucida* 59). But Barthes would restrict this "blind frame" to those photographs that contained, for him, what he calls a *punctum-effect*, while it seems to me that it concerns every photograph. Which mental operations (of "thinking") are induced by such awareness of an absence? Is it just, for the spectator, a projection, a desire to go "beyond"? But this desire has to be made possible by something in the photograph, something both powerful and subtle (since we are never constrained by it). The figure which operates here is an oscillation, a beat: an excess, but one which points to a lack; a "signifier in excess," but one which has to do with "a permanent state of depletion"; an "accent," but one which cannot be articulated, etc. It is as if we were indeed "at the source," an imaginary locus where the repertory of forms makes and unmakes itself, through the play of primary processes (displacement, condensation, substitution, figuration).

It could be said, of course, that photography lacks the mobility necessary to represent the dynamism of a passage, of a transformation—that it can, at best, only suggest a moment when the viewer shifts from the apparent image to something else, a metaphoric or metonymic displacement. That is true. But the essential dynamism of photographs lies in their implosive character. From the appearance of the scene represented, the gaze passes on to the oscillation I have been speaking about, only to go up against the edges of the frame and to fall back on the represented subject, collapsing it into "the shadows behind the curtain."

Of course, by looking long enough at a photograph, it is possible to reinscribe it (in imagination) in space-time. It is one of the possible forms of hallucination, and that is not at all what I am pursuing here. What I am after is how the tension and organization with the image itself point, not to a "spatialized duration," but to *a modulating duration*. Such a complex of dynamic duration can be attempted through various devices: the use of sequencing, of superimposition, of blurring, of the composition of planes and volumes in the depth-of-field. But it would be useless to draw a list of devices, since none of them are significant in themselves, and only become so differentially, within a particular mode of discourse.

It is interesting also to take into account those points at which perception shifts from one regime to another—for example, how in some photographs attention moves from the thing represented to an awareness of texture, say the grain of the skin or the weave of foliage as they become identified with the photographic texture itself. When that happens, it is a real event, a moment of purely visual thought that takes place—as we shift from a regime of pure opticality to the optical-tactile (or "optical-haptic" in Alois Riegl's terminology).

Photography is particularly rich in events of this kind, which have to do with its ability to modulate distance infinitely, to rely on the frame in order to extract significant blocks of space (not unlike the *haruspex* with his rod tracing an area in

the sky within which signs could be read as significant). Just how this theater of signs and memory is constituted, whether it be through contemplation, capture, or intensification, remains to be studied in detail.

WORKS CITED

Barthes, Roland. *Camera Lucida*. Trans. Richard Howard. New York: Hill, 1981.
———. "Leaving the Movie Theater." *The Rustle of Language*. Trans. Richard Howard. New York: Hill, 1986. 345–50.
———. *Roland Barthes by Roland Barthes*. Trans. Richard Howard. New York: Hill, 1986.
———. "The Third Meaning." *The Responsibility of Forms*. Trans. Richard Howard. New York: Hill, 1985. 41–62.
Bazin, André. "Theater and Cinema." *What Is Cinema?* Trans. Hugh Gray. Vol. 1. Berkeley: U of California P, 1967. 76–124.
Broch, Hermann. *The Guiltless*. Trans. Ralph Manheim. Boston: Little, 1974.
Deleuze, Gilles. *The Movement-Image*. Trans. Hugh Tomlinson and Barbara Habberjam. Minneapolis: U of Minnesota P, 1986.
Freud, Sigmund. *The Standard Edition of the Complete Psychological Works of Sigmund Freud*. Ed. and trans. James Strachey. 24 vols. London: Hogarth, 1954–74.
Riegl, Alois. *Spätrömische Kunstindustrie*. 1901.
Schefer, Jean Louis. *L'Homme ordinaire du cinéma*. Paris: Seuil, 1980.

7

Photography *Mise-en-Film*
Autobiographical (Hi)stories
and Psychic Apparatuses
Philippe Dubois
Translated by Lynne Kirby

INTRODUCTION

FOR SEVERAL YEARS now, my study of media has focused increasingly on the intersection of several forms of visual representation. In work in the early 1980s on photography, and more recently on video,[1] I approached each medium from the point of view of its aesthetic essence, its specificity. Since that time, I have come to believe that it is no longer possible in today's audiovisual and theoretical landscape to speak of an art in and of itself, as if it were autonomous, isolated, and self-defining. On a theoretical level, I think it is no longer useful or even pertinent to treat photography as a thing in itself, or cinema as an ontology, or video as a specific medium. Though I have already begun to explore various interconnections among film, photography, and video,[2] I think that we have never been in a better position to approach a given visual medium by imagining it in light of another, through another, in another, by another, or like another. Such an oblique, off-center vision can frequently offer a better opening onto what lies at the heart of a system. Entering by the front door, where everything is designed and organized to be seen from the front, seems to me to be less sharp, less pertinent, less prone to yield discoveries than slipping in *from the side*. Entering through a small side door may provide access to new things, things never seen *as such*, and often more significant and original things. To "anamorphose" different image forms (a mobile point of view, one that hinges on moving) is often more penetrating and surprising than to observe prudently from the front, where though the image may appear to be fully visible, it also forms a screen (a static point of view, that of someone who does not see what is taking place behind him or her).

The thing is to practice this kind of oblique, sideways approach deliberately. We might begin with this simple idea: that the best *lens on* photography will be found outside photography. Thus, to grasp something of photography we must enter

through the door of cinema (though it may end up being rather the opposite). In short, we must insert ourselves into the *fold* (in Deleuze's sense), the intersection that relates these two media so often deemed antagonistic. For example, is there anything that tells us more or in a better way about the fundamental stakes of the photographic imaginary than, say, Antonioni's *Blow Up*, the hallmark film in this area? Or anything more central than Chris Marker's *La Jetée* for understanding photographically the nature of cinema (and vice versa)? And in theoretical and aesthetic terms, is the film frame (*photogramme*) not somewhere near the heart of the fold, in other words before an "un-nameable" object that is simultaneously beyond photography and before cinema, more than the one and less than the other, while being a little of both at the same time?

In imagining all the possible relational figures that link cinema and photography, there is a variety of intersections and relatively rich and unique figures to consider. There are many side doors into this house; it would take at least a book to be able to approach them all.[3] Here I will focus on and develop in greater detail one figure: that of photograph-films that deal with autobiography.

I will be concerned with the *mise-en-film* of photography in the work of five film authors who are also masters of modern autobiography: Raymond Depardon, Agnès Varda, Robert Frank, Chris Marker, and Hollis Frampton. Why choose these authors? Why focus on autobiography? My choices have in fact both external and intrinsic justifications.

The external reasons are simple. First, Depardon, Varda, Frank, Marker, and Frampton are all filmmakers who are *equally* photographers (though Frampton, it should be remembered, died in 1982). Most were first photographers, *then* filmmakers. In other words they came to cinema by way of photography, sometimes returning to or just touching upon it, or devoting themselves equally to both practices, switching between them with no sense of distinction. All are inseparably photographers *and* filmmakers, yet practice both arts independently. One might call them "cine-photographers." Moreover, these five cine-photographers are all more or less contemporaries: all began working in the 1950s, plunging headlong into the diverse film movements that marked those years—in France, the New Wave, documentary film, and political events; in the U.S., independent and underground cinema. They then developed parallel careers in the decades to follow. Historically and aesthetically, we might say that these five come straight out of what has been called "cinematic modernity," that is, *personal cinema*. This is a cinema that is critical and reflexive, authentic and ironic, subjective and detached; a cinema of flatness and opacity, self-questioning and existential angst, risk and experience; a cinema resistant to objective transparency and the confident self-mastery embodied by classical cinema. The historical overlap is, of course, not merely coincidence: autobiography is a quintessentially *modern* mode.

This is my most basic reason for choosing to focus on autobiography: the five "moderns" we are dealing with have each produced at least one film that reflects a

particular enunciative posture, that of the "story of self" told through images and sound. The films are *Les Années-déclic* by Raymond Depardon, *Ulysses* by Agnès Varda, *Conversations in Vermont* by Robert Frank, *Si j'avais quatre dromadaires* by Chris Marker, and *Nostalgia* by Hollis Frampton. These films, which I will analyze in detail, are rooted in what might be called a "cinema of the Self," defined by the mise-en-scène of the subject by him- or herself. In this type of film, the fact that the story told is always that of the filmmaker is recognized with an explicit enunciative protocol. The enunciation seals a pact with the spectator, what Philippe Lejeune has called the *autobiographical pact*—in other words, the generic and avowed identity of the author, the narrator, and the character.

A focus on autobiography brings with it important general, theoretical problems. Debate on the subject is fairly substantial, given the studies in this area by Elizabeth Bruss, Philippe Lejeune, and Raymond Bellour, and major conferences at Brussels, Valence, and Montreal.[4] These debates raise certain questions: can we truly speak of autobiography in cinema? How can we reconcile the unique subjective authenticity of autobiography with the always artificial and objectifying collectivism that the production of a film entails? What distinctions can be made in this area among fiction, documentary, and personal essay films? And so on. Beyond these discussions, however, the chief interest autobiography holds is that, for one thing, it implies a self-reflexive gaze that allows a self-questioning of the apparatus. Turned toward itself, the subject has no other exteriority than its mise-en-scène, thus exhibiting its own conditions of existence as image. On the other hand, and perhaps most importantly, the question of autobiography places the problematic of images in the explicit order of subjectivity, the order of the psychic life and memory processes. Whether it takes place via film or photography (or, more often, via the two simultaneously), autobiography sets in motion an essential reflection on the notion of mental images. And this is what interests me most of all, because this is what allows us to grasp in a single theoretical coup the triple question of cinema, photography, and the psychic life of the subject.

Indeed, in analyzing our five cine-photographers' films it is clear right away that this "cinema of the Self" occurs in each case *through the mise-en-scène of photography*. The autobiographical "I" is put into place only through the necessary mediation of the photographic image. One cannot exist without the other. Each of these films begins by posing *in its own way* two questions: How can the photograph speak, or be made to speak, in and through film? And why is the photograph the privileged vehicle (*l'objet transitionnel*) of autobiographic inscription in the cinema? The only response to both is that each of these photo-films is typically a film *de dispositif*, an apparatus film.[5] The photograph marks the autobiographical inscription of the "I" by putting into place a particular apparatus—a unique configuration of image and speech, the very thing that articulates psychically the photo-cinema relation as a whole. The apparatus itself is as significant as the photographs it conveys and is thus in a way always theoretical—a concept as much as a form, a machination as much as a machine.

Thus I have chosen to focus on the five films because of their "photobiographical" (*phautobiographique*) *mise-en-film*. Moreover, each represents an exemplary, theoretical apparatus *type*—a great mode of functioning of mental images—and together the five types form a system. That is, each of the films corresponds for me to an abstract model: each is an apparatus of image and speech, of cinema and photography, that finds a precise analogy in a model of memory and mental image. As we will see, there are four such theoretical models, all developed in areas of thought outside the territory and objects of film and photography, namely, ancient rhetoric, psychoanalysis, and aesthetic history. But these models lend themselves perfectly to our purposes. And put into perspective, aligned on the same axis, together they construct a basic interpretation of the modern question of the relation of the subject to the image.

To simply list them, before applying them to our five films, we begin with the model of the arts of memory as developed in the rhetorical tradition of antiquity. The best description can be found in Frances A. Yates's invaluable reference text *The Art of Memory*. The second and third models are actually one, a double analogical model of the functioning of the psychic apparatus in Freud's work: the metaphor of ruins (itself double: Rome on the one hand, Pompeii on the other) and that of the photographic process.[6] The last model is borrowed from Walter Benjamin's aesthetic history: the model of the *aura* in relation to the work of art. In short, we will be dealing with *memory*, the *unconscious*, and *aura*. These various models operating implicitly and aptly in each of the five films together form a highly articulated system of postures. All hark back to the concept of a psychic and metaphysical status of images that the "cine-photographic" autobiography lays bare. All tell us that, in the end, the photographic *mise-en-film* of modern autobiography is not so much a matter of real images as it is a subtly played game of *mental images*.

PART I. ARS MEMORIAE: *LES ANNÉES-DÉCLIC*
BY RAYMOND DEPARDON

Les Années-déclic is a medium-length film produced in 1983 by photographer/filmmaker Raymond Depardon. It began as a commission by the *Rencontres Internationales de la Photographie* in Arles, which asked Depardon to look back on his career as a photographer by commenting on his images before an audience. From this commission, Depardon retained the basic apparatus that came to structure the entire film, in which we witness a literal procession of photo and film images organized strictly by chronology (1957–1977) and accompanied by Depardon's "live" voice, which is reserved and hesitating. His face appears in close-up from time to time, punctuating like his improvised statements the succession of images that unfold as so many film frames from his life. These images reconstitute progressively, in order, a memory made up entirely of images, from his first snapshots as a child at the family farm in Villefranche-sur-Saône to the death of his father in 1977. For

nearly an hour, Depardon soberly and stubbornly exposes himself with a subtle blend of distance and complicity, lucidity and hesitation that characterizes all of his work.

The "Depardonian apparatus" is a good example of a "classically modernist" mise-en-scène of photographic autobiography. The film's apparatus is based on three points and a small machine. The three points: (1) a simple and continuous chronological linearity that molds the discursive unfolding of the images around a factual unfolding of events; (2) an unrehearsed discourse on the images that includes all the quiverings, hesitations, stutters, silences, and intonations of a live voice, and that thereby casts the act of reading images of the past in the historical present of speech; and (3) a double frontality, that of the memory images that unfold on the screen before us *and* Depardon, and that of the on-screen commentator, who explains to us and points out (with his finger) the images in front of him. This doubly frontal mode of address thus refers simultaneously to the comment (*l'énoncé*) and the commentator (*l'énonciation*, Depardon as narrator), placed in mirror relation to each other and both before us. The succession of images and the frontality and the uncertainties of spontaneous commentary all help create the impression of inspecting something. We slide across the surfaces of image-screens, of a life whose memory is not so much penetrated as skimmed, at the same time exposed and hidden, spoken and quiet.

The "small machine" is what Depardon created originally for showing the procession of his images. The machine is a kind of small-scale table illuminated from the inside, with a window on its top side that faces Depardon as he gazes down upon it. With a lateral, right-to-left movement, he manually draws through this window a strip of slightly enlarged photographs selected and arranged to reconstitute the (auto)biographical journey. The machine is a kind of personal, intimate viewing unit that also functions as an overhead projector (*rétroprojecteur*) allowing for a much larger projection of the images on a wall/screen located in back of Depardon—*in his back*—and meant to be seen by the spectator. An insistent scraping noise produced when the images slide through the machine follows the rhythm of Depardon's speech and expression. This creates the impression of turning the pages of a photo album, or, better yet, of unwinding the scroll of a memory *volumen*—that might have been better left unwound. As time passes, the film, the photos, and the life drift together to form a single entity.

In its simplicity and obviousness, the Depardonian apparatus would seem to represent almost exactly one of the famous arts of memory as systematized in the great rhetorical tradition of antiquity. As mentioned earlier, Frances A. Yates has written the definitive archaeology of these systems in her book *The Art of Memory*. The "art of memory" originated in ancient Greece and was handed down through great Latin texts like Cicero's *De oratore*, Quintilian's *Institutio oratorio*, and the *Ad Herennium*, written by an anonymous author. Defined as one of the five great categories of ancient rhetoric (*inventio, dispositio, elocutio, memoria, actio*), it was

conceived as a collection of rules permitting an orator to speak effectively. Its basis was the easy and simple inscription of the tools of discourse in the speaker's memory. In other words, it was conceived as an artificial procedure of memorization in which a bundle of thoughts could be assembled and ordered, and a precise element instantly located. The art of memory rests, in fact, upon a game involving two fundamental notions: sites (*loci*) and images (*imagines*). To quote Cicero:

> Persons desiring to train this mental faculty that is Memory must first select distinct *sites*, then form mental *images* of the facts they wish to remember, and *arrange* those images within the sites. The result is that the order of the sites will preserve the order of the facts, for the images of the facts will recall the facts themselves. The sites are wax tablets on which we write; and the images are the letters written upon it. (86, 354)

In this basic definition of *Ars Memoriae*, Cicero clearly sums up the basic ideas. The basis of the system is the many sites that form a precise and methodical series. They are the invariables, empty receptacles, blank surfaces able to receive the *imagines*, which are full (of meaning), yet transitory. The *loci* form the structure of this memory apparatus. It is therefore essential that they be linked together in the mind according to a relatively "automatic" logic. They must be able to be recalled *in order*, so that they can be located at any time. Common systems of *loci* include the arrangement of rooms in a house, the disposition of human body parts, the alphabet, the zodiac, the spatial organization of theaters, etc. In short, any topography that is so familiar that it can easily be scanned in the mind can form a useful set of *loci*. These same places can also be recycled, once we no longer have any need to recall the images they contain, to receive another set of images destined for other memory work. Returning to one of the most common metaphors in ancient discourses, Yates states: "*Loci* are like wax-coated tablets which are blank when the writing has been erased, ready for a new use" (19).

The ancient authors each stress that *imagines* should by no means be indifferent. Images should basically be symbolic, allegorical, composite, and somewhat articulated. If the apparatus is to function well, the images must be striking, out of the ordinary and active (*imagines agentes*, as the author of *Ad Herrennium* states). Moreover, there is a kind of double nature running through the *imagines*: on the one hand, we find a constant reference to *writing*, to figures of inscription (the author of *Ad Herrenium* would go so far as to say: "the art of memory is exactly like internal writing"); on the other hand, the images reaffirm the value placed upon the sense of *sight*. Everything, therefore, must be translated into images. Memory is either visual, or it is not memory. This visual practice of memory, however, occurs in the mind. Everything happens there; we might sum it up as "*interior image writing.*" This is where the art of memory and photography meet as mental mnemonics.

In ancient Greece and Rome, the art of memory was essentially an appointed branch of rhetoric. Subsequently, in the Middle Ages and the Renaissance, as Yates

notes, the *Ars Memoriae* retained and, to a degree, refined the same basic processes (*loci* and *imagines*) to include other subjects and evolve toward other areas, notably ethics and moral philosophy (during the gothic Middle Ages); painting (Giotto, especially in the frescoes of the basilica of Saint Francis of Assisi); literature (Dante, especially in his description of Hell); the occult (Giordano Bruno); and theater (Robert Fludd and the Globe Theatre).

In light of all this, we can easily see how photography is a modern form particularly well suited to the arts of memory. Light-sensitive plates have replaced wax tablets, but the material base matters little, since everything happens within the subject's mind. For if memory is a psychic activity that finds its technological equivalent in photography, the metaphor is of greater interest in another sense, as a positive/negative inversion: photography as a psychic phenomenon as much as (or rather than) an optical-chemical activity; or photography as a memory machine, made of *loci* (the framing receptacle or window) and *imagines* (impressions, images that slide in and across the frame).

Depardon's film is revealing in that it engages precisely this aspect of the photographic. *Les Années-déclic* functions literally and figuratively as an art of memory. Depardon's "small machine" (a personal viewing and public overhead projection unit) and the film itself, which is a pure extension of it, form a fairly exact articulation of *imagines* (the memory pictures passing by) and a *locus* (the stationary window frame or screen whose organization rests on chronological order). And the dual nature of the whole device, its "physical" and "psychic" dimensions, rests in fact in the *mise-en-film* of memory images: in the way the photographs as material objects—the manipulation of the strip in Depardon's hands, the scraping of paper across the window frame, the index finger pointing out a detail in the image—are reshot by cinema, and therefore caught up in a process of visual dematerialization associated with the impalpable nature of all projected images (especially the temporal cinematic image). After a typical viewing of Depardon's film, the spectator is left only with the memory of the images and their inherent instability. It is a memory, however, of images that were never more than images of memory: a photographic autobiography put on film, hence a double instability—mental images twice removed. It is this "weakness," which can be revealed only through cinema, that in fact gives photography its power.

PART II. EXCAVATING THE STRATA OF A MUMMY-IMAGE: AGNÈS VARDA'S *ULYSSES*

In 1982, at about the same time Depardon was working on *Les Années-déclic*, Agnès Varda produced *Ulysses*, a film that also aimed to be autobiographical and also focused on photography. *Ulysses* is at once the title of the film, the title of the photograph on which the film is based—a photo taken by Varda twenty-eight years earlier, in 1954—and the name of one of the protagonists in both the film and the

photograph (it is actually a nickname, as we learn at the end). *Ulysses* the film is structured by an apparatus that, in principle, is the exact opposite of Depardon's. Whereas Depardon uses diachrony to evoke twenty years of his life in a continuous, ordered procession of images, Varda opts for the *synchronic slice* or cut (*coupe synchronique*), using a single photograph to make a journey—a round trip—across twenty-eight years. This reference-photograph, which is also the first shot of the film, becomes the subject of a veritable inquest conducted in several successive waves. The investigation functions as a series of archaeological excavations peeling away, layer by layer, all the levels of possible meaning clinging to the original picture.

The film's structure is woven through a series of steps:

1. The presentation and simple description of the photo-object, the intact trace of the past, fixed once and for all in a single picture, "definitive" yet "enigmatic."

2. The first phase of the inquiry: the search, after twenty-eight years, for the protagonists in the photograph—a man, a child, and a goat—and an attempt to make them remember the incident. The result: nothing. The man, an Egyptian named Fouli Elia, at the time a model and now director of photography at *Elle* magazine, no longer wants to remember. The child, now an adult (a bookseller in the *Marais*), is unable to remember. Instead, his mother Bienvenida, who was present when the snapshot was taken, emotionally remembers *in his place*, speaking to Varda of her son's illness and the work-friendship that linked them at the time. The dead goat, reincarnated by a representative of its species, is reduced to silently consuming (literally eating) its own picture. There is no, or almost no, memory. For those captured by it, the photograph is a dead letter, a black hole, a blank memory. We, as spectators, however, are able to see, in and through the film, what happens after twenty-eight years of living: memory fades. The film registers this act of forgetting, of blotting out memory; it measures, in other words, *the real work of time*.

3. On the off chance of finding something, Varda extends her investigation to children the same age as the young Ulysses of the photograph, since the adult Ulysses is almost completely silent. She presents them with a drawing of the same scene the photo shows, done by the child Ulysses at the time. Once again nothing constructive turns up other than a few rudimentary reflections comparing photographs to painting.

4. A second wave of excavation occurs: an investigation of the historical context. Varda poses the question, "What happened on May 9, 1954" (the date of the photograph)? In the manner of Prévert, she goes through a vast inventory, enumerating all she can possibly find after digging through archives and news of the time, searching through everything: national and international politics, social and cultural events, etc. Once again the inquiry turns up nothing capable of explaining the photograph and giving it the substance needed to fill in the blanks ("none of that context can be seen in this image"). One important fact, to which we will return, is provided at the end: the photograph was taken in May 1954, the same year that

Varda shot her first film, *La pointe courte*, in Sète, France, after years of working as official photographer for the *Théâtre National Populaire*.

5. In the end, Varda conducts an investigation of the photograph itself, this time without the use of any external data. She gives herself over to free interpretation, borrowing from myths and mythology (the very name *Ulysses* demands this). But even this open investigation appears to be little more than a game in which any interpretation is possible ("you can see anything you want in a picture"). It is as if the image had nothing to offer that could put an end to this search for meaning.

6. There remains little that can be done. After his mother comes and tells us that Ulysses was a borrowed name used as a term of affection (Antonio is his legal name), we return to the original photograph, the last shot of the film, this time without commentary. "The picture is there, that's it." We are left with the opaque presence of the photo, which stubbornly, obsessively, and silently resists to the end. Despite the excavations, the stripping away of successive layers of possible meaning, it remains enigmatic; the photograph says nothing. It is the trace of something that fails to resurface in consciousness, remaining in the order of a certain unconscious of the image, outside speech. Thus indirectly, in a silent manner, and by the very fact that the film exists, we bear witness to twenty-eight years in the life of Agnès Varda.

If any meaning is to be drawn from *Ulysses* (the film *and* the photograph, which are inextricably linked), it is the following: Varda is unable to give her photograph semantic substance in the act of stripping away its sedimented layers; the image resists the pickax and scraper to remain pure surface, and all attempts to unearth meaning skid across it. This is because Varda only attacks the photograph itself. However, if we consider the *film*, which includes the photograph *and* the work on it, then something else surfaces: Varda's *becoming-cinema photograph*. Ulysses—there is a reason for this double name—is the process through which Varda signifies and designates herself as a filmmaker through and at the expense of photography. Between the first and last shot (both the same photo), nothing definitive has emerged to shed light on the content of the image-enigma. To put it simply, there has been only the film itself. To get from the first to the last shot, there had to be the film, which lends its own substance to the photograph. In other words, the photograph's meaning only exists in and through cinema.

Varda undoubtedly chose this photograph from May 1954, perhaps unconsciously, because it was the same year that she stopped being a photographer and became a filmmaker. Her synchronic *slice* truly is just that. This retrospective gesture is literally auto-biographical, recording her own life story through a film based on her "last" photograph and revealing how it carried within it the cinema to come. This is the meaning of the "Ulysses" photograph: it contained without knowing it a potential film that was to be made twenty-eight years later. This is the meaning

of the film *Ulysses*: the construction of a cinematic apparatus designed to show us that the evolving filmmaker in the author-photographer was always there, dormant, waiting to rise to the surface from the unconscious bottom of the picture's memory. Varda, the archaeologist of her own memory, works as an analyst, digging through her photographic unconscious to recover her cinematic self. This could only occur suddenly, years later, in a single slice of image recorded long ago and then rediscovered in its entirety like a mummy unearthed in its original state. This is Ulysses as Pompeii.

PART III. A PILE OF RUINS FROM PHOTOGRAPHIC LIFE: THREE AUTOBIOGRAPHICAL FILMS BY ROBERT FRANK

Robert Frank is a key photographer of his generation. He is also a filmmaker whose work is seen all too rarely. Frank's "(ph)autobiographic" films (to be distinguished from his "fiction" films, from *Pull My Daisy* to *Candy Mountain*) correspond to milestones in his own life. There are three such films which, taken together, form a sort of structured apparatus: *Conversations in Vermont, Life Dances On...*, and *Home Improvements*. This triptych concerns Frank's investigations of himself, of his past life, and, especially, of the history of his relationship with his children Pablo and Andrea. A retrospective stripping away of a father's memory, it occurs in an almost obligatory way through photography. Frank makes use of all of his photographs: the public and the private, the well known and the intimate, contact sheets and prints, with all the categories mixed together in an "inescapable" disorder. Speech is also important to this work—not so much a secure and distant voice-over, which can be soothing and healing, serving to reconstruct and organize after the fact, but live, unrehearsed dialogue, which involves some risk. The risk is apparent in his conversations with characters from the past and his own children, who rediscover themselves spontaneously in countless pictures that their father took of them, which they take back, exchange, reject, handle, investigate, leaf through, and pile up.

The three films follow one another in close and painful relation to the story of Robert Frank's life and emotions, spanning the history of a progressive and terrible loss. The first, *Conversations in Vermont*, is an attempted reunion between the father and his children. After gathering together a stack of photographs, Frank sets off for Vermont where his son Pablo and daughter Andrea live. He tries to catch up on lost time by talking to them about the memory and image they have kept of their father. Things are not simple. Memories come back only with difficulty and embarrassment. We sense old wounds ("a tense and painful experience for all three of us," he states in his 1989 retrospective book, *The Lines of My Hands* [7]). This tangled web of emotions, thoughts, and personal relations, with words and images mixed together, reflects Frank's disordered filming style perfectly: everything is

systematically agitated, shaken up, disturbed, pushed around, and swept by the camera's eye. Refusing to stay still, the camera searches for coherence, in vain perhaps, by rummaging through everything in sight. In this first attempt at a family reunion, the photographs serve as possible rallying points for improbable memories, and distance and disjuncture are already at work.

The second film, *Life Dances On . . .* , takes place eleven years later and is even more painful. Made shortly after Andrea's death in an airplane accident in Tikal, Guatemala, the film is an expression of mourning. Frank the father returns to his photographs, searching for a soothing balm. Instead, he finds scars, image-scars, and greater self-doubt. He still has his son, Pablo, whom he proceeds to find, talk to, and film along with his friend Sandy. There is a lot of talk about stars, the sky, and meteors. Things are both simple and hard. The disorder only grows, producing the effect of a life coming to ruin in and by images.

The last film in the triptych, *Home Improvements* (shot on half-inch video), is the most painful. Frank is at home in his house facing the wild sea in Mabou, Nova Scotia. It is an icy, stormy winter, and Frank is now destitute, a recluse with his wife June. The images are often terrifying: the son, Pablo, has disappeared with the stars into another universe, a psychiatric hospital. Photographs are no longer of any use. These are images of the end of the world. Frank's past and life seem far away, almost lost, buried. There is a pervasive sense of irreparable loss, loss of the future, loss of self, the self ruined.[7]

With Depardon, the memory-pictures of his life are arranged in a sober and rigorous manner. They pass methodically before our eyes on his small machine. Commenting on them from a distance with restrained complicity, he erects a serene monument to his own life. Varda, on the other hand, proceeds very selectively from a single picture through inquiry and successive investigations. Layer by layer (in highly elaborated visual work on the "layout" of a photograph as it is filmed), she articulates, through the unconscious work of time, the becoming-cinema of her photography. Frank, however, sets forth a distraught treatise on photographs, a work based on multiplicity, disorder, accumulation, explosion, a chaos constructed out of fragments, a pile of odds and ends. This is the form the "Frankian" photographic autobiography takes—disorder to the point of ultimate loss, the crumbling away of references, and the dissolving of the subject. Agnès Varda's constituent act of self-as-filmmaker (at the expense of photography and via a borrowed child) finds its opposite in the self-destructive gesture of Robert Frank's self-as-father (at the expense of photography and via cinema).

Behind and beneath the work of images and narration, there is a *psychic process* embodied in both of the basic models represented in the work of Varda and Frank. They are really mutually exclusive, yet complementary, models. A detour is now in order by way of one of Freud's metaphors for the psychic apparatus, that of archaeology. As we will see, this metaphor is a double one.

PART IV. THE ARCHAEOLOGY OF UNCONSCIOUS RUINS:
THE MODELS OF ROME AND POMPEII

Archaeological metaphors appear frequently in Freud's writings. A primary example can be found at the beginning of *Civilization and Its Discontents* in the famous comparison between Rome the Eternal City and Rome in ruins. Another is the equally celebrated analysis of the symbolism of Pompeii, the petrified city, in *Delirium and Dreams in Jensen's* Gravida. Rome and Pompeii: two archaeological topics that are both similar and opposed, or rather complementary. Although Freud never developed a real theory of memory as such, he always concerned himself with the psyche's methods for recording the past, with what he called the "conservation of psychological impressions" or, put another way, "mnesic traces." Two distinct models are then found in the examples of Rome and Pompeii.

Freud clearly states in *Civilization and Its Discontents*: "[N]othing in the life of the psyche can be lost, nothing disappears that has been formed. Anything conserved in the slightest way can reappear under favorable circumstances given satisfactory regression" (11). To underscore the meaning of this basic principle, Freud resorts to "a comparison borrowed from another domain," that of Roman archaeology. Rome is seen as a paradox. In one scenario, it is a ruin—the Ruin, in fact: the accumulation of layers of history, sediment, and stratification, all the different periods of history superimposed on a single place, but in the form of more or less destroyed, damaged, or incomplete fragments. This is Rome as the wild accumulation of odds and ends, leftovers, deposits, and other debris; it is Rome as the shards of History. At the same time, there is another Rome, the *Eternal City*—the very picture of durability, the imaginary of total preservation throughout the ages. One city is reality—debris, partial traces, gaps, holes; one city is fantasy—the impossible dream of preserving everything, complete and in its place. This is Rome as an immense archaeological palimpsest. To quote Freud: "Imagine for a moment that Rome were a psychological being where nothing that had been produced was ever lost. All of the recent developments would subsist along with the ancient.... The observer would only have *to change the direction of his gaze or point of view* and one of the many architectural aspects would emerge" (13; author's emphasis).

Rome becomes a matter of points of view and changes in direction, authorizing a kind of transparency of the gaze. It is a virtual city, like its memories, where we would only have to turn our gaze to experience in each view (literally a view in the mind) an intact aspect of the city, image after image, layer upon layer, as if leafing through a book of collected photographs in three dimensions. It is Rome as a hologram, in fact, or a synthetic image.

The other archaeological metaphor is Pompeii. In his analysis of *Gravida* by Jensen, Freud read Pompeii as a symbol of repression, writing: "There is, in fact, no

better analogy for repression, by which something in the mind is at once made inaccessible and preserved, than burial of the sort to which Pompeii fell a victim and from which it could emerge once more through the work of spades" (40). In focusing on the analogy between repression and burial (and its corollary, the analogy between the return of the repressed and exhumation), Freud advanced his idea of the complete and unalterable preservation of the past. This preservation was only possible through the relatively "instantaneous" burial that made of Pompeii, in the wake of a unique catastrophe, a city suddenly suspended, frozen for all time. Pompeii can give us only a picture of *one* layer of its past, one historical slice, but it gives us a picture that is almost completely intact. Pompeii is truly a *photographic city.*

In short, the archaeological metaphors of Rome and Pompeii provided Freud with two distinct systems of temporality. Both illustrate, in a complementary fashion, the functioning of the psychic apparatus: on the one hand, the temporality of accumulation, application, overloading, which is only fragmentary; on the other, the temporality of grasping something in its entirety, but only for an instant, a slice of time. Clearly the difficulty lies in the fact that these two systems seem mutually exclusive: either you have Rome, a multiplicity of layers but always in broken fragments, or Pompeii, preserved in its entirety but as a single layer. Freud's impossible dream is to have both of them *at the same time*: multiplicity *and* wholeness, Rome *and* Pompeii, duration *and* the moment. The trick is to find something like a "change in the direction of the gaze" that would articulate both of these entities at once. For the psychic apparatus evidently is these two things in one. At the heart of our psyches, we all have a Rome and a Pompeii, indistinct from each other and part of our innermost selves. The mnesic traces buried in our unconscious are both always there and always whole. Only their rise to the surface is selective. All virtualities are recorded, but their actualizations or revelations in consciousness occur precisely and according to a thousand procedures that act as filters—slips of the tongue, dreams, lapses, associations, etc. The analyst, like the archaeologist, is there to facilitate their emergence, to dig, scratch, excavate, bring to light, and reveal. The analyst-archaeologist is the one who takes the photograph, developing latent into manifest images, which can be image- (or memory-) screens, images displaced, transferred, condensed, and manipulated by all the devices of the psychic dynamic.

In light of all this, the dual archaeological metaphor developed by Freud can easily be applied to the films of Varda and Frank. Frank's triptych, *Conversations in Vermont, Life Dances On . . .* , and *Home Improvements*, incarnates the Roman ruin model: piles of fragments, accumulated scraps of memory, the shards of history. Again there is the fantasy of the impossible preservation of the whole, which is always lacking, necessarily and increasingly lost. *Ulysses* is the opposite: a photomummy examined in the minutest detail, which in the Pompeiian model is a single block of space-time preserved intact since "ancient times" (those of Varda the photographer in the age of the repressed filmmaker) and unearthed in the "new age"

of Varda the filmmaker. The archaeological models through which we read these photograph-films, however, are only meaningful if we *turn them around* in relation to the Freudian metaphors they are meant to illuminate. We should not, like Freud, study psychic phenomena as ruins, but conversely see the "ruins-esque" practices of photographer-filmmakers as psychic processes. As *revealed through the cinema* of Frank and Varda, photography resembles the work of the unconscious.

PART V. DISTANCE, THE PAUSE, AND AURA: *SI J'AVAIS QUATRE DROMADAIRES* BY CHRIS MARKER

Chris Marker defines himself primarily as a traveler and a memory. A kind of sensitive and receptive plate that wanders the world, observing people and things, Marker records his impressions and reconstitutes them for us as separate thoughts in a variety of forms: books, photographs, films, informative memoirs. Material differences among the media hold little significance for him. For instance, he makes films as if they were photographs accompanied by text. He also publishes his films in the form of books and entitles them *Commentaires*. And this intermingling of words and images is always a *travelogue*. Whether he is in Japan, Siberia, Cuba, Peking, Paris, Africa, or America, Marker will send us some news from time to time.

The "letter" is one of his preferred forms of communication, as in "I am writing to you from a faraway country . . . " (*Letter from Siberia*). With the film letter, Marker is one of the first to have systematically practiced the "autobiographical documentary." But these films are not about the story of his own life, in the vein of Depardon's *Les Années-déclic* or Frank's triptych. Marker speaks above all of others, the world, the people and landscapes he visits, the animals he worships and the societies he observes. It is the way he speaks, the type of gaze he brings to an apparent exteriority that is distinctive. This gaze of irony and fascination, love and distance, sympathy and criticism, a gaze that is both wise and partisan, forms the incomparable, assumed personalization, the "I" of Marker's documentary approach.

Si j'avais quatre dromadaires (*If I Only Had Four Camels*) is presented as a stroll across our *"petite planète"* (the title of the famous collection of Marker's short travel books, which he created and edited for Le Seuil, a French publishing house). The film finds its point of departure in the vast collection of photographs taken during the filmmaker's itinerant life. This "photo album of his travels," shot on an animation stand, quite literally *is* the film. Constructed solely of still images, this is a *photo-film* in the most materialistic sense of the word. As such, it would seem to be a very anti-cinematic apparatus: the story of a journey whose visual figuration is the pause, the freeze-frame, the still image. It is, in fact, the *distancing of a memory object*. The exclusively photographic presence of the world gives an object-like reality to memory. The film is composed not of memories but of the image of those

memories; it is not about the uninterrupted fluidity of movement (of life, cinema, the past) but the distanced freezing of time in this same movement. It is a kind of stepping aside or back to be able to see and speak, a fundamental disjuncture that marks the (ph)autobiographical strategy in Marker's work, a disjuncture replayed in the off-screen commentary that *doubles* the still images he has strung together.

On the soundtrack, the off-screen Marker "tells" us in his own way about the photographs, which are his "impressions" of his travels, or at least their supporting evidence: his love of Russian faces and women, his view of Korea and its rituals, his discovery of Black Africa, his reflections on French society, etc. The photographs follow one another in a nonchronological, nongeographical order. They are simply linked together in complete freedom, by cross-referencing or contrast, *carried along by the discourse* that accompanies and "autobiographizes" them. The commentary is, however, neither descriptive nor narrative, neither anecdotal nor even thematic; it is highly subjective. In other words, Marker returns his object-images back to the distanced and disjointed subject observing them obliquely with this inimitable double effect of love and distance, fascination and amused intelligence. The photographs acquire a kind of inner strength; named and discussed, they possess an *exhibition value* that can be turned into *cult value* through this distancing strategy. Their quite remakable *aura* is based on this reversible system, on the near-cult value of exhibition itself.

This analysis leans quite clearly on Walter Benjamin's well-known terminology in "A Short History of Photography" and "The Work of Art in the Age of Mechanical Reproduction." Certain celebrated phrases are especially memorable: "The definition of the aura as a 'unique phenomenon of a distance, however close it may be' represents nothing but the formulation of the cult value of the work of art in categories of space and time perception." With this generic definition of the measurement of the symbolic value of an artwork, Benjamin advances a veritable *principle of distance*, which he considers fundamental and irreducible since it works even in the closest proximity to the object. In so defining aura, Benjamin reaffirms the cult value of the artwork as fundamentally distant and unapproachable: "The essentially distant object is the unapproachable one. Unapproachability is indeed a major quality of the cult image. True to its nature, it remains 'distant, however close it may be.' "[8] In other words, a work of art like a great classical painting—for example, Giotto's frescoes depicting the life of St. Francis in the Basilica of Assisi—is endowed in its historical context with a very strong "cult value": everything that makes it a unique object, embedded in ritual, an object of belief and faith as much as of vision. But this original, auratic value tends to weaken in proportion to the reproduction, distribution, and banalization of the work—for example, by photography. That is, aura fades in relation to exhibition value.

This is what we retain most often from Benjamin's texts. What we tend to forget is that it actually concerns a problem of the particular use of a medium: the photograph as a tool of reproduction of works of art. It would be a grave error to

apply this concept as defined by such a limited use of the medium to photography as a whole or in principle. It is even a contradiction. For the cult value of the image asserts itself in the photographic apparatus much more fully than in most other image forms. Of all the visual arts, photography is the one in which representation is simultaneously, ontologically, closest to the object and furthest from it: closest since it is the direct, physical emanation of the object, its luminous imprint, which sticks quite literally to its skin (the celluloid); furthest because it maintains the object as absolutely separate, distant, *opposite to* the real. This is precisely what Marker's film puts into play.

This separation within representation is what actually informs the effect of looking at a photograph, inducing perpetual movement on the part of the spectator-subject: we pass continually from the object's *here-and-now* to its *elsewhere-in-the-past* when looking at the image. Endlessly and intensely gazing at the image (which is truly present as image), the spectator plunges into it in order better to experience the effect of absence (both spatial and temporal) and the untouchable referents it offers for our sublimation. The photograph acts as an instrument of travel in time and memory. To see something that existed, somewhere, sometime, something that is much more present in our imagination now that we know it has actually disappeared—to see it and not be able to touch, pick up, or manipulate it—is to be frustrated by a metonymic substitute for the thing that is gone forever, now a simple trace on a piece of paper instead of a single, palpable memory. The frustration is all the stronger as the indexical substitute signifies the absence of the referent, offering itself, *qua* representation, as a concrete object endowed with real, physical substance.

The fetishism of the photographic image derives from this double posture: the photograph is an object that can be touched, framed, collected, enclosed, burned, torn up, and embraced, yet it can only show us the untouchable, the inaccessible, a memory, an absence. In photography, therefore, there is never just one image, separate, disjunct, alone in its solitude, haunted by the one, intimate moment it had with a real that has vanished forever. It is this hauntedness, formed by distance in proximity, absence in presence, the imaginary in the real, the virtuality of memory in the effectiveness of a trace, that draws us to photographs and gives them their aura: *the unique phenomenon of a distance, however close it may be.*

In this sense, *Si j'avais quatre dromadaires* is as much a voyage in time, memory, and the mind as it is as a voyage in space across our small planet. This applies as well to *La Jetée*, which turned this mental journey into the theme of its autobiographical, "futurist" fiction with "the story of a man marked by a childhood image." *Le Fond de l'air est rouge* does something similar, but in the area of the memory of political and social battles. In short, this is one of the major figures in all of Marker's work, in which all the genres intermingle. The distance required for such a temporal journey can only be found in the image-object, which is stopped, frozen, observable from the outside, like a fixed, tangible thought. The still photographic

image serves this function in *Si j'avais quatre dromadaires* (as much as in *La Jetée*). A work of memory and distance, it allows us to see thought in images; it allows time travel. The photograph may be turned into film, yet it still remains photographic. Photography is, after all, an instrument of psychological distancing. The inherent exhibition value of the photographic is reinvested in and through the cinema of still images to the point of bringing out the cult value of these same images. Exposed, replayed like image-thoughts, these are *auratic* images, worshiped by the cult of memory and fixation in time. "The story of a man marked by a childhood image."

PART VI. THE SYNTHETIC EXPERIMENT: *NOSTALGIA* BY HOLLIS FRAMPTON

Though, like Depardon, Varda, Frank, and Marker, he was both a photographer and a filmmaker, Hollis Frampton did not belong to the world of documentary filmmaking. Rather, he came out of what is called "experimental cinema." Hence he was able to adopt with unparalleled perversity all the various postures of photographic autobiography in a kind of *experiment in synthesis*. Playing with the viewer, the critic, and himself by playing with illusion, Frampton confused reality with fiction and true with false autobiography. This different way of telling his life story is perhaps, in the end, more "subjectively documentary" than any other.

Nostalgia, a thirty-six-minute film shot in January 1971, is composed of thirteen shot-sequences that each present one of Frampton's photographs. Each photo represents a moment in the author's life, from his beginnings as a photographer in New York in 1958 to the time the film was made in 1971. The images unfold in chronological order, as a voice-over commentary describes, locates, and comments on each of the pictures. We see a succession of self-portraits and portraits of friends (Frank Stella, James Rosenquist, Michael Snow) and personal images of different places and objects. So far, this is nothing more than classical cinema: a simple and linear system, very "art of memory," and very like *Les Années-déclic*. Through their films, Frampton and Depardon both establish a memory that is the story of their respective photographic lives. But of course this is far from the whole story.

Nostalgia's thirteen photographs are presented *burning up*, in real time, on an electric hotplate. The duration of each shot-sequence is determined by the time it takes for the photograph, seen initially intact, to heat up, grow progressively blacker, shrivel, and become carbonized paper. The end result is the ruin of representation and a fascinating experiment in time. The psychic effect produced by the continuous viewing of the photograph's auto-consumption is intense, as if we felt physically that this carbonization of memory-images were actually taking place. We are left with the shriveled fragments of a life that in the end is little more than ashes. Something irreparable has happened before our very eyes.

In this, *Nostalgia* recalls Robert Frank's three films, which are also marked by

an intense expression of pain, injury, and irreparable loss. Frampton's "nostalgic" suffering, however, is presented entirely without pathos. As he notes: "In Greek the word [nostalgia] means 'the wounds of returning.' 'Nostalgia' is not an emotion that is entertained; it is sustained. When Ulysses comes home, nostalgia is the lumps he takes, not the tremulous pleasure he derives from being home again. In my film, there is a remastering of a certain number of lumps I took during those years as a still photographer in New York" (159). The photograph is a blow, a lump, the trace of a wound, while the burn is a scar; one is an extension of the other. Burning a photograph is itself only an extension of the photographic process: the photograph is a sensitive surface (like the soul) burned by the light that strikes it, and gnawed from within by the very things that allow it to exist: light and time.

The relationship between the pictures and the voice-over invites comparison with Marker's films. At a certain point in the film, we begin to notice that the spoken text is out of synch with the image we see on the screen at that particular moment. The commentary in fact corresponds to the *following* picture, which appears only once that particular commentary is over and the commentary relating to the following picture begins. This systematic disjuncture means that we are unable to hear the commentary on the first photograph and do not see the last of the thirteen photographs. We are dealing, in fact, with a series of *fourteen* sound/picture units, one of which is always at least partially absent, either at the beginning (the commentary) or at the end (the photograph). Therefore, it is also always only partially present, as we have the photograph without commentary in the first sequence and the commentary without photograph in the last. The disjuncture is obviously a distancing device, a reminder of the distant, intelligent irony and refined sense of playfulness in Marker's work, except that here the style is more "structural" and less "humanist."

From this point of view, Frampton is quite perverse. Because the voice-track is detached from the image as such, it requires close analysis to realize how many calculated ambiguities it contains. In fact, the spoken text is rife with half-truths and hidden lies. Autobiography can here be grasped only through a game of hide-and-seek with reality. It would be tedious to list all the gestures of manipulation and diversion found in these words. Some of them, however, can be spotted quite easily. For example, it is not Hollis Frampton's voice that we hear telling, in first person, the autobiographical story; it is that of Frampton's friend, Michael Snow. This lends great humor to the eleventh shot-sequence, which is devoted to Snow: "If you look closely, you can see Michael Snow himself, on the left, by transmission, and my camera, on the right by reflection. . . . I believe that Snow was pleased with the photograph itself, as I was." Fictitious dates are also deliberately given (shots six, ten, and twelve, for example). There are also obvious provocations: sequence nine presents a photograph of two toilets, "interpreted" by the commentator "as an imitation of a Renaissance crucifixion." Certainly, one of the first effects of

this perversity is to cast doubt on Frampton's "autobiographical" undertaking. Shrouded in suspicion, autobiography survives only in a general imperceptibility, adrift in a sea of uncertainty and questioning in almost every sentence and image.

The film's true perversity, however, lies in producing *the effect of truth through fiction*. The height of this perversity appears most clearly in the last shot, the one where we do not see the image being discussed (like the Winter Garden photo in Roland Barthes's *Camera Lucida*). In this sequence, Frampton gives free reign to his equivocating impulse, claiming "I must confess that I have largely given up still photography," though he obviously has not. He then invents—we think—a whole story of a photograph he botched because the subject was hidden by a truck just when the shot was being snapped. Later, in the darkroom, through progressive enlargements (*Blow Up* strikes again), he discovers *something* reflected in the truck's rearview mirror, which itself contains the reflection of a window. The grain of the photograph renders this "small detail" unrecognizable, but the "something" fills him with such terrible, unbearable fright "that I think I shall never dare to make another photograph again." *Nostalgia* ends with these words about a photograph that is terrifying because it is invisible, therefore mental—*the last picture* in an autobiography made truer than life by its perverse falseness. The film seems to say, "Here it is! Look at it! Do you see what I see?" The truth in autobiography as Frampton practiced it lies in the act of these partial truths and half-lies.

Faced with Frampton's apparatus, how can we not conclude with a last model of the unconscious—the famous concept of the "screen memory" that Freud perfected in 1899 shortly before *The Interpretation of Dreams* was published. Freud describes a psychic apparatus similar to the workings of the dream, making use of memory, transfer, and repression simultaneously. A screen memory? Here it is the display of a transferred memory, a nominal picture, which in appearance is simple and obvious. The memory is certainly present, but it takes the place of an absent, buried, and repressed other in a reciprocal game of one standing for the other. To return to the memory's abstract pathways, it is necessary to lift the veil that hides, to leave the eye behind, for it is always too blind. In the words of Jean Guerreschi, "[Photographic] [n]egatives are memories that bring us back to the plane of separation between the eye and the memory" (73).

As for photographs, don't believe everything you see. Know how not to see what is shown (and what hides itself). Know how to see beyond, through, and beside them. Look for the negative in the positive and the latent image at the heart of the negative. Move from the consciousness of the picture to the unconscious of the thought. Retrace once again the endless path of the psycho-photographic apparatus, from the eye to memory, from appearances to the unrepresentable. Cut through the layers and strata like an archaeologist. A photograph is only a surface, lacking in depth, but burdened with fantastic weight. A photograph always hides another, at least one, either below, behind or around it. A matter of screens: this is where the fiction in all autobiography begins.

NOTES

1. For photography, see *L'Acte photographique et autres essais*. For video, see *La Vidéo de création* and *Vidéo et écriture*.

2. For treatment of relations between cinema and video, see for example my essays "Cinéma et vidéo: interpénétrations" and "La Vidéo pense." For work on relations between photo and cinema, see my article "Les Métissages d'images." See also Bellour, *L'Entre-Images*.

3. Currently I am writing such a book, to be entitled *Le Cinéma suspendu et la photographie tremblée*, forthcoming from the publishing house Jacqueline Chambon (Nîmes) in a new collection called "Penser la photographie."

4. See Bruss, "Eye for I"; Lejeune, *Je est un autre, Moi aussi*, and "Cinéma et autobiographie"; and Bellour, "Autoportraits." Various conferences also resulted in publications: that of the Université Libre in Brussels in 1986, catalog edited by Adolphe Nysenholc, "L'Ecriture du Je au cinéma," in *Revue belge du Cinéma* 19 (1987); that of Valence (France) in the catalog *Lettres, Confessions, Journaux intimes*, edited by Francoise Calvez and Dominique Paini in 1984; and the catalog of *Le Mois de la Photo de Montréal* in 1992 (which took autobiography as its theme), edited by Nicole Gringras.

5. Translator's note: In French film theory, the word *dispositif* is most commonly used to mean "apparatus"—both the technology and machines of cinema and the psychic system of spectatorship that is produced by the machinery and the film system. The term also means system, structure, and device. In this paper, Dubois is using *dispositif* to mean something that borrows on all of these meanings, though "system" is perhaps closest to what he means most of the time. Still, I have chosen "apparatus" because Dubois is quite concerned with the psychic implications of the theoretical use of the term, and with the ways in which literal machines are used in relation to the psychic systems of the films. Most importantly, however, this is also the sense most familiar to English readers since Jean-Louis Baudry's essay on *Le Dispositif* was first translated as "The Apparatus."

6. See Freud, *Civilization* and *Delirium*. The photographic metaphor—that of the camera as well as that of the chemical process of development of negatives and positives—comes up several times in Freud's texts as a figure of the functioning of the psychic apparatus. See in particular *The Interpretation of Dreams*, chapter 7, "Notes on the Unconscious in Psychoanalysis," and *Introduction to Psychoanalysis*.

7. On a happier note, Frank has just produced a new work for French Channel Seven, a one-hour shot-sequence in Super-8 video entitled *C'est vrai*. The film is coauthored by "Robert Frank *and his son*."

8. Translator's note: I have translated the two Benjamin quotes directly from the French edition of *Illuminations*. For Benjamin's ideas on aura and distance see "Work of Art" 222–24.

WORKS CITED

Barthes, Roland. *Camera Lucida: Reflections on Photography*. Trans. Richard Howard. New York: Hill, 1981.

Baudry, Jean-Louis. "The Apparatus." Trans. Jean Andrews and Bertrand Augst. *Camera Obscura* 1 (1976): 104–26.

Bellour, Raymond. "Autoportraits." *Communications* 48 (1988): 327–87.

————. *L'Entre-Images: Photo, Cinéma, Vidéo*. Paris: La Différence, 1990.

Benjamin, Walter. "A Short History of Photography." Trans. Stanley Mitchell. *Screen* 13 (1972): 5–27.

————. "The Work of Art in the Age of Mechanical Reproduction." *Illuminations*. Trans. Harry Zohn. New York: Schocken, 1969. 219–53.

Bruss, Elizabeth. "Eye for I." *Autobiography: Essays Theoretical and Critical*. Ed. James Olney. Princeton: Princeton UP, 1980. 296–320.

Cicero. *De Oratore*. Paris: Les Belles Lettres, 1965.

Deleuze, Gilles. *Le Pli*. Paris: Minuit, 1987.

Depardon, Raymond, dir. *Les Années-déclic*. 1983.

Dubois, Philippe. *L'Acte photographique et autres essais*. Paris: Nathan, 1983. Expanded edition, 1990.

————. "Les Métissages d'images (Europe 1970–1990)." *La Recherche photographique* 13 (1992): 24–35.

————. *Vidéo et écriture électronique*. Paris: Nathan, forthcoming.

————. "Video Thinks What Cinema Creates." *Jean-Luc Godard: Son + Image 1974–1991*. Ed. Raymond Bellour with Mary Lea Bandy. New York: Museum of Modern Art, 1992. 169–85.

Dubois, Philippe, and Marc-Emmanuel Mélon. *La vidéo de création en Belgique*. Paris: Musée d'Arte Moderne de la Ville de Paris, 1990.

Dubois, Philippe, Marc-Emmanuel Mélon, and Colette Dubois. "Cinéma et vidéo: interpénétrations." *Communications* 48 (1980): 267–321.

Frampton, Hollis. Interview. By Scott MacDonald. *Film Culture* 67–68–69 (1970): 158–80.

————, dir. *Nostalgia*. 1971.

Frank, Robert. *The Lines of My Hands*. New York: Pantheon, 1989.

————, dir. *Conversations in Vermont*. New Yorker Films. 1969.

————. *Home Improvements*. 1984–85.

————. *Life Dances On . . .* American Federation of Arts. 1980.

Freud, Sigmund. *Malaise dans la civilisation (Civilization and Its Discontents)*. Paris: PUF, 1971.

————. *Delusions and Dreams in Jensen's* Gradiva. Vol. 9 of *The Standard Edition of the Complete Psychological Works of Sigmund Freud*. Trans. and ed. James Strachey. London: Hogarth, 1953. 7–93.

————. *A General Introduction to Psychoanalysis*. Trans. Joan Riviere. Garden City, NY: Garden City, 1943.

————. *The Interpretation of Dreams*. Trans. A. A. Brill. New York: Modern Library, 1950.

————. "Note sur l'inconscient en psychoanalyse" ("A Note on the Unconscious in Psychoanalysis"). *Metapsychologie*. Paris: Gallimard, 1972.

Guerreschi, Jean. "Territoire psychique, territoire photographique." *Les Cahiers de la Photographie* 14 (1984): 64–67.

Lejeune, Philippe. "Cinéma et autobiographie: problème de vocabulaire." *Revue belge du cinéma* 19 (1987): 7–12.

————. *Je est un autre*. Paris: Seuil, 1980.

————. *Moi aussi*. Paris: Seuil, 1986.

Marker, Chris, dir. *Le Fond de l'air est rouge*. 1977.

————. *La Jetée*. CRM/McGraw-Hill Films. 1962.

————. *Letter from Siberia*. New Yorker Films. 1958.

————. *Si j'avais quatre dromadaires*. 1966.

Quintilian. *Institutio oratorio*. Trans. H. E. Butler. 4 vols. Cambridge: Harvard UP; London: Heinemann, 1920–22.

Varda, Agnès, dir. *Ulysses*. 1982.

Yates, Frances A. *L'Art de la mémoire*. Paris: Gallimard, 1975.

8

An Empirical Avant-Garde
Laleen Jayamanne and Tracey Moffatt
Patricia Mellencamp

A DETOUR: THE ROMANTIC AVANT-GARDE

WHAT WERE ONCE fierce binarisms for 1960s and 1970s North American, European, and Australian avant-garde filmmakers have now become choices and tactics. For an earlier avant-garde, invested in heroic visions, quests, and ontologies, there were only irrecoverable oppositions: still photography versus moving images, art versus mass culture, narrative versus formalism, and silence versus sound. This was a Cold War logic of duality.

The glory days of what I will call the romantic avant-garde began in the 1960s and flourished into the early 1980s. From the beginning, these "visionary" filmmakers were inspired by film history, particularly silent cinema—Brakhage and Méliès, Anger and *Hollywood Babylon*. The 1970s set the intellectual agenda. "Structuralist" films dissected the ontology of still photography and cinema—modern theories of vision resonant with turn-of-the-century Continental debates. Film became theory *and* art.

In addition to philosophies of ontology and perception, there was a wider intellectual context for this work. André Bazin's essays on film and photography had been published in translation in 1967 and 1971. Susan Sontag published *On Photography* in 1973, one year after John Berger's *Ways of Seeing*. Both Berger and Sontag linked still images—especially publicity images—with anxiety. Sontag called for narrative: "Only that which narrates can make us understand" (123). Her metaphor for consumption was one of addiction: "citizens become image-junkies" (24).

However, for Sontag and many intellectuals, photography's worst offense was sentimentality. The past becomes "tender regard, disarming historical judgements" (71). Consumption (not then consumerism, an activist movement led by Ralph Nader), and perhaps popular culture, were bad things, aided and abetted by photographs which replace, then produce, the real. For Sontag, photography was tainted by emotion, commercial culture, and reproducibility—in short, by unreality. No

wonder she never mentions gender—for other intellectuals of that period, these negative traits were, for some strange reason, "feminine" attributes.

While still photography was important to U.S. avant-garde filmmakers from the mid-1960s on—for example, Hollis Frampton and Michael Snow worked as still photographers—ontological rigor mattered. For Ken Jacobs in *Tom, Tom, the Piper's Son*, stop framing is used to halt the story, to abstract the characters, to freeze time in history, to countermand emotion. The effect is a tour de force of studiousness. In *Nostalgia*, the biography of art that is told over burning still photographs prevents identification and derails memory, even of the images. This use of still photography in moving pictures involved what Eisenstein called "contrasts, juxtapositions," resulting in "contemplative dissection," perceptual activity which avoids emotion. The purist ontology, actually a duality, revealed what we all called "the cinematic apparatus," which included a thinking spectator. It also repudiated not only Eisenstein's valuation of emotion, of affective logic, but also the centrality he granted to vertical montage—the play *between* sound and image (which does exist, out of sync, in *Nostalgia*).

The "apparatus" and an aesthetics of distantiation called bliss or boredom by Barthes and paralysis or agitation by Lyotard took over film theory. For the romantic (male) avant-garde, identification was denied, story defused, and affect minimalized. All affect was concentrated in the crazy, heroic quest for art—the Harold Bloom psychoanalytic syndrome. Effect (not affect) existed in the form, and it was cool, intellectual, distanced, single-minded. Eisenstein's later writing, which emphasized emotion, was divorced from his early theories and seen as a political compromise.[1] The formal aesthetics that we believed could change the world were strictly rational and, like abstract expressionist painting versus figuration, an ethics of duality. In retrospect, and despite Brakhage's claims to the contrary, the romantic avant-garde saw life and art as distinct. One had to do with personal experience and emotions, the other with thought and intellect. Life came after the film, at the party.

THE EMPIRICAL AVANT-GARDE

> Empiricists are not theoreticians, they are
> experimenters: they never interpret.
> —Deleuze and Parnet

What I am calling the empirical avant-garde of the 1980s and 1990s was interested neither in ontology nor in first principles. Logics of purity and origin excluded these artists, or were used violently against them. While the empirical avant-gardists speak to history, it is with the wary skepticism of those whose stories have been eradicated or forgotten. As Laleen Jayamanne notes, we must prevent "the erasure of memory and of our capacity to remember" ("Love Me Tender"). Thus,

rather than history (or anthropology), these works of memory—real and imagined, factual and fictional, experiential and experimental—sketch what Deleuze calls a "geography of relations." This "geography" can recall what has been ignored or gone unrecorded, fashioning what Deleuze calls a "logic of the non-preexistent": "Future and past don't have much meaning, what counts is the present-becoming" (23).

The empirical avant-garde destabilizes history through the experimental, granting women the authority of the experiential (which includes both knowledge and memory). The focus is on *becoming*, on *relations*, on what happens *between* experience and thought, between "sensations and ideas," between sound and image, between cultures, between women. This is a logic and an aesthetics of "and," of connections, of actions. Becomings, according to Deleuze, "are acts which can only be contained in a life and expressed in a style" (3).

WHY SERGEI EISENSTEIN AND GILLES DELEUZE?

There are three obvious ways to approach independent films by transnational women of color—through theoretical analyses of "third cinema" and concepts of the postcolonial (for example, Teshome Gabriel, Clyde Taylor, Gayatri Spivak, Benita Parry); through the representation of race (for example, bell hooks, Michele Wallace); and through feminist film theory—my personal vantage point which takes certain avant-garde films as theory.

The reasons I chose the eclecticism of avant-garde/feminism, Gilles Deleuze, and Sergei Eisenstein to illuminate radically different films made in Australia by extremely diverse women of color (an Aboriginal-Australian and a Sri Lankan-Australian) need some explanation. First the obvious. Deleuze and Eisenstein are *film* theorists who have influenced Moffatt, Jayamanne, and me. Although our histories and contexts are radically different, women have transnational film theory in common. The international history of film belongs to women filmmakers and feminist critics, white and of color, just as much as to men, white and of color.

Now the more complex, polemical reasons. Just as Eisenstein is central to Deleuze's theory of cinema and affect, so are Eisenstein's arguments embedded in contemporary precepts of "third cinema" (a body of thought which will benefit from concepts of Deleuze and Guattari). And just as the issues of women and race concern Deleuze and Guattari, recent critiques of "third cinema" have paralleled or been influenced by feminism, although this is rarely acknowledged. For example, the writing of Teshome Gabriel, Homi Bhabha, Clyde Taylor, Manthia Diawara, and Geeta Kapur, along with other critics of the postcolonial and the post-aesthetic, are asking comparable questions and using the same theoretical models (particularly Mikhail Bakhtin and Michel Foucault) as did feminist film theorists from the mid-1970s on. While I have learned much about specific films and histo-

ries from "third cinema" analyses, the theoretical principles are derived from primarily Western critics.[2]

Invoking Foucault's history and Bakhtin's social theory of hybridity and heteroglossia, Bhabha advocates a space of hybridity—"the construction of a political object that is new, neither the one nor the Other . . . a sign that history is happening, a tactic of negotiation rather than negation."[3] "This negotiation of contradictory and antagonistic instances . . . opens up hybrid sites and . . . destroys those familiar polarities between knowledge and its objects" (118).[4] Bhabha's "contradictory," "ambivalent" space of enunciation is what Jayamanne calls the "space of contamination." *A Song of Ceylon*'s "economy is post-colonial in the sense that is enamored of corruption, contamination, hybridisation" ("Speaking" 162).

That Bakhtin's culture, then the Soviet Union, was hybrid, culturally and racially diverse, a collection of republics spanning Eastern and Western traditions, makes the application of his ideas (drawn from literature) to film pertinent and logical. An even stronger case can be made for Sergei Eisenstein, a Russian *film* theorist whose thought was inflected by Eastern culture along with Western cinema. Eisenstein's analysis of the political differences between techniques of U.S. and Soviet montage is in the same spirit as Teshome Gabriel's list of film techniques particular to third cinema, a taxonomy also indebted to André Bazin's analysis of the techniques of "spatial realism." Long takes capturing the rhythm of life, crosscutting for simultaneity not suspense, close-ups not used for individual psychology, panning shots for integrity of space, the concept of silence, and the concept of the hero are the hallmarks of "third cinema style."

Like 1970s British film theorists, Gabriel argues for the importance of popular memory, "the oral historiography of the Third World" (54), and folklore (an argument comparable to the Frankfurt School's distinction between folk and mass culture) which comes from "people's primary relation to the land and community" (54). I suspect that Moffatt and Jayamanne would second Geeta Kapur's caution against authenticity or the "glorification of the folk." Rather than the folk and the land, Kapur argues that the third cinema is about "self-representation, about the articulation of the colonised individual . . . into history" (179).

Unfortunately, there has been a divide between those who write about race and the third world and those who write about women and the first world. Many third cinema critics overlook women. When read through feminism, as Jayamanne does, these theorists are radically revised and claimed for/by women. In fact, Moffatt and Jayamanne's work supersedes current theory, including feminist film theory, by fashioning new models of history, politics, and subjectivity for transnational women of color and white women. For me, their films *are* central theoretical constructs that outrun any application *of* theory.

Many of the arguments about third cinema, race, and nation resonate in the personal remarks of Jayamanne and Moffatt. However vernacular and chatty, this is sophisticated theory. For example, Moffatt's "I may be black but I have the right

to be avant-garde" speaks volumes about the prejudicial linkage between documentary realism and the representation of blacks. It is also a serious critique of the white, middle-class maleness of avant-garde cinema. "I don't believe in talking down to aboriginals" speaks to the unstated racism of the belief that the avant-garde is too difficult for ordinary folks. *Theory* has been taken into these women's lives and comes out in their films as politics and aesthetics.[5] I repeat: the history of film theory, like film history, belongs to women, white and of color, as much as to men, white and of color.

I have placed this feminist work in tandem with Deleuze for several *specific* reasons: The first is contextual. Deleuze (and Guattari) rather than Freudian psychoanalysis has been central for postmodern Australian feminism. The second is rhetorical. Deleuzian thought, which critiques Freudian psychoanalysis, is not a binary logic; rather, it argues for a third term, a logic akin to Eisenstein which can invent subjectivities where none existed, a logic that moves away from Cartesian cause-effect linearity, erasing opposition between art and popular culture, mind and body, intellect and emotion (or thought and feeling), the seen and the unseen, and even the past and the present. The third is logical: Deleuze's cultural object is cinema. Like Eisenstein, who for me is the key to Deleuze, cinema *is* modern thought. However, by reading Deleuze and Eisenstein *through* Moffatt and Jayamanne's films and comments, their theories are revised by and reclaimed for feminism.

Since the mid-1980s, Australian feminists have taken issue with the limits of U.S./British feminist film theory, weary of its relentless focus on sexual difference and psychoanalysis.[6] Jayamanne calls this "subservience to theory" a "failure of the imagination" which refuses to "let films surprise and unsettle the feminist doxas of film theory . . . a limited number of theoretical propositions are plastered on to a variety of texts coming up with more of the same" ("Speaking" 153). She made *A Song of Ceylon* "in a context of thorough dissatisfaction with this state of affairs" (153). This earlier film, like Moffatt's work, *is* postcolonial theory and a revision of feminism, of the most sophisticated, moving kind. Regarding affect, feminist film theory has an extremely limited model. Pleasure (or desire) is the only rubric, a catchword which has become almost meaningless. Thus, I look to Eisenstein and Deleuze for an initial theory of affect, a model which includes sound along with vision, and to Australian women for a feminist context which considers race.

Cinema 1, the Movement-Image is a revival of Eisenstein's thought as much as Bergson's. Not surprisingly, Deleuze relishes in Eisenstein what had been earlier repudiated—the central place of affect and the body, his love of popular culture, and his wild eclecticism. Eisenstein's is indeed a theory of "and," of cultural connections, of political "becomings," which draws on a vast array of artifacts, ranging from John Ford's *Young Mr. Lincoln* to linguistic theories of inner speech. Thus, his "rhizomatic" bent can suit many interpretations. The line of flight I will trace from Laleen Jayamanne, Tracey Moffatt, then on to Eisenstein and Deleuze, from the

U.S. to Australia and then to France, and back again—has a common, influential thread in U.S. popular culture, and particularly its cinema. But Meaghan Morris is the central connection. I am indebted to her friendship.

What Adrian Martin says of Australian independent film applies in equal measure to Eisenstein. Martin celebrates a "cinephiliac" aesthetic—which "gleefully admits that every film takes its context and meaning from . . . other films. . . . Cinephile films do not presume to show real life; rather they head straight for the mediations of this life experience . . . contained in the popular cultural well of cinematic images and fictions" (98). Although eclectic, this aesthetic is not pop or postmodern. It is brilliantly formal. Martin again echoes Eisenstein: "form can move content through a whole series of complex attitudes and contradictory positions" (98), not the least of which is the struggle between mother and daughter, in tandem with the tragedies of colonial history.

Both Moffatt and Jayamanne—rigorous formalists—have been deeply influenced by the history of cinema, including Hollywood movies. As Moffatt explains: "I learned to make films by watching them. A childhood spent glued to the television, then a diet of very commercial cinema through to avant-garde films." *Mary Poppins*, she adds, had "very high production qualities, quite artificial and cartoon like. I remember *Mary Poppins* (because Daphne, my real Mother took us out to see it). There were the B-grade Hollywood Biblical epics—Anglo-Saxon actors wearing lots of eyeliner and darkish pancake makeup to look 'middle-Eastern.' The sets were minimal and lighting hard, very stagy. I'd stare at these images for hours. I don't know why I liked them."[7] These images are refracted in the mise-en-scène, the affective geography, of *Night Cries*: Hollywood and the 1950s read through the paintings of the Aboriginal painter Albert Namatjira. As Moffatt says, "Whatever sort of film it is, whatever it's about, it's show biz" (McNeil 14).

For Jayamanne, the highly stylized, excessive melodramas of Sri Lankan cinema—completely amazing films which make Douglas Sirk look like Emile Zola—have been influential, along with performance art. The specific movies their work recalls, *Vertigo* for Jayamanne, and *Jedda* for Moffatt, are fifties technicolor features—rather than forties Hollywood films which influenced first-generation film feminists, or the early 1900s cinema which influenced the romantic avant-garde. Both *Jedda* and *Vertigo* portray male desire as an obsession that is deadly for women. These films (and their feminist psychoanalytic interpretations) are revised to focus on women and history rather than male subjectivity and sex, the focus of much feminist film theory. Lesley Stern has urged feminist theory to look at "what's happening in other spaces—photography, theater, dance, performance," and to rethink what she calls "the genre of feminist criticism" (296).

In this tradition of Australian independent film, the energy lies in the "impulse to incorporate—in however dislocated or perverse a way—vivid fragments of the cultural environment—TV, music, cinema" (Martin 98). Unlike "decon-

struction," this tradition is "less overt critique and more emotional" (Martin 98). For me, the key is "more emotional." The filmmakers I will discuss use the affective quality of photography—of composition and the close-up—to make intellectual arguments. Jayamanne, a Sri Lankan film writer working in Sydney, begins from family photographs and Hollywood film stills—to which she adds performance, dance, theater. Moffatt, an Aboriginal Australian, is a still photographer, well known for her serial installations, which are influenced by movies. Every frame of her films is a composition, a portrait, a still life.

For these filmmakers, still photographs lead to sound, to story, and comprise an affective logic. Instead of "contemplative dissection," they aim for "emotional fusion." These films exist in the intersections between sound and image, history and experience, art and life. Their affect and their intellect emerge from the relations among women. Rather than a logic of ontology or duality, they operate according to what Deleuze calls the "Anomalous"[8] and Jayamanne calls the hybrid, a tactic of assimilation. This tactic, of course, is political—these are films by women of color.

JAYAMANNE AND MOFFATT

Jayamanne and Moffatt each live simultaneously in at least two cultures that are industrially and technologically divergent. If time is measured by industrial development (as it is in linear histories of progress), they live in two time periods. They remember, speak from within, colonial experiences which are vastly dissimilar—Sri Lanka (Ceylon) and Aboriginal Australia.

However, these women have no illusions about lost grandeur or the good old days. Jayamanne has no patience with nostalgic theories of pristine, colonial others, no sentimentality about lost origins. She tells a story about returning to her parents' grave in a Sri Lankan fishing village. Although they were middle class and therefore had a gravestone, it had vanished. No matter, she had a photograph of herself standing beside the grave marker. "I have the photograph, not the real place." Her place of origin, Sri Lanka, is a place of memory tied to "images and sounds" instead of a real place. (Whether memory enhances or diminishes the past is personal. My grandmother's big house of memory was, in reality or the present, an ordinary house.) "I do not see this as impoverishing. . . . I am neither marginalised or in a state of deprivation. . . . I straddle two traditions with a degree of comfort and a tolerable degree of discomfort. I like it" ("Image" 34). Although Jayamanne advocates ambivalence, there is nothing ambivalent about her thought. *Bivalent*, multiple knowledges are more accurate than current theories of difference as lack or ambivalence.

Moffatt is equally matter-of-fact. "My people grew up on an Aboriginal mission outside of Brisbane. . . . I was fostered out to a white family along with my

brother and two sisters. . . . It wasn't against my mother's will" (qtd. in Rutherford 152). "My work may feature brown faces but it could be anybody's story." Moffatt wants to be taken as an artist, not an Aboriginal artist. "Yes I am Aboriginal, but I have the right to be *avant-garde* like any white artist" (qtd. in Murray 21).

Jayamanne's and Moffatt's films return to the compelling, colonial moment, cast as scenes of childhood memory. The past, a question of memory *and* history (which is intimate and emotive), haunts the present of their films like a primal scene. Having said this, I am not thinking of Freud but of something he (and many postmodern women) could never understand—the mutual struggle of women for independence, of mothers and daughters to love *and* to let go, to be together and separate. This lifelong journey, away from and with the mother, is taken into history and into their films, resulting in what Eisenstein would call a "qualitative leap": "A transition from quantity to quality. A transition to opposition" (*Film Form* 173) or to "emotional quality" (*Film Form* 32).

Eisenstein, read through feminism and Deleuze, reverberates in Jayamanne's and Moffatt's work. And this is logical. His is a theory of affect, of emotional intensities, a theory permeated by Eastern *and* Western culture. Colonial subjectivity is hybrid—like separate hieroglyphs fusing into ideograms (*Film Form* 30), or akin to yin-yang, "each carrying within itself the other, each shaped to the other . . . forever opposed, forever united." This "emotional fusion" (*Film Form* 251) is what Deleuze and Guattari call the one in the many, or what Eisenstein calls "unity in diversity," a transcendent, political achievement.

REHEARSING

Jayamanne's 1987 film, *Rehearsing*, begins with photographs and film stills (for Jayamanne, poses of ecstasy), recombined with critical texts, stylized performance, and music, then recycled in photo essays and moving pictures. It is a simple Super 8mm experiment which refers back to *A Song of Ceylon* (1985) and anticipates a feature film in the planning stage. The setting is the sparse kitchen of a Sydney flat, a space rendered through details in close-ups. Two men and a woman are sifting through photographs, talking about a story—a film and a life. Jayamanne's voice-over declares her presence, sets the scene, and gives direction. She tells a story about the photograph. It is a melodrama. The godfather who threw himself at the train, his body flung in pieces along the railway tracks, is the young boy in the photo, the brother of the young girl, Jayamanne's grandmother. "This is the man you will talk about who killed himself." Of the story, "it's all possible because of the child," her mother as a baby.

History is private and political. The men discuss Sri Lankan racial politics, colonial disputes. Tamil is the indigenous name of people in southern India and northern Sri Lanka; Singhalese is the majority language and culture of Sri Lanka

(Ceylon). The history between the two factions continues to be bloody. The men briefly rehearse an awkward scene of confrontation—which has homoerotic dimensions. Jayamanne is in charge—until the photographs take over, although the camera keeps passing quickly over them as if it isn't ready to stop and look, not wanting to be nostalgic or sentimental.

The still photograph glimpsed earlier, which becomes the focus of the last section, is of Jayamanne's grandmother, who died in childbirth. She is on her death bier, surrounded by her family. The infant is Jayamanne's mother. We see other photographs of the famous Chilean painter/performer Juan Davila, an exile living in Sydney, who impersonated Kim Novak in *A Song of Ceylon*. This handsome, sweet-looking, gay man paints huge, shocking works about terrorism, death, mutilation, and ecstasy. Davila—a displaced artist and Jayamanne's alter ego—is the main performer in this film.

Rehearsing moves from glance to story, from opera to Louis Armstrong singing "Summertime," from preparation to rehearsal—a film not yet performed, not yet made. The last words on the soundtrack come from the U.S., from the blues: "Your daddy's rich and your mamma's good looking. . . . One of these mornings, you're gonna rise up singing, you'll spread your wings," which is what the feature, a "becoming," is about.

John Berger's valuable distinction between private and public photography—developed in a dialogue with Sontag's work—suggests something of the simple richness of this film. The private photograph preserves context and continuity while the public photograph is "torn from context," a "dead object" lending "itself to any arbitrary use" (56). For Berger, like Bazin, photographs are relics, traces of what happened. To become part of the past, part of making history, they "require a living context." This memory "would encompass an image of the past, however tragic . . . within its own continuity."[9]

Photography then becomes "the prophecy of a human memory yet to be socially and politically achieved" (57). The hint of the story to come "replaces the photograph in time—not its own original time for that is impossible—but in narrative time. Narrated time becomes historic time" which respects memory (Berger 61–62). The film begins from something remembered—as Freud says, "every affect is only a reminiscence of an event"—and then begins to construct what Berger calls "a radial system" around the photograph in "terms which are simultaneously personal, political, economic, dramatic, everyday, and historic" (63).

Jayamanne calls the photo a "maternal tableau" which has been

generative for me. I have used it since 1979, first in an obsessively biographical mode . . . but I've moved out of that and am able to fictionalize it. Juan found the image fascinating because of the virtual space, that empty space running from the dead woman's face. The baby is my ma—her mother died at 18 in childbirth. During *Rehearsing*, I saw the young boy for the first time. I saw him only through

Fig. 1. Laleen Jayamanne. Still from *Rehearsing* (1987).

the Super 8mm camera. When I am stuck, that image seems to help me to move on. So it's not a primal scene in the Freudian sense. I dream of using it in the 35mm film in Sri Lanka. Photos or magical appearances that come to life to complicate the plot is standard stuff of our family melodramas.[10]

As Judith Mayne's last chapter of *Woman at the Keyhole* illustrates, Jayamanne is her own best critic. In the interview Mayne cites, Jayamanne says that one of her projects is to "confuse" gender identity. In *A Song of Ceylon*, Davila impersonated an image of Kim Novak taken from stills of *Vertigo*. A shot of Davila as Kim is on the cover of Mayne's book. Did Mayne know this was a man disguised as a woman? There is a line in *A Song of Ceylon* which is also the title of the interview: "Do You Think I Am a Woman, Ha! Do You?" Mayne must have known. Jayamanne's photo essay, "Passive Competence," using audio text from *Rehearsing*, documents Davila's makeover, including this photograph, a pose of ecstasy and sacrifice.

Jayamanne wanted to make a synthetic man as Kuleshov had made a nonexistent woman. "The montage of these body fragments, he said, created the image of a woman who had no existence outside the image" (Jayamanne, "Passive" 119). By creating an imaginary man, Jayamanne wanted to make woman strange and unfamiliar. For her, producing "ambivalent" representations of bodies was a better tactic than the feminist obsession with female sexuality. "Let us see the famous bisexuality thesis spread a bit more evenly so that the nonexistent men will also be

Fig. 2. Laleen Jayamanne. Still from *Rehearsing* (1987).

able to share in the pleasures and burdens of bisexuality." Taking Kuleshov into transvestism and Deleuze into drag is no small leap for feminism.[11]

Jayamanne's larger project is to represent cultures undergoing transformations—the economic collision of the plantation economy and international trade in Ceylon which is now Sri Lanka. Her Deleuzian metaphor is "the body under duress," "the body neither here nor there," a body which, for her, "did not exist before the technology of cinema" ("Do You Think" 50–51). As Deleuze says, "Bodies are not defined by their genus or species ... but by what they can do, by the affects of which they are capable" (Deleuze and Parnet 60). Jayamanne's film bodies are renderings of classic postures and gestures of Western cinema, in spaces haunted by the history of vanishing cultures.

Jayamanne's theoretical comments also describe Moffatt's work—the tactic of "postcolonial hybridization," despite what she calls the "efforts of chauvinistic forms of nationalisms to erase such heterogeneity and regress into some mythical ideal of pure identity, whether of nation or gender. We have seen the bloody aspect of this in the history of Sri Lanka in the last decade" ("Do You Think" 55). Jayamanne and Moffatt "use the messy inheritance that is exacerbated by the in-

troduction of electronic media into postcolonial societies" (57). With cinema, one cannot work with the "pristinely national" any longer.

NICE COLORED GIRLS

Moffatt's films are a politics and an aesthetics of assimilation—a "matter of method and also of survival.... Survival not in a cultural ghetto but in the market as well as in the domains of cultural visibility and legitimacy" (Jayamanne, "Love Me Tender" 4). Hybridization/assimilation is history which is neither pristinely indigenous nor completely other.

Although much history is not recorded in print or film, particularly in indigenous cultures, it cannot be erased. For Moffatt, history comes back to haunt us. Like age, we carry our history, our forebears, on our face, their spirits indelibly imprinted in our memory. History can be reincarnated, recollected, its spirit given new life as living memory. This is history of recognition. And this is the history told by her films *Nice Colored Girls* and *Night Cries: A Rural Tragedy*. This history of presence is inhabited by the filmmakers; their lives are spiritually connected to their forebears—as if they know and love them. This is what Eisenstein would call ecstatic history, a history of pathos. It also resembles Walter Benjamin's Messianic time, a time of upheaval, of change.

Nice Colored Girls is a story of two Aboriginal young women who get a middle-aged, white man drunk and then gleefully steal his wallet. This contemporary scene of nightclubs and restaurants (actually, painted sets) is disrupted by history, made strange through images from the past. Aboriginal paintings cover the walls, the camera dollies past the set, the color of the image fades, and an Aboriginal woman looks at us from the past, centuries ago. The present is permeated *and* sanctioned by the past—the 1780s exploitation of Aboriginal women by white men is reversed in the 1980s. History speaks in several ways in this film: assault on the image and on representation is an attack on the doggedness of colonial history— like the Terminator, it won't die. The historical image is sprayed with black paint, the glass is smashed with a rock, and finally the wall on which it hangs crashes over. Revising the history of representation takes years of direct assault.

The founding legend of Australia, the landing at Sydney Harbor, or conversely, the white invasion, is told in voice-overs taken from diaries of explorers, one of whom is William Bradley, who wrote in 1788. The colonizers resemble ethnographers: "Indigenous women were viewed by the colonisers as inferior but challenging, or as exotic victims.... In the guise of ethnographic study, relations between 'explorers' and 'researchers' and Indigenous women were coveted and prized," becoming "the basis of thought" during colonization (Sidney 28). The founding story becomes the backdrop, the performance scene, for telling the tale from another point of view, one that was not recorded in print.

This story is performed by Aboriginal women, in the present, on the streets

Fig. 3. Tracey Moffatt. Still from *Nice Colored Girls* (1987).

and bars of King's Cross in Sydney and as avant-garde performance in front of the historical image. The "exploited/exploiter, predator/prey" dyad is thereby inverted (McNeil 2). Moffatt undercuts and remakes colonial history through an intellectual, vertical montage that also revises Eisenstein. Sounds of water are cut into Sydney streets; the historical, the indigenous, is always there.

The point of view of adolescent Aboriginal women reminded me of this brief footnote in Freud: "Childhood memories are only consolidated at a later period, usually at the age of puberty . . . this involves a complicated process of remodeling, analogous in every way to the process by which a nation constructs legends about its early history" (*SE* 10:206n1). The gleeful, wicked girls of the film who go to King's Cross, pick up a captain (the Aboriginal term for "sugar daddy"), and roll him caused an upset within the Aboriginal community. Their vengeance is autobiographical. As Moffatt explains, "I used to do it, I used to do it with my sisters . . . we're not little angels." Moffatt is a member of a "generation that feels comfortable in talking about Aboriginal society" (Rutherford 152).

Just as Moffatt breaks the painting's frame, so the fourth wall of the studio is broken. Space is not empty but full of meanings—particularly the black space of the frame in *Night Cries*. Like Aboriginal landmarks we cannot see, space is filled with history, haunted by sound. It is the space out of which a forgotten figure from the fifties, Jimmy Little, can emerge, and recede back into. It is a space of becom-

ing, a space in-between. For Moffatt, history is an empty canvas of light, full of forgotten actors, a cast waiting to be remembered, recollected, assembled. Like Eisenstein, Moffatt "composes for the frame, even making *Night Cries* look like a painting." "I wanted it to be my big canvas" (McNeil 2). The frame resembles what Eisenstein called "The Dynamic Square."

Form and story are equivalent in value, and include the collision between sound and image, the formal work on the minimalist soundtrack. As Moffatt puts it: "It's not enough to just be black and a filmmaker and right on, you have to be responsible for exploring film form at the same time" (McNeil 2)—not to reveal the "apparatus" but to invoke memory, to configure the past with a logic "of the non-preexistent." Like Jayamanne's critique of anthropology, Moffatt reacts against ethnography, the realist tradition of representing black Australia—"It's black, we can't experiment with form . . . it was always a gritty, realist approach representing black lives" (McNeil 2). "I don't believe in talking down to Aboriginal people" (Rutherford 153). Moffatt says, "I am not concerned with verisimilitude. . . . I am not concerned with capturing reality, I'm concerned with creating it myself" (Rutherford 155).

For women of color, the history of representation, a geography of women's lives, is being made. By inscribing what has been there but not visible to everyone, by telling the tale from the point of view of women, the landscape changes. The struggle is complicated by mixed race and age in Moffatt's later, extraordinary film *Night Cries: A Rural Tragedy*. The images of the old, dying, withered, unseeing white mother, enduring pain and facing death, and the voluptuous, middle-aged Aboriginal daughter—in a dry, orange, saturated desert mise-en-scène—are intercut with scenes of childhood memory on the beach, when both were young. The affect is high (experimental) pathos—the experiential crashes into the historical, painting and photography meet.

NIGHT CRIES: A RURAL TRAGEDY

For U.S. audiences of *Night Cries*, cultural knowledge, although not essential, benefits reception. Australia's racial policy was the inverse of that in the U.S.; it was a policy of assimilation which took Aboriginal children away from their parents and gave them to white foster parents. The race would thus be absorbed by intermarriage. This is the opposite of the miscegenation of the U.S. The intent and the effects of both are horrifying.

The 1955 Australian feature *Jedda* was a big, technicolor, cinemascope film directed by Charles Chauvel in an attempt to emulate an American Western with Aborigines. Of this film, Moffatt says, "It is very American, very *Bonanza* . . . I decided to recreate the set in a film." *Night Cries*, however, is concerned with *Jedda's* prologue, the brief relationship in the ranch home between Jedda, the Aboriginal daughter, and her white foster mother. For Chauvel, this scene is only a prologue,

Fig. 4. Tracey Moffatt, Alkira Fitzgerald, and Liz Gentle on location during the filming of Moffatt's *Night Cries* (1989).

a prelude to the capture, chase, and death of Jedda. For Chauvel, Jedda's relationship with men determines her life, her identity. For Moffatt, the mother is the central figure in women's history: "I took two of the film's characters, Jedda, the black woman, and her white mother, and aged them as if thirty years had passed. In the original film, Jedda is thrown off a cliff and killed. I wanted to resurrect her" (qtd. in Murray 22). The actress playing Jedda resembles Moffatt remarkably: "but as I developed the script, the film became less about them and more about me and my white foster mother. I was raised by an older white woman and the script became quite a personal story. The little girl who appears in some of the flashback sequences looks a lot like me. That was quite intentional" (qtd. in Murray 22).

An aged woman, Old Mother (Elizabeth Gentle), is facing death in a landscape that is almost deserted. Her middle-aged Aboriginal daughter (Marcia Langton) cares for her—wheeling her to the outhouse, feeding her, tenderly then aggressively. The flashbacks of the little girl on the beach with her mother are terrifying. The beautiful child panics when she can't see her mother. With seaweed wrapped around her neck (a vague reference to Deren's *Meshes of the Afternoon*), her sobbing captures all the pain and fear of childhood—of death, of separation. This terror can paralyze us, can haunt us, no matter how much our bodies mature and age. The terror comes from fear of leaving and the horror of staying, of being trapped

Fig. 5. Tracey Moffatt. Still from *Night Cries* (1989).

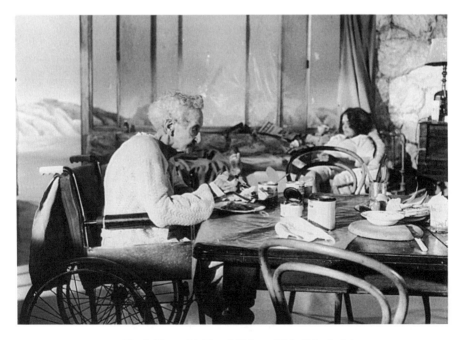

Fig. 6. Tracey Moffatt. Still from *Night Cries* (1989).

enstein calls "an inner synchronization between the tangible picture and the differently perceived sounds" (*Film Sense* 71).

The film's use of close-ups evokes Eisenstein's essay, "Dickens, Griffith, and the Film Today." This 1944 essay—which includes an analysis of the differences between the close-ups of D. W. Griffith and Eisenstein—is a key text of Deleuze's *Cinema 1* and becomes, I think, the basis for Deleuze and Guattari's notion of faciality in *A Thousand Plateaus*, a concept which links face, race, and cinema. There is a close affinity between the notion of faciality and photography.

Eisenstein asserts that "Montage thinking is inseparable from the general content of thinking as a whole" (*Film Form* 234). Moffatt also *thinks* through montage. Her films and her series of photographs embody what Eisenstein calls "an inner unity," not the "outer unity of story" (*Film Form* 235). One key distinction between Hollywood cinema (specifically Griffith's cinema) and Eisensteinian montage revolved around the meaning and the use of the close-up. For Eisenstein, it meant "large scale" rather than nearness or proximity. For the Americans, the close-up signified viewpoint. For Eisenstein, it referred to significance, "to *the value of what is seen*" (238). This explains *how* Moffatt signifies historical scope and why her work elicits such strong responses. We don't just witness history, we *experience* history *as* memory.

The close-up does not "*show* or *present* as to . . . give meaning"; rather, it "creat[es] *a new quality of the whole from a juxtaposition of the separate parts*" (*Film Form* 238), a "qualitative leap" (239), the "montage trope" (240). The shots of the old woman, her gnarled hands, her swollen foot, her unseeing eyes, fashion a montage trope. This is the "secret of the *structure of emotional speech*" (249)—*affective logic*, "inner speech" (250), "sensual thinking" (251). In this film without speech, without dialogue, Moffatt works on a deeply emotive level akin to the affective logic of inner speech.

Eisenstein's distinction between "contemplative dissection" and "emotional fusion" (*Film Form* 251) separates Moffatt's work from the romantic avant-garde. "Contemplative dissection" concerns contrasts, juxtapositions, before and now— what Eisenstein calls "*un-crossed parallelisms.*" "They are united neither by a unity of composition or by the chief element, emotion" (252). "Emotional fusion" involves "some *new quality*" (251). This "qualitative leap" is enabled by feminism. Despite the many interpretations of Eisenstein, this radical possibility has not been noted.

In *Cinema 1, the Movement-Image*, Deleuze theorizes the Affect-image, inflecting Eisenstein with Henri Bergson and Charles Sanders Peirce. For Deleuze, the face is a reflecting surface and a series of intensive micromovements. The face thinks or it feels. The thinking face is compared to an outline (the Griffith close-up), the feeling face, an intensive series of movements (the Eisenstein close-up). For Deleuze, the intensive face expresses a pure Power, the reflexive face expresses pure

Quality. A feature can express the same intensity as a whole face, and parts of the body are as expressive, Deleuze argues. Objects also elicit affect.

The distinction made by Peirce between images of firstness and secondness is interesting here—in the latter case, things exist in relation to something else, which leads to action. For Peirce, firstness is *felt* more than conceived; it "concerns what is new ... fleeting ... eternal" (Deleuze 98). For Deleuze, affects, or quality-powers, can be grasped in two ways: either as actualized in a state of things or as expressed by a face or a proposition. Paraphrasing Peirce, Deleuze writes: "Affection images ... refer to firstness" (99). He talks of a "nudity of the face much greater than that of the body, an inhumanity much greater than that of animals" (99). The "affection-image" is impersonal, radical; it fractures space and history.

The influence of Deleuze on Australian feminists might be more direct than in Britain and the U.S.—at least for now. As Meaghan Morris writes: "In the 1970s, I learned very little from British feminist film theory; I was not interested in psychoanalysis, and so my own work looked instead to Gilles Deleuze and Michel Foucault." For most U.S. and British feminists, even Foucault was endorsed much later, and Deleuze is still held in abeyance or disregard.

Jayamanne describes *Rehearsing* as "a combat of sorts between 2 men & 8 photographs or a rite of passage dramatising homoeroticism's debt to the maternal conceived not simply as the dead mother but also as virtual space" (qtd. in Cantrill 8). These are Deleuzian thoughts. The virtual is akin to thought and opposed to cliché: Sontag's critique of photography and commerce. The virtual image can be banal, but it exists in ways we cannot yet grasp. It leads us to what is concealed from thought. Through "virtual images," cinema can film not the world but our belief in the world. Here Deleuze and Jayamanne overlap. Deleuze calls this a "cinema of the body ... in the sense of bringing about the genesis of an unknown body" (Abbas 187). In his review of *Cinema 1*, Ackbar Abbas argues that Deleuze is particularly astute about how "the effects of colonialism have put whole societies into a state of minority and precipitated a collective identity crisis" (187). People have to be invented, with new stories.

For many Australian women, British/U.S.-based feminist theory, in lockstep with academia, has soured to formulaic careerism, what Jayamanne calls "a rhetoric of validation ... the same set of propositions recycled with snazzy marketable titles ... bereft of all energy ... not to mention political effectiveness" ("Image" 33). As Lesley Stern has said, "There's a kind of generic predictability about the enterprise that has to do with academic disciplines," a "restrictive repertoire" to which she has developed "an abhorrence" (295).

Certain works break this "restrictive repertoire." By remaking history as a becoming, a geography of relations of virtual images and sounds, women are enabling theory to move on. I prefer "unity and diversity" to theories of difference and ambivalence. Through "emotional fusion," the "[m]ontage removes ... contradictions by abolishing ... parallelism in the realms of sound and sight" (*Film Form* 254).

Form—which is intensity, energy—infuses history with the complexity and clarity of experience. In the collision *and* fusion between sound and image, a visual and acoustic space is revealed out of which forgotten figures can emerge and can be heard. Thus, these films, "contained in a life and expressed in a style," are "becomings"—"directions, entries, exits. . . . It is essential that women enter this becoming to get out of their past and their future, their history" (Deleuze and Parnet 2).

NOTES

1. I am thinking particularly of David Bordwell's influential essay, "Eisenstein's Epistemological Shift." Gregory Taylor traces the various ways Eisenstein has been interpreted and used, particularly by Annette Michelson.

2. Along with the disciplinary regime and panoptic gaze of Michel Foucault, Bakhtin's notions of the dialogic, the place of official and unofficial culture, the performative ritual, and the enunciative horizon which includes the audience as an active participant have been central to my model of feminist avant-garde films and video. Not surprisingly, Bakhtin can be read in tandem with Walter Benjamin's "storyteller," and Teshome Gabriel's "folkloric" which returns to the Frankfurt School critics' work on folk culture. Haile Gerima's triad of Community, Storyteller, Activist is uncannily comparable to Benjamin. Deleuze's concept of the "minor" is along the same lines, an analysis which Meaghan Morris has revised through feminist film theory, specifically the life and film criticism of Claire Johnston.

3. 117. Bhabha's model reverberates with Deleuzian thought.

4. Clyde Taylor's term is "popular syncretism" (105). The "post-aesthetic" which is "assimilationist," citing the irony of Julie Dash's *Illusions*, is a shift away from Western aesthetics, away from what he calls the "seductions of aesthetics in favour of liberative strategies." For him "modernism for blacks is hardly over, has in fact hardly begun. Blacks can only dubiously be post-modernists since they were never permitted to be 'modernists' in the first place" (108). Repeating Linda Nochlin's famous question, "Why Have There Been No Great Women Artists," Taylor wonders why in the history of aesthetics have no great non-Western thinkers or artists become centrally important.

Hybridization has been taken up in U.S. debates as well, for example, by Tricia Rose.

5. What has been called "third cinema" argues that a "Black diaspora links these developments internationally." This idea is derived from England, "where black independent practitioners were challenging the old 'race relations' paradigms and experimenting with new forms of (black) representation" (Pines, "Preface" viii). The important films of Isaac Julien and Sankofa which apply avant-garde formal techniques to social issues can be directly compared to Moffatt, and perhaps Jayamanne. Ironically, it is the avant-garde which links the U.S., England, and Australia—all three countries orchestrated cooperatives in a comparable manner.

6. In addition to the conditions of production, there are cultural differences between Australia and the U.S. (the second part of this essay deals with U.S. critics). While the British/Birmingham take on popular culture as a site of resistance is recently catching on within the U.S. around black culture, this is old hat in Australia. British cultural studies proponents—for example, Tony Bennett—have been teaching in Australia for years. And John Fiske taught in Australia before emigrating to the U.S.

7. Correspondence with Moffatt, December 8, 1991, and March 21, 1992.

8. For Deleuze, the Anomalous is "always at the frontier," the "Outsider" (Deleuze and Parnet 42).

9. 57. The essay is dedicated to Susan Sontag. .

10. From correspondence with Jayamanne, December 18, 1991.

11. Jayamanne's approach is much more interesting than Stephen Peirce and Wayne Hensley's recent recreation of Kuleshov's experiments in *Cinema Journal*—which concluded that they were not conducted in a scientific manner and are not accurate.

12. 16. The contributor's note refers to an Ingrid Perry, while the byline is Periz. Whichever, *she is a great critic.*

WORKS CITED

Abbas, Ackbar. Rev. of *Cinema 1, the Movement-Image* and *Cinema 2, the Time-Image* by Gilles Deleuze. *Discourse* 14.3 (1992): 174–87.

Benjamin, Walter. "The Storyteller: Reflections of the Works of Nikolai Leskov." *Illuminations.* Trans. Harry Zohn. New York: Schocken, 1969. 83–110.

Berger, John. "Uses of Photography." *On Looking.* New York: Pantheon, 1980. 56–63.

Bhabha, Homi K. "The Commitment to Theory." Pines and Willemen 111–32.

Bordwell, David. "Eisenstein's Epistemological Shift." Intro. by Ben Brewster. *Screen* 28.4 (1987): 29–46.

Cantrill, Arthur. *Cantrill's Film Notes* 55/56 (1988): 8–15.

Deleuze, Gilles. *Cinema 1, the Movement-Image.* Trans. Hugh Tomlinson and Barbara Habberjam. Minneapolis: U of Minnesota P, 1986.

Deleuze, Gilles, and Félix Guattari. "Year Zero: Faciality." *A Thousand Plateaus: Capitalism and Schizophrenia.* Trans. Brian Massumi. Minneapolis: U of Minnesota P, 1987. 167–91.

Deleuze, Gilles, and Claire Parnet. *Dialogues.* Trans. Hugh Tomlinson and Barbara Habberjam. New York: Columbia UP, 1987.

Eisenstein, Sergei. *Film Form.* Ed. and trans. Jay Leyda. New York: Harcourt, 1949.

———. "Synchronization of Senses." *Film Sense.* Ed. and trans. Jay Leyda. New York: Harcourt, 1942. 69–112.

Freud, Sigmund. *The Standard Edition of the Complete Psychological Works of Sigmund Freud.* Ed. and trans. James Strachey. 24 vols. London: Hogarth, 1955.

Gabriel, Teshome. "Third Cinema as Guardian of Popular Memory: Towards a Third Aesthetic." Pines and Willemen 53–64.

———. "Towards a Critical Theory of Third World Films." Pines and Willemen 30–52.

Jayamanne, Laleen. "Do You Think I Am a Woman, Ha! Do You?" *Discourse* 11.2 (1989): 49–64.

———. "Image in the Heart." *Framework* 36 (1989): 31–41.

———. "Love Me Tender, Love Me True, Never Let Me Go: A Sri Lankan Reading of Tracey Moffatt's *Night Cries: A Rural Tragedy.*" ms.

———. "Passive Competence." *Screen* 28.4 (1987): 107–20.

———. "Speaking of 'Ceylon,' a Clash of Cultures." Pines and Willemen 150–69.

Jedda. Dir. Charles Chauvel. Australia, 1955.

Kapur, Geeta. "Articulating the Self into History: Ritwik Ghatak's *Jukti takko ar gappo.*" Pines and Willemen 179–94.

McNeil, Shane. "Relativity, Roeg, and Radical Forms: An Interview with Tracey Moffatt." *Lip Sync* Aug./Sept. 1991: 1–3, 14.

Martin, Adrian. "Nurturing the Next Wave." *Back of Beyond: Discovering Australian Film and Television*. North Sydney, NSW: Australian Film Commission, 1988. 90–105.

Mayne, Judith. *The Woman at the Keyhole: Feminism and Women's Cinema*. Bloomington: Indiana UP, 1990.

Morris, Meaghan. " 'Too Soon Too Late': Reading Claire Johnston." ms.

Murray, Scott. "Tracey Moffatt." *Cinema Papers* 79 (1990): 19–22.

Nice Colored Girls. Dir. Tracey Moffatt. Australia, 1987. 16mm, 16 min.

Night Cries: A Rural Tragedy. Dir. Tracey Moffatt. Australia, 1990. 35mm and 16mm, 19 min.

Peirce, Stephen, and Wayne Hensley. "The Kuleshov Effect: Recreating the Classic Experiment." *Cinema Journal* 32.2 (1992): 59–75.

Periz, Ingrid. "*Night Cries*: Cries from the Heart." *Filmnews* Aug. 1990: 16–17.

Pines, Jim, and Paul Willemen, eds. *Questions of Third Cinema*. London: BFI, 1989.

Rehearsing. Dir. Laleen Jayamanne. Australia, 1987. Super 8mm.

Rose, Tricia. "Black Texts/Black Contexts." *Black Popular Culture*. Ed. Gina Dent. Seattle: Bay, 1992. 223–27.

Rutherford, Anna. "Changing Images: An Interview with Tracey Moffatt." *Aboriginal Culture Today*. Dangaroo, 1988. 147, 157.

Sidney, Karen. "Nice Coloured Girls." *Independent Media Magazine*. United Kingdom, 1989. 28–30.

A Song of Ceylon. Dir. Laleen Jayamanne. Australia, 1985. 16mm and Super 8mm, 51 min.

Sontag, Susan. *On Photography*. New York: Dell, 1973.

Stern, Lesley. "The Spectatrix." *Camera Obscura* 20–21 (1989): 294–96.

Taylor, Clyde. "Black Cinema in the Post-Aesthetic Era." Pines and Willemen 90–110.

Taylor, Gregory. " 'The Cognitive Instrument in the Service of Revolutionary Change': Sergei Eisenstein, Annette Michelson, and the Avant-Garde's Scholarly Aspiration." *Cinema Journal* 31.4 (1992): 42–59.

9

Just in Time
Let Us Now Praise Famous Men and the Recovery of the Historical Subject
Charles Wolfe

> Like Orpheus, the historian must descend into the nether world to bring the dead back to life. How far will they follow his allurements and evocations? They are lost to him, when, re-emerging in the sunlight of the present, he turns in fear of losing them. But does he not for the first time take possession of them at this very moment—the moment when they forever depart, vanishing in a history of his own making?
>
> —Siegfried Kracauer

> If the public photograph contributes to a memory, it is to the memory of an unknowable and total stranger. The violence is expressed in that strangeness.
>
> —John Berger

BACKED BY AN angled shelf of books in a warmly lit study, David McCullough opens a 1988 episode of the PBS series *The American Experience* with an instructively conventional prologue. Over his shoulder, in the deep recesses of the shot, a table lamp illuminates a landscape painting on the study wall; in front of the table is a typewriter, an uninsistent reminder of the mechanical technology that only a decade ago was still the writer's chief tool of trade. From his perch closer to the camera, public television's most visible American historian introduces us to the topic under review, James Agee and Walker Evans's 1941 photo book, *Let Us Now Praise Famous Men*, valuable, McCullough suggests, for a history that encompasses not simply the lives of politicians and soldiers but that of ordinary people, such as the sharecroppers who inhabited the cotton fields of the American South. "Because of this great book," McCullough observes, "which neither Agee nor Evans saw as a work of history, people like Floyd and Allie Mae Burroughs, Frank and Elizabeth Tingle and their children, people who knew little of books or the world, who knew mostly deprivation and toil, are now part of our history, their lives, the look in their eyes, forever fixed in the national memory."

As McCullough speaks, the camera reframes him more intimately, underscor-

ing the connection a look at a camera might invite. Having defined how the intellectual ambitions of author and photographer, and the social horizons of the families they studied, are divorced from the historical function the book now serves, McCullough seeks to bridge this division by linking historical comprehension to the work of collective memory, binding and abiding across generations. The look in the eye of these sharecroppers—photographed, suspended, met decades later by our own—provides a point of contact. The photographic fix becomes an occasion for historical fixing, a commemoration and reparation, as McCullough locates a place for these people in the national memory by reciting their names and sketching a context in which the look in their eyes will make sense. First, a historical cue: "In the depression years, the average income for a sharecropper and his family was $400—in a good year." Then the setup and exit line: "This is *Let Us Now Praise Famous Men—Revisited*, the narration largely taken from James Agee's own words. This is a story from Hale County, Alabama." Fade to black.

In this fashion we are guided toward a documentary history by television's modern variant on the public historian, his prop typewriter superseded by new ways of representing the American "experience," by technologies of visual and sonic storage and retrieval capable of orchestrating documentary pictures and recorded sounds. The look of a photographed subject becomes a nodal point in the construction of a shared past; processes of remembrance, in turn, are linked to those of narration, the telling of "a story from Hale County, Alabama." This route to the past is established, moreover, by way of McCullough's direct address to the camera, as if in conversation with us, in a now familiar form of simulated public discourse, on film, by way of the video screen.

Broadly viewed, this prologue, like the documentary program it prefaces, seems part and parcel of a wider effort in recent years to establish a historical ground for the assessment of familiar documentary photographs from the 1930s and their relation to an understanding of American culture and the politics of everyday life. The object of these investigations has been varied. To the extent that photographers themselves remain of central concern, it is less as solitary artists with a powerful vision of the world than as social agents, ethnographers of a kind, whose work follows from certain ideological premises, is supported and hemmed in by institutional constraints, and is embedded in specific relations of power with the people, settings, and events they survey. Attention has turned to the personal stories of the subjects of these photographs, tracing out biographies beyond the moment of photographic capture and arrest in an effort to grasp the impact of the photographic act on the long-range trajectory of a representative life. Government archives have been searched for fresh images that set overly familiar ones in a new context, providing a framework for new stories to be told, and patterns of photographic circulation and display have been mapped and defined. Beyond the microhistory of New Deal institutions and the culture of the Great Depression, moreover, broadscale changes in American social history provide a master narrative

within which these images can be placed: not simply the story of farmers displaced from cotton fields or dust bowls, but a more fundamental historical narrative of modernity and modernization, technological innovation, capital expansion, and industrial retooling which reconfigured the relation of human labor to land and city throughout the course of the nineteenth and twentieth centuries—an epic history of which the story of tenant farming is simply a single (if highly suggestive and resonant) subplot. Despite wide differences in targets, tactics, and polemical stance, a common thread running through these studies is the plausible assumption that the isolated photograph is inadequate as an object of historical inquiry, that photographic production and reception takes place in a social context, and the institutional structures and discursive fields that define such a context must be marked out.[1]

Produced by the British Broadcasting Corporation in 1979, and recycled for *The American Experience* nine years later, *Let Us Now Praise Famous Men—Revisited* shares common ground with these initiatives in at least two respects. Photographs by Evans and fragments of commentary by Agee are woven together with contemporary testimony by surviving members of the three tenant farm families who served as the subjects of the original book. Fictional names are stripped away—with Agee's pseudonymous Gudgers, Ricketts, and Woods identified as the Burroughs, Tingles, and Fields—as eight living members of these families recall their initial encounter with Agee and Evans and their subsequent and varied reactions to the photo book, a work composed without their knowledge. In addition, a broader narrative of economic exploitation and agricultural reform frames this lattice work of personal testimony. At the outset of the film, excerpts from Pare Lorentz's New Deal documentaries, *The Plow That Broke the Plains* and *The River*, laced together with newsreel footage from FDR's first inauguration, establish a social and political backdrop for these anecdotal accounts, a backdrop on occasion foregrounded when recollections turn to work in the cotton fields, the control exercised by landlords, and the impact of new technology on the farming family's work habits and sense of home. At the close, a ten-minute epilogue, *Want in the Midst of Plenty*, produced for *The American Experience* to round out the program, is appended. Here the tales told by survivors yield to the more analytical accounts of two professional historians—Pete Daniel of the Smithsonian Institution and Leon Litwack of UC-Berkeley—who outline a history of Southern agriculture from the Civil War through the Great Depression and describe the painful process by which New Deal policies brought the era of Southern sharecropping to a close. To this, novelist Tillie Olsen adds some personal observations concerning the psychological impact of the depression and New Deal beyond the regional story of Alabama tenant farming.

In short, the evidential force of Evans's photographs and Agee's verbal account are recruited for, and worked over by, documentary cinema in the construction of two kinds of history: first, a history of personal experience, with individuals

called upon to speak about and make sense of their memories, to find motives for and causal links among enduring sentiments and judgments, voiced across or at a tangent to pictures placed before the eye; second, a social history, for which any such particular and individual response acquires meaning only in illustration of broader categories of social thought: Allie Mae Burroughs as exemplary cotton-country mother, surrounded by photos of her offspring, or Elizabeth Tingle as exemplary field hand whose gestures convey the pinched, constrictive manual labor of picking the cash crop of cotton in order to survive. In effect, these figures are slotted into a catalog of social types from which a historical narrative of the American "peoples" can be composed. Conceiving history as, at root, experiential, *The American Experience* thus weds the personal to social perspectives. Evans and Agee's initial journey to Hale County serves as the occasion for a return visit to Alabama to invest a story of agricultural exploitation with idiosyncratic testimony, the details of specific lives, as refracted through a now celebrated effort to comprehend these events, "on the ground," in the period.

At the very center of this project, then, is an effort to recover these individual sharecroppers for history, a recovery all the more compelling for the sense that without a motion picture camera and the technology of recorded sound, the animated figures and authentic voices of these people would be forever lost. His monologue opened up to other voices, Agee's authority is complicated by the spoken testimony of those interviewed, by the perspective they bring to past events and their knowledge of a (now past) future that Agee risked forecasting but could not foretell. Concomitantly, the graphic juxtaposition of photographic portraits from the 1930s with contemporary footage grants these figures historical resonance; a temporal charge is sparked across pictures of the survivors as they appear before us, "then" and "now." Layering voice on image, the film exploits the complex and pleasurable movement of retrospective and prospective thinking, making palpable the process by which historical configurations are prefigured in the ordinary discourse we use to make sense of past encounters and anticipate future events, to mark our place in time.

In opening up the original photo book to historical inspection of this kind, however, *Famous Men—Revisited* also closes down the challenging dimension of Agee's experimental method, a method born of a vehement critique of social documentary photo texts of the period. In an effort to bring Evans and Agee's fifty-year-old project up to date, the film orchestrates and generates tensions across a variety of representational forms—photographs and motion pictures, written text, recorded speech, music and song—with the format of a television series providing an overarching frame for presentation on PBS. Yet it is no small testimony to the enduring power of the original book that this retrospective documentary, in its very attempt to define the source impulses and legacy of the earlier work and recast them in a new medium, rubs up against a critique of its own methodology, one common to historical documentary in public television programming today.

As a form of historical discourse, *Famous Men—Revisited* relies not only on our belief in the power of the photographer to attend to the visible particulars of an observable social reality, but on a temporal dimension to cinema, its capacity to evoke a sensation of unfolding and changing experience. Taken up for cinema, Evans's photographs are subject to the regulated pull of different registers of temporality: to the motion of the grain of emulsion that animates the surface of a projected film, to the movement of the camera as it scans an image for significant elements or tracks in more closely to intensify a photographed gaze, and to the ordering of images in sequence, with the time of our inspection governed by the duration and direction of any individual shot.[2] The impact is visceral, motor, and logical as specific images are articulated within larger patterns of chronology, causality, and abstract conceptual ordering. Concurrently, these temporal articulations confront a counter-pull: the drag of the (almost) still image, framed so that its borders are coextensive with that of the film frame, recalling in this instance not simply another order of temporality but, more precisely, a *historical* vantage point, a social perspective in time. We might say that if a freeze frame discloses a vestigial photogram at the root of the cinematographic image—a sense of picture-taking (like picture-making) as the *drawing* of a world made still—filmed photographs for which a historical referent has been specified direct our attention beyond the material properties of film as a phenomenal object to an anterior state of affairs.[3] This moment of arrest, a pause within the ongoing movement of the film, thus couples a temporal delay to a conceptual shift in which time becomes historically tagged, marked in relation to past human events, actions, desires, struggles, triumphs, defeats, births, and deaths. The impact of a stilled image in such a context is not so much to take us out of time but to place us in relation to other times, complicating narrative emplotment by playing historical registers off one another.

Voices play a central role here as well. Through music and sound effects, our sense of the temporal duration of the image is modulated rhythmically and tonally; through the distribution of an array of voices, multiple temporal levels and centers of focus for the construction of a historical narrative may open up. In *Famous Men—Revisited*, for example, we first hear an omniscient, disembodied narrator— low-key and unobtrusive, in the contemporary documentary style—who, with consummate tact and patience, condenses material, negotiates logical transitions, and attends to broader historical concerns. This voice, then, trades off with that of an actor; through the work of anonymous lungs and larynx, and of invisible microphones and speakers, fragments of Agee's commentary are realized on the soundtrack as concrete acoustic acts. These passages, unlike those spoken by the first narrator, are charged with drama by a voice sometimes hushed, sometimes incantatory, speaking in the first-person singular, evoking a bodily identity that quickly hooks up with the construction of "Agee" as a character, visible in photographs, a protagonist of the events he himself recounts. Agee's voice and picture, in turn, provide a bridge to the fully embodied voices of the Burroughs, Tingles, and Fields from whom recorded interviews have now been extracted. Through their recollections, at

Figs. 1 & 2. Movement and memory: Allie Mae Burroughs "looks back" at a photograph of Agee.

lazy, malingering" Junior, we learn, is a successful farmer who adjusted to mechanized agriculture once the tenant system disintegrated; Squeaky, whose "shriveled and hopelessly pitiful body," Agee claimed, "will not grow," appears before us now, mature and balding, insisting he would not give up his present way of life for the hardships of past days. Charles, moreover, openly expresses bitter feelings about the book, published without the consent of the family and not to their profit, an injustice he compares to their exploitation by landowners in the 1930s. The women, for varying reasons, are more charitable, recalling Agee (but not Evans) with affection and in general confirming his version of events. Mary Fields (Allie Mae's sister) describes Agee's secret tour through the Burroughs' house in search of its most intimate details to be "not nice" but corroborates his description of their mutual flirtations and seems flattered to have been the object of the erotic fantasies he recounted. Elizabeth Tingle recalls that her father was pleased that the book documented for posterity the family's struggles. Her sister Sadie claims the book puts her to sleep, yet believes most of it is accurate, and what is not is probably there to make "things come out right."

But it is through the testimony of Allie Mae, in particular, that Agee's account is verified. The book is truthful, she twice insists, and, given their predicament at the time, she feels no shame that the story has been told. Furthermore, mise-en-scène, editing, and sound work in concert to buttress Agee's account of burdens borne. We hear his interpretation of the weariness he sensed upon first meeting Allie Mae—"You have not lacked in utter tiredness like a load in your entire body a day since you were a little girl, nor will you ever lack it again"—as we see the image of her aging, prostrate body. Work as a condition of family life dominates the testimony that follows, with the voice of "Agee" returning to make plain, in phrasing more cutting and caustic than the narrator's, that the economic plight of this family is typical of sharecroppers. The point of this discussion ("what's left, once doctor bills and other debts have been deducted, can be nothing, can be less than nothing") is grounded, in the end, in a terminal image, dissolving from the familiar, fixed photographic portrait of Floyd to his cemetery marker, its engraved inscription sketching that most skeletal of biographies—a name, a date of birth, a date of death.

This motif returns at several points in the film, most dramatically perhaps when Evans's photo of Lucille, accompanied by Agee's description of her vital, penetrating stare, is followed by a shot of her gravestone as the narrator reports that, having married twice, she took her life with rat poison. This passage, in turn, strongly colors the penultimate sequence of the film in which Agee's description of Allie Mae's bottomless, infinite weariness is replayed over the image of her in sickbed, and she reminisces, recalling the hope for her children's future, that the visitors from the North had long ago inspired. The camera searches the room for pictures she has saved, revealing photos of Charles and Lucille as adults, smiling and

apparently happy, but also Evans's haunting portrait of Lucille, framed behind glass on Allie Mae's wall. As the camera moves in, so that the image fills the film's frame, the plane of Lucille's face is broken by an angular reflection off the photo's pane of glass. We hear Allie Mae say, as if in summation, "and, after all, life's been worth living." A clock is heard, ticking. A decade later, *The American Experience* provides the scripted epitaph toward which this scene—with its shifts between future and past, projection and retrospection—seems drifting; in the first in a series of closing titles updating the fate of those interviewed for the film, we learn of Allie Mae's death shortly after its completion.[8]

At work here, at least in part, is a trope of melodrama in which premonitions and recollections of death invest our awareness of time with pathos. "Just in time," we might be led to think when we are informed of Allie Mae's passing: a thought with a double edge, for the companion of revelation here is a sense of loss, mitigated only by a commitment to genealogy through which, in an act of mental reckoning, aspirations for the future are, in effect, *passed on*. The effect depends less on any single authentic act of "eye witness" by the camera than on the temporal relation of one imagined moment to another, to a sense of a bidirectional movement—forward and back in time—triggered by this relation.

This temporal play and embedded subjectivity in *Famous Men—Revisited* echo certain effects of Agee's prose style, not only the striking shifts in address from reader to character ("Your holy house, Floyd"; "You, Allie Mae") that the film on occasion quotes, but also complex changes in tenses (especially the backshifted tenses of indirect discourse, which Agee adopts when recounting encounters) and the eccentric cadences and internal rhymes that break up the powerful, forward momentum of his prose. For example, Agee's description of something profoundly withheld in the look of these people, as "drawn tightly back at bay against the backward wall and blackness of its prison cave," is phrased so as to catch a receding movement along the back/backward/blackness triplet even as the clause advances a thirty-seven-line Faulknerian sentence, posed as a question (99–100). We can also observe a fascination with regulated temporality in Agee's metacommentary on his own project. "This is a book by necessity only," he announces at the outset, advising the reader that the text "was written with reading aloud in mind" since "variations of tone, pace, shape, and dynamics are here particularly unavailable to the eye alone, and with their loss, a good deal of meaning escapes." Moreover, it "should be read continuously, as music is listened to or a film watched, with brief pauses only where they are self-evident" (xlvii–xlviii). Attention frequently turns to the power and pleasure of talk, the need for which he likens to a profound hunger (373) and the satisfactions of which he finds "beyond comparison of cocaine" (470). He laments the ways in which details of memory, sharpened and heightened through intimate conversation, or "the music of what is happening" during the course of an encounter, cannot be gotten down on the printed page (241, 404, 417).

"The forms of this text," he at one point appends in a footnote, "are chiefly those of music, of motion pictures, and of improvisation and recordings of states of emotion, and of belief" (244).

To pursue these analogies between Agee's text and *Famous Men—Revisited*, however, is also to bring into sharp relief the degree to which this particular documentary shuns the more radical implications of Agee's approach for what Hayden White has labeled "historiophoty"—the composition of historiographical discourse through photography and film. *Famous Men—Revisited*, for example, foregrounds narrative continuities over and against Agee's self-consciously opaque structure, picking out strands of narrative fragments from different sections of his 450-page commentary so as to work the interviews with survivors into an investigatory plot. This entails not simply realigning Agee's structure—which defers the introduction of any principal character until page 57 and withholds the scene of his first night spent with the Burroughs to the closing section of the text (labeled "introit," under the general heading of "inductions")—but the wholesale fabrication of a new story in which Agee and Evans appear as companion travelers to the Burroughs household on that summer Sunday in July.[9] More to the point, in smoothing out this narrative line the film elides the inconvenient digressions of Agee's original text, the collage of detailed description, social polemics, erotic reverie, and self-abasing auto-critique which turns Agee's narrative of investigation back on itself, calling the entire project into question.

Indeed, for all its democratic attention to the voices of the survivors, who offer varied and at times competing assessments of its accuracy and appeal, what is conspicuously lacking from *Famous Men—Revisited* is the element of auto-inquiry that drives Agee's text, the reasserted invocation of the limits to its own ground of knowledge. The truth of experience, Agee proposes, can only be discerned at the intersection of four different planes of action: first, "as it happened" (a phrase he employs suspiciously, placing it in quotation marks), that "straight narrative at the prow as from the first to the last day it cut unknown water"; second, a plane of recall and contemplation close to the event, commencing with a late moment in his visit and reconstructed in the section "On the Porch" in 1937; third, a plane of recall and memory open to the free play of the imagination, inspired by the moment of writing (a "moment" which in fact stretched out over several years, resulting in footnotes that modify and occasionally retract a sentiment expressed in the main body of the text); and fourth, metacommentary on the problems of recording and reconstructing, itself an organic part of the experience as a whole. Thus, "the 'truest' thing about the experience," Agee concludes, "turns up in recall . . . casting its lights and associations forward and backward upon the then past and the then future, across that expanse of experience" (243). In contrast, *Famous Men—Revisited* unfolds like a novel woven from intersecting biographies, a drama rich in personal details, with death as its defining moment and a scholarly backdrop supplied. Its formal density and resonant shifts in time and tense harnessed to a sense of tragic

fate, this account, unlike the original photo book, sticks closely to a prescribed historical plot.

The difference is most baldly evident in the handling of the photographs and photographic subjects. It is a central conceit of Agee and Evans's photo book that images are cordoned off in a zone unmarked by verbal text, prefacing even its title page, so that the reader must work to reconstruct links between pictures and text across the divide the book imposes. In contrast, Evans's photos in *Famous Men—Revisited* are seamlessly woven into the fabric of the narrative. Intercutting photographs of the Tingle house with that of the Burroughs, the film constructs a new, fictional space for Agee's clandestine tour of the Burroughs' home. Likewise, Evans's FSA photographs of remote areas of Alabama, taken subsequent to his stay with the tenant farmers, are incorporated into the film's fabricated journey into Centerboro. The gazes captured in Evans's photographs are interpolated into a narrative syntax that effaces the original production of these portraits. Even Evans's shadow, visible in the foreground of a photograph of "Paralee Rickett," becomes wedded to the figure of Agee as we hear him address the girl intimately; in this fashion, a new, phantasmic author is forged from the separate labors of photographer and writer.[10] Moreover, the staging of the interviews, with "talking heads" at a quarter-turn away from the camera, facing an unseen interrogator, allows for the inscription of these figures into an anonymously narrated story. Twice during the interviews, a woman's voice is heard off-screen, first to encourage Elizabeth Tingle to demonstrate how she picked cotton, second to inquire of Allie Mae Burroughs whether she received letters from Agee. Otherwise, no signs of the interviewers are in evidence. At the outset of the story, the narrator informs us that "many years later we returned to Alabama to retrace the footsteps of Agee and Evans," yet never is it revealed to us who this "we" is.

In the PBS prologue, direct address returns, but this time on behalf of that television fiction by which a "host" presumes to speak as if to someone present. Poised at the threshold of the screen, McCullough fronts for the unidentified filmmakers, feigning a link between the space of the television studio and the domestic space of reception. In the PBS epilogue, the narrative McCullough promises is then recast in the voice of official historical discourse, with no lingering ambiguities, no motives left in doubt. Another omniscient narrator, previously unheard, instructs us to consider "what Agee and Evans could not have known," a broader history, constructed through the expert testimony of professional historians who in cadence and tone balance a compassion for victims of agricultural policy with the detachment that undergirds their authority as professional adjudicators of what counts— and does not count—as history. In this context, the faces of photographed sharecroppers are readily interpreted; the economic and spiritual desperation of the times, one historian tells us, is revealed by the look in their eye. With this, the connection first promised by McCullough between an individual gaze, caught in a photograph, and collective memory is secured. Expanding the historical compass be-

Fig. 3. "Paralee Ricketts" and her phantasmic author: Evans's
shadow/Agee's voice.

yond Hale County, circa 1936, the voices of these historians reign in, pin down, the
meaning of this documentary evidence, filling in gaps, kneading out knots, getting
the story straight.

 As counterexamples, we might briefly consider three other works, composed in
different genres, that draw, if only obliquely, on the work of Evans and Agee from
this period. Faye Kicknosway's *Who Shall Know Them?*, a collection of poems pub-
lished in 1985, features nameless and elusive characters imagined in response to
Evans's FSA photographs. On the cover of the book we find his oft-reprinted por-
trait of the Fields family in the bedroom of their home. Disclaiming an intention
to write of the "real lives of actual people," Kicknosway in the volume's opening
poem dramatizes the process by which one might seek to discern who these people
are. Initially, the narrator confesses that she does not know, nor does she care to
know, *any* of the characters, since "they've all/been dead/longer years than I been
born and living" (2). Midway through, however, they begin to emerge as recogniz-
able types, and by the end all seem capable of being known save one: a woman on

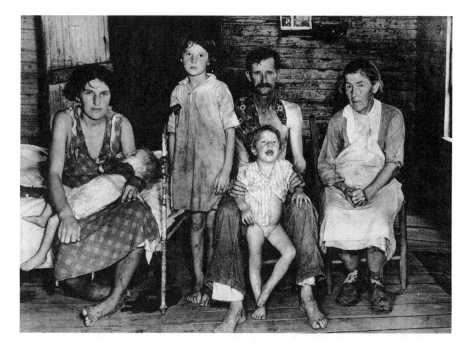

Fig. 4. "Who shall know them?": Evans's photograph of the Fields family (1936).

the left, sitting "sloppy-shouldered and squint-eyed" on the bed, a baby in her arms, a character for whom the narrator now begins to fabulate a story of surreptitious escape from the scene and erasure from the picture. Once gone, this woman cannot be proved to have ever existed, the narrator tells us, should we ask her "to story the picture" for us. And although we might conceivably meet this woman on the street, the narrator concludes:

> I wouldn't hear her.
> You got to know
> someone before you can hear them.
> Before you can answer back.
> And I don't know her. (7)

Halfway through the book, this erased figure returns in another poem, entitled "Who Is She?"; but now the narrator-spectator finds her own fate strangely wedded to the woman in the picture, and fears that:

> She'll catch me by my arm,
> and this picture
> will be lying
> on an ironing board

and where she sat
will be empty; she'll have scraped
herself free and she'll force me
to sit there,
where she was,
and she'll iron me down,
making me flat
so that I fit. (36)

Six poems later, the woman returns again, but the narrator is now inside the picture, minding meals and tending garden for the family, and dreaming herself adrift in the river. Finally, in the next to the last poem, entitled "I Come In," the narrator enters what appears to be the space of the empty house, "the doorframe around me like I was a picture hung from a wall" (79), in search of her sisters and brothers, and her father and mother, all of whom have vanished.[11] In a style as restrained and laconic as Agee's is intemperate and fervid, Kicknosway's poetry evokes a kind of imaginative engagement with the photographs that, like Agee's prose, puts to a highly personal test the reveries these figures evoke, and confronts, as does Agee along that fourth plane of metacommentary, the limits to our knowledge of any documentary subject, however deep the seductions of photographs or the fantasies they arouse.

A similar note is sounded, albeit in a very different key, by Andrea Fischer in *Let Us Now Praise Famous Women: Women Photographers for the U.S. Government, 1935 to 1944*, a book based on an exhibition at the British National Museum of Photography, Film, and Television, curated by Fischer with John Tagg. In her text accompanying the photographs, Fischer charts a shift in approach to documentary photography in the 1940s in the work of Esther Bubley, Marjory Collins, Pauline Ehrlich, Martha McMillan Roberts, Ann Rosener, and Louise Rosskam, a movement away from Roy Stryker's preoccupation with rural and small-town America toward "highly sensuous urban subjects . . . marked by reverie and reminiscent of filmic narrative" (3). A crisis in personal identity accompanying ruptures in the social fabric during the depression and the Second World War, Fischer argues, found expression in the work of these women photographers; although constrained by a gendered discourse on documentary practices, their photography altered the means by which the very notion of personal identity could be experienced and understood. At the same time, Fischer is at pains to resist any casual, chronological narrativizing of this "crisis in the intimate," proposing instead a form of historical comprehension that emphasizes simultaneity over sequence and the force of memory in the writing of history from the perspective of the present moment. In her report on a meeting with Esther Bubley, pointedly labeled a "conversation" rather than an "interview," interpretations of the photographs by Bubley and Fischer clash, but Fischer uses the conflict productively to argue for a notion of history in

which writing, memory, and narrative "may all float, side by side, as partial evocations of a related past" (129).

Evans and Agee figure in Fischer's account largely as representatives of a scientific discourse on documentary that treated objectivity as the central goal of photographic practice, a goal that came up against Agee's own passionate involvement with his subjects. Yet Agee's search for new formal strategies, his adamant refusal to treat history as a sphere apart from memory, his inscription of erotic reveries and family romances into the social field he sought to comprehend, and his sensitivities to the imbalances in power that characterized not only the social field he was documenting but his very effort to bring this field into view, all anticipate concerns that surface in critical histories such as Fischer's. Given Agee's willingness to rework, and turn upon, the quotations he weaves into his text, it also seems fitting that Fischer appropriates and transforms the book's title, which Agee first took from the book of the biblical Apocrypha, *Ecclesiasticus*, and which, with calculated impertinence, he undercut by attacking the corrosive meaning "fame" has accrued in the modern world. In *Let Us Now Praise Famous Women*, Fischer follows something of Agee's double approach to his subjects: seeking to bring to historical consciousness the work of socially grounded women photographers, while at the same time calling into question the procedures and possibilities of historical recovery as conventionally conceived and institutionally implemented and validated.

Closer in ambition and scope to *Famous Men—Revisited* is *And Their Children after Them*, a photo book by journalist Dale Maharidge and photographer Michael Williamson, published in 1989. Drawing upon the research they conducted over a three-year period in the Deep South, the authors offer a multigenerational history of the Burroughs, Fields, and Tingle families against the backdrop of the collapse of the economy of the Cotton Belt from the 1930s through the 1980s. As in *Let Us Now Praise Famous Men*, all the photographs are placed prior to the main body of the text. The book pays further homage to its predecessor by matching four of Evans's pictures with new ones by Williamson—the same locations and people viewed a half-century later. On the matter of captions, however, the authors hedge their bets, identifying the subject of each photograph at the back of the book. And while Maharidge, after the fashion of Agee, acknowledges the "curious" nature of his project at the outset, he explicitly eschews Agee's participatory method and poetic style, assuming the more conventional role of investigative reporter, interweaving anecdotes, statistics, and excerpts from conversations, letters, and diaries, seeking to reconstruct, and assessing conflicting versions of, a legendary encounter in which "each side thought it understood the other, but time proved that neither side was as right as it deemed itself" (56).[12]

Despite this bid for objectivity, Agee's self-consciousness and doubt shadow Maharidge's account, gaining an upper hand in the book's final section when his chronology catches up with his own arrival on the scene in Hale County in the

mid-1980s, and he faces the task of drawing conclusions and tying up the loose ends of the story. The Ricketts, in particular, pose a problem: having unearthed tales of child abuse, incest, unimaginable filth, and cruel social ostracism, confronting a family riven by intolerable memories yet bound by powerful emotional ties, Maharidge is forced to abandon any effort to slot these particular individuals into convenient sociological or historical categories. His inquiry then turns reflexive; these eccentric figures, he concludes, expose "an ugly and voyeuristic side in the townsmen, in journalists, in this book, in society" (170). Toward the close, Maharidge with increasing frequency quotes extended passages from the diary of Mary Field, as if searching for the central logic to her late-life solitude within her own distinctive prose. ("He was a mess," Mary says of Agee. "My goodness, I could turn around and write a book on him" [175].) And, in the end, Maharidge is left to muse, albeit in prose more plain than Agee's, on his incapacity to fully fathom any of these figures, let alone make intelligible what he dimly understands.[13]

In lining up elements of Kicknosway's poetry, Fischer's historical criticism, and Maharidge and Williamson's social history with Agee's approach, I do not wish to imply that photo *books*—which permit readers to chart their own path through a text—have a greater purchase on complex historical thought than does film. To do so would be to fall prey to a logic whereby the presumably essential properties of each medium invariably determine the interpreted time of the image (on the one hand, simply arrested or "frozen"; on the other, fleeting and successive). As I have sought to suggest above, the phenomenal sense of duration and arrest generated by the interplay of moving and still images in cinema can be aligned with conceptual shifts of considerable intricacy. Indeed, the makers of an otherwise routine documentary like *Famous Men—Revisited* seem to understand very well the power of a temporal pause to break and reroute the flow of a filmic narrative and compound perspectives as a story folds back on itself and is retold. Philippe Dubois, in his contribution to this volume, further demonstrates how the perceptible friction between the stillness of photographs and the movement of cinema (including the "movement" of the recorded human voice as a component of cinema) may be linked to a variety of conceptual devices for the staging of autobiography: a dematerializing of the photograph as memorial image, an archaeological excavation of the photograph's buried meanings, a dissolution of the subject of photographic activity, or an ironic subjectifying of the photographic object.[14] In a similar vein, one might note a tradition of experimental documentary filmmaking in which mental processes of recollection are evoked through the alignment of voices with still and moving images, powerfully evident, for example, in works such as *Night and Fog* (Resnais/Cayrol, 1954) and *Hiroshima-Nagasaki, 1945* (Ronder/Barnouw, 1970) which experiment with ways to represent histories of a social horror on a mass scale. Without forfeiting the evidential force of images of incalculable suffering—of corpses stacked high in concentration camps, of the burned flesh of atom bomb survivors—these films make no claim that such images simply "speak for

themselves," or that any single thing is sufficient to say about them, foregrounding instead the restive movement of memory upon these images and positing a blank space, at the lightless edge of historical consciousness, where horrific events are acknowledged but cannot be described. Emphasis on subjective processes of recollection, over and against the prepackaged assertions of the professional historian, may direct our attention to patterns of discovery, revision, and uncertainty of this kind. Here knowledge of what a witness thinks may be less important than discerning how a witness thinks, an awareness of the weight and force of testimony, and of those accents, inflections, and rhythms by which such testimony is vocalized.

Nor in privileging the self-critical stance of these various authors do I wish to underestimate the potential value of those documentary projects that are not composed in an elliptical, opaque, or otherwise "difficult" style. Sometimes getting a story straight can defamiliarize and demythologize what we know of the past, bringing to consciousness terrain that the twists and turns of an official account have blocked from view. Sensitivity to the limits of historical or ethnographic interpretation, in any case, does not free us from the obligation to see our way *through* such difficulties. Memory may be distinguished from reverie precisely to the degree that it is responsive to historical concerns, bolstered by the discoveries that a struggle to understand the past brings to our imagination of future social relationships. The antidote to the violence of the public photograph, John Berger proposes, is not the abandonment of any commitment to the photographic referent but the investment of private knowledge into a public discourse saturated by commodity interests, of human memory into a culture of spectacle that renders photographs, wrested from the context of social production, susceptible to any use. With this, the power of the photograph returns not as a datum of historical evidence but as "the prophecy of a human memory yet to be socially and politically achieved" (57). This entails, one might add, not the appropriation of public images for private pleasure or for opportunistic political gain, but the more difficult work of reconstructing unfamiliar narratives that have long gone unheard and now may disturb. Such an effort requires a willingness to imagine the photographic subject as something other than the object of our narcissistic contemplation, a figure no less capable of reflection and projection than ourselves.

To possess the historical subject is to lose it—Kracauer's ironic gloss on the historian's predicament recasts the dilemma of Agee's ethnographic project in historiographic terms. Yet it is the implicit argument of Agee's original study that respect for the autonomy of the people of whom he wrote—for the specificity and opacity of their ambitions, inclinations, fantasies, and fears—did not foreclose social engagement or historical speculation; at issue, instead, was the honesty of the observer about the terms of this transaction, the context in which it transpired and the purposes to which it might be put. From this perspective, the circumscription of its range of inquiry by *The American Experience* seems institutionally, not formally, dictated, a sign of a complacency that may explain the odd refusal to ac-

knowledge (save some final credits) the procedure by which a BBC production is absorbed a decade later by PBS, under the elastic rubric of the "American experience," for an armchair discourse on national memory that public television has devised. A defense of visual and acoustic historiography, composed in the public interest, might instead forego a metaphor like "revisiting the past"—with a credentialed commentator as companion travel guide—and embrace a more challenging conception of historical thought, quickened by pictures and voices: the possibility that the comfortable and tractionless commonplaces of our current thinking can be revised in anticipation of a future not yet known.

NOTES

My thanks to Edward Branigan, Nataša Ďurovičová, and Patrice Petro for their close readings of an earlier version of this essay.

1. Biographical information concerning the lives of the Burroughs, Fields, and Tingle families was published by journalists Osborne and Raines around the same time that *Let Us Now Praise Famous Men—Revisited* was in production; a more substantial and sensitive account can be found in Maharidge and Williamson, discussed later in this essay. Florence Thompson, the subject of perhaps the most widely known FSA photograph, Dorothea Lange's "Migrant Mother," likewise attracted the attention of journalists in the late 1970s; see, for example, "Famed Photo's Subject Feels She's Exploited." Recent research in government archives has yielded fresh appraisals of federally sponsored documentary photography and provocative reassessments of the cultural function of photo archives by Daniel, Fischer, Foresta, Levine, Stange ("Record" and "Publicity"), and Stein, Stoeckle, and Trachtenberg. Tagg's analysis of the discursive contexts in which Farm Security Administration photographs circulated has been highly influential. Also, see illuminating discussions of the distribution of National Youth Administration photos by Stein (1987) and FSA photos by Stange (1989).

2. About half of the photographs used in the film actually appear in either the first or second edition of *Let Us Now Praise Famous Men*. Most of the others are culled from Evans's FSA work in Hale County or other areas of the South. Two key photographs in the film, interestingly enough, are uncredited portraits of Agee not by Evans but by Helen Levitt, taken at Monk's Farm, New Jersey, in 1939 and in Agee's Greenwich Village apartment in the 1940s. Both are used in the shot/countershot sequence with an aging Allie Mae Burroughs as she recalls Agee's visit to her home in 1936. The Greenwich Village photo also is used to elicit memories of Agee from Mary Fields.

3. I borrow the distinction between the freeze frame and the filmed photograph from Stewart, who employs it to distinguish between alternative stylistic strategies for the figuration of death in fiction films.

4. Even when quoting Agee's text directly, the film substitutes the real names of the various family members for the fictional ones Agee supplied. Curiously, however, his fictional name for Greensboro, Alabama, "Centerboro," is retained. That individual identities have a different documentary status than do locations is symptomatic perhaps of the film's emphasis on recovering the experiences of the people photographed rather than mapping a real geographic terrain. The pres-

sure to narrativize Evans's photographs in this passage is reflected in the fact that two of the images are not of Centerboro at all and, in Agee's account in the book, Evans did not accompany him on this Sunday morning drive through the town (see note 9).

5. In contrast, consider the rather different narrative established for these photographs in Sedat Pakay's documentary *Walker Evans: His Presence, His Time, His Silence*. Opening with a close-up of a rifle in the background of Evans's photograph of the Burroughs bedroom, Pakay links Evans's portraits of Floyd, Annie Mae, and their children to the photographer's description of the hostile reception he and Agee received from the landowners and police. The gun and the stares, in this context, appear ominous, whereas in Agee's account the family is a haven from such hostility.

6. In a ten-minute passage in his biographical documentary, *Agee*, Ross Spears also treats the author's stay in Alabama as a narrative journey and return but presents the survivors very differently. The voices of Elizabeth Tingle and Allie Mae Burroughs, for example, are not synchronized with their appearance on screen. Instead, we hear fragments of their recorded comments as they stand stiffly, eyes darting, before the camera, their true identities disclosed in subtitles. Backed against the side of a house, in imitation of Evans's photo of her in the book, Allie Mae Burroughs, for example, appears trapped as the camera zooms in on her face. Deprived of either the sense of reserve and privacy that is evoked by Evans's method of formal portraiture or the full vocality generated by the body that characterizes the appearance of the survivors in *Famous Men—Revisited*, Allie Mae offers little or no resistance to this ongoing saga of Agee's life.

7. The film also establishes a more flattering view of Charles from the outset by substituting a photograph by Evans in which the boy stares directly at the camera for the one used in *Let Us Now Praise Famous Men*; in the latter, the boy's gaze, in keeping with Agee's description, indeed is "milky."

8. We also learn in the closing titles that William Tingle has died of cancer and that Charles Burroughs has stopped granting interviews. As in the case of the deceased witnesses, we may be led to think that Charles's testimony in the film has been delivered "just in time." But our sense of privilege in this instance is perhaps also undercut by Charles's self-willed silence, which implicitly protests the way he has come to be used by more recent investigators. Yet, instead of pursuing the implications of this silence for their own project, the producers of *The American Experience* shift focus to the "larger" lesson of Southern sharecropping as related by professional historians.

9. In the passage from which the commentary for the travel sequence is taken, Agee has left Evans in Birmingham to return to "Centerboro," drawn back to the "Gudger" family for reasons he claims not fully to fathom. The elaborate passage contains a series of digressions—flashbacks to Agee's childhood, speculations about the future, a sexual fantasy—all of which are elided in the film version (374–407).

10. In this instance only, the filmmakers retain Agee's fictional name for one of the family members, "Paralee Ricketts," perhaps because her real name was unknown. In the Library of Congress files of Evans's FSA photographs, she is referred to as "Dora Mae Tengle [*sic*]." Spears and Cassidy in their book, *Agee: His Life Remembered*, identify her as Floura Lee Tingle (65). When the same photograph appears in Spears's documentary film, it is accompanied by the voice of Evans, who describes his detachment from his subjects, in contrast to Agee's intense involvement. A subtitle over the image identifies the voice we hear as belonging to Evans; in contrast to *Famous Men—Revisited*, this further anchors the photograph on the side of the photographer, "fleshing" out the absent observer that the shadow marks.

11. My quick gloss of the gradual entry of Kicknosway's narrator into the imaginary space of Evans's photograph(s), I should stress, extrapolates a narrative pattern from a series of poetic images widely spaced across the various poems; this hardly does justice to the associative, nonlinear structure of the poems, read in their entirety. From this vantage point, Kicknosway's poetry

illustrates how photographic material can inspire a formal response only weakly attentive to matters of narrative continuity and causality when the demand for historical explanation is not pressing or is willfully resisted.

12. From the outset, Maharidge and Williamson also widen the social compass of the original book to incorporate the family of a struggling landowner and the descendants of black sharecroppers, figures who are treated only at arm's length in the original book. This expanded genealogy makes for a social matrix of greater refinement than one finds in *Famous Men—Revisited* and places far less weight on any single figure to represent the Southern farmer as a historical type. It is of more than passing interest, moreover, that the responses of the survivors in *And Their Children after Them* on occasion widely differ from those presented in *Famous Men—Revisited*. Mary Fields ("Emma Woods") thinks much of the book is not true (175); Sadie Tingle ("Katy Ricketts") hates the book (rather than is simply bored by it) and denies she was even part of the original project (168), and Junior Burroughs ("Gudger") is most angered by the financial exploitation of his family, while his brother Charles ("Burt") is too shy to talk (139–41). The inconclusiveness of "eyewitness" testimony and of the reporting of that testimony is amply illustrated by these discrepancies, bringing into question its evidential status. But exposure to the vagaries of memory and recorded testimony—eccentricities that juridical proceedings seek to efface through standard rules of evidence—also opens up new ways of conceiving the relation of documentary forms to historical consciousness, and of both to historical composition on film.

13. Maharidge's decision to retain the fictional names Agee invented for the members of the family and supply new ones for their offspring likewise nudges *And Their Children after Them* away from straight investigative journalism. In the book, in an effort to cast themselves in a different role than that of previous journalists, the authors also announce that all profits from its sale will be placed in a trust fund for the education of the descendants of the three families (xxii).

14. At the close of his essay, Dubois treats the photographic "negative" as a metaphor for a register beyond or below the flat surface of the nominally "positive" image, where autobiography screens subjectivity as fiction. Elsewhere I have argued that the rhetorical effect of the portrait of "Annie Mae Gudger" in *Let Us Now Praise Famous Men*, as annotated at a distance by Agee and viewed in relation to conventional social documentary practices of the period, evokes a zone of privacy, signaled but not defined by the text, which we might label "negative subjectivity" (68). Such an effect functions as a form of biographical screening, positing a "side" to the image that cannot be possessed, yet may be understood, after a fashion, through imaginative projection. In light of my topic here, the proper question might be this: How can a "negative" subject be "recovered" for a historical text without robbing it of its power to surprise and disturb? This may seem less of a problem for the autobiographer, whose fictions can be taken to refer simply to multiple masks designed by a stable, centered, authorial self; yet, in attempting to articulate a join between that self and history an autobiographer may confront this same question. For a provocative discussion of the various ways in which subjectivity, located at the intersection of autobiography and history, has been interrogated by contemporary film and video makers, see Renov.

WORKS CITED

Agee. Written, prod., and dir. Ross Spears. James Agee Film Project, 1978.

Agee, James, and Walker Evans. *Let Us Now Praise Famous Men.* 1941. Boston: Houghton, 1960.

Berger, John. "Uses Of Photography." *About Looking.* New York: Pantheon, 1980. 48–63. Opening quotation 52.

Daniel, Pete. "Command Performances: Photography from the United States Department of Agriculture." *Official Images* 36–42.

"Famed Photo's Subject Feels She's Exploited." AP report. *Los Angeles Times* 18 Nov. 1978: sec. 2:1, 12.

Fischer, Andrea. *Let Us Now Praise Famous Women: Women Photographers for the U.S. Government 1935 to 1944*. London: Pandora, 1987.

Fleischhauer, Carl, and Beverly W. Brannan, eds. *Documenting America, 1935–1943*. Berkeley: U of California P, 1988.

Foresta, Merry A. "Art and Document: Photography of the Works Progress Administration's Federal Art Project." *Official Images* 148–55.

Kicknosway, Faye. *Who Shall Know Them?* New York: Viking Penguin, 1985.

Kracauer, Siegfried. *History: The Last Things before the Last*. New York: Oxford UP, 1969. Opening quotation 79.

Let Us Now Praise Famous Men—Revisited. Prod. Alan Yentob. Dir. Carol Bell. BBC, 1979.

Levine, Lawrence W. "The Historian and the Icon: Photography and the History of the American People in the 1930s and 1940s." Fleischhauer and Brannan 15–42.

Maharidge, Dale, and Michael Williamson. *And Their Children after Them*. New York: Pantheon, 1989.

Official Images: New Deal Photography. Washington: Smithsonian Institution, 1987.

Osborne, Scott. "A Walker Evans Heroine Remembers." *American Photographer* 2 (79): 70–73.

Raines, Howell. "Let Us Now Revisit Famous Folk." *New York Times* 25 May 1980: 31–42, 46.

Renov, Michael. "History and/as Autobiography: The Essayistic in Film and Video." *Frame/Work* 2.3 (1989): 6–13.

Spears, Ross, and Jude Cassidy, eds. *Agee: His Life Remembered*. New York: Holt, 1985.

Stange, Maren. "Publicity, Husbandry, and Technocracy: Fact and Symbol in Civilian Conservation Corps Photography." *Official Images* 66–71.

———. " 'The Record Itself': Farm Security Administration Photography and the Transformation of Rural Life." *Official Images* 1–5.

———. *Symbols of Ideal Life: Social Documentary Photography in America, 1890–1950*. New York: Cambridge UP, 1989.

Stein, Sally. "Figures of the Future: Photography of the National Youth Administration." *Official Images* 92–107.

———. "Marion Post Wolcott: Thoughts on Some Lesser Known FSA Photographs." *Marion Post Wolcott: FSA Photographs*. Carmel, CA: Friends of Photography, 1983. 3–10.

Stewart, Garrett. "Photo-gravure: Death, Photography and Film Narrative." *Wide Angle* 9.1 (1987): 11–31.

Stoeckle, John D., and George Abbott White. *Plain Pictures of Doctoring: Vernacular Expression in New Deal Medicine and Photography*. Cambridge: MIT P, 1985.

Tagg, John. "The Currency of the Photograph." *Thinking Photography*. Ed. Victor Burgin. London: Macmillan, 1982. 110–41.

Trachtenberg, Alan. "From Image to Story: Reading the File." Fleischhauer and Brannan 43–73.

Walker Evans: His Presence, His Time, His Silence. Prod. and dir. Sedat Pakay. 1969.

Walker Evans: Photographs for the Farm Security Administration, 1935–1938. New York: Da Capo, 1973.

Want in the Midst of Plenty. Blue Ridge Mountain Films, Inc. for *The American Experience*. PBS. WGBH, Boston, 1988.

Wolfe, Charles. "Direct Address and the Social Documentary Photograph: 'Annie Mae Gudger' as Negative Subject." *Wide Angle* 9.1 (1987): 59–70.

Negativity and History

Fig. 1. Anonymous. The last photograph of Benjamin; it
appears on the upper left-hand corner of his death certificate.
Courtesy of Konrad Scheurmann and the community of Port Bou.

10

Words of Light
Theses on the Photography of History
Eduardo Cadava

> The true picture of the past flits by. The past can be seized only as an image which flashes up at the instant when it can be recognized and is never seen again. . . . For it is an irretrievable image of the past that threatens to disappear with every present that does not recognize itself as intended in it.
>
> —Walter Benjamin, "Theses on the Concept of History"
> (*Illuminations*; trans. modified)[1]

I

THE STATE OF emergency, the perpetual alarm that for Benjamin characterizes all history, corresponds with the photographic event. In his "Theses on the Concept of History," assembled shortly before his suicide in 1940 while fleeing from Nazi Germany, Benjamin persistently conceives of history in the language of photography, as though he wished to offer us a series of snapshots of his latest reflections on history. Written from the perspective of disaster and catastrophe, the theses are a historico-biographical time-lapse camera that flashes back across Benjamin's concern, especially in his writings of the thirties, over the complicity between aesthetic ideology and the fascist aestheticization of politics and war. Evoking images of the past that flash up only to disappear, inaugural moments of new revolutionary calendars that serve as moving cameras, and secret heliotropisms that link the past to the history of light, the theses work to question those forms of pragmatism, positivism, and historicism that Benjamin understands as so many versions of a realism which establishes its truth by evoking the authority of so-called facts.[2]

For Benjamin, there can be no fascism that is not touched by this ideology of realism, an ideology that both belongs and does not belong to the history of photography. Benjamin's consideration of the historical and philosophical questions suggested by the rise and fall of photography can therefore be understood as an effort on his part to measure the extent to which the media of technical reproduction lend themselves to social and political forces that, for him, go in the direction

of the worst. It can also be understood as a means to think through the revolutionary potential of such media, especially in their deconstruction of the values of authority, autonomy, and originality in the work of art, values which, for Benjamin, helped to formulate "the national-aesthetic myths of origin" prevailing in fascist Germany at the same time.[3] The advent of photography, for Benjamin, raises the problem of the work of art in the age of its technological reproduction as the problem of fascism and hence inaugurates a rethinking of a series of "concepts, such as creativity and genius, eternal value and mystery . . . whose uncontrolled (and at present uncontrollable) application would lead to a processing of data in the Fascist sense" (*Illuminations* 218).[4]

His insistence on the necessity of addressing these questions and relations is, above all, a call to responsibility that requires a passionate and determined effort of reflection.[5] What must be thought and acted upon, under the illumination or darkness of these questions, is the possible convergence of photography and history, a convergence that Benjamin often locates within the historiographical event. "The tradition of bourgeois society," he writes, "may be compared to a camera. The bourgeois scholar peers into it like the amateur who enjoys the colorful images in the viewfinder. The materialist dialectician operates with it. His job is to set a focus (*festzustellen*). He may opt for a smaller or wider angle, for harsher, political or softer historical lighting—but he finally adjusts the shutter and shoots. Once he has carried off the photographic plate—the image of the object as it has entered social tradition—the concept assumes its rights and develops it. For the plate can only offer a negative. It is the product of an apparatus that substitutes light for shade, shade for light. Nothing would be more inappropriate than for the image formed in this way to claim finality for itself" (*Gesammelte* 1.3:1165).[6]

II

There has never been a time without the photograph, without the residue and writing of light. If in the beginning we find the Word, this Word has always been a Word of light, the "let there be light" without which there would be no history. In Villiers de L'Isle-Adam's *Tomorrow's Eve*, God gives Adam the gift of history by giving him photography. Linking biblical exegesis to questions of electricity, Villiers raises the question of why God had to make light more than once. For light to survive, to survive itself, it must come again, and this coming again has, as one of its names, the name of photography.[7] In the ancient correspondence between photography and philosophy, the photograph, relayed by the trope of light, becomes a figure of knowledge as well as of nature, a solar language of cognition that gives the mind and the senses access to the invisible. What comes to light in the history of photography, in the history that is photography, is therefore the secret rapport between photography and philosophy. Both take their life from light, from a light which coincides with the conditions of possibility for clarity, reflection, speculation,

and lucidity; that is, for knowledge in general. For Benjamin, the history of knowledge is a history of the vicissitudes of light. For him, there can be no philosophy without photography. As he writes in his *Passagen-Werk*, "knowledge comes only in flashes" ("N" 1), in a moment of simultaneous illumination and blindness.

III

Photography prevents us from knowing what an image is. It is in fact no accident that Benjamin's essay "A Short History of Photography" (1931) begins, not with a sudden clarity that grants knowledge security, but rather with an evocation of the "fog" which he claims surrounds the beginnings of photography and clouds both knowledge and vision. From the very beginning, then, the fog disturbs the possibility of a linear historical account of photography's origins. Immediately different from itself, always taking another form, the fog spreads its mist throughout the essay and in so doing interrupts the dream of knowing and seeing that structures the history of photography, that informs the desire of the photographic event—even before it begins.[8] If a fog encircles the childhood of photography, it is in part because, in the experience of the photograph, it is as if we cannot see a thing. In the twilight zone between seeing and not seeing, we fail to get the picture.

IV

The incunabula of photography—its beginnings, its childhood, but also its burial place, its funereal plot, its relation to printing and inscription flashes the truth of the photo, a truth which says that what structures the relationship between the photographic image and any particular referent, between the photograph and the photographed, is the absence of relation, what Benjamin calls—referring to what, in Eugène Atget's photographs of deserted streets in Paris, anticipates surrealist photography—"a salutary estrangement between man and his surroundings" (*One-Way Street* 251). This is why, he explains, "it would be a misreading of the incunabula of photography to emphasize their *artistic perfection*" (*One-Way Street* 248; trans. modified). Rather than reproduce, faithfully and perfectly, the photographed as such, the photographic image conjures up its death: The home of the photographed is in fact the cemetery. Benjamin exhibits this insight in his discussion of the early portraits of David Octavius Hill. "All of the possibilities of this portrait art," he writes, "arise because the contact between actuality and photography has not yet occurred. Many of Hill's portraits originated in the Edinburgh Greyfriar's cemetery—nothing is more characteristic of this early period, except maybe the way the models were at home there. And indeed this cemetery, according to one of Hill's pictures, is itself like an interior, a separate closed-off space where the gravestones propped against gable walls rise from the grass, hollowed out like a chimney, with inscriptions inside instead of tongues of flames" (*One-Way*

Street 244–45; trans. modified). For Benjamin, Hill's Edinburgh portraits offer a *literarization* of the conditions of all life: We live as if we were always in a cemetery and we live in this deadly way among and *as* inscriptions. The portraits bear witness to the recognition that we are most ourselves, most at home, when we remember the possibility of our death. This experience of our relation to memory, of our relation to the process of memorialization, is not at all accidental: nothing is more characteristic. Subjects of photography, seized by the camera, we are mortified: objectified, thingified, imaged. "The procedure itself," Benjamin explains, "caused the models to live, not out of the instant, but into it; during the long exposure they developed, as it were, into the image" (*One-Way Street* 245; trans. modified).

What is most striking about the strange situation that Benjamin describes is that it allows us to speak of our death *before* death. We need only know that we are mortal—the photograph tells us one day we will no longer be here, or rather, we will only be here the way we have always been here, *as* images. It announces the death of the photographed. This is why what survives in a photograph is also what survives of the dead—what departs, desists, and withdraws. "Man withdraws from the photographic image" (*Illuminations* 226), Benjamin writes in his artwork essay. A small funerary monument, the photograph is a grave for the living dead. It tells their history—a history of ghosts and shadows—and it does so because it *is* this history. If the photograph bespeaks a certain horror, it is because, as Roland Barthes has suggested, "it certifies that the corpse is alive, *as corpse*: it is the living image of a dead thing" (79).[9] If the photograph is the allegory of our modernity, it is because, like allegory, it is defined by its relation to the corpse. Like the characters of the *Trauerspiel* who die because, as Benjamin says, "it is only thus, as corpses, that they can enter the homeland of allegory" (*Origin* 217), the photograph dies in the photograph because only in this way can it be the uncanny tomb of our memory.

V

Photography is a mode of bereavement. It speaks to us of mortification. "Whatever we know will soon cease to exist," Benjamin writes, "becomes an image" (*Charles Baudelaire* 87; trans. modified). Like an angel of history whose wings are marked by the traces of this disappearance, the image traces an experience that cannot come to light. Although what the photograph photographs is no longer present or living, its having-been-there now forms part of the referential structure of our relationship to the photograph. The return of what was once there takes the form of a haunting.

"The image wanders ghostlike through the present," Siegfried Kracauer explains, anticipating Benjamin's insight. "Ghostly apparitions occur only in places where a terrible deed has been committed. The photograph becomes a ghost be-

Fig. 2. David Octavius Hill, "The Artist and the Gravedigger,"
a calotype taken at the Greyfriar's Cemetery in Edinburgh. Collection, Scottish National Portrait Gallery.

cause the costume doll lived.... This ghostlike reality is *unredeemed*.... A shudder goes through the view of old photographs for they do not illustrate the recognition of the original but rather the spatial configuration of a moment; it is not the person who appears in his photograph, but the sum of what is to be deducted from him. It annihilates the person by portraying him, and were he to converge with it, he would not exist" (31–32). This is why it is precisely in death that the power of the photograph is revealed—it continues to evoke what can no longer be there. In photographing someone we know that the photograph will survive him—it begins, even during his life, to circulate without him, figuring and anticipating his death

each time it is looked at.[10] The photograph is a farewell. It belongs to the afterlife of the photographed. It is permanently inflamed by the instantaneous flash of death.

VI

The forgetting of the photograph's ghostly or spectral character corresponds to what Benjamin refers to as "the decline of photography." This decline is at first presented as a decline that can be understood temporally, that can be traced within the history of the photographic event. Early photographs are described as having an aura, an atmospheric medium that lends them a phantasmatic, instantaneous, hallucinatory quality, whereas later photographs are said to be marked by an increasingly mimetic ideology of realism, an ideology reinforced by advances in the technical sophistication of the camera. What is surprising is that photography's decline does not coincide, as one might expect, to a decline in the technical efficiency of the camera, to a decline in its capacity to register what is photographed. Rather, it corresponds to the technical refinement of the camera's performance. "In that early period," Benjamin writes, "subject and technique are as exactly congruent as they become incongruent in the following period of decline. For soon advances in optics made instruments available that overcame darkness entirely and recorded appearances like a mirror" (*One-Way Street* 248; trans. modified). The conquest of darkness by the increased light of photography conjures a link of fidelity between the photograph and the photographed. Yet it is precisely the conviction in this coincidence, in the photographic possibility of faithful reproduction, that marks the decline of photography.

For Benjamin, the historical and mimetological schema presupposed and enacted within the time of the decline of photography perverts, because it forgets, the disjunctive power that Benjamin locates in the structure of the photographic event. This is why the photographic light that "overcomes darkness entirely" fails to illuminate the photograph, and fails precisely because it dissimulates the photograph's inability to represent. Benjamin's reversal of the values of infidelity and fidelity suggests that the decline of which he writes is not a decline that occurs in and with time. "There are no periods of decline" ("N" 2), he explains elsewhere. If there are no *periods* of decline, it is because there is no period *without* decline. This is why the decline of photography needs to be understood as a structural element of any photograph, rather than as merely a moment in a temporal process. The decline of photography names the photograph's own decline, its movement away from the schema of mimetic reproduction. It suggests that the most faithful photograph, the photograph most faithful to the event of the photograph, is the least faithful, the least mimetic one—the photograph that remains faithful to its own infidelity. The doctrine of mimesis that organizes Benjamin's essay on photography presupposes a congruency between subject and technique that corresponds to an essential in-

congruency.[11] The photograph, the medium of likeness, speaks only of what is unlike. It says, "the photograph is an impossible memory." Because this forgetting is inscribed within every photograph, there is history—the history of photography as well as the history inaugurated by the photograph.

VII

The aura of a work of art refers to its presence in time and space, "its unique existence at the place where it happens to be" (*Illuminations* 220). "The here and now of the original," Benjamin writes, "brings forth the concept of authenticity. ... The whole sphere of authenticity is outside technical—and, of course, not only technical—reproducibility" (*Illuminations* 220; trans. modified). In removing the criteria of authenticity from the evaluation of an artwork, the possibility of reproducibility contributes and corresponds to the decay of the aura: "what withers in the age of technological reproducibility is the aura of the work of art ... the technique of reproduction, one might say generally, detaches the reproduced object from the domain of tradition" (*Illuminations* 221; trans. modified). This capacity for reproduction and circulation undermines the notion of an artwork's singularity, what Benjamin calls its "cult value" (*Illuminations* 224). It "detaches" the artwork from the history of a tradition that has always privileged the artwork's uniqueness, that has always valued the concepts of genius, creativity, and originality. Rather than being defined by its "cultic value," the artwork is now characterized by its "exhibitional value," by its ability to circulate and to be exhibited. Benjamin's discussion of "technological reproducibility" therefore indicates the transformation effected on the significance of the work of art by the predominance of techniques of replication: to the extent that technology is related to the realm of aesthetics, it works to question aesthetics as an autonomous realm by exposing its reliance upon historical processes of production and distribution.

The questioning of aesthetics that Benjamin traces in relation to the advent of film and photography recalls his argument about the relation between allegory and art in his earlier work on the *Ursprung des deutschen Trauerspiels*.[12] The intrusion of baroque allegory into the field of art can be described, he writes, "as a harsh disturbance of the peace and a disruption of law and order in the arts" (*Origin* 177). Its emphasis on the inevitability of repetition, on the citational and scriptural character of history, suggests that the notion of an "original" or "unique" work of art is already as difficult to sustain in the German baroque mourning play as it will be with the emergence of photography and film. "Origin," he claims, in a famous but enigmatic formulation, "although granted an historical category, has, nevertheless, nothing in common with emergence. What is meant by Origin is not the becoming of something that has sprung forth, but rather what springs forth out of coming to be and passing away. ... The original is never revealed in the bare and manifest existence of the factual" (*Origin* 45; trans. modified). What is "mourned"

within baroque allegory is not only the loss of the artwork's originality or singularity, however, but also that of the transcendent radiance "which was at one time ... used in an attempt to define the essence of artistry" (*Origin* 180). In both instances—the loss of the aura of originality and the loss of the artwork's relation to transcendence—the *Trauerspiel*'s technical and allegorical emphasis on emblems, ruins, and inscriptions, like the techniques of reproduction characteristic of film and photography, raises a series of questions about the possibility of defining the specificity or "essence" of the artwork.

These questions are often organized in Benjamin's discussions around the scriptural or linguistic dimension of either allegory or photography. As Samuel Weber has argued, "in the same way that film and photography come to require captions, legends, and inscriptions, the fragmentation and dislocation of the phenomenal world in baroque allegory engenders a temporality of repetition characterized by a prevalence of inscription: legends become necessary to mark the way and to bridge an image with its meaning, with the result that the images themselves signify only as elements in a pictorial script (*Bilderschrift*)" (18). It is not surprising that these legends share in the light of photography. Referred to as "flashes of light in the entangling darkness of allegory," they have the same function "as lighting in baroque painting" (*Origin* 196–97). For Benjamin, the lesson "inherent in the authenticity of the photograph" is in fact the link between the photograph and writing, between photography and the "prevalence of inscription": as he states at the end of the photography essay, " 'The illiteracy of the future,' someone has said, 'will be ignorance not of reading or writing, but of photography.' But must not a photographer who cannot read his own pictures be no less considered an illiterate? Will not the inscription become the most important part of the photograph?" (*One-Way Street* 256; trans. modified).

VIII

There will have always been technological reproducibility. What Benjamin means by technological reproducibility, however, is not what the French and English translations have always seemed to believe, mere "mechanical reproduction." For Benjamin, the "technical" is not the same as the "mechanical," its meaning is not circumscribed by the machinery of science. As he explains in his essay on Eduard Fuchs, "Technology is obviously not a purely scientific phenomenon. It is also an historical one" (*One-Way Street* 357). In other words, technical reproduction is not an empirical feature of modernity. Rather, it is a structural possibility within the work of art. "In principle," Benjamin tells us, "a work of art has always been reproducible" (*Illuminations* 218). In the seeming progression from Greek founding and stamping, to bronzes and coins, to woodcuts, and on through printing, lithographs, photography, and film, if the technological reproducibility of a work of art suggests something new, it is the intense acceleration of a movement that has al-

ways already been at work within the work. "Historically," Benjamin notes, technical reproducibility "advanced intermittently and in leaps at long intervals, but with accelerated intensity" (*Illuminations* 218). The "something new" with which Benjamin is concerned is not, then, merely "reproduction as an empirical possibility, a fact which was always more or less present since works of art could always be copies," but, as Weber suggests, "rather a structural shift in the significance of replication itself."

"What interests Benjamin," he goes on to say, "and what he considers historically 'new,' is the process by which techniques of reproduction increasingly influence and indeed determine the structure of the art work itself" (18)—or rather, of our existence in general. For as we know, every instant, every moment of our life, of our relation to the world, is touched today, directly or indirectly, by this acceleration, an acceleration that had already prepared for the coming of the camera—where replication and production tend to merge. Indeed the technology of the camera resides in its speed, in the speed of the shutter, in the flash of the reproductive process. Like the irrevocable instantaneity of a lightning flash, the camera, in split-second temporality of the shutter's blink, seizes an image that Benjamin himself likens to the activity of lightning: "The dialectic image flashes [*aufblitzendes*]. The past must be held like an image flashing in the now of recognizability" ("N" 21; trans. modified). An instrument of citation, the camera here cites the movement of lightning, a movement that never strikes the same place twice. In the same way, reproducibility has always reproduced itself, but never in an identical manner. The question of the meaning and origin of photography precedes or at least corresponds to the question of the meaning of technology. This is why technology can never simply clarify or explain the photographic event.[13] This is also why the age of technological reproduction includes all of history. "To each age correspond quite specific techniques of reproduction," Benjamin writes, reproducing a passage from Fuchs. "They represent the prevailing possibility for technological development and are . . . a result of the specific requirements of the time" (*One-Way Street* 384; trans. modified).

IX

What is at stake in the question of technological reproducibility, in the question of photography, is not whether or not photography is art, but rather in what way is all art photography. For Benjamin, as soon as the technique of reproduction reaches the stage of photography, a break line traverses the whole sphere of art. The presumed uniqueness of a production, the singularity of the artwork, the value of authenticity are practically deconstructed: "technological reproducibility emancipates the work of art from its parasitical attachment to ritual. To an ever greater degree the work of art reproduced becomes the reproduction of a work of art designed for reproducibility. From a photographic negative, for example, any number

of prints is possible; to ask for the 'authentic' print makes no sense. But the instant the criterion of authenticity ceases to be applicable to artistic production, the total function of art is reversed. Instead of being founded on ritual, it begins to be founded on another practice—that is, to be founded on politics" (*Illuminations* 224; trans. modified). The changes in the technical conditions for the production and reception of art constitute a break with tradition that effectively removes the previous ritual bases of art and facilitates the predominance of its political function. If politics, however, depends on photography and film's capacity to exhibit and manipulate bodies and faces, then all politics can be viewed as a politics of art, as a politics of the technical reproduction of an image.[14]

In his "Work of Art" essay and in his "Theories of German Fascism," Benjamin interprets fascism's aesthetics of violence—indeed, with all its regalia and spectacles, Nazism proved itself to be perhaps the most aesthetically self-conscious regime in history—as the culmination of *l'art pour l'art*: "The most rabidly decadent origins of this new theory of war," he writes, "are emblazoned on their foreheads: it is nothing other than an uninhibited translation of the principle of *l'art pour l'art* to war itself" ("Theories of German Fascism" 121–22).[15] Seeking a restoration of the aura within the framework of aesthetic autonomy, and originating as a reaction against the rampant commodification of art, *l'art pour l'art* presents itself, within fascism's own efforts to stage the nonpolitical essence of the political, as the truth of the political. Benjamin responds to this situation by mobilizing the so-called forces of aesthetic production toward political ends. Whereas fascism aestheticizes politics, Benjamin wishes to politicize aesthetics: "The concepts which are introduced into the theory of art in what follows differ from the more familiar terms in that they are completely useless for the purposes of Fascism. They are, on the other hand, useful for the formulation of revolutionary demands in the politics of art" (*Illuminations* 218).

X

History comes to a head in a moment of disaster. In the almost no time of this breakdown, thinking comes to a standstill. As Benjamin explains, historical thinking involves "not only the flow of thoughts, but their arrest as well" (*Illuminations* 262). The catastrophe of history corresponds to history's efforts to arrest this arrest. In other words, the catastrophic is the insistence on history as organic or progressive. "That things just go on," Benjamin tells us, and have gone on this way, "this is the catastrophe": "Catastrophe is not what threatens to occur at any given moment but what is given at any given moment" ("Central Park" 50).[16]

The head to which history comes during the time of the catastrophe of this catastrophe is, as he notes in his *Trauerspiel*, "a death's head" (*Origin* 166). It is the deadly head of Medusa. For Benjamin, there can be no history without the Medusa effect, without the capacity to arrest or immobilize historical movement, to isolate

Fig. 3. Holland House Library view after 1940 air raid in London.
RCHME Crown Copyright.

the detail of an event from the continuum of history. Adorno himself recognizes this point when, in his 1955 portrait of Benjamin, he claims that the glance of Benjamin's philosophy is "Medusan" (233). The Medusa's gaze stalls history in the sphere of speculation. It short-circuits the temporal continuity between a past and a present. This break from the present enables the rereading and rewriting of history, the performance of another mode of historical understanding, one which would be the suspension of both "history" and "understanding" (that is, the end of history and understanding as the directional and teleological paths we have always understood them to be). This other mode of historical understanding would be that of the historical materialist, of the one who "breaks the epoch away from its reified *historical continuity*" (*One-Way Street* 352). Whereas "historicism presents the eternal image of the past," historical materialism offers "a specific and unique experience with it. . . . The task of historical materialism is to set in motion an experience with history original to every new present. It has recourse to a consciousness of the present that shatters the continuum of history. Historical materialism conceives historical understanding as an after-life of what is understood, whose pulses can still be felt in the present" (*One-Way Street* 352; trans. modified).

Benjamin's sixteenth thesis claims that this leap out of a predetermined history and into "true" history takes place in "a present which is not a transition, but in which time hesitates and comes to a standstill" (*Illuminations* 262). Arguing according to the logic of the photographic image, that is, negatively, Benjamin characterizes his position on history and historiography against prevailing ones, and does so by affirming a movement of interruption that suspends the continuum of time. By retaining the traces of past and future—a past and future it nonetheless transforms—the photograph sustains the presence of movement, whose rhythm marks the afterlife of what has been understood, within the movement it gorgonizes. Only when the Medusan glance of either the historical materialist or the camera has momentarily transfixed history can history *as* history appear in its disappearance. Within this condensation of past and present, time is no longer to be understood as continuous and linear, but rather as spatial, an imagistic space that Benjamin calls a "constellation" or a "monad" (*Illuminations* 262–63). If this break from the present signals the taking over of a past (in theses VI and XIV, for example), the arrest of present thought in a constellation or monad "blasts" this past open. It "shatters the continuum of history" and in so doing discloses the breaks, within history, from which history emerges. Focusing on what has been overlooked or hidden within history, on the transitoriness of events, the historical materialist seeks to delineate the contours of a history whose chance depends upon overcoming the idea of history as the mere reproduction of a past.

The radical temporality of the photographic structure coincides with what Benjamin elsewhere calls "the caesura in the movement of thought" ("N" 24). It announces a point when "the past and the present moment flash into a constellation." The photographic image—like the image in general—is "dialectic at a standstill" ("N" 8). It interrupts history and opens up another possibility of history, one that spaces time and temporalizes space. A force of arrestment, the image translates an aspect of time into something like a certain *space*, a certain interval, and does so without stopping time, or without preventing time from being time.[17] Within the photograph, time presents itself to us as this "spacing." What is spaced here—within what Benjamin elsewhere calls "the space of history [*Geschichtsraum*]" ("N" 3)—are the always becoming and disappearing moments of time itself. It is precisely this continual process of becoming and disappearing that, for Benjamin, characterizes the movement of time.

The photographic event interrupts the present, it occurs *between* the present and itself, between the movement of time and itself. This is why nothing can occur in either the continuous movement of time or the pure present of any given moment. As Jean-Luc Nancy explains, "nothing can *take place*, because there is no place (no 'spacing') between the presents of time, nor between time and itself" (156). For Benjamin, nothing can take place before the photograph, before the event of the photograph. Effecting a certain spacing of time, the photograph gives

way to an occurrence. What the photograph inaugurates is history itself, and what takes place in this history is the emergence of the image.

From the very moment of the photographic event, this abbreviation that telescopes history into a moment suggests that what inaugurates history is written into a context that history itself may never completely comprehend. This context exceeds the limits of its representation. To write history is therefore not to re-present some past or present presence. "To articulate the past historically," Benjamin writes, "does not mean to recognize it 'as it really was.' It means to take possession of a memory as it flashes up at a moment of danger" (*Illuminations* 255). History therefore begins where memory is endangered, during the flash that marks its emergence and disappearance. It begins where the domain of the historical cannot be defined by the concept of historicality—where representation ends. For Benjamin, neither the Medusa nor history can be viewed or comprehended directly[18]— not even in the technologically lit realm of the headlight.

XI

To say that history withdraws from sight or understanding is not to say that history is what is past, but rather that it passes away; not that it has disappeared, rather that it "threatens to disappear," is always on the verge of disappearing, without disappearing. The possibility of history is bound to the survival of the traces of what is past and to our ability to read these traces as traces. That these traces are marked historically does not mean that they belong to a specific time—as Benjamin explains in his early essay on the *Trauerspiel*, "The time of history is infinite in every direction and unfulfilled in every instant. This means that no single empirical event is conceivable that would have a necessary connection to the temporal situation in which it occurs" (*Gesammelte* 2.1:134). Rather, as he says of the image in general, they only come to legibility at a specific time. This "coming to legibility" marks "a specific critical point of the movement within them" ("N" 8). This critical point is a moment of danger, a moment when historical meaning finds itself in crisis. "The image that is read," he writes, "I mean the image at the moment of recognition, bears to the highest degree the stamp of the critical, dangerous impulse that lies at the source of all reading" ("N" 8).

History is what such legibility comes to. The place of this legibility is constructed by what Benjamin refers to as "the time of the now" (*Jetztzeit*). This time is to be understood according to the structure of photographic temporality, which conceives of the relationship between a past and a present as dialectical, as imagistic. This image emerges in the now-time of reading. "Every present is determined by those images which are synchronic with it," he explains, "every now is the now of a specific recognizability. In it, truth is loaded to the bursting point with time (this bursting point is nothing other than the death of intention, which accordingly

coincides with the birth of authentic historical time, the time of truth). It isn't that the past casts its light on what is present or that what is present casts its light on what is past; rather, an image is that in which the Then and the Now come together into a constellation like a flash of lightning. In other words: an image is dialectics at a standstill" ("N" 8; trans. modified). "Historic" time is always *full*, even if, as Benjamin says, it is never fulfilled at any given moment. It is a time filled to the bursting point by its own *spacing*, by all of the images that are synchronic with it. As Benjamin writes elsewhere in the theses, "History is the object of a construction whose place is formed not by homogeneous, empty time, but rather by time filled by 'now-time' [*Jetztzeit*]" (*Illuminations* 261; trans. modified). History, according to this formulation, is still to come. It is what we come to, what is produced through an activity of construction, an activity whose place is in turn constituted by a temporal structure: the time of "now-time" (see Bahti 11–12). The truth of these images is neither timeless—since it is full of time—nor bound to the time of a historical subject—since it coincides with the death of intentionality. It is instead written into the temporality of the photographic structure operating in every moment, producing the image's legibility. History is made in its being read and photographed. Yet, whenever the "coming to legibility" of the photograph is interrupted, as it must be, history, as a process of appropriation and self-realization, is all over.

For Benjamin, the activity of reading is charged with an explosive power that in no way preserves but rather, in the interruption of its movement, tears the image to be read from its context. Only when reading undoes the context of an image is a text developed, like a photographic negative, toward its full historical significance.[19] The photographic image therefore comes only in the form of a coming, within the messianism of its "event": photography promises that everything may be kept for history, but the everything that is kept is the everything that is always already in the process of disappearing. What is kept is only the promise, the event of the promise. As Benjamin would have it, "Nothing that has ever happened should be regarded as lost for history" (*Illuminations* 254).

XII

Benjamin's use of the language of photography, in the "Theses" and elsewhere, coincides not only with his conviction that the image must be understood as historical, but also with his more radical suggestion that history be conceived as imagistic. History, in the sense of either "things as they are" or "things as they have been," can only be figured with and as an image. The movement of history therefore corresponds to what happens during the photographic event—to what happens when an image comes to pass. Benjamin's fifth thesis, for example, concerns the possibility of seizing the image of the past for and in the present, suggesting that the "true picture" of history intends the present: "For it is an irretrievable

image of the past that threatens to disappear with every present that does not recognize itself as intended in it" (*Illuminations* 255; trans. modified). What "threatens to disappear" here is not the past but an "irretrievable image of the past." The time of the truth of this picture of history coincides with an interruption of both recognition and intention: it is irretrievable, it can neither be recognized nor intentionally realized in the present. This is why what the image intends is the irretrievability of the present itself.

This image of the past—and of the irretrievable present it intends—may be "fleeting" and "flashing" but it is also susceptible to being held fast—even if what is seized is only the image in its disappearance. In other words, if "the true picture of the past flits by," it is not so much that we are unable to grasp the truth of the past, but rather that the *true* picture of the past *flits by*, the *true* picture of the past is the one that is always in a state of passing away. If Benjamin suggests that a "true picture of the past" does not give us history—or rather, is the only thing of history we get—he still suggests that it can be viewed as true. Nevertheless, as we have seen, it is precisely this "correspondence theory" of historical truth—in which an image corresponds to a historical truth—that is the target of Benjamin's critique (compare here to Bahti 10). To understand history as an image, as Benjamin does, is neither to assert that history is a myth nor to suggest that a certain "historical reality" remains hidden, behind our images. Rather, in Benjamin, it is always as if we were suspended between both: either something happens that we are unable to represent, or nothing happens but the production of historically marked fictional images. In either case, the image is a principle of articulation between language and history. This principle is indissociable from what, within the image, inaugurates history according to the laws of photography, the laws that determine the involuntary emergence of the image. As Benjamin suggests in his notes to the "Theses," "History in the strict sense is an image from involuntary memory, an image which suddenly occurs to the subject of history in the moment of danger. . . . Historiography confronts this constellation of dangers. It has to test its presence of mind in grasping fleeting images" (*Gesammelte* 1.3:1243, 1242). For Benjamin, the laws of photography not only account for the force of images upon whatever we might call the "reality" of history, but also for the essential imagism at work within the movement and constitution of history. Images are essentially involved in the historical acts of the production of meaning. Their links with knowledge give them their force, and hence their consequence within the domains of history and politics. This is why the materialism of Benjamin's theory of history can be allegorized in the photographic image. To the extent that the function of the camera is to make images, the historiography produced by the camera involves the construction of photographic structures that both produce and reconfigure historical significance and understanding. Benjamin makes this point in his drafts to the "Theses," in a passage that not only understands history as imagistic, as textual, but also links it to the citational structure of photography itself: "If one wants to consider history as a text, then what a

recent author says of literary texts would apply to it. The past has deposited in its images, which one could compare to those captured by a light-sensitive plate. 'Only the future has developers at its disposal which are strong enough to allow the image to come to light in all its details. Some page of Marivaux or Rousseau reveals a secret sense, which the contemporary reader cannot have deciphered completely.' The historical method is a philological one, whose foundation is the book of life. 'To read what was never written,' says Hofmannsthal. The reader, to be thought of here, is the true historian" (*Gesammelte* 1.3:1238).

XIII

The emergence of photography concurs with the advent of psychoanalysis. "It is another nature that speaks to the camera than to the eye," Benjamin writes, "other in the sense that a space informed by human consciousness gives way to a space informed by the unconscious. . . . Photography, with its devices of slow motion and enlargement, reveals it to him. It is through photography that he first discovers the existence of the optical unconscious, just as he discovers the instinctual unconscious through psychoanalysis" (*One-Way Street* 243; trans. modified). Photography reveals what sight cannot see, what, before sight, makes sight impossible. The photograph tells us that when we *see* we are unconscious of what our seeing cannot see. In linking, through the photographic event, the possibility of sight to what he calls "the optical unconscious," to what prevents sight from being immediate and present, Benjamin follows Freud himself, who, in his own efforts to trace the transit between the unconscious and the conscious, often returns to analogies drawn from the technical media, and in particular from photography.[20]

What links the laws of photography to those of psychoanalysis is that both require a thinking of the way in which this passage between the unconscious and the conscious, the invisible and the visible, takes place. The emergence of an image, however—within either the psyche or photography—does not mean that the image is the transcription of the unconscious into the conscious. For both Benjamin and Freud, neither the unconscious nor the conscious can be thought independently of one another. In other words, the unconscious, strictly speaking, is never simply the unconscious, is never simply elsewhere waiting to be transposed or transported. The unconscious tells us that we may never experience our experience directly, that everything begins with reproduction.[21]

This is why the structure of the psychical apparatus can be represented by a camera, why psychical content can be represented by a photograph: there can be no psychic operation without the transit between light and writing we call "photography." If the psyche and photography are machines for the production of images, however, what is produced is not simply any image, but an image of ourselves. We are who we are when we are photographed, when we become an image, a photograph. Or better yet, we are most ourselves when, not ourselves, we are an image or

a photograph—an image or photograph we may never see "before our gaze." As Benjamin writes in his 1932 speech on Proust: "Concerning the *mémoire involontaire*: its images do not only come without being called up; rather, they are images which we have never seen before we remember them. This is most clearly the case in those images in which—like in some dreams—we ourselves can be seen. We stand in front of ourselves, the way we might have stood somewhere in a prehistoric past, but never before our gaze. And it is in fact the most important images, those developed in the darkroom of the lived moment, that we get to see. One might say that our most profound moments have been furnished, like some cigarette packages, with a little image, a photograph of ourselves. And that 'whole life' which, as we often hear, passes before the dying or people in danger of dying, is composed precisely of those tiny images" (*Gesammelte* 2.3:1064).

XIV

In Benjamin's etiology, shock is what characterizes our experience. While linked to a particular experience—an experience of danger and bereavement—it exemplifies, in the wording of Miriam Hansen, "the catastrophic and dislocating impact of auratic experience in general" (211). While Benjamin identifies this process of transformation with technologies that have "subjected the human sensorium to a complex kind of training," and that include the invention of the match and of the telephone, the technical transmission of information through newspapers and advertisements, and our bombardment in traffic and crowds, he singles out photography and film as media that—in their techniques of rapid cutting, multiple camera angles, instantaneous shifts in time and place—raise the experience of shock to a formal principle: "Of the countless movements of switching, inserting, pressing, and the like," he explains, "the 'snapping' of the photographer has had the greatest consequences. A touch of the finger now sufficed to fix an event for an unlimited period of time. The camera gave the moment a posthumous shock, as it were" (*Illuminations* 174–75). In linking the experience of shock to the structure of delay built into the photographic event, Benjamin evokes Freud's own discussions of the latency of experience, discussions which are themselves often organized in terms of the language of photography. In *Moses and Monotheism*, for example, Freud claims that "the strongest compulsive influence arises from impressions which impinge upon a child at a time when we would have to regard his physical apparatus as not yet completely receptive. The fact itself cannot be doubted; but it is so puzzling that we may make it more comprehensible by comparing it with a photographic exposure which can be developed after any interval of time and transformed into a picture" (23:126). Freud goes on to suggest that the delay of the shock experience is due on the one hand to the remoteness of the period concerned and on the other hand to the process whereby the event is met, our reaction to it.

Freud links the event's remoteness not simply to the remoteness in time of the

events of our childhood, but more importantly to the distance between an event and our experience or understanding of it—a distance that tells us that we experience an event, not directly, but through our mediated and defensive reaction to it. As in Benjamin, what characterizes experience in general—experience understood in its strict sense as the traversal of a danger, the passage through a peril[22]—is that it retains no trace of itself: experience experiences itself as the vertigo of memory. For both Freud and Benjamin, consciousness emerges as memory begins to withdraw.

The notion of shock in fact requires that history emerge where understanding or experience cannot: "The greater the extent of the shock factor in particular impressions, the more incessantly consciousness has to be present as a screen against stimuli, the more efficiently it operates, the less they enter *Erfahrung*; rather, they fulfill the concept of *Erlebnis*. Perhaps the special achievement of shock defense may be seen in its function of assigning to an incident a precise point in time in consciousness at the cost of the integrity of its contents" (*Illuminations* 163; trans. modified). "Only what has not been experienced explicitly and consciously," Benjamin explains elsewhere, only "what has not happened to the subject as an experience, can become a component of the *mémoire involontaire*" (*Illuminations* 160–61). It is what is not experienced in an event that paradoxically accounts for the belated and posthumous shock of historical experience. If history is to be a history of this "posthumous shock," it can only be referential to the extent that, in its occurrence, it is neither perceived nor experienced directly. As Benjamin suggests elsewhere, "The dialectical image is one that flashes. Thus—as an image that flashes in the now of recognizability (*Erkennbarkeit*)—the image of the past is . . . to be held fast. The recovery that is accomplished in this manner and only in this manner always lets itself be won only as what irretrievably loses itself in the course of perception" ("Central Park" 49).

For Benjamin, history can be grasped only in its disappearance. This is the lesson that Benjamin offers, not only in his writings on photography, but also in a passage from his memoirs of his childhood in Berlin, a lesson itself framed within the language and temporality of photography: "Anyone can observe that the duration for which we are exposed to impressions has no bearing on their fate in memory. Nothing prevents our keeping rooms where we spent twenty-four hours more or less clearly in our memory, and forgetting entirely where we passed months. It is not, therefore, owing to an all too short exposure time if no image appears on the plate of remembrance. More frequent, perhaps, are the cases when the halfflight of habit denies the plate the necessary light for years, until one day from alien sources it flashes as if from burning magnesium powder, and now a snapshot transfixes the room's image on the plate. But in the center of these rare images, we always stand ourselves. And this is not so enigmatic, since such moments of sudden illumination are at the same time moments when we are beside ourselves, and while our waking, habitual, everyday [*taggerechtes*] self is involved actively or pas-

sively in what happens, our deeper self rests in another place and is touched by the shock, as is the little heap of magnesium powder by the flame of the match. It is to this sacrifice of our deepest self in shock that our memory owes its most indelible images" (*Reflections* 56–57).

XVII

Death, both the word and the event, is a photograph, a photograph that comes as the suspension of reality and its referents. As Benjamin suggests in "Central Park," the photograph, like the souvenir, is the corpse of an experience (49, 55). A photograph, therefore, speaks *as* death, as the trace of what passes into history. Yet, speaking as death, the photograph can be neither death nor itself. At once dead and alive, it opens the possibility of our being in time.[23]

This is why the event of photography is necessarily anterior to any history of photography—photography does not belong to history, it decides history. Nevertheless, the photograph—as what is never itself, and therefore always passing into history—asks us to think the remains of what cannot come under a present. How can an event that appears only in its disappearance leave something behind that opens history? How can the photographed guard a trace of itself and inaugurate a history? To pass through these questions is to think not only of what is incomprehensible about photography but also of what makes photography photography. We could say that photography escapes history when history orients itself toward a "history of photography" rather than a photography of history. For Benjamin, history happens when something becomes present in passing away, when something lives in its death. "Living means leaving traces," he tells us in his Baudelaire book (169). History happens with photography. *After life.*

XVIII

Gershom Scholem closes his memoirs of his friendship with Benjamin with an account that evokes the relations among photography, death, and cemeteries, and does so in relation to the death of Benjamin himself. "I learned about Benjamin's death," he says, "on November 8th in a brief letter—dated October 21st, 1940—from Hannah Arendt, who was then still in the south of France. When she arrived at Port Bou months later, she sought Benjamin's grave in vain. 'It was not to be found; his name was not written anywhere.' Yet Frau Gurland had, according to her report, bought a grave for him in September for five years. Hannah Arendt described the place: 'The cemetery faces a small bay directly overlooking the Mediterranean; it is carved in stone in terraces; the coffins are also pushed into such stone walls. It is by far one of the most fantastic and most beautiful spots I have seen in my life.' Many years later, in the cemetery that Hannah Arendt had seen, a grave with Benjamin's name scrawled on the wooden enclosure was being shown

Fig. 4. Blow-up of Fig. 1.

to visitors. The photographs before me clearly indicate that this grave, which is completely isolated and utterly separate from the actual burial places, is an invention of the cemetery attendants, who in consideration of the number of inquiries wanted to assure themselves of a tip. Visitors who were there have told me that they had the same impression. Certainly the spot is beautiful, but the grave is apocryphal" (226). In telling us of the absence of the inscription that would identify the place of Benjamin's burial, of any marker that might serve to memorialize Benjamin's death, Scholem can reveal only what Benjamin has already told us: Death may never be a referent—even if it is always referred to. If Benjamin is without an epitaph, is perhaps in no need of an epitaph, it is because he has already written that epitaph in the form of his corpus. Not only is this corpus traversed by an insistent reflection on mourning, a meditation in which bereavement and memory are indelibly inscribed, but it is also the prosopopeia that he addresses to us from a death all the more sublime for having no grave. Beyond the grave and its funereal inscriptions, Benjamin's voice speaks through the tomb that is his writing. In death, Benjamin experienced what he had already experienced in life—death. The shock of his death—breaking in upon his own history and giving it, in this way, an end

and a future—the shock of his death corresponds to the terrifying lucidity of his corpus. Death, corpse, decay, ruin, history, mourning, memory, photography—these are the words Benjamin has left for us to learn to read. These are the words that prevent his writings and readings from being crystallized and frozen into a merely negative method. Words of light, they correspond to the cremation of his work, a cremation in which the form of the work—its suicidal character—reaches its most brilliant illumination, immolated, as it is, in the flame of his own criticism.

NOTES

This essay is part of a larger project on Benjamin's concept of history. A more complete version of the essay appears in *Diacritics* (Fall 1992). I would like to thank Dr. Konrad Scheurmann, the Scottish National Portrait Gallery in Edinburgh, the Royal Commission of the Historical Monuments of England in London, and the community of Port Bou, all of whom granted me the permission necessary to reproduce the photographs included within the essay.

1. Translations have been modified whenever necessary. I am grateful to Anke Gleber for her help with the translations.

2. Compare this point with Hamacher's analysis of the "logic" of such realism in his "Journals, Politics."

3. The phrase is Hamacher's in "Journals, Politics" 443. For a recent analysis of the relationship between the political project of national socialism and aestheticism see Lacoue-Labarthe.

4. That Benjamin saw his attempt to rethink the status and nature of the work of art as a means to combat fascism is well known. See Wolin, especially 183–98, and Düttmann. On the political stakes of his thinking on photography, see Puppe. For analyses on the role of art and the technical media within the political agenda of national socialism, see Syberberg, Virilio, and Ronell.

5. While today we may understand the importance and relevance of these reflections it is no longer simply a question of crisis. Everything happens as if we all acknowledged the massive role that photographic technologies—their productions, diffusion, and manipulation—have in what we call "our historical reality." We need only recall the "War in the Gulf." If this war taught us anything, it taught us what has been true of all wars—there can be no war that does not depend upon technologies of representation. This was a war whose entire operation depended upon the technologies of sight: satellite and aerial photography, light-enhancing television cameras, infrared flashes and sighting devices, thermographic images, and even cameras on warheads. The war machine was in every way a photographic machine.

6. Benjamin is not the first to suggest the urgent necessity of thinking photography and history together. Siegfried Kracauer, in his 1927 essay "Photography" (an essay to which Benjamin's own essay on photography refers; see *One-Way Street* 245), had already seen photography as a means for reconsidering the relation between history and historicism. Early in the essay, he claims that historicism "became dominant at approximately the same time as modern photographic technology" (23). Mobilizing his discussion of photography toward a questioning of the

historicist assumption that history is linear and sequential, he goes on to attempt to transform both the concept of history and a thinking of photography by emphasizing what for him is their interruptive, even dangerous, character: "The turn to photography," he writes, "is the life and death game [*Vabanque-Spiel*] of the historical process" (37). For both Benjamin and Kracauer, what gives thinking history to think about is photography.

7. See Villiers de L'Isle-Adam, especially the section entitled "Snapshots of World History."

8. For a discussion of the relation between the weather and perception in Benjamin, see Hamacher, "The Word *Wolke*."

9. In his discussion of the baroque mourning play, Benjamin insists that life is always judged from the perspective of death. "From the point of view of death," he writes, "life is the production of the corpse" (*Origin* 218). On the relation between death and photography, see, in addition to the above, Derrida's two essays, "The Deaths of Roland Barthes" and "The Right to Inspection."

10. Compare on this point what Derrida says about the power of the name in *Mémoires* 49, and in "Signature Event Context" 7–8.

11. It is no accident that Benjamin refers to both the language of photography and the fleeting character of the image in his discussion of the perception of similarity. In "The Doctrine of Likeness," he writes: "The perception of similarity is in every case bound to a flashing up [*Aufblitzen*]. It flits by, may perhaps be won again, but can never really, unlike other perceptions, be held fast. It offers itself to the eye as fleetingly, passingly as an astral constellation" (*Gesammelte* 2.1:206–207).

12. I am indebted in this discussion of Benjamin's *Trauerspiel* book to Weber.

13. Compare Derrida's formulation concerning the relation between the question of technology and that of writing in *Of Grammatology* 8.

14. On this point, see Düttmann 532. This link between the domain of the political and the reproduction of images is made explicit in Benjamin's essay "Surrealism: The Last Snapshot of the European Intelligentsia." There he describes the sphere of political action as "a sphere reserved one hundred percent for images" (*Reflections* 191).

15. Benjamin makes a similar point in the appendix to his artwork essay. There, he writes, "All efforts to render politics aesthetic culminate in one thing—war" (*Illuminations* 240–41).

16. For a parallel passage see "N" 21: "The concept of progress should be grounded on the idea of catastrophe. That things 'just keep on going' *is* the catastrophe. Not something that is impending at any particular time ahead, but something that is always given. Thus, Strindberg (in 'To Damascus'?): Hell is not something that lies ahead of us, but this very life, here and now."

17. This discussion of the relation between space and time is itself a fragmentary, photographic montage of Jean-Luc Nancy's essay, "Finite History."

18. For a reading of the relation between the figure of Medusa and Benjamin's reflections on history, see Abbas 57.

19. Wohlfarth discusses this point in "Walter Benjamin's Image of Interpretation" 89.

20. On Freud's use of metaphors drawn from the technical media in order to figure the relation between the conscious and the unconscious, see Rickels and Ronell.

21. I am indebted to Derrida's analysis of the relation between the unconscious and techniques of reproduction in "Freud and the Scene of Writing."

22. I refer here to the fact that the word *experience* derives from the Latin *experiri*, to undergo. The radical is *periri*, which we find again in *periculum*, peril, danger. This etymological link between traversing and danger is kept in the German *Erfahrung*, experience, which itself derives from the old high German *fara*, danger, from which we get *gefahr*, danger, and *gefährden*, to endanger. To experience something, and here we may recognize the strict sense that Benjamin gives the word *Erfahrung*, is to put oneself in danger, is to exist within a permanent state of danger and

emergency. For a fuller discussion of the etymology of "experience" see Roger Munier, "Résponse à une enquête sur l'expérience," in *Mise en page* 1 (1972), cited in Lacoue-Labarthe, *La poésie* 30–31.

23. Compare here Hamacher's analysis of the relation between death and poetry in "History, Teary" 73.

WORKS CITED

Abbas, Ackbar. "On Fascination: Walter Benjamin's Images." *New German Critique* 48 (1989): 43–62.

Adorno, Theodor W. "A Portrait of Walter Benjamin." *Prisms*. Trans. Samuel Weber and Sherry Weber. Cambridge: MIT P, 1967. 227–41.

Bahti, Timothy. "History as Rhetorical Enactment: Walter Benjamin's Theses 'On the Concept of History.' " *diacritics* 9.3 (1979): 2–17.

Barthes, Roland. *Camera Lucida: Reflections on Photography*. Trans. Richard Howard. New York: Farrar, 1981.

Benjamin, Walter. "Central Park." Trans. Lloyd Spencer. *New German Critique* 34 (1985): 32–58.

———. *Charles Baudelaire. A Lyric Poet in the Era of High Capitalism*. Trans. Harry Zohn. London: New Left, 1973.

———. *Gesammelte Schriften*. Ed. R. Tiedemann and H. Schweppenhäuser. 7 Vols. Frankfurt: Suhrkamp, 1971–.

———. *Illuminations*. Ed. Hannah Arendt. Trans. Harry Zohn. New York: Schocken, 1968.

———. "N [Theoretics of Knowledge; Theory of Progress]." Trans. Leigh Hafrey and Richard Sieburth. *The Philosophical Forum* 15.1–2 (1983–84): 1–40.

———. *One-Way Street, and Other Writings*. Trans. Edmund Jephcott and Kingsley Shorter. London: New Left, 1979.

———. *Origin of German Tragic Drama*. Trans. John Osborne. London: New Left, 1977.

———. *Reflections*. Ed. Peter Demetz. Trans. Edmund Jephcott. New York: Harcourt, 1978.

———. "Theories of German Fascism." Trans. Jerolf Wikoff. *New German Critique* 17 (1979): 120–28.

Derrida, Jacques. "The Deaths of Roland Barthes." Trans. Pasale-Anne Brault and Michael Naas. *Philosophy and Non-Philosophy since Merleau-Ponty*. Ed. Hugh Silverman. New York: Routledge, 1989. 259–96.

———. "Freud and the Scene of Writing." *Writing and Difference*. Trans. Alan Bass. Chicago: U of Chicago P, 1978. 196–231.

———. *Mémoires: For Paul de Man*. Trans. Cecile Lindsay, Jonathan Culler, and Eduardo Cadava. New York: Columbia UP, 1986.

———. *Of Grammatology*. Trans. Gayatri Chakravorty Spivak. Baltimore: Johns Hopkins UP, 1976.

———. "The Right to Inspection." Trans. David Wills. *Art and Text* 32 (1989): 20–97.

———. "Signature Event Context." *Limited Inc*. Trans. Samuel Weber. Evanston: Northwestern UP, 1988. 1–23.

Düttmann, Alexander Garcia. "Tradition and Destruction: Benjamin's Politics of Language." Trans. Debbie Keates. *MLN* 106.3 (1991): 528–54.

Freud, Sigmund. *The Standard Edition of the Complete Psychological Works of Sigmund Freud*. Ed. and trans. James Strachey. 24 Vols. London: Hogarth, 1953–74.

Hamacher, Werner. "History, Teary: Some Remarks on *La Jeune Parque*." Trans. Michael Shae. *Yale French Studies* 74 (1988): 67–94.

———. "Journals, Politics." Trans. Peter Burgard et al. *Responses: On Paul de Man's Wartime Journalism*. Ed. Werner Hamacher, Neil Hertz, and Thomas Keenan. Lincoln: U of Nebraska P, 1988. 438–67.

———. "The World *Wolke*—If It Is One." *Studies in Twentieth-Century Literature* 11.1 (1986): 133–62.

Hansen, Miriam. "Benjamin, Cinema and Experience: The Blue Flower in the Land of Technology." *New German Critique* 40 (1987): 179–224.

Kracauer, Siegfried. "Die Photographie." *Das Ornament der Masse. Essays*. Frankfurt: Suhrkamp, 1977. 21–39.

Lacoue-Labarthe, Philippe. *Heidegger, Art and Politics*. Trans. Chris Turner. Oxford: Blackwell, 1990.

———. *La poésie comme expérience*. Paris: Bourgois, 1986.

Nancy, Jean-Luc. "Finite History." *The States of Theory*. Ed. David Carroll. New York: Columbia UP, 1990. 149–72.

Puppe, Heinz W. "Walter Benjamin on Photography." *Colloquia Germania* 12.3 (1979): 273–91.

Rickels, Laurence. *Aberrations of Mourning: Writings on German Crypts*. Detroit: Wayne State UP, 1988.

Ronell, Avital. *The Telephone Book: Technology, Schizophrenia, Electric Speech*. Lincoln: U of Nebraska P, 1989.

Scholem, Gershom. *Walter Benjamin: The Story of a Friendship*. Trans. Harry Zohn. New York: Schocken, 1981.

Syberberg, Hans-Jürgen. *Hitler: A Film from Germany*. Trans. Joachim Neugroschel. New York: Farrar, 1982.

Villiers de L'Isle-Adam. *Tomorrow's Eve*. Trans. Robert Martin Adams. Urbana: U of Illinois P, 1982.

Virilio, Paul. *War and Cinema: The Logistics of Perception*. Trans. Patrick Camiller. New York: Verso, 1989.

Weber, Samuel. "Theater, Technics, and Writing." *1–800* 1 (1989): 15–20.

Wohlfarth, Irving. "Walter Benjamin's Image of Interpretation." *New German Critique* 17 (1979): 70–98.

Wolin, Richard. *Walter Benjamin: An Aesthetic of Redemption*. New York: Columbia UP, 1982.

11

Flat-Out Vision

Herbert Blau

She closed her eyes, and Felix, who had been looking into them intently because of their mysterious and shocking blue, found himself seeing them still faintly clear and harmless behind the lids—the long unqualified range in the iris of wild beasts who have not tamed the focus down to meet the human eye.

—Djuna Barnes, *Nightwood*

Tokay grapes are like photographs, Mr. Ekdal, they need sunshine. Isn't that so?

—Henrik Ibsen, *The Wild Duck*

We don't see what we look at.

—Alexander Rodchenko, "The Paths of Modern Photography"

MY OWN FIRST reflexes, when thinking of photography, are somehow not a remembrance of pictures but, in the unqualified range of the iris, a regressive association through the tactility of the form: fingers on a glossy surface, grained, a stringent odor at the eyes. That phototropic sensation might have come from some old forgotten experience of a darkroom, but I suspect it was, like the daguerreotype itself, nurtured in the theater, where I've spent much of my life as a director, sitting in the dark, I mean really in the dark, struck by the wild and furtive odor, when the sunshine hits the grapes, of the thing forbiddingly seen, in a landscape of specularity that is, all told, a field of dispersed speech. This has been extended through the camera obscura into that rhetoric of the image which is, according to Barthes, a message without a code, or like the mutely alluring syntax of the stains upon the ground (tar like blood? behind that man, a shadow?) in Rodchenko's picture with the somewhat duplicitous name: *Assembling for a Demonstration* (Szarkowski 210)—a flat-out vision in an estranging frame. If we don't *see* what we look at there, it's not only because of the unpurged persistence of "old points of view," as Rodchenko thought, what he called " 'shooting from the belly button'—with the camera hanging on one's stomach" (Phillips 246); rather, it's because the thing to be seen is in its copious imaging, like the theater's god itself, or its ghosts, essentially

Fig. 1. Rodchenko, Alexander. *Assembling for a Demonstration*. 1928. Gelatin-silver print, 19 3/8 x 12 3/4". Collection, The Museum of Modern Art, New York. Mr. and Mrs. John Spencer Fund.

imageless, invisible, though the stomach is a decisive factor, as we shall momently see.

Meanwhile, the synesthesia in these thoughts corresponds to what Lacan describes—in answering the question, "what is the gaze?"—as "the function of *seeingness*," from which the I emerges as eye in the radiant "flesh of the world, the original point of vision" (82), as it does with the smell of defilement, the hunt, the feast, in the most ancient drama we know. If this is myth and not history, it is of some historical significance that Ibsen preserved it, late in the nineteenth century, in the subliminal wilderness of *The Wild Duck*, the recessive hunting ground of his devastating realism, where there is the compulsion "to find that imperceptible point at which, in the immediacy of the long past moment, the future so persuasively inserts itself that, looking back, we may rediscover it." That is actually what Benjamin says, in his "Short History of Photography," about the optical unconscious, "a different nature that speaks to the camera from the one which addresses the eye" (7). The double exposures of Ibsen's play, and its time-lapse dramaturgy, occur with photography in the foreground, already commodified, as the emblematic image of the illusions of history, whether in the retouched portrait of the family romance or the culinary theater of the bourgeois parlor, where the Fat Guest says, savoring his Tokay, "it's an excellent thing for the digestion to sit and look at pictures" (225).

This is a virtual setup, of course, for the later critique by Brecht, of theater, of photography, which has subsequently grounded further critique, including the question raised by Benjamin about "the aesthetics of *photography as an art*" ("Short History" 22). But before we return to that it may be chastening to remember, or particularly difficult for some of us to digest, that the realism of Ibsen—driven, like Marx, toward a "ruthless criticism of everything in existence"—is about nothing more devastating than the vanities of critique, as if the future of illusion were the illusions of demystification. I take that liability as the anxious datum of any pretense of deconstruction, as well as the limiting prospect of any "oppositional practice," inhabited by the structures it would oppose, as photography still seems to be inhabited by painting (an avatar of theater) despite the mechanical reproduction that, repetitively, punctures the auratic and brings an end to art; or the beginning of the end which has been our history, repeating that beginning, almost from the time that photography began. That is, I suppose, what we mean by modernism.

As for the looking at pictures, I won't review the history that brings us to the indigestion, which may be, in our fast-food version of the "gastronomy of the eye," the symptomatic condition of the postmodern scene, where the *flâneur* memorialized by Benjamin is caught up in the visual orgy deplored by Baudrillard. This tactile vertigo of the image can be exhausting and was so, apparently, long before Baudrillard, as in *The Waves* of Virginia Woolf, where in the receding voices of an undertow of consciousness, there is longing for release from a surfeit of pictures,

image upon image producing a torpor, and the desire to find something *unvisual* beneath. But in the lugubrious perspective of Baudrillard, release from the vertigo can hardly be imagined, for the superfetation of image is a function of the obscene, which "is no longer the hidden, filthy mien of that which can be seen," but its paralyzed frenzy, "the abjection of the visible" (42), a sinkhole of fascination in which—with America controlling the fantasy machine, the viral contamination of image satellized through the world—the real is nullified and there is nothing to see.

Whether things are all that null in the void we'll put in abeyance, but at the still-breeding end of the real, the question before us, perhaps, is whether seeing— the most impatient activity of the senses, ever avid for more to see—has been irreparably damaged in our visual economy, the proliferous spectacle in which, to say the least, there is now without respite too much to see. If seeing was once the most dangerous of the senses, punished in myth for overweening desire, looking at the forbidden, the subject of taboo, it has now become a sort of endangered species. "We must revolutionize our visual reasoning," said Rodchenko (Phillips 262), after he reduced painting to its primary colors, said it's all over, and turned to photography and photomontage. But in the atmosphere of recent discourse, the other side of seeing too much, or having too much to see, is that one is almost induced by the critique of the specular—the hegemony of surveillance, its secret archives—to conduct one's life with lowered eyes. (Or in the now obsessive rhetorics of the body, to reverse the hierarchy of the senses, as if the essential truths were certified by touch or, without the taint of logocentrism, metaphysics came in through the pores.) For we think of sight as a categorical faculty, analytic, obstrusive, discriminative, even exclusive, encroaching on otherness with an appropriative gaze, as if the scopophilic drive itself were engendered in the unconscious as an ideological fault and the dialectic of enlightenment spawned in Plato as a mere bourgeois hoax.

Neurobiologists tell us, however, that the dominion of vision actually began with a single, light-detecting spot like the aperture of a camera in the body of an animal three million years ago. That spot may be, with a certain "protoplasmic irritation" (in a speculation by Freud, the reluctant source of life) the site of the incipience of *time* as well, drawn into history by the sun. That was—in its huge imagining of the unremembered, hinged on the granting of sight, with fire, to subhuman creatures underground—the heliotropic substance of the Promethean myth, the still-flaming divinity of which haunts our visual technologies, and which, despite all deconstruction, is still sovereign on the mediascape. That is why we can still argue whether or not the photograph is "an emanation of the referent" that was indubitably there, as Barthes insists in *Camera Lucida*, invoking the phenomenology of Sartre and the memory of his mother (in the photograph he withholds: "just an image, but a just image" [70]) against his semiological past. This emanation

comes not from a mere historical construction but, he says, "a real body," whose radiations "will touch me like the delayed rays of a star. A sort of umbilical cord links the body of the photographed thing to my gaze: light, the impalpable, is here a carnal medium, a skin I share with anyone who was photographed" (81).

One may not want to go so far as to revive the "layers of ghostlike images" or "leaflike skins" that, in the paranoid theory of Balzac reported by Nadar, would be "removed from the body and transferred to the photograph" each time someone had his or her picture taken, every successive exposure entailing "the unavoidable loss of subsequent ghostly layers, that is, the very essence of life" (9). Yet in the concept of the photographic trace there linger variants of this notion, a photochemical transfer of the real resembling fingerprints or palmprints, the tracks of birds on beaches, or, with intimations of spirit photography, "death masks, cast shadows, the Shroud of Turin" (Krauss and Livingston 31), or the stains upon the stancher, the handkerchief or Veronica, which, in the camera obscura of Beckett's *Endgame*, with its attrition of ghostly layers, inscribes the face of the blinded Hamm. And if in this memorial plenum of imprints there is still anxiety about what is being left *out*, and *why*, what also remains at issue, unresolved, is whether photography's essence is to ratify what it represents, if not claiming it as recoverable—that imperceptible point at which, in the immediacy of the long-past moment, the future seemed persuasive—then attesting that it *was*. Whatever it was, it came to us in a dazzle of light, and it is this "solar phenomenon," eventually acceded to by Alphonse de Lamartine, who had called photography "a plagiarism of nature" (qtd. in Newhall 69), that still shadows our finest photographs in something like a foundation myth. It may strike us now, however, as the shadow of a shadow, and there are some memorable photographs that seem to attest to that, if not, as in the lamentations of *Endgame*, to the waning of the light.

There is a picture by Brassaï, in the *Paris de nuit* series—there are others of spectacular light at the opera or splayed in a brilliant haze over the Place de la Concorde—of the railroad tracks at Saint-Lazare taken from the Pont de l'Europe. The tracks curve dimly from the foreground, with several trains at the *quais*, a monitoring trestle overhead, and a wash of light on the tracks from the banded glare in the concourse and the headlights of the trains. It is a picture which seems to require scanning, for there is nothing conspicuous to compel attention, except perhaps for the leaning ray from an indeterminate source. But then, in back of this angled ray, recessed in the frame, there is a row of nubby bulbs leading to another glare, and high above, as if it were the enlarged memory of that spot on the brain, looking for a moment like the moon, a clock, its handles barely perceptible, but an immanence in the scene, presiding not over the movement of traffic, half forgotten here, but over the spectral fact, the negative itself, which is to say the dark obscure. There is, as a variation on this theme, a photograph by Minor White that seems, in its most startling element, the inverse of Brassaï's. Over a frozen field, with the spikes of a gathered crop, the granaries behind, there is way up in the frame, about

the size of Brassaï's clock, not the image of an eclipse but an adventitious black sun. It was caused, according to White, by a temperature so cold that when the picture was taken the camera's shutter froze, and in the severe overexposure certain tones were reversed. "I accept the symbolism with joy," White wrote. And then with the vanity of imagination whose power yields nothing but its complicity to the operations of chance: "The sun is not fiery after all, but a dead planet. We on earth give it its light" (*Great Photographers* 217). Every now and then we may see a photograph whose startling contingency is such that it seems justified in getting its science—in this case, astronomy—wrong. I am reminded of William Butler Yeats who, when informed that the sun doesn't rise, simply said that it should.

Rising or setting, it is in terms of the solar phenomenon, its economy of exchange, that we may think of the history of photography as an analogue of our cultural history. Or—not only because the camera disrupts the envisaged tissue of our cultural codes—as the fate of representation which is the representation of our fate. I was very conscious of this recently in Japan, land of the rising sun, at the Tokyo Metropolitan Museum of Photography, which had just bought up an astonishing collection of the earliest work, much of which was hard to see in the vigilantly low kilowatts of the exhibition: daguerreotypes, including Chavaut's *Portrait d'un mort*, death in the photograph doubled over, that vision, light unto light protected from the light in the miniature of a coffin, its velvet reliquary box; salted paper prints, including the famous autoportrait of Hippolyte Bayard, the photographer who, because unrecognized like Daguerre and Niepce for his pioneering effort, performed (for the extended period of the exposure) his own death; calotypes and calotype negatives, suggesting the double hauntedness of photography in the hauntedness of its object. It was, in the remembered suspension of light, a spectacle of disappearance.

Which is why Barthes, speaking of entering, with the photograph, into *"flat Death,"* associates photography with the theater, the economy of death whose substance is disappearance: now you see it now you don't, the photograph raising the question in its apparent permanence of whether you see *it* at all, "it all, it all" as the figure says in Beckett's *Footfalls*, for "it is a denatured theater where death cannot 'be contemplated,' reflected and interiorized" (Barthes 90). However lifelike, then, the photograph may be, however activated its surface, it is the energetics of its flatness that makes it a kind of primitive theater or *tableau vivant*, "a figuration of the motionless and made-up face beneath which we see the dead" (32). This is a theater, however, in which there remains the abyss between actors and audience, like that between the living and the dead, which was, in Benjamin's imagining of an epic theater, filled in with the orchestra pit, and its indelible traces of a sacred origin. The earlier Barthes was Brechtian too, remaining so through much of his career, and the ontology of photography in *Camera Lucida* is quite specifically con-

Fig. 2. Hippolyte Bayard, "This is the Corpse of the Late
Bayard . . . " (1840). From Claude Nori, *French Photography: From
Its Origins to the Present* (New York: Pantheon Books, 1979) 3.

scious of the illusory status of a sacred origin, which required us to seek in the
modern world a new image of "an asymbolic Death, outside of religion, outside of
ritual" (92). Yet if he claims that putting aside the social and economic context
permits us, provisionally, to think of photography *more* discretely, not less, that is
because the click of a camera literalizes, for him, the division between this life and
a "total, undialectical Death" (92)—the representation of which is, as the first and
last vanity of the dispensation of light, the fate of representation.

We may have ideological sentiments in the matter, but on the difference be-
tween Benjamin's vision of a tribunal rising from the abyss and Barthes's vision of
a severed space, an edge, shutter closed, between the living and the dead—these
two forms of theater, and what they imply for action and demand of actors—his-
tory itself has thrown a variable light, from culture to culture, and particularly re-
cent history. As for the course of our cultural history seen in terms of the history
of photography, there the darkness drops again, as in the nightmare vision of
Yeats's poem, where images came out of the *Spiritus Mundi* with all the wonder of
their appearance on a photographic plate. The question, of course, was how to keep
them there, and, as Ibsen saw in the constructed wilderness behind the photo-
graphic studio, where the miracle was to occur, as in the darkroom itself, there was
the reality of the image that won't take.

Thus, even before Fox Talbot's calotypes—the photogenic but unstable botanical specimens and light-gathered lace—there were Thomas Wedgewood's frustrating experiments, around 1800, with the imprinting of leaves, the wings of insects, and images of paintings on glass. The problem with these early "sun prints" or photograms was how to preserve them before they turned black. Wedgewood had to keep them in the dark, virtually unseeable, snatching a peek in tremulous candlelight, because the unexposed silver salts were insoluble in water, and without discovering how to dissolve them, it was impossible to fix the fugitive image. This task, to *fix the image*, marks the laborious history of early photography, as of early modernism, sometimes to the point of fanaticism, the crux of the problem being, as with the history of culture, *how to ward off the action of light before it goes too far*. The distressing thing is that it seems to have gone too far even after the quick fix, as if the hypo released hysteria, a cataract of the eye.

"History is hysterical," writes Barthes, of the history inseparable from the photographic image: "it is constituted only if we consider it, only if we look at it—and in order to look at it, we must be excluded from it. As a living soul," he declares, working up thus a little hysteria of his own, "I am the very contrary of History, I am what belies it, destroys it for the sake of my own history (impossible for me to believe in 'witnesses' . . .)" (65). But as he examines the rip, the tear, the wound, the breach, the *punctum* in the personal array of photographs, in what might be regarded as the self-mesmerized domain of a capricious eye, ahistorical, arbitrary, purely affective, the hysteria seems contagious. (Barthes, we know, was perfectly capable of reading the photograph as a cultural production or a specimen of mythology.) And even when we return to what he calls the *studium*, the reading that passes through knowledge and culture, none of us is excluded, for there seems to be a *punctum* or puncture in reality as well, between private and public, the two kinds of history, and there are times when, fixed and fascinating as they are, monocular, quicker, chemically occulted, the hallucinatory profusion of photographs around us seems to be an immense defense mechanism of culture itself, a last-ditch defense, trying to drain the light before another sort of breach, when the ozone layer widens and, after an imprint of the "intense inane," it all turns black, a photogram of apocalypse—the one master narrative of the modern that we can hardly do without.

Which is why mourning, or the repression of mourning, has been, when we think it over—as a photographically oriented art history has started to do—the constitutional emotion behind the politics of the postmodern, with Benjamin's panoramatic vision of the baroque as its material setting: a place of ruins and corpses, funerary, bereaved, the seeds of history spilled upon the ground (*Origin* 92). I am reminded of the stains of Rodchenko's picture, assembled for a demonstration, like the Soviet youths in formation at the top of the street, demonstrating nothing after all but the making of a picture. Without eschatology, as Benjamin said, only allegory in sight, but as in the photomontage of John Baldessari today, a

"blasted allegory," where even the captions are collapsed into the combinatory sets, with meaning as a prospect, but always impeccably severed from any semblance of truth. These are not at all, however, the Brechtian captions whose antecedents were, in the ruined landscape of the baroque, the emblematic inscriptions around the tombs. Nor is the mood of Baldessari's work, the wit and irony of its teasing opacity, anything like what suffuses Benjamin's study of the *Trauerspiel*, no less the emotion which rises from the surface of Rodchenko's photograph if, the revolution already failing him then, we happen to look at it now.

Could we really contain that within a caption? And what kind of caption would it be? The problem of the caption posed by Brecht was brought up by Benjamin in the "Short History," that of attaching an instructive reading to a photograph of the Krupp works, since without a construction put upon it, the indifferent camera "yields almost nothing about these institutions" (24), where, with reality slipping into the merely functional, reification takes over. It is at this point, Benjamin writes, that "the caption must step in, thereby creating a photography which literarizes the relationships of life," directing attention to the scene of action like, presumably, the photographs of Atget (25). That the photographs of Atget seem to lead, as Benjamin implies, to the scene of a crime doesn't seem to me invariably true, but even when they do (impossible for me to believe in witnesses), what crime are we supposed to see? "Is it not the task of the photographer—descendant of the augurs and haruspices—to uncover guilt and name the guilty in his pictures?" (25). This is the mystical side of Benjamin mixed with his social conscience. We can also see in his feeling for prophecy and divination that, while he rejected the mystical-scientistic nexus in photography, he was always fascinated by the prospect of the aura, its rematerialization, even when as in Atget the object seemed to be liberated from it.

As a practitioner of the art of light, Atget is surely in the tradition of the augurs and haruspices, like Fox Talbot himself speaking of photography as the pencil of nature. But if he was not quite in the tradition of the spirit photography described by Huysmans in *Against the Grain*, or that of Buguet, who was called upon after the Franco-Prussian War to photograph the first ghosts, which he did—by overexposures superimposed upon images of the living dead who would thus return—he did photograph himself as mirrored in the entrance of a café, and among the ten thousand pictures in the archive there are numerous multiple exposures and superimpositions that suggest either playing with visual identities or experiments in spatial geometries or the resources of light itself or the self-reflexivity of the photograph rehearsing how it was made. However we read all this, and the enormous body of Atget's work—whether as mostly utilitarian, documentation for artists, or, with various ventures into the mysteries of form, the slow emergence of a master with the most scrupulous certitude of craft, or, as Rosalind Krauss does, the

visual accumulation which is, to begin with, in the service of the archive itself, "*subjects*, . . . functions of the catalogue, to which Atget himself is *subject*" (149)—one certitude we do not have, because of his reticence, is how he stood on any questions that bear upon politics, aesthetics, the relation between them, or photography as a discursive space.

It is hard to believe that a man so observant was totally unaffected by the innovative artists—Braque, Utrillo—he also served. But so far as his own technique is any testimony, and the processing of his prints, they suggest that he was very much of the nineteenth century, and there is reason for Beaumont Newhall saying, in his history, of Atget, that "it is often hard to believe that he did most of his work after 1900" (195). Even if one distrusts Newhall's contribution to the ideology of the aesthetic in photography, and the canonical in his history, there is more than sufficient evidence that Atget shared those nineteenth-century habits of mind that, as with other photographers, still moved between science and its other, whatever that was; and it could be more or less spiritistic. Thus, a photograph might have both the qualities of an effigy or fetish, while the registration of an object, the activity of the trace, might still convey its material status in an actual world. The trace itself might be understood, as in countless photographs of Atget, as a manifestation of meaning, though I'd hesitate to say with any confidence that I knew what that meaning is. There is the possibility that, at the scene of the crime, he may have, in a precipitation of consciousness, uncovered guilt, as in the store window on the Avenue des Gobelins (Atget 4:136), with its grinning mannequins (male) in stiff collars, all of them with a price, so caught up, however, in reflections of buildings, trees, and the window's fabric that the photograph was thought to be a mistake; or the pictures of brothel life commissioned by the artist André Dignimont, one outdoor scene so astutely composed that the sloping cobbles and angled walls lead to the self-possessed woman, oddly perched on the porch (she seems not exactly to be sitting or standing) with a shadow flowing from her black skirt into the rectangular blackness of the corridor (4:107). The minimalist geometry of that black plane may be telling a story, as of something blocked or off-limits, but it is still hard for me to imagine Atget *naming* the guilty in his pictures.

Or, if he should approach something like that, not anymore, surely, than two pictures actually taken at the Krupp Cast-Steel Factory, by anonymous photographers, one in 1900, the other in 1911, and shown at an exhibition at the Museum of Modern Art in 1989 (Szarkowski 143, 161). It may be that being shown at MOMA is, any way you look at it, the wrong construction to put upon a photograph, even the most demystifying by Atget, about whom Benjamin conjectures that, as a former actor "repelled by his profession, [he] tore off his mask and then sought to strip reality of its camouflage" ("Short History" 20). There is nothing so melodramatic in either of the anonymous photographs, which seem part of the history of utilitarian reports on factories, machinery, industrial processes; and while they lack the "pristine intensity" of the imaged materiality in Atget's pictures—the quality

Fig. 3. Worker with Locomotive Wheel Tire, Fried.Krupp
Cast-Steel Factory, Essen (1900). Photo: Historisches Archiv,
Fried.Krupp AG, Essen.

attributed by Benjamin to the photographs in Breton's *Nadja*—it seems to me that
they more specifically uncover guilt, if you're looking for it, than the more impas-
sive revelations you'll find in Atget; and, though maybe intended as nothing but
documentation, without any captions.

The first picture is of a worker rolling the steel tire of a locomotive wheel. The
man, wearing a cap, is stripped to the waist, with what looks like the waistband of
his trousers flipped down, slouched below the belly's flesh. The leading edge of the
tire and the man's back foot are cut off at the frame, like (if you'll forgive the
conjecture) the projected logic of advancing capitalism, though the muteness of ef-
fortless muscle might bring it down on either side of the unstable equation, *then*, of
exploitation/productivity in an irreversibly industrial world. The second photo-
graph is, in a retrospective look, potentially more ominous. There is another man
in a cap, his somewhat grimy jacket buttoned, and a grimly mustached face, at the
lower end of the frame dominated by a turbine tube. He is holding a ruler verti-

Fig. 4. Inside of the Turbine Tube, Fried.Krupp Cast-Steel Factory, Essen (1911). Photo: Historisches Archiv, Fried.Krupp AG, Essen.

cally to measure the diameter of the tube, of which he is—disconsolate? embarrassed? indifferent? bored?—less than half the size. Possibly because the photographer told him to, he is turned half away from the camera, looking somewhere beyond the frame, perhaps at a supervisor also giving instructions. Already diminished by the massive tube, it is as if he were belittled additionally by the photographic occasion, a "technique of diminution" (Benjamin), and so far as I can read his expression, his sense of inconsequence is not at all disguised. But then, of course, he doesn't speak.

Could this muteness be a preface to action, calling for a caption? And, given the guesswork in my readings, any readings, what might a caption do? That would depend, of course, on where the photographs might be shown again, when, and for whom. That would have been true at least since the Brechtian distrust of the unaided camera and the unarmed eye, but we are especially vigilant now about the social formations in which photography occurs, having become aware of the emergence of an economy in which it functions everywhere as the instrumental means of a system of surveillance and documentation. And within this dispensation of thought, the measure of photography as practice, artwork perhaps, but always suspiciously art, would be the degree to which the work itself contained an analysis, along the lines of Martha Rosler or Hans Haacke, of the institutional frame: gallery,

museum, systems of distribution, the curatorial elite, and the long investment, pay-ing off in the rising prices for photography, of the idea of photography as art. We are quite a long way now from what Nadar could say about photography in 1856, putting aside what was required for a portrait, no less the portrait of his mother (or wife), which Barthes—comparing it to the Winter Garden photograph of his mother—called one of the loveliest ever made: psychological acuity, a combination of directness and empathy, communion with the subject, the sitter, all of which we might consider humanistic garbage now. "Photography is a marvellous discovery," said Nadar, "a science that has attracted the greatest intellects, an art that excites the most astute minds—and one that can be practiced by any imbecile. . . . Photo-graphic theory can be taught in an hour, the basic technique in a day. But what cannot be taught is the feeling for light" (Newhall 66).

It was light that once gave meaning to photography, and I want to return to that; but if it is true, as current theory would have it, that photography has no meaning outside of the specific relations of production in its historical context, one thing is clear about our present context: any caption that I might imagine for the Krupp factory photograph would contribute no more, nor less, to the class struggle, the ostensible motive of a caption, than the critical discourse and photographic practice, some of it in museums, that is presumably aligned with it. Abigail Solo-mon-Godeau has written of "critical practices not specifically calibrated to resist recuperation as aesthetic commodities," that they "almost immediately succumb to this process" (72). One can hardly think of a practice of any consequence, Rosler's, Haacke's, Brecht's itself, that does not succumb anyhow, just as eliminating the hard-and-fast distinction between art and activism does not prevent, even for some activists, the "apparent collapse of any hard-and-fast distinction between art and advertising" (73). In this collapse of art, advertising, activism, the enigma, I sup-pose, is Andy Warhol, who also collapses the distinction between art, photography, and performance.

Since I have reflected on photography as a form of theater, in the drift of the-ory determined by Brecht, what follows is not exactly an aside, though I am con-scious of a certain wariness about theorizing from experience: having directed some of the earliest productions of Brecht's plays in the United States, including the American premiere of *Mother Courage*—attentive to the class struggle (San Francisco, at the time, was a rabid labor town, with a Communist newspaper be-sides), scrupulous about historicization, estrangement, the emblematic coding of events, the caption, I am still not at all convinced that the double articulation of a narrative has any more ideological potency than the autonomous image in the in-directions of thought, depending on the intelligence that went into the image and who, in the activity of perception, is doing the thinking. (It is very likely to be, as with Brecht's own productions at the Berliner Ensemble in East Berlin, an audi-ence of bourgeois intelligentsia, to puzzle with him over why all the captions in the

world or other alienating devices couldn't keep Mother Courage from eliciting sympathy, misleading emotion, and undoing what he wanted us to understand.) The fact of the matter is that the most efficacious political production of that period in San Francisco—a matter of timing and attunement to the exigencies of the time, yet almost a matter of chance—was the rather bewildering action, then, or want of it, in Beckett's *Waiting for Godot*, which corresponded, in the plaintive image of its negative capability, the waiting, the passivity, the sitdowns, to the early stages of the civil rights movement, as well as to the waiting, the slave/master consciousness, at San Quentin Prison, where it became legendary, and a model for alternative forms of theater, in prisons, factories, Indian reservations, the ghettos, the streets, wherever. Beckett, by the way, told me shortly after our production that he had always thought of political solutions as going from one insane asylum to another; this didn't prevent him from working, during the occupation by the Nazis, in the French resistance.

"[One] feels the need," says Hal Foster, "all the more urgently for a historically redemptive, socially resistant cultural practice" (25). One may feel the need but practice quite differently than anticipated by those who share it, and some who do not share it, the need, may turn out to be more redemptive, socially resistant—over a period of time, historically—than those who might articulate their resistance, some of them eloquently, movingly, but rarely so, as always in art, most of them predictable, outguessable, always already heard. At the same time, the argument for a self-conscious, intentional oppositional practice has again been put in question by chance, in the political uproar around the works of Andreas Serrano and Robert Mapplethorpe.

Serrano, by his own testimony, is a somewhat reclusive artist whose earliest pieces reworked Christian iconography in stylized tableaux, the images growing more rather than less abstract as he approached various social and religious taboos, using a variety of body fluids: breast milk, menstrual blood, semen, and the piss which caused a scandal when he immersed a crucifix in it. He remains fascinated with religious iconography, though transplanted now to a more specifically political terrain: his photographs of the Klan and the homeless. The style was never quite political before, and there is nothing inarguably oppositional in his practice now. The Klan pictures—and the rapport he had to establish with the Klansmen to get them—are equivocal; and who is not sympathetic to the homeless, whom he similarly ennobled *as images*, after paying them to pose, though we are surely more conflicted when we encounter the Klansman in full regalia and the same style. Actually, Serrano's current style—which I saw at the Galerie Templon in Paris, something like being shown by Leo Castelli in New York—is not radically different from the indirection and ambiguity of his earlier work, the technique cool, conceptual, symbols outside the mainstream (like symbolism itself), charged with his own emotions as a former Catholic who does not mind, even today, being called a Christian (Fusco 43).

What made Serrano's *Piss Christ* oppositional, then, was the award from a gov-

ernment agency that occasioned the controversy; not anything designed as opposi-
tional practice, but an unexpected attack by the fundamentalist Right, whom he is
trying to understand better now in the formal if not formalist portraits of the
Klansmen. As for Mapplethorpe, here we have various ironies, given the ideological
animus of the critique of modernism. I am hardly the only one to think his photo-
graphs were not in any way oppositional, whatever his sexual practices. They were
adept, rather, in drawing upon the formal resources of modernist photography, but
as if filling in the prescription with a more powerful medicine, S&M, B&D, without
any criticism whatever in the photographic space of the artistic regimen or its in-
stitutional structures that he was more or less ripping off. In this regard, one may
want to contrast the photographs of Mapplethorpe with certain pictures by the
fashion photographers Richard Avedon or Irving Penn, both of whom extend the
resources at their disposal or, critically, even severely, narrow them down, as Penn
did quite literally in the portraits where celebrities (Noel Coward, the young Joe
Louis) are wedged into a corner, as if the imperiousness of the modernist artist
were being literalized in the visual text (Coward playing it to the hilt; in the case
of Joe Louis, a standoff, since he was there, ready to go, a menace in the corner).
All of this is to say, again, as Brecht did to Lukács, that formal innovation may be
dissident content in the mind as content alone is unlikely to be, at least for very
long. As for the controversy over Mapplethorpe's most repellent content, the hard
stuff itself, need I comment on the hypocrisy that eventuates when, in the necessi-
ties of a legal defense, those who have bought all the platitudes about modernism
and formalism assure us that content, as such, has no existence in a work of art
except as form. How, indeed, are you going to caption that?

Which is not to say that captioning can't be honest and complex, with a sug-
gestiveness in its own right, as it is in Rosler or Baldessari, although it's a toss-up
as far as I'm concerned as to which of the two is more effective politically. With
both of them, of course, we are dealing for the most part with either deliberately
banal or appropriated photography, as on the billboards of Barbara Kruger, which
for all her intelligence, and a commendable politics, are obviously not in the same
ballpark with the photomontages of John Heartfield—impact muted in any event
by the dispersions of our history and, however specifically calibrated her resistance,
the counter-appropriation of the institutions that commission her. I moved into this
discussion of the caption through Benjamin's designation of Atget, the actor who
tore off his disguise, as a figure of oppositional practice, but it should be obvious
that whatever politics we have in the photographic work of the postmodern, little
of it has the quality of feeling, the tonality, the texture, that confronts us in Atget,
who almost reverses the loss of aura by drawing the banality from a boot, a door-
knob, a lampshade, a leaf, making them iridescent, not unlike Pound's petals on a
wet black bough; or when the reflections deepen and glisten, warmed in the brown-
ing of overexposures, the datum of that image, not the crowd, which is "the social

basis for the decay of the aura" (Benjamin, *Illuminations* 225), but "the apparition of these faces in the crowd," as Pound wrote: direct treatment of the object, even when mirrored, reduced to essentials; in short, that concentrate of an image, fixed, an intellectual and emotional complex in an instant of time.

If that should make the photographs of Atget in any way a model of revolutionary practice—as Allan Sekula suggests at the end of a finely researched essay on the juridical use of archives of images of the body—it is not merely because of the detective work or spying in the telling detail, but because of the *precise ambiguity* of the detail, its *profane illumination*—like the materiality of light, to which we give light—"a materialistic, anthropological inspiration," which was precisely the quality discerned in Atget by the surrealists, about whom Benjamin, in his remarkable essay on surrealism (entitled "The Last Snapshot of the European Intellectuals") used that term with that definition (*Reflections* 179).[1] The surrealists also responded, no doubt, to intimations of "convulsive beauty" in the capacious reflections surrounding the details, as in another store window on the Avenue des Gobelins (4:137–38), with the curled (beckoning?) fingers of the mannequins (this time female, also with a price); or leading up to the details, the classical statues like dolls in the distance, in the lonely curvature of the pond at St. Cloud (3:122–31), trees, clouds, topiary lyrically mirrored, a chrysalis of time, as if mourning the passing of the formal existence of that culture whose barbarities paid for it—which hardly seems to me, overcast as it may be, an incrimination of the exploitative indulgence of civic beauty by institutionalized state power, represented perhaps by the exquisite presence, in some of the many views, of the Petit Trianon (3:39, 59).

Such beauty is always liable, of course, as it reflects itself in art—and while there are many boring prints of Atget, I insist that this is art—liable to what has become the much theorized crime or vice of representation: "stylistic transcendence." This is, we know, the incessant charge brought against modernist art and its desire in a world divested of the sacred for what might also be described as profane illumination, epiphanic in its materialism or "shot through with chips of Messianic time," as in Benjamin's "Theses on the Philosophy of History," the shock, the blast, the arrest, crystallized into a *monad*, "the sign of a Messianic cessation of happening, or, put differently, a revolutionary chance in the fight for the oppressed past" (*Illuminations* 264–65). This chance would seem to come from that "secret heliotropism" of which "a historical materialist must be aware" (257), the past seized only as image, flashing up in an instant, more or less intoxicating in its accomplishment of form. Thus it is, it seems to me (without the Messianism perhaps, although what are we to make of the obsessional patience in the archive?) in the prints of Atget, with their early morning light, made through long exposure, on aristotype paper toned with gold chloride, as if to affirm the photograph's autonomy, whether the image was a historic monument, a ragpicker with his cart, the inside of a palace, or a bourgeois home. Or like his predecessors who struggled with preserving the image, the encrypted trace of natural things, spectral twigs or fallen leaves, the

seeds of history scattered on the ground, as on the elegiac landscape of the baroque.

As for those with a heavy investment today in mechanical reproduction as the instrumental means, indeed, the basic principle for undoing formalism and its vice of transcendence, with photography as the ground of an oppositional aesthetic, they have not always been able to absorb from Benjamin's study of the *Trauerspiel*, along with the ethos of montage, its tone of lamentations. Nor have they picked up from its modernist inclination to disjuncture and obscurity that it may be closer to the T. S. Eliot of *The Waste Land*, and its heap of broken images, than to the plays of Brecht, unless it be the early Brecht, creator of Baal, that imageless image of the Canaanite god. Born of the great sky above, Baal exists in his successive deteriorations, like the light first trapped on a sensitized plate. The intractable referent of the photograph, what it can't get rid of, suffuses our sense of both, the referent and the photograph, as Barthes says, with an "amorous or funereal immobility, at the very heart of the moving world," which is like a description of Baal, who is also "glued together, limb by limb, like the condemned man and the corpse in certain tortures, or even like those fish . . . which navigate in convoy, as though united by an eternal coitus." Yet, in aspiring to be a sign, this fatality of the photograph gets in the way: "photographs are signs which don't *take*, which *turn*, as milk does" (Barthes 6). Baal is a sign that does not take, which turns, and in turning smells to high heaven, abode of his mother and mother's milk. We may be reminded of the wild and furtive odor in the beginning, in the theater's landscape of dispersed speech, and the conflation of theater and the diorama and painting and photography (and ideology as well) through the camera obscura, so that "whatever it grants to vision and whatever its manner, a photograph is always invisible, it is not it that we see" (Barthes 6). The scenes of *Baal* occur with the rapidity of photographic exposures, each of them with a caption that he escapes, while his swelling and stinking body—that pale lump of fat that makes a man think, like the fat in the fetishes of Joseph Beuys—seems in its mortifications like an imprinted residue of the radiant flesh of the world, original point of vision, flat-out vision, susceptible at every moment not to the logocentrism but to the maternal womb, vast and hugely marvelous, in the vicissitudes of light.

This dubious imprint was foreshadowed in the "ungainly luminous deteriorations" of the early photograph—a phrase I take from the "shuttered" night of Barnes's *Nightwood* (34)—and the issues focused in those deteriorations have become today, as with Brecht's turn to a more rationalizable drama, profoundly ideological. That the solar phenomenon remains confounding we can also see in the negative theology of poststructuralist thought, but most particularly in Derrida's essay on Levinas, which tries to make distinctions about violence and metaphysics within the orders of light, its commandment, conceding at the outset that "it is difficult to maintain a philosophical discourse against light." So, too, "the nudity of the face of the other—the epiphany of a certain non-light before which all vio-

lence is to be quieted and disarmed—will still have to be exposed to a certain en-
lightenment" (85). If this "certain" seems a little uncertain, or begrudging, that
may be attributed, by those who have been critical of poststructuralist thought, to
an incorrigible ahistoricism.

Yet, as we historicize the matter in a visual culture whose history moves before
us in the blink of an eye, we find ourselves faulting vision, the mandate of light in
the spot on the brain, the ethic in the optic, the specular drive, precisely when it
finds itself baffled by overdrive: eyesight fading from too much sight, and with it the
difficult-to-attain, costly powers of discrimination; that is, the capacity in seeing to
distinguish this from that, which remains the basis of any moral measure we have,
and without which a politics is only a question of power. I say this with full knowl-
edge of the possibility of vision's excess, the voracity of the eye which is, in the
critique of modernism, the ubiquitous issue I've described. I also realize that I have
conflated in passing various meanings of the word *vision*, eliding the difference at
times between what's in here and what's out there, although I have wanted to pro-
ject in all this not only the ideological but the discretionary basis of simple sight,
its capacity for *distinction*, which may sometimes occur—as it does, I think, in the
greatest art—*by eliding the difference*, and in the process bringing to simple sight
the resources of the imaginary. As for the ability to sort things out in the micro-
physics of power, that remains without vision a mere vanity of thought, or—not
that *this* not this *that*, click, click, like a parody of distinction—the metonymic long-
ing of semiotic desire.

I alluded before to the new rhetorics of the body, and a reversal of the order of
things in the hierarchy of the senses, all of which are in their way, as Marx called
them, "direct theoreticians"—none of them getting their way, theoretically, without
incursions of the other senses, which are intersected at every moment, as Marx also
said, by the entire history of the world. It may be that the theory of the eye—the
evil eye, the envenomed eye, the eye whose erection constitutes the gaze—has been
caught up from time to time in the wrong part of that history. But there is also the
eye of conscience, the eye that parses, cuts, gets to the heart of the matter, and the
eye that keeps an eye, as Shakespeare knew, on the liabilities of the other senses.
We may hear around corners without knowing who's there, and if touch has been
sentimentally restored as the privileged sense of intimacy, it is also the tactile
measure of an unnegotiable distance of which, in the microphysics of affections, the
intimacy is the index of what we'll never cross.

As we reach, then, an impasse in the quest of eyes—amid the media into which
all our senses have passed, and now seem prosthetically to surpass our senses—it
is the photograph that still retains the pathos of this distance, as if its surface were
a screen, the flat truth of the dimension between seeing and not-seeing, where the
thing to be seen remains the still compelling shadow of what we've seen before. In
my view, or viewfinder, there are those who can see and those who can't. And while
I am prepared to believe that what they see or choose to see may occur within a
system of representation that tends to reproduce its power, there are also those who

see so profoundly deep or so thick and fast—with such flat-out vision, in short—
that it seems at times that the codes are merely catching up, while the signifying
practices are in their self-conscious transgressions suffering in comparison a semi-
otic arrest. Not that this, not this that, another version, *this*, like the tireless facet-
planes of Cézanne, studied by the artists of the Photo-Secession after the scandal
of the Armory Show.

"We have to learn how to see," said Steiglitz, who stayed in the shadows but
masterminded the show. And then maybe with a sense that his *Flatiron Building*,
photographed ten years before, was a little too misty for flat-out vision, repeated as
if referring to himself, "We all have to learn to use our eyes. . . . "[2] I know Steiglitz's
reputation, that he could be imperious, that he also masterminded the perhaps du-
bious terms for photography as an art, but I suspect he also understood, like the
superlative modernist he was, that in urging us to see, there was no guarantee
that—even in his *Equivalents*, of inner and outer, the (in)capacities of all the
senses—we would ever see at all.

NOTES

1. It was in that essay, too, that he issued a premonitory caveat to our cultural critique and,
as in Peter Bürger, its view of the avant-garde, the new "obligatory misunderstanding of *l'art pour
l'art*." "For art's sake," Benjamin adds, "was scarcely ever to be taken literally; it was always a flag
under which sailed a cargo that could not be declared because it still lacked a name" (*Reflections*
183–84). If this suggests certain contradictions in the apparent politics of Benjamin, what he had
in mind is a project that would illuminate what, in the year of our stock market crash, he consid-
ered the crisis of the arts. This project, "written as it demands to be written," would arise not from
critique itself but from "the deeply grounded composition of an individual who, from inner com-
pulsion, portrays less a historical evolution than a constantly renewed, primal upsurge of esoteric
poetry—written in such a way that it would be one of those scholarly confessions that can be
counted in every century. The last page would have to show an x-ray picture of surrealism" (184),
like a rayograph of Man Ray, its precise mystifications, a deposit through light of reality itself,
inscribed.

2. Qtd. by Guido Bruno, "The Passing of '291,' " *Pearson's Magazine* 38.9 (1918): 402–403; my
source for this is Dijkstra 12.

WORKS CITED

Atget, Eugène. *The Work of Atget*. Ed. John Szarkowski and Maria Morris Hambourg. 4 vols. New
 York: Museum of Modern Art, 1985 (Vol. 3: *The Ancien Regime*; Vol. 4: *Modern Times*).
Barnes, Djuna. *Nightwood*. New York: New Directions, 1937.
Barthes, Roland. *Camera Lucida: Reflections on Photography*. Trans. Richard Howard. New York:
 Hill, 1981.

Baudrillard, Jean. "What Are You Doing after the Orgy?" *Artforum* 22.2 (1983): 42–46.

Benjamin, Walter. *Illuminations*. Ed. Hannah Arendt. Trans. Harry Zohn. New York: Schocken, 1977.

———. *The Origin of German Tragic Drama*. Trans. John Osborne. London: NLB, 1977.

———. *Reflections: Essays, Aphorisms, Autobiographical Writings*. Ed. Peter Demetz. Trans. Edmund Jephcott. New York: Harcourt, 1978.

———. "A Short History of Photography." Trans. Stanley Mitchell. *Screen* 13 (1972): 5–27.

Brassaï. *Paris de nuit/Nächtliches Paris*. Texts by Paul Morand, Lawrence Durrell, Henry Miller. Munich: Schirmer/Mosel, 1979.

Derrida, Jacques. "Violence and Metaphysics: An Essay on the Thought of Emmanuel Levinas." *Writing and Difference*. Trans. Alan Bass. Chicago: U of Chicago P, 1978. 79–153.

Dijkstra, Bram. *Cubism, Stieglitz, and the Early Poetry of Williams Carlos Williams: The Hieroglyphics of a New Speech*. Princeton: Princeton UP, 1969.

Foster, Hal. *Recodings: Art, Spectacle, Cultural Politics*. Port Townsend, WA: Bay, 1985.

Fusco, Coco. "Andreas Serrano Shoots the Klan: An Interview." *High Performance* 14.3 (1991): 40–45.

Great Photographers. New York: Time-Life Books, 1971.

Ibsen, Henrik. *The Wild Duck. Four Great Plays*. Trans. R. Farquharson Sharp. New York: Bantam, 1958. 217–305.

Krauss, Rosalind. "Photography's Discursive Spaces." *The Originality of the Avant-Garde and Other Modernist Myths*. Cambridge: MIT P, 1985. 131–50.

Krauss, Rosalind, and Jane Livingston. *L'Amour fou: Photography and Surrealism*. Washington: Corcoran Gallery of Art; New York: Abbeville, 1985.

Lacan, Jacques. *The Four Fundamental Concepts of Psychoanalysis*. Ed. Jacques-Alain Miller. Trans. Alan Sheridan. New York: Norton, 1978.

Nadar (Gaspard-Felix Tournachon). "My Life as a Photographer." *October* 5 (1978): 7–28.

Newhall, Beaumont. *The History of Photography: From 1839 to the Present*. New York: Museum of Modern Art/New York Graphic Society; Boston: Little, 1988.

Phillips, Christopher, ed. *Photography in the Modern Era: European Documents and Critical Writings, 1913–40*. New York: Metropolitan Museum of Art/Aperture, 1989.

Sekula, Allan. "The Body and the Archives." *October* 39 (1986): 3–64.

Solomon-Godeau, Abigail. "Living with Contradictions: Critical Practices in the Age of Supply-Side Aesthetics." *The Critical Image: Essays on Contemporary Photography*. Ed. Carol Squiers. Seattle: Bay, 1990. 59–79.

Szarkowski, John. *Photography until Now*. New York: Museum of Modern Art, 1989.

12

After Shock/Between Boredom and History
Patrice Petro

Banality? Why should the study of the banal itself be banal?
—Henri Lefebvre

Boredom is a very useful instrument with which to explore the past, and to stage a meaning between it and the present.
—Fredric Jameson

For the historian there are no banal things.
—Siegfried Giedion

My TITLE PROPOSES a rather unconventional relationship between modernity and the image by locating film and photography *after* the "shock of the new" and *within* what might be called an intermediary zone between boredom and history. By "after shock" I mean to suggest another side to modernity, when the "shock of the new" ceased to be shocking, when change itself had become routinized, commodified, banalized, and when the extraordinary, the unusual, and the fantastic became inextricably linked to the boring, the prosaic, and the everyday. The term *after shock* preserves an element of shock, but nonetheless signals the fading of its initial intensity. Not unlike the term *afterimage*, it invokes an impression, or experience, or affect that persists long after an image or stimulus has passed from view.

The second part of my title, "between boredom and history," posits a relationship between terms otherwise kept separate, given their distinct temporalities and identification with either subjective or historical time. Boredom, for instance, is typically thought to describe a subjective experience—a time without event, when nothing happens, a seemingly endless flux without beginning or end. History, by contrast, is commonly understood to document that which happened—a series of events, or, at least, moments thought to be eventful, which suggest that something occurred (rather than nothing at all). In locating film and photography *between* boredom and history and *after* the shock of the new—in other words, between the

Kiki de Montparnasse—
Kiki with her friends Therese
Treize de Caro and Lily (c. 1932).
Photograph by Brassaï. © Copy-
right Gilberte Brassaï. Photo
courtesy The Metropolitan Mu-
seum of Art, Warner Communi-
cations Inc. Fund, 1980.
(1980.1023.10).

psychic and the social, after that which happens and that which fails to occur—I aim to provide a different framework and series of questions for thinking historically about film, photography, and discourses of subjectivity in modernity.[1]

Two sets of images will serve to ground this analysis. The first is a selection of photographs taken by the French-Hungarian artist Brassaï in the late 1920s and early 1930s, entitled *The Secret Paris* and *Paris by Night*, which document Parisian life in the streets, brothels, alleyways, cabarets, and gay and lesbian nightclubs of the period—what Brassaï himself called "Paris at its least cosmopolitan, at its most alive, its most authentic."[2] The second set of images is a contemporary remake of Brassaï's work in the pages of *Rolling Stone*, a series of photographs taken by the American photographer Steven Meisel, featuring Madonna, and entitled "Flesh and Fantasy." By juxtaposing these two sets of images, and by exploring their views of sexuality and looking, I aim to stage an encounter between the past and the present, and thus to demonstrate the usefulness of the concept of boredom to an understanding of history and of historical change. In the case of Brassaï, for example, the representation of sexual otherness remains a nonevent, precisely banal, located in the moment after shock, and within the terms of everyday life. The Madonna remake, by contrast, reinvests sexuality with a sense of the eventful; as a result, sexual otherness reemerges in our own time as both provocative and shocking, the purported proof that something (rather than nothing at all) is taking place.

Before proceeding to these images, I would like to say something about the difficulty of writing about boredom—a difficulty that has little to do with the risks of complicity with the object. The pressing and more serious difficulty involves writing about boredom as *historical*, precisely because boredom is often considered to be without event, an experience (of being) suspended in time. Needless to say, just as it was once important to overcome the idea of history as mere reproduction of the past detached from the work of a writing subject, it is now important to overcome the idea of boredom as merely subjective, as somehow beyond historical forces or social change. There is, in fact, an extensive (if sometimes elusive) literature on boredom as a peculiarly modern experience, which encompasses romantic, scientific, psychoanalytic, and postmodern thought.[3] I therefore begin my analysis by providing a brief account of boredom theory which, not coincidentally, remains inextricably linked to modernity and to debates about the historical status of the image.

THE END OF HISTORY?

What were once vaguely apocalyptic pronouncements about photographic reproduction and "the end of history" have recently been reformulated according to a logic of cultural appropriation and cultural banality. In his book *Postmodernism, or, The Cultural Logic of Late Capitalism*, Fredric Jameson argues that the contemporary fascination with recycling past images and former styles merely fuels a per-

vasive sense of ahistoricity in the present. To counter this trend, he proposes—albeit briefly and rather tentatively—both a theory and an aesthetic practice of boredom. In the process, he makes three basic arguments about postmodernism and media, which I would like to consider further here.

First, Jameson claims that the Hollywood nostalgia film, a genre which appropriates and recycles historical images and styles, actually responds to a genuine "craving for historicity," only to then block or paralyze any real historical understanding. As he explains in a recent interview:

> The increasing number of films about the past are no longer historical; they are images, simulacra, and pastiches of the past. They are effectively a way of satisfying a chemical craving for historicity, using a product that substitutes for and blocks it. . . . [N]ostalgia art gives us the image of various generations of the past as fashion-plate images that entertain no determinable ideological relationship to other moments of time: they are not the outcome of anything, nor are they the antecedents of our present; they are simply images. (Stephanson 18)[4]

It is not, according to Jameson, simply historical consciousness that is lost in postmodernism. In a second and related argument, he further claims that such time-honored concepts as anxiety and alienation, much elaborated by philosophers of existence and the unconscious, "are no longer appropriate to the world of the postmodern" (14). This leads to his third and, for my purposes, final observation. Drawing upon his experience of reading modernist literature and of watching independent video, Jameson raises "the question of *boredom* as an aesthetic response and a phenomenological problem" in an effort to restore historical thinking and to refuse the (commodity) logic of postmodern practices. In one of the few extended passages about boredom in his book, he explains that, in the Freudian and Marxist traditions,

> "boredom" is taken not so much as an objective property of things and works but rather as a response to the blockage of energies (whether those be grasped in terms of desire or of praxis). Boredom then becomes interesting as a reaction to situations of paralysis and also, no doubt, as defense mechanism or avoidance behavior. Even taken in the narrower realm of cultural reception, boredom with a particular kind of work or style or content can always be used productively as a precious symptom of our own existential, ideological, and cultural limits, an index of what has to be refused in the way of other people's cultural practices, and their threat to our own rationalizations about the nature and value of art. (71–72)

One might argue with Jameson's own rationalizations about the nature and value of art, particularly his views of popular culture and high modernism. Of course, Jameson seems to anticipate this critique by attributing boredom with certain works and styles to a kind of (critical) paralysis, a reaction formation based as much on personal taste as on ideological grounds. One might nevertheless question Jameson's own nostalgia and personal taste for an aesthetic of self-alienation and anxiety (what Jacqueline Rose has called a nostalgia for "the passing of a fantasy of the male self" [243]). I am more interested here, however, in exploring his all too

brief, but nevertheless extremely suggestive, remarks about boredom as a mode of refusal, and boredom as a symptom of our existential, ideological, and cultural limits.

BOREDOM THEORY

To begin with the terms of Jameson's own analysis: How is boredom both an aesthetic response and a phenomenological problem? If it is an aesthetic response, to what does it respond? A blockage of energies? A situation of paralysis? In other words, is boredom a defense mechanism or avoidance behavior—an aesthetic response to the blockage or paralysis of historicity—or, is it, in fact, the thing itself? Questions must also be raised with respect to the phenomenological problem of boredom and subjectivity. Is boredom a passing mood? A more lasting disposition or mindset? Or is it an emotion or, rather, the very opposite of an emotion, a lack or waning of affect? In this regard, boredom reemerges as both an aesthetic and a phenomenological problem, which is to say, boredom seems to be about both too much and too little, sensory overload and sensory deprivation, anxieties of excess as well as anxieties of loss.

These issues are further complicated by the slippage or semantic permeability of the term *boredom* itself—its ability to begin as one thing, only to turn into something else, usually some other particularly intense emotion, disposition, or mood. In philosophical, clinical, and scientific discourses, boredom seldom exists in isolation from another term or set of terms. For example, in eighteenth-century theories of the sublime, boredom is typically assumed to mask uneasiness, anxiety, or terror; as such, it is theorized as a reaction to privation or absence, a refusal to engage the unattainable or unrepresentable by remaining resolutely within the realm of the common, the ordinary, and the everyday.[5] In nineteenth-century romanticism, boredom takes on the quality of negative passion, associated both with the nothingness and nonbeing of the sublime as well as the unbearable experience of being in the everyday (in other words, a negative passion is transformed into passion for negativity).[6] In the twentieth century, particularly in the discourses of psychoanalysis and clinical practice, boredom becomes inextricably linked to depression, and to anger, grief, or loss as the source of a depression which must be experienced, overcome, and worked through.[7] (In this respect, the psychoanalytic cure of boredom is similar to that evoked by the romantics.) In critical theory, particularly German critical theory of the 1920s and 1930s, boredom is understood in relation to leisure, and also to waiting, to an expectation or future orientation of subjectivity devoid of anxiety or alienation.[8] Finally, in contemporary theories of the postmodern, boredom is associated with both frustration and relief, or, in other words, with the frustration of the everyday and with the relief from frustration in the gesture of aesthetic refusal; boredom thus becomes, as in Jameson's text, both a symptom and a cure.

What this points to, among other things, is that boredom has a history, which is as much a history of the subject as it is of cultural change. In a recent study of *ennui* and its discourses, French theorist Michèle Huguet refers to this "socio-cultural permeability" of boredom and its subjectivities when she writes:

> There is not one psychology of boredom but many, the common feature of which betrays the way in which, when confronted with a void which is painfully experienced, the subject can elaborate its defenses according to an ideal that is perceived as absent, unsatisfying, or impossible. . . . The subject experiencing boredom is not suffering from an absence of desire, but from its indetermination, which in turn forces the subject to wander, in search of a point of fixation. (215)[9]

The notion of indetermination—of a desire, of an ideal, and of a void—helps to situate historically the various permutations of boredom I have already described. In his analysis of melancholy and European society, for instance, Wolf Lepenies explains that boredom and *ennui* are at least in part the expressions of a social class that has lost or has failed to achieve public significance. The French aristocracy in the eighteenth century and the German bourgeoisie in the nineteenth century, for example, had been cut off from acting in or influencing the world and thus, according to Lepenies, they articulated their powerlessness in literary forms of melancholy and *ennui*. Thomas Weiskel similarly maintains in his study of the romantic sublime that theories of boredom and anxiety assume their modern, secular quality only at the end of the eighteenth century; in other words, at the beginning of the formation of the modern bourgeois state. The modern period, which witnessed the growth of technology and urban spaces, the emergence of mass society, mass culture, and changes in the understanding of sexual difference, also witnessed a proliferation of literary discourses on boredom, which functioned to articulate the fading of subjectivity and the cure for its relief: a sublime experience of terror and astonishment, a romantic abandonment of self to negative passions, a modernist vision which revels in its own operation and, hence, in its own existence.[10]

Importantly, both the fear and the lure—and the gendered connotations—surrounding the loss of self undergo significant changes in the course of the nineteenth and twentieth centuries. These changes, moreover, are registered in contemporary dictionary definitions of *ennui* and *boredom*.[11] *Ennui*, for instance, is defined as "a feeling of weariness and discontent, resulting from satiety or lack of interest"; as such, it designates a quality of spiritual malaise or inner migration produced by the difference or the gap between an ideal and its realization. As understood by the romantics, the first moderns of the nineteenth century, *ennui* involved an affective experience of anger and discontent, an anxiety of abundance and absence, and a perception of either too much or of nothing at all—themes that would later be taken up, in emergent theories of psychoanalysis, to describe a specifically masculine subjectivity, and the threat of symbolic castration involved in the subject's encounter with a feminine body perceived as both excessive and lacking.

In contrast to the passive and pathos-laden term *ennui*, boredom is defined more actively; indeed, its primary definition takes the form of a verb: "to weary by dullness, tedious repetition, unwelcome attentions; a cause of ennui or petty annoyance." Notably undervalued in boredom are the affects of anger and discontent, and the anxieties associated with both abundance and absence. Although *ennui* is still a part of the definition of boredom, it is subordinated to a secondary clause, treated on the same level as a "petty annoyance." What is more interesting, however, is that the definition of boredom introduces a potentially *visual* dimension to the experience of repetition and tedium in the form of "unwelcome attentions."[12] The term *boredom* thus anticipates a visual economy of repetition notably absent from *ennui*, and a displeasure in being seen while looking which simultaneously evokes the experiences of the classical male voyeur as well as the ostensible (feminine) object of his gaze.

This kind of looking in boredom further suggests an important link between boredom and theories of the image. As several commentators have pointed out, theories of the image have long been split between spiritualism and science; in other words, between philosophical and theological traditions on the one hand and scientific studies and documentary practices on the other.[13] The same could be said of boredom theory, of course, particularly given the way in which, in the nineteenth and twentieth centuries, boredom increasingly became a matter of visual perception, and therefore as much a scientific problem as a philosophical one. In a recent study of vision and modernity in the nineteenth century, Jonathan Crary explains that

> from the 1890s until well into the 1930s one of the central problems in mainstream psychology had been the nature of attention: the relation between stimulus and attention, problems of concentration, focalization, and distraction. How many sources of stimulation could one attend to simultaneously? How could novelty, familiarity, and repetition in attention be assessed? It was a problem whose position in the forefront of psychological discourses was directly related to the emergence of a social field increasingly saturated with sensory input. ("Spectacle" 102)

The fading of subjectivity and loss of conscious agency, registered in the term *ennui* and in other nineteenth-century discourses, were thus similarly in evidence in empirical studies of the eye and its tendency toward distraction and fatigue. Indeed, in Crary's view, scientific studies of experience and mental life merely underscored changes taking place elsewhere in conceptions of knowledge, as a direct result of the subject's encounter with "a social field increasingly saturated with sensory input." "Vision," he writes,

> rather than a privileged form of knowing, becomes itself an object of knowledge, of observation. From the beginning of the nineteenth century a science of vision will tend to mean increasingly an interrogation of the physiological makeup of the human subject, rather than the mechanics of light and optical transmission.

> It is a moment when the visible escapes from the timeless order of the camera obscura and becomes lodged in another apparatus, within the unstable physiology and temporality of the human body. (*Techniques* 40)

BOREDOM, DISTRACTION, SHOCK

Early scientific studies of visual perception were soon complemented, and complicated, by an emergent sociology, which interpreted the experience of boredom in far more critical, and less instrumental, terms. In his 1903 essay "The Metropolis and Mental Life," for example, Georg Simmel describes the effects of transportation and industrial production on the human sensorium and explains how overstimulation produces a peculiarly modern form of boredom in what he calls the "blasé attitude" or "outlook":

> There is perhaps no psychic phenomenon which is so unconditionally reserved to the city as the blasé outlook.... [For] just as an immoderately sensuous life makes one blasé because it stimulates the nerves to their utmost reactivity until they finally can no longer produce any reaction at all, so, less harmful stimuli ... force the nerves to make such violent responses, tear them about so brutally that they exhaust their last reserves of strength and, remaining in the same milieu, do not have time for new reserves to form.... This psychic mood is the correct subjective reflection of a complete money economy to the extent that money takes the place of all the manifoldness of things and expresses all qualitative distinctions between them in the distinction of "how much." (329–30)

Although Simmel never uses the term *distraction* in this essay, the violent sense impressions he describes are clearly the equivalent of distraction—an experience of sensory stimulation as sensory overload that leads to boredom, exhaustion, and indifference—the perception of a universal equality of things. Significantly, Simmel suggests that boredom is no longer the sole possession of a particular class (as it was thought to have been in the eighteenth and nineteenth centuries, especially in the attitudes and practices of those who pursued "an immoderately sensual life"). Instead, he argues that, by the turn of the century, boredom had become available to all through the leveling effects of a money economy, which had permeated leisure as well as labor time.

These ideas had a tremendous impact on the writings of Siegfried Kracauer and Walter Benjamin, two of the most important theorists of film in the twentieth century. It is well known, for example, that Kracauer and Benjamin extend the notions of distraction, sensory stimulation, and shock, initially elaborated by Simmel, to describe the aesthetics and reception conditions of photography and film. According to both theorists, film and photography rehearse in the realm of reception what Taylorism and industrial management impose on the human body in the realm of production; these media are, in Kracauer's words, "the aesthetic reflex of the rationality aspired to by the prevailing economic system" ("Mass Ornament" 70). Importantly, neither Kracauer nor Benjamin sees film and photography as

symptoms of a general cultural or historical decline; instead, they celebrate the cultural negativity of the new media for subverting the bourgeois cult of art and its aesthetic of illusionist absorption. Reception in a state of distraction, they argue, allows for a complex kind of training, sharpening the senses and enabling the subject to parry the shocks of a new, and often antagonistic, reality.[14]

While Kracauer and Benjamin are best known for their theories of modernity based on shock and distraction, what is less known, and less remarked upon, is their central preoccupation with boredom. As Heide Schlüpmann has argued in an extremely influential essay on early German film theory:

> The relation between film and the end of bourgeois culture is not so much captured in the term distraction [*Zerstreuung*], in which, after all, capitalism protects itself from its loss of metaphysical elevation. It is captured rather in what are interruptions in the production process: in a boredom that protects itself against organization, in a form of leisure as waiting. (50)

For Benjamin and Kracauer, boredom becomes a key concept for exploring subjectivity in modernity, not least of all because, in its German formulation (*Langeweile*, literally "a long whiling away of time"), boredom captures the modern experience of time as both empty and full, concentrated and distracted (the experience of temporal duration as well as temporal disruption in the sense of "killing time"). Whereas Benjamin tends to theorize boredom in relation to emptiness and *ennui* (typical of nineteenth-century formulations), Kracauer emphasizes the distracted fullness of a leisure time become empty (a twentieth-century view). The differences between these views of boredom are perhaps best illuminated by the images of modernity that emerge from their work: in Benjamin, the empty streets of Atget's Paris; in Kracauer, the crowded stadiums and picture palaces of 1920s Berlin.[15]

Both theorists nonetheless agree that boredom retains a radical edge—not unlike that attributed elsewhere to distraction and the sensation of shock—in that it helps to sustain subjectivity rather than simply contribute to its loss. "Monotony nourishes the new" (962), writes Benjamin in the notes to his unfinished Arcades project, where he also remarks, "boredom is the threshold of great deeds" (162). Similarly, in a 1924 essay devoted to boredom, Kracauer criticizes the restless pursuit of novelty in modernity and extols the virtues of boredom as perhaps "the only activity that may be called proper, since it offers a certain guarantee that one will have, so to speak, an existence at one's disposal" ("Langeweile" 324). Boredom and distraction, in other words, are complementary rather than opposing terms, whose relationship might be stated as follows: reception in a state of distraction reveals cultural disorder and increasing abstraction; the cultivation of boredom, however, discloses the logic of distraction, in which newness becomes a fetish, and shock itself a manifestation of the commodity form. To reverse the slogan of the Russian formalists, *boredom habitualizes renewed perception*, opening up differences that

make a difference, and refusing the ceaseless repetition of the new as the always-the-same.

In this regard, the relationship between boredom and waiting becomes especially important, for it is in a waiting without aim or purpose that the possibility of change may be sighted. "The more that life is regulated administratively," writes Benjamin, "the more people must learn waiting" (*Passagen-Werk* 178). Or, as Kracauer puts it, "He who decides to wait neither closes himself off from the possibilities of faith like the stubborn disciple of total emptiness, nor does he force this faith like the soul searchers who have lost all restraints in their longing" ("Die Wartenden" 116). Otherwise expressed, hidden in the innovation of distraction and shock is a despair that nothing further will happen. Hidden in the negativity of boredom and waiting, however, is the anticipation that something (different) might occur.

This becomes especially apparent when boredom, understood as a twentieth-century experience, is refracted through the lens of sexual difference. It is not insignificant, for example, that Kracauer describes boredom in relation to Taylorized labor and rationalized leisure and chooses a twentieth-century female figure—a middle-aged, working-class woman, who stops outside a movie theater, to stand for "those who wait." Benjamin, by contrast, describes boredom primarily as a form of leisure and embodies this figure in a variety of heroic nineteenth-century male types: "the gambler just killing time, the flâneur who charges time with power like a battery, and finally, a third type, he who charges time and gives its power out again in changed form—in that of expectation" (*Passagen-Werk* 164; trans. and qtd. in Buck-Morss 104). If we recall that, for many intellectuals at this time, the boredoms of modern life included "the spread of democracy to women and the lower classes, the replacement of governmental authority by popular votes, [and] the liberation of sexual activity from state and church dictates" (Jay 238), then we might reformulate the relationship between boredom and shock, and boredom and anxiety, along the lines of historical and gender difference.[16] As Jean-François Lyotard has written, "Shock is, *par excellence*, the evidence of (something) happening, rather than nothing at all" (40). Boredom, in this view, might be seen as evidence of nothing happening—a nothingness that accounts for women's experiences of modernity (especially in relation to the promises and failures of social change), and for men's perceptions of feminine excess and lack typical of nineteenth-century discourses on *ennui*.

Boredom, in other words, helps to describe a post-shock economy—that moment after the shock of the new described by Simmel—when exhaustion and indifference are no longer the preserve of a particular class (or, indeed, the sole prerogative of men). This is a moment when the new ceases to be shocking, when leisure as well as labor time becomes routinized, fetishized, commodified, and when the extraordinary, the unusual, and the unfamiliar are inextricably linked to the bor-

ing, the prosaic, and the everyday. Maurice Blanchot remarks of this relationship among boredom, perception, and everydayness that "boredom is the everyday become manifest: as a consequence of having lost its essential—constitutive—trait of being unperceived" (16). Or, in the words of Henri Lefebvre:

> The days follow one after another and resemble one another, and yet—here lies the contradiction at the heart of everydayness—everything changes. But the change is programmed: obsolescence is planned. Production anticipates reproduction; production produces change in such a way as to superimpose the impression of speed onto that of monotony. Some people cry out against the acceleration of time, others cry out against stagnation. They're both right. (10)

In contrast to eighteenth-century theorists of the sublime, who saw boredom as a reaction to the indeterminate and the sublime as an antidote to the ordinary and the everyday, twentieth-century theorists of boredom locate the indeterminate precisely within the realm of the everyday—that site of both change and stasis, identity and nonbeing, happenings and nonevents.

In this respect, boredom shares important affinities with traditions of the avant-garde, particularly those which come after political modernism and refuse its aesthetics of distraction, sensory stimulation, and shock. One thinks, for example, of the attitude of actively passive waiting in Beckett's *Waiting for Godot* (where "nothing happens, twice"), or of Warhol's notoriously esoteric and nearly unwatchable early films: *Eat* (forty-five minutes of a man eating a mushroom), *Kiss* (one closeup after another of people kissing), *Sleep* (six hours of a man sleeping), and *Empire* (eight hours of the Empire State Building).[17] To this, one might add Chantal Akerman's *Jeanne Dielman, 23 Quai du Commerce—1080 Bruxelles*, which explores the intolerably routinized, repetitious, and painful experience of time between events in a day in the life of a middle-class housewife. As these examples suggest, an aesthetic of boredom retains the modernist impulse of provocation and calculated assault. (How long must one watch and wait until something actually happens? How much tedium can one possibly stand?) It nevertheless abandons the modernist fiction of the self-contained aesthetic object, precisely by exploring the temporal and psychic structures of perception itself. The tedium and irritation of perceptual boredom, in other words, enable an awareness of looking as a temporal process—bound not to a particular object but to ways of seeing—at once historical and, as the examples above suggest, often gender specific.

BRASSAÏ, MADONNA

But if an aesthetics (or, rather, an anti-aesthetics) of boredom shares certain affinities with the avant-garde, it also shares characteristics with popular cultural practices, particularly those which attempt to render material otherwise immaterial or ephemeral experiences of everyday life. My examples of aesthetic and phenomenological boredom are therefore taken from photography and popular culture:

Brassaï's 1930s photographs of *Paris by Night* (as well as previously censored photographs from his collection entitled *The Secret Paris*), and the remake of these images by American photographer Steven Meisel in the pages of *Rolling Stone*, featuring Madonna and entitled "Flesh and Fantasy."

Brassaï was not only a photographer but also a painter, sculptor, and writer who photographed the prostitutes at the Bastille as well as the members of the Jockey Club, and who wrote a book about his housekeeper, Marie, as well as a book about Picasso. Although his intellectual affiliations were much closer to surrealism, Brassaï nonetheless earned the reputation as a "pioneer of documentary photography" as a result of having captured in images the underside of Parisian life in the 1930s, what he himself called "the cesspool cleaners, the inverts, the opium dens, the *bals musettes*, the bordellos, and the other seedy spots with their fauna" (Hill and Cooper 40). Brassaï nonetheless rightly rejected the title of "photojournalist" or "photo-reporter" for, as he put it, "it is not sociologists who provide insights but photographers of our sort who are observers at the very center of their times" (Hill and Cooper 40).

Brassaï published his photographs of Parisian nightlife in two separate editions. The first book, *Paris by Night*, was published in 1933; the second book, *The Secret Paris of the 1930s*, was initially censored and formally published only in 1976, decades after Brassaï had attained recognition for his other artistic work. The images included in both books nonetheless provide a view of Paris as the site of sexual otherness, and as the capital of a modernity that exudes boredom, exhaustion, and petty annoyance. The city as represented by Brassaï, for instance, is no longer the source of sensory overload or sensory deprivation. It is rather the site of an unsettled heterogeneity after the "shock of the new," when sexuality ceases to be shocking, and when boredom itself assumes the quality of a relief from anxiety. The mythic metaphors of progress that had long permeated historical and philosophical discourses are here unmasked and exposed: whether the images are of graffiti, of empty streets, or of prostitutes in dull sleep, there is no material abundance, no surface glitter or glamorous appearance, to offer proof of progress before our eyes. The lure is that of depersonalization. As Brassaï himself once said, "In photography you can never express yourself directly, only through optics, the physical and chemical processes. It is this sort of submission to the object and abnegation of self that is exactly what pleases me about photography" (Hill and Cooper 40).

Significantly, the photographs censored in the 1930s reemerge almost fifty years later via a discourse that promises to reveal the "secrets" and "mysteries" associated with sexual otherness and the body. A closer look at censored images themselves, however, suggests less the mystery than the banality of sexuality and sexual orientation—the everydayness of lesbian and gay life, for example—behind which there is no secret, no truth to be revealed or disclosed. Although sexual curiosity is undeniably part of their appeal, Brassaï's photographs do not exactly, or do not only, invite a voyeuristic gaze: within the confines of the carefully composed

and studied compositions, the figures seem at once aware of the photographer's presence and either mildly annoyed or entirely indifferent to his gaze.[18]

It is, of course, this calculated stance of indifference—this cultivation of boredom—that is notably missing from the remake, which dramatizes a longing for an active and unrestricted self at a mythical point in history.[19] One immediately notices, for example, that the remake chooses not to envision a city, or a street, or, indeed, any social or historical context. There is only the untrammeled personality of Madonna, played out across a series of photographs, which remain much slicker, much more aesthetic and sleekly calculated, than their prototype—in many ways closer to contemporary fashion photography than to Brassaï's representation of 1930s Parisian life. The remake, of course, is premised upon an internalized identification based on fantasy—not unlike other Madonna remakes of classic images, whether of Marlene or Marilyn, or of a film like *Metropolis*. The fantasy of sexual mobility, in other words, is confined to a single individual, and to the desire for a feminine identity that transgresses, by incorporating, traditional symbolic and social definitions.

This accounts in part for the very different structures of looking in the remake, and the distance it actually takes from Brassaï's work. Madonna's direct and knowing look at the camera, for instance, could not be further from the indifference of the female gaze registered in Brassaï. (Compare, for instance, Madonna's sultry look at the camera in the remake of Brassaï's "Kiki de Montparnasse and Two Friends.") Of course, one might wonder what prompted the remake of Brassaï in the first place. Madonna, somewhat disingenuously, explains: "For me, it was a great chance to re-create an era that I feel I would have really flourished in, that nothing I would have done would have been censored" ("Flesh and Fantasy" 44).[20] The appeal is thus to the apparently timeless secrets and mysteries of feminine sexuality, which allow Madonna to construct versions of herself as a way of acting out a narcissism across different subjectivities: the lover of women, the dominatrix, or the pin-up girl, draped in the American flag. To be sure, the remake discloses the disappearance of the photographer in a way similar to what occurs in Brassaï. Here, however, the disappearance of the photographer signals the reappearance of the performer. It is Madonna (and not the ambiguities of the image) that remains the ultimate curiosity.

To put this another way: whereas Brassaï admits to perceptual boredom in modernity, the remake aims to recuperate boredom as the fantasy of distraction and the sexualization of shock. As I have already indicated, the "shock effect" of the remake coincides with the return of aura, with what Benjamin called "the phony spell of the commodity" in the artificial buildup of the personality of the star. In this respect, and in this respect alone, no image in the series is boring. As Roland Barthes has put it, "You are not obliged to wait for the next in order to understand and be delighted; it is a question not of a dialectic (that time of pa-

tience required for certain pleasures) but of continuous jubilations made up of a summation of perfect instants" ("Diderot" 35).

This is not to say that the remake is beyond boredom, whether of an aesthetic or phenomenological kind. Indeed, whereas the Brassaï images remain provocative in their utter banality (they seem to have been censored for their representation of sexuality in its everydayness), the remake is banal in its attempt to shock and provoke. The Brassaï images, moreover, revel in the sexually indeterminate as a source of relief from the anxiety of modernity, whereas the remake discloses a panic surrounding indeterminacy, and a certain anxiety of nonbeing outside of representation. (One recalls Warren Beatty's remark in *Truth or Dare* that, for Madonna, there seems to be no existence, or, perhaps, no point of existing, off camera. The figures who populate Brassaï's Paris, by contrast, appear to have far less investment in the image and in photographic immortality, even though they have been immortalized—and depersonalized—by the camera.) For all its play with sexual difference and sexual orientation, the remake ultimately neutralizes and blocks the indeterminate in the realm of sexuality. Unlike the Brassaï images, which assume sexuality to be banal, precisely noneventful, a mask behind which "there is nothing at all," the remake stages the purported truth of feminine identity as sexuality, and thereby attempts to reinvent the sexual as the source of identity—as proof that something, rather than nothing at all, is taking place.

This returns us to the question of nostalgia art and consumer culture, postmodernism and the possibility of historical knowledge in the present. In contrast to Jameson, however, I would argue that nostalgia art neither annihilates history nor completely effaces its ideological relationship to the past. The Madonna remake, regardless of its slickness, and despite its banality, nevertheless returns us to a specific past, and to a particular set of photographs, in order to retrieve a moment in history when it seemed possible to inhabit (if only in the realm of images) a world of sexual differences and unregulated ways of seeing. Given that much of Brassaï's early work was censored, this is, of course, a mythical past, and an imaginary solution, and yet no less historical or ideological for that. Indeed, the historical distance that separates the two sets of photographs—and the two visions of sexual identity—reveals at once how much, and how little, has changed: whereas Brassaï makes visibly palpable the experience of a world and a subjectivity in fragments, the Madonna remake registers the desire to reinvent this particular past, only to cling to a subjectivity in the hope of surviving its historical shattering.

It would therefore be a mistake to dismiss the remake as merely imagistic or simply banal—or, as Jameson might have it, "effectively a way of satisfying a craving for historicity, using a product that substitutes for and blocks it" (Stephanson 18). For there is a historical quality to the remake, even though this quality has more to do with repetition and duration—with a history in which nothing happens—than with transformation or change. The photographs that feature Ma-

donna, I have argued, represent the relationship of a feminine self to the female body in terms of sexual provocation and self-display, thus reviving the conventions that give existence to a masculine economy of vision. The Brassaï photographs, by contrast, represent this relationship in terms of depersonalization, banalization, and loss—pleasures of the narcissistic self, to be sure, but pleasures which acknowledge, with neither the anxiety nor the disingenuousness of the remake, that nothing happens in the realm of sexuality, and therefore that something happened after all, after shock.

NOTES

I would like to thank the Center for Twentieth Century Studies and the Graduate School at the University of Wisconsin–Milwaukee for providing me with the fellowship support which enabled me to research and write this essay. I would like especially to acknowledge the support and intellectual generosity of Kathleen Woodward, Director of the Center, who read this essay in draft form and who offered many useful suggestions for further reading and revision. This essay is part of a larger study of boredom, sexual difference, and historiography.

Unless otherwise indicated, all translations are my own.

1. The retrospective viewing of a photographic image is, of course, already on the side of history. As Susan Sontag puts it, "A photograph passes for incontrovertible proof that a given thing happened. The picture may distort; but there is always a presumption that something exists, or did exist, which is like what's in the picture" (5).

2. On Brassaï's life and work, see Hill and Cooper as well as the series of essays and photographs published by Brassaï himself.

3. After completing a draft of this essay, I came across two books that attempt to chart a history of boredom and *ennui*, particularly in the eighteenth and nineteenth centuries: Kuhn's *The Demon of Noontide* and Wolf Lepenies's *Melancholy and Society*. Neither Kuhn nor Lepenies distinguish boredom from melancholy or *ennui* (as I attempt to do here, precisely by emphasizing the visual dimension to perceptual boredom in the twentieth century). And both theorists are uninterested in questions of boredom, gender, and sexual difference.

Kuhn, for example, excludes four types of boredom from his analysis, since he believes they are tangential to the metaphysical concerns of a properly literary history: momentary boredom (what he calls "désoeuvrement"), psychosomatic boredom (which he describes in relation to the typical portrait of the female suburbanite), sociological boredom (or the boredom that results from industrialized labor and leisure), and anomie (or the "total loss of the will to life"). The misogyny of Kuhn's approach is palpable. He distinguishes the sublime from *ennui*, for example, via a hypothetical situation: a man attends a concert unexpectedly one night, arrives early, and "while waiting is delighted by the beautiful gowns he sees. The heady perfume of a woman sitting next to him intoxicates his senses" (9). So much for the sublime. To describe *ennui*, Kuhn continues the example: the following week the same man attends another concert. It is a planned event, he is assailed by "cacophonous noises coming from the orchestra pit," and then "notices with ir-

ritation that next to him is seated a fat woman with a pimple on her nose" (10). Although this description confirms that the woman is the source of the man's *ennui* (as well as his experience of the sublime), it also runs counter to Kuhn's supposed disinterest in forms of "momentary boredom." In a more scholarly tone, Kuhn concedes that women may experience *ennui* as much as men do. He nonetheless insists that the woman's *ennui* is only of interest when given literary representation: "It is a generally accepted interpretation that Flaubert's Emma Bovary presents symptoms similar to those felt by the bored suburbanite. And yet to reduce her ennui to this level is to misunderstand the very complex condition of which she is victim. The former suffers from a metaphysical malady, and the latter only feels a superficial and vague disquiet. It is this difference in dimension that makes the one a great literary figure and of the other an undistinguished and uninteresting representative of a group" (9).

Lepenies's sociological analysis offers a far more expansive and compelling account of boredom than Kuhn's expressly literary approach. And yet even Lepenies reduces the phenomenology of boredom to a particular class condition. Judith N. Shklar alludes to this in her introduction to the English translation of Lepenies's book, when she writes: "It is not likely that the displaced aristocrat, the excluded bourgeois, and the isolated artist are the only people to be reduced to melancholy by social changes they cannot control in any way.... Gender as much as class is a locus of melancholy" (xvi).

4. See also Jameson's remarks about the nostalgia film in *Postmodernism*, especially chapter 9, "Nostalgia for the Present."

5. On eighteenth-century theories of the sublime, see Lepenies, Kuhn, Weiskel. On the relationship between boredom and the sublime, for example, Weiskel writes: "Clearly, the sublime was an antidote to the boredom that increased so astonishingly throughout the eighteenth century. Addison had celebrated the *Uncommon* along with the *Great* and the *Beautiful* (*Spectator*, no. 412), and Burke began his treatise by laying down a premise that the passions are never engaged by the familiar. Boredom masks uneasiness, and intense boredom exhibits the signs of the most basic of modern anxieties, the anxiety of nothingness, or absence. In its more energetic renditions the sublime is a kind of homeopathic therapy, a cure of uneasiness by means of the stronger, more concentrated—but momentary—anxiety involved in astonishment and terror" (18).

6. On the romantic sublime, see Kuhn and Weiskel, cited above. Giacomo Leopardi explicitly made the connection between boredom and passion when he wrote: "The emptiness of the human heart, the indifference, the absence of any passion is boredom, and yet boredom is passion. ... Thus it is that the living cannot really ever be without passion. This passion, if the heart at the moment is captured by nothing else, we call boredom. Boredom is proof of the uninterrupted duration of passion. Were it not passion, it would not exist when nothing occupies the soul" (trans. and qtd. in Schachtel 177n9). Glossing the work of Ernesto Grassi, Schachtel adds that "in the suffocation of boredom man experiences, on the one hand, nothingness and nonbeing, and—in the *unbearable* quality of boredom—being."

7. For an interesting discussion of boredom and affect in psychoanalysis and clinical practice, see Schachtel, cited above, and Fenichel.

8. The writings of Kracauer and Benjamin are especially illuminating in this regard. For an overview of their theories of subjectivity and media, see Hansen, Petro, Schlüpmann, and the special issue of *New German Critique* devoted to "Weimar Film Theory." On Kracauer's theories of distraction and boredom, see Kracauer, *Ornament der Masse*, especially the essay "Langeweile" ("Boredom") included in this edition. See also Kracauer's "Cult of Distraction." On the affinities between distraction and shock experience, see Benjamin's "Das Kunstwerk im Zeitalter seiner technischen Reproduzierbarkeit" (first version, 431–469; second version, 471–505. The second version is included in *Illuminations*). For Benjamin's (scattered) remarks on boredom, see *Das Passagen-Werk*.

9. Huguet's definition of *ennui* is similar to that of Senancour's, written at the beginning

of the nineteenth century: "Ennui is born of the opposition between what we imagine and what we feel, between the poverty of what is and the vastness of what we want; it is born of the diffuseness of desires and the indolence of action; of this state of suspension and incertitude in which a hundred struggling sentiments mutually extinguish themselves; in which we no longer know what to desire, for the simple reason that we have too many desires, nor what to wish because we would wish for everything; in which nothing seems good because we seek the absolute good; . . . in which the heart cannot find satisfaction because the imagination has promised too much; in which we find repellent all good because all good is not radical enough; in which we are tired of life because it is not new" (trans. and qtd. in Kuhn 226).

10. As Baudelaire put it, in a notation in *My Heart Laid Bare*, "Of the vaporization and of the centralization of the I, that is the entire problem" (trans. and qtd. in Kuhn 12).

11. According to *The Oxford English Dictionary*, the verb "to bore" arose after 1750, although its etymology remains unknown. The definitions of *ennui* and boredom cited here are taken from *The Random House Dictionary of the English Language*, revised edition.

12. Although I speculate here about a modern, visual dimension to boredom suggested by the phrase "unwelcome attentions," I am aware that this phrase equally refers to seventeenth- and eighteenth-century France, specifically to rules and manners of the salons and the court. The word "attentions," for example, referred in literary discourses of the time to the attentions of a flirt or suitor, which were more often verbal or written rather than specifically visual. Given the etiquette of the time, one had to respond in some polite and elaborate manner to these attentions—one had to pay attention—thereby prolonging them, whether wanted or not; hence, a cause of *ennui*. On seventeenth- and eighteenth-century French society, see Lepenies.

13. See, for example, the collection of essays included in *Thinking Photography*, esp. Sekula, "On the Invention of Photographic Meaning."

14. For a perceptive analysis of Benjamin's views on film and distracted reception, see Hansen.

15. See, for example, Benjamin's "A Short History of Photography" and Kracauer's "The Mass Ornament" and "Cult of Distraction."

16. Jay quotes Eliot's 1930 essay on Baudelaire, where Eliot writes: "the possibility of damnation is so immense a relief in a world of electoral reform, plebiscites, sex reform and dress reform, that damnation itself is an immediate form of salvation—of salvation from the ennui of modern life, because at last it gives some significance to living" (qtd. in Jay 238). Tom Gunning writes about Maxim Gorky, who expressed his boredom with modern life in terms of a boredom with cinema: "For Gorky," writes Gunning, "the cinematographe presents a world whose vividness and vitality have been drained away: 'before you a life is surging, a life deprived of words and shorn of the living spectrum of colors—the grey, the soundless, the bleak and dismal life.' . . . Belief and terror are larded with an awareness of illusion and even, to Gorky's sophisticated palate, the ennui of the insubstantial, the bleak disappointment of the ungraspable phantom of life" (34). Finally, in his essay "The Journey and the Return," Jean-Paul Sartre poses the question of modernity and boredom in gender-specific terms: "What did 'terror' mean to a woman? What was 'boredom'? How could one translate into speech an experience that had been lived through without it?" (154).

17. These descriptions of Warhol's films are taken from Koch.

18. Sontag explains: "Brassaï denounced photographers who try to trap their subjects off-guard, in the erroneous belief that something special will be revealed about them" (36–37).

19. This reading of the Madonna remake was inspired by Tim Corrigan's illuminating new book, *A Cinema without Walls*.

20. Madonna may have been reacting to a photo-documentary book published in 1989 entitled *Kiki's Paris: Artists and Lovers 1900–1930*. This book traces the history—in a voyeuristic, pseudo-documentary style—of artists, models, and prostitutes of the time, and chooses Kiki, "the most well-known woman of Montparnasse," as its emblem and its muse.

WORKS CITED

Barthes, Roland. *Camera Lucida: Reflections on Photography.* Trans. Richard Howard. New York: Hill, 1981.

——. "Diderot, Brecht, Eisenstein." Trans. Stephen Heath. *Screen* 15.2 (1974): 33–39.

Benjamin, Walter. "Das Kunstwerk im Zeitalter senier technischen Reproduzierbarkeit." *Gesammelte Schriften.* Ed. Rolf Tiedemann and Hermann Schweppenhäuser. Frankfurt: Surhkamp, 1974. First version, 431–66. Second version, 471–505.

——. *Das Passagen-Werk.* Ed. Rolf Tiedemann. 2 vols. Frankfurt: Suhrkamp, 1982.

——. "A Short History of Photography." Trans. Stanley Mitchell. *Screen* 13.1 (1973): 5–26. Originally published in three parts in the *Literarische Welt* (1931).

——. "The Work of Art in the Age of Mechanical Reproduction." *Illuminations.* Trans. Harry Zohn. New York: Schocken, 1969. 217–51.

Blanchot, Maurice. "Everyday Speech." Trans. Susan Hanson. *Yale French Studies* 73 (1987): 12–20.

Brassaï. *The Artists of My Life.* New York: Viking, 1982.

——. *Brassaï.* New York: Pantheon, 1988.

——. *Conversations avec Picasso.* Paris: Gallimard, 1964.

——. *Graffiti.* Paris: Temps, 1961.

——. *Henry Miller grandeur nature.* Paris: Gallimard, 1975.

——. *Paris by Night.* New York: Pantheon, 1987.

——. *Paris de nuit.* Paris: Arts et Métiers Graphiques, 1933.

——. *Le Paris secret des années 30.* Paris: Gallimard, 1976.

Buck-Morss, Susan. *The Dialectics of Seeing: Walter Benjamin and the Arcades Project.* Cambridge: MIT P, 1989.

Burgin, Victor. *Thinking Photography.* London: Macmillan, 1982.

Corrigan, Timothy. *A Cinema without Walls: Movies and Culture after Vietnam.* New Brunswick: Rutgers UP, 1991.

Crary, Jonathan. "Spectacle, Attention, Counter-Memory." *October* 50 (1989): 97–107.

——. *Techniques of the Observer: On Vision and Modernity in the Nineteenth Century.* Cambridge: MIT P, 1990.

Fenichel, Otto. "On the Psychology of Boredom." *Organization and Pathology of Thought: Selected Sources.* Ed. David Rapaport. New York: Columbia UP, 1959. 349–61.

"Flesh and Fantasy." A Portfolio by Steven Meisel. *Rolling Stone* 13 June 1991: 34–50.

Giedion, Siegfried. *Mechanization Takes Command: A Contribution to Anonymous History.* New York: Oxford UP, 1948.

Gunning, Tom. "An Aesthetic of Astonishment: Early Film and the (In)credulous Spectator." *Art & Text* 34 (1989): 31–45.

Hansen, Miriam. "Benjamin, Cinema, and Experience: 'The Blue Flower in the Land of Technology.' " *New German Critique* 40 (1987): 179–224.

Hill, Paul, and Thomas Cooper, eds. *Dialogue with Photography.* New York: Farrar, 1979.

Huguet, Michèle. *L'Ennui et ses discours.* Paris: Presses Universitaires de France, 1984.

Jameson, Fredric. *Postmodernism, or, The Cultural Logic of Late Capitalism.* Durham: Duke UP, 1991.

Jay, Gregory S. "Postmodernism and *The Waste Land*: Women, Mass Culture, and Others." *Rereading the New.* Ed. Kevin Dettmar. U of Michigan P, 1992. 221–46.

Klüver, Billy, and Julie Martin. *Kiki's Paris: Artists and Lovers 1900–1930.* New York: Abrams, 1989.

Koch, Stephen. *Stargazer: The Life, World, and Films of Andy Warhol.* New York: Marion Boyars, 1991.

Kracauer, Siegfried. "Cult of Distraction." Trans. Thomas Y. Levin. *New German Critique* 40 (1987): 91–96.

———. "Langeweile." *Das Ornament der Masse. Essays 1920–31*. Ed. Karsten Witte. Frankfurt: Suhrkamp, 1977.

———. "The Mass Ornament." Trans. Barbara Correll and Jack Zipes. *New German Critique* 5 (1975): 67–76.

———. "Die Wartenden." *Das Ornament der Masse. Essays 1920–31*. Ed. Karsten Witte. Frankfurt: Suhrkamp, 1977.

Kuhn, Reinhard. *The Demon of Noontide: Ennui in Western Literature*. Princeton: Princeton UP, 1976.

Lefebvre, Henri. "The Everyday and Everydayness." Trans. Christine Levich, with Alice Kaplan and Kristin Ross. *Yale French Studies* 73 (1987): 7–11.

Lepenies, Wolf. *Melancholy and Society*. Trans. Jeremy Gaines and Dorris Jones. Cambridge: Harvard UP, 1992. Trans. of *Melancholie und Gesellschaft*. Frankfurt: Suhrkamp, 1969.

Lyotard, Jean-François. "The Sublime and the Avant-Garde." Trans. Lisa Liebmann. *Art Forum* 22 (1984): 36–43.

New German Critique 40 (1987). Special Issue on "Weimar Film Theory."

Petro, Patrice. "Modernity and Mass Culture in Weimar: Contours of a Discourse on Sexuality in Early Theories of Perception and Representation." *New German Critique* 40 (1987): 115–46.

The Random House Dictionary of the English Language. Revised ed. 1975.

Rose, Jacqueline. "*The Man Who Mistook His Wife for a Hat* or *A Wife Is Like an Umbrella*—Fantasies of the Modern and Postmodern." Ross 237–50.

Ross, Andrew. *Universal Abandon?: The Politics of Postmodernism*. Minneapolis: U of Minnesota P, 1988.

Sartre, Jean-Paul. "The Journey and the Return." *Essays on Language and Literature*. Port Washington, NY: Kennikat, 1964. 145–206.

Schachtel, Ernest G. *Metamorphosis: On the Development of Affect, Perception, Attention, and Memory*. New York: Basic, 1951.

Schlüpmann, Heide. "Kinosucht." *Frauen und Film* 33 (1982): 45–50.

Sekula, Allan. "On the Invention of Photographic Meaning." *Thinking Photography*. Ed. Victor Burgin. London: Macmillan, 1982. 84–109.

Simmel, Georg. "The Metropolis and Mental Life." *Georg Simmel: On Individuality and Social Forms*. Ed. Donald N. Levine. Chicago: U of Chicago P, 1971. 324–34. Rpt. from *Social Sciences III Selections and Selected Readings*. Trans. Edward A. Shils. U of Chicago P, 1948. Trans. of "Die Grosstadt und das Geistesleben." *Die Grosstadt: Jahrbuch der Gehe-Stiftung* (1903).

Sontag, Susan. *On Photography*. New York: Dell, 1973.

Stephanson, Anders. "Regarding Postmodernism—A Conversation with Fredric Jameson." Ross 3–30.

Weiskel, Thomas. *The Romantic Sublime: Studies in the Structure and Psychology of Transcendence*. Baltimore: John Hopkins UP, 1976.

13

The Pencil of History

John Tagg

Reality succumbs to this reversal: it was the given described by the phrase, it became the archive from which are drawn documents or examples that validate the description.
—Jean-François Lyotard

I

MY TITLE PROMISES something with a definite point, something sharply and clearly drawn. And, in the beginning, I indeed had hopes of making an argument that would adhere to a single line. I should have known, however, that in following this line, I could not help but be oblique.

Its path runs first through Milwaukee where, in April 1992, I found myself taking the stage at the furthest edge of the conference "Visual Culture: Film/Photography/History," at a point when everyone in the auditorium might have been expected to be thinking of the end of all the talking—of its end and of other ends that had found no voice, but remained unspoken and, perhaps, unphrased, except as a feeling of pain or frustration. The conference had seemed to project a way beyond the daunting recent debates on "visual culture," by a tempting addition of terms: not "theory" but "history" was to be put alongside film and photography, as a luminous horizon within which research could free itself of its narrow confinement in the claustrophobic, internalized spaces of theoretical debate. In this expansive light, what caught my eye must seem little better than specks: quite marked, certainly, yet not pronounced; remaining silent, because unhearable, in the very interior of the competition of academic discourses about the visual, culture, film, photography, and history—or, at least, in the words that hung over it. What I saw were two dots and two slashes: unspoken marks that joined the terms of the conference title, linking them together as in a syllogism yet, at a stroke, dividing them and dividing the title within itself, leaving the trace of a deep uncertainty and an unresolved incoherence.

Then as now, constraints allowed the pursuit of only one line: the slanted con-

junction of "photography"—"/"—"history" (a conjunction that seems to have no choice but to incline to the right). But let me not be too precipitous. Something else prevents me from getting straight to it.

I remarked that what I wanted to speak about could be traced back to April of 1992. That was a time, you may recall, when the incontrovertible photographic evidence of the bombing of Iraq was beginning to be hedged about by the belated hesitancy of the Pentagon's expert readers, and when the incontrovertible photographic evidence of the beating of Rodney King in Los Angeles County was beginning to be shown, by lawyers for the defense, to be the very model of a process of *semiosis* and a sliding of the signifier that might well take with it any jury caught in its path. At that time, between the burning of Baghdad and the burning of South Los Angeles, we might have been tempted to welcome one demise of evidence and damn the other. What could be more decisive than to take a stand on the real and against the impositions of power to which it is vulnerable, rather than turn to the more uncertain ground of the conditions of witness and the politics of disputable meanings? If, however, it is in the direction of this uncertainty that I want to go, and if this leads me at first away from scenes of violence into the seemingly unconnectable pastoral spaces of Edwardian Surrey, it is not to forget those infrared guidance images or that home video or all that was wagered on them. Even at this remove, they remain part of the stake in any discussion of what William Henry Fox Talbot, almost one hundred fifty years ago in *The Pencil of Nature*, called "the mute testimony" of the photograph, with its promise of "evidence of a novel kind."

I shall not then deny what is risked in the politics of this argument. But that is not all. For we should also not forget how much is riding on it for practices of historical investigation that, even if eschewing any general doctrine of History, still rest their claims to truth on protocols and hierarchies of *evidence*. However pragmatic, however preoccupied with the seemingly modest questions of professional technique, such practices cannot escape their own conditionality. For the court of appeal of history, therefore, as for photography, the status of evidence is always on the line. And, if recent work on photography has opened up the apparatus to expose the cliché of the evidential status of the photograph, what abyss of uncertainty opens in history through the door of a "history" of evidence or, indeed, of a "history" of the archive—the archive of history, the archive that constitutes history?

But I am getting ahead of myself. I ought to begin.

II

"The same century," Roland Barthes reminds us, "invented History and Photography" (*Camera* 93). "Invented" is a fulcrum here: these two formidable apparatuses, "History" and "Photography," these two steam-age engines of representation, are given to us as inventions, devices, machines of meaning, built in the same epoch, within the same code, no doubt, in the same epistemological space, part of

the engineering of the same positivist regime of sense, under the sign of the Real. Yet, such a loaded reading rests too much on the coding of capitalization. It asks Barthes's twin capitals to carry a burden that is, at once, overloaded and insubstantial: a weight of meaning that is monolithic yet hollow.

As Stephen Bann has shown in *The Clothing of Clio*, the forms of nineteenth-century historical imagination—and by this he is referring only to what can be found in Germany, Britain, and France—were multiple and complex. To confine History to the professional practice of history as an academic discipline would therefore constitute an unwarranted narrowing, which would fail to see the play of devices and strategies—of what Bann calls a "historical poetics" (*Clothing* 3)—across a "vast and sprawling domain, which extends from historiography proper, through historical novels to visual art, spectacle and the historical museum" (3-4). Indeed, even within academic historiography, the rhetoric of historical representation was more heterodox and strategically varied than has been suggested by the reading of Ranke's famous injunction, "to show how, essentially, things happened," as the exhaustive program of a positivist "new history." If the demand for authenticity and authentication was persistently renewed throughout the nineteenth century, then it provoked the development of a range of quite different representational possibilities, just as later it invoked an ingeniously diverse array of responses to the equally persistent effects of doubt and irony.

So, too, with photography. What Barthes's sentence presents as a general domain was a field of differences elaborated over time, as a technology of sense was specified and multiplied in discursive regimes that had to be embedded, institutionalized, and enforced in processes we have hardly yet begun to understand. And if, across these diversified fields of historical representations and heterogeneous photographies, there were multiple points of contact and convergence—from the facsimile to the souvenir, from the record to the tableau—then the statuses of these hybrid historical-cum-photographic forms had to be secured in local negotiations, as the customized mechanisms of two adaptive machines were coupled and bolted together to generate new powers of meaning.

The discursive fields of history and photography are not, therefore, reducible to ponderous unities that we can wheel into action *or* into the breaker's yard, where we can flex our muscles dismantling "the nineteenth century's" baleful bequest. It is necessary to insist on this before we turn to consider the strategic attempt to embed the status of history and photography in the uncontestable denotative ground of the document and evidence. The closing of the rhetoric of historiography at the level of the fact and the closing of the meaning of the photograph at the level of its indexicality have operated in fields of historical and photographic discourse they have never saturated. Whatever their ambitions, they remain local ploys, whose grounds have always been in dispute.

Let us head for the local, then, to see how, in particular, the line has been drawn or erased between a practice of "History" and a practice of "Photography."

In 1916, in London, Messrs Gower, Jast, and Topley—respectively Survey Secretary, former Curator, and Treasurer of the Photographic Survey and Record of Surrey—published "a handbook to photographic record work for those who use a camera and for survey and record societies" (iii). More succinctly, they titled their work: *The Camera as Historian*. It is a promising starting point, though I make no "historical" claims for it. We are no longer, of course, in the century to which Barthes was referring. However, Gower, Jast, and Topley's book could certainly be read against half a century of photographic survey work in Britain, going back sporadically to the 1850s and 1860s, but gathering momentum among amateur survey societies in the late 1880s (compare Milligan; and Tagg, *Burden* 139). Indeed, the book itself is dedicated to the late Sir J. Benjamin Stone, M.P., founder in 1897 of the National Photographic Record Survey and, in the words of the dedication, "during his lifetime the greatest personal force in the movement for Photographic Record" (v).

The term *movement* is significant, here. Yet, in presenting their own work, the authors were sure: "This is the first attempt to deal with the subject in a volume" (vii). Whether this claim is justifiable or not could be said to be a matter of record. The book's catalog of photographic survey and record activities—primarily in Britain, but also in Belgium, Germany, and the United States—was, however, admittedly partial and selective. Even so, Gower, Jast, and Topley had set themselves to give us something "honest" and practical; and if, as a manifesto for a "movement," it was belated, then it was a manifesto that strove to be all the more powerful for having the function of a modest and eminently practical manual, which simply and without any fuss "collated" and "conserved" what common sense knew and experience had elaborated (vii–viii).

It is, then, the banality of the text that is its interest. And this is not only a matter of its exemplary attention to the micro-level of bureaucratic technique and its unabashed resolve to speak about the smallest detail of method, materials, rules, and equipment. We might, indeed, be grateful for this and hesitate to condescend toward the utter seriousness with which the authors hold their office. But the book's tone is also part of the machinery of a particular effect that goes beyond its clubbish earnestness.

The presentation of historical investigation as a modest set of techniques and protocols, calling on no general doctrine or philosophical schema, is crucial to the sense that, in the practical craft of history, theoretical decision is not in play. All we have is a practice that turns on what Lynn Hunt has called "the connoisseurship of documentary evidence" (95), within which a certain regimen of photography can then be mobilized. Yet, as in the rules and practices of common law, which developed in parallel to the techniques of professional history, the claim to produce and evaluate evidence is a philosophically powerful one, which—as Mark Cousins has argued—profoundly privileges the notion of the event as a singular entity, pres-

ent in time, whose existence it is the task of historical investigation to establish. However, while legal categories and rules of evidence constitute truth as what may be argued, judged, and appealed in terms of the mode of instantiation of acknowledged law, historical practice and rules of historical verification exceed even this enforced litigation in their claims to delimit and exhaust the event of the past as having only one mode of existence.[1] In the framework of modest technique, what the eventhood of the event consists in is decided in advance and, in this decision without theory, the action of the discursive regime in which eventhood is inscribed—the regime of history—is placed beyond dispute.

This takes us back to what common sense knows: that, as the authors of *The Camera as Historian* put it, "the claim of photographic record to superiority over all other forms of graphic record is incontestable" (2–3). Later, we shall see that, as in other spheres of documentation, this "superiority" proves in need of the most careful protection by organizational rules and archival protocols, but it is the unquestioned point of departure. What it is taken to provide is a self-evident measure of the failures of earlier illustrations, such as those in Pugin's *Examples of Gothic Architecture*, to accomplish the aim of displaying "every subject exactly as it exists" (qtd. in Gower, Jast, and Topley 2). (The echoes of Ranke's dictum in this quotation from Pugin are pointed here and are not in themselves to be called into question.) Yet, in breaking through the limits to "absolute fidelity" (Gower, Jast, and Topley 1) inherent in drafting techniques, photography is also understood to continue to capitalize on a more general power that is taken to reside in all techniques of *visualization*:

> The means whereby the past, particularly in its relation to human activities and their results, may be reconstructed and visualized, can be roughly grouped under the four headings of material objects, oral tradition, written record, and lastly, graphic record, whether pictorial or sculptural. It is no part of our purpose to belittle the value of any of the first-named tools of the historian or the scientist; but it will probably be conceded that in many respects the last named has a value greatly outweighing the others. (Gower, Jast, and Topley 1)

Since the *a priori* aim is "visualization," one cannot help feeling that the odds were stacked against material culture, oral tradition, and written record. But this aside, we are not dealing with a new theme: it haunts the nineteenth-century historical imagination and disturbs the security of historical writing from the early years of the century. What moves the argument is a sense of loss, against which images—on condition they are also "correct representations" (Stothard; qtd. in Bann, *Clothing* 64)—are attributed a capacity to arrest the decay of the present and vivify the resurrection of the past. In the words of the artist and antiquarian Charles Alfred Stothard, "To history they give a body and a substance, by placing before us those things which language is deficient in describing" (Stothard 2; qtd. in Bann, *Clothing* 65).

Curiously enough, Stothard is describing the flattened engravings of funerary monuments that illustrate his *Monumental Effigies of Great Britain*, published in parts from 1811 till 1833, twelve years after Stothard's untimely death. We shall have to come back to this odd relation of the picture, the monument, death, and the life of the past, foreshadowing as it does the themes of Barthes's last work. But, for now, let us note that the printed image excites a double desire of history: on the one hand, for the careful sifting and assembling of detailed and objective records; and, on the other, for the restoration of history as a "lived reality." Yet, in each direction, the power of the image falls flat until it is inserted in another system: on the one side, into the cross-referenced series of the file and the archive; on the other, into what Bann calls "a discourse which mimes the process of chronological sequence" (*Clothing* 67), that is, into a system of narration. At the same time, however, the system of the archive and the system of narration, which encompass the image and variously determine its "vivifying" effect, must also remain in some way "external" to what Gower, Jast, and Topley call the "absolute independence of each print" (80). This is because the record image's discursive value depends on its neither being seen as having its meaning in a network of differences nor being read as having absorbed narration into itself, lest it be thought to have been contaminated by the suspect opulence and sentimental melodrama that had already eroded the documentary status of history painting.

Thus, for Gower, Jast, and Topley, narrative and archive can be treated as the purely technical issues of labeling and storage, which remain supplementary to the camera's work. It is, they tell us, "the discovery and development of photography" that "has placed in our hands a power incomparably greater than existed before of enabling the rapidly changing phases of our country and its people to be 'fixed' by means of authentic pictorial record" (3). The status of the photographic record—the assurance of its accuracy and authenticity—is anchored in an ontology of the photographic image which, in the imaginary of history as Stephen Bann describes it at work in the nineteenth century, promises "to annihilate the gap between the model and the copy" and to realize "the Utopian possibility of a restoration of the past in the context of the present."[2] Yet, in effect, this truth function of the image evinces little confidence. As Bann again has commented, "the quest for historical realism risked becoming a vicious circle in which the period details could never be sufficiently copious, and the effect of resurrection never overwhelming enough" (*Clothing* 139). The accumulation of detail in the print will never be enough; the accumulation of prints will never cover the field that is to be surveyed.

This fear of a lack is, however, inseparable from a horror at what may be too much. If there is always something wanting in the photographic record and the photographic archive, then there is also something more than desired, and this *excess* of photographic meaning must be brought within bounds. Here, the very want of skill of amateurs is welcomed as a relative virtue, since what is needed is a certain technical innocence, in that, we are told, "it is often the case that the processes

by which pictorial excellence are secured [*sic*] in photographic work (partial suppression of detail, double printed atmospheric effects and the like) are detrimental, if not fatal, to the production of a useful record photograph" (Gower, Jast, and Topley 35). The code for photographic excess is here the influence of a popularized Pictorialism:

> Thus, to those photographers who desire to infuse individuality into their work, such processes as gum-bichromate or pigmoil will appeal, by reason of the extent to which they are amenable to modification of the image at various stages.
> The record worker, however ... will seek other qualities, and chief amongst them may be placed permanence of the image and straightforwardness of manipulation, with capacity to record detail and produce in accurate gradation a wide range of tones. (Gower, Jast, and Topley 213)

Gower, Jast, and Topley's strategy has therefore to be the location of the effects of Pictorialism and individuality as *external* to what is *proper* to photography and to the workings of the camera. Ideally, "the camera" should be left to itself—which is why it is "the camera" that is, in effect, "the historian." Whereas, for the purposes of Record, writing is dangerously liable to proliferate, "the camera," we are told, ensures that "the photographer must keep strictly to the business in hand, which is to take something; and though to focus the mind upon an object to the exclusion of everything else even for a few moments is a difficult enough undertaking for most people in these days, the camera is fortunately unable to wander from the object upon which *it* is trained" (99–100).

In part, this marked concern to control photographic meaning is driven by a utilitarian ethic, which dreams of greater "efficiency" and productivity in the use of the camera. This, in turn, demands that the work of amateurs be *systematically* organized:

> To the engineer it is abhorrent that any energy be allowed to run to waste.
> But in the domain of photography the amount of "horse-power running to waste" is appalling—and all for lack of a little system and co-ordination. Shall this be allowed to continue? Shall the product of countless cameras be in the future, as in the past (and in large measure to-day), a mass of comparative lumber, rapidly losing interest even for its owners, and of no public usefulness whatever? This is a question of urgency. Every year of inaction means an increase of this wastage. (Gower, Jast, and Topley 6)

At the same time, however, "efficiency" is not all that is at stake. Pleasure is clearly at issue. For the amateur, record work provides a way beyond the waning of "the first flush of pleasure at the power photography places in one's hands" (Gower, Jast, and Topley 5). What lies beyond is the more acceptable employment of leisure hours, or, in other words, a regulated economy of pleasure: "in many cases the turning of one's energies to systematic photography will open up avenues of thought and lead to studies which will enrich life with the purer pleasures of the intellect" (6). By contrast, unbridled or undirected pleasure is incompatible with the ethic of

the archive. Out in the field, for example, "[t]he practice of exposing promiscuously upon any object which happens to attract attention is of far less value than that of selecting such subjects only as are of importance (from a record not an aesthetic point of view)" (177). Or again, from the point of view of the officers:

> Mere aimless wandering about and casual snap-shotting is not only poorly pro-
> ductive in itself, but tends to beget a slipshod attitude towards the work which it
> should be the aim of Survey organizers to combat, and is moreover less produc-
> tive of enjoyment to the participants in the excursion than is work intelligently
> directed to an end of real value. (Gower, Jast, and Topley 160–61)

So, for this end and in the end, the policing of pleasure and the themes of utility and efficiency are one. What each demands is discipline and the imposition of *systematicity*. Indeed, the very definition of the Survey is, for Gower, Jast, and Topley, "the organization of systematic photographic work" (48). But the demand for systematicness takes us back to the anxieties aroused by the truth function of the Historical Survey and Record and to a striking displacement these anxieties provoke. While in its comprehensive effect the archival project always fell short, its accumulative impetus threatened to overwhelm in an entirely different sense. For, as the number of photographic prints grew, it was clearly impossible to handle them or access their collective record without a system of storage—one in which "it must be possible to insert new prints at any point and to any extent" (80)—and without what the authors call a "proper *arrangement*" (94): "not only ... *some* arrangement, but ... an arrangement which will serve as an efficient key to the scope and con-
tents of the collection, not merely as it is, but as it will become" (94). Here, the motifs of economy, efficiency, and systematicness return at a new level:

> When time, labour, skill and money are to be expended in making a survey which
> shall do credit to the workers and benefit the present and future generations, it is
> worth the most careful consideration to so marshal the collection that it shall
> yield its information in the most direct, immediate, and specific way. This end can
> only be attained by a *systematic* order.[3]

To the evident enthusiasm of the authors, this question of order opens on a number of rich themes. While the meaning of the photograph can be taken as read in little more than two pages and a single strategic plate, more than a third of the book's two hundred sixty pages needs to be given over to questions of storage, the relative merits of boxes, drawers, and vertical files, the mount and the mounting process, the masking and binding of lantern slides, the label, the "contributors' schedules" (Gower, Jast, and Topley 71), the quality of marking ink, the decimal system of classification and the subject order, the advantages of national standard-
ization, the method of Ordnance map referencing, vertical file guides and their proper use, the technical demands of the catalog and subject index, and the impor-
tance of the secretary's Register of Prints.

There is, for example, the label, without which the pictorial record—this index

of truth—is said to be "useless or next to useless" (Gower, Jast, and Topley 70). But the codes of the label are not self-evident. The authors are insistent that

> something more than a mere indication is required in a photographic record. Such matters as the nature of the process employed, the time of day when the exposure was made, the direction of the camera, and the date, above all, the date, belong to the essentials of the record, and should be supplied whenever possible. At the same time the information asked for should be limited to what is really needed to make the print intelligible. . . . An historical or antiquarian fact may add greatly to the interest of the print, but the survey label is not the place for detailed information of this kind. A reference to an account or description in some authoritative book or article is always worth making, when such information is at hand. But any source so named should be authoritative, and the references should be exact and precise. (70)

An extraordinary expenditure of commentary and moral fervor thus devolves onto this little slip: how much it should say; to whom it should speak; to what code it should summon both object and viewer. The label must be a feat of condensation and, as in the voluminous writings of contemporary museum officials such as George Brown Goode of the Smithsonian Institution, it is believed to repay the most exacting analysis (see Goode). In the museum as in the archive, the label must be mastered and become the instrument of a refined and interconnective narrative that will "impart instruction of a definite character and in definite lines," marking out the space of the archive and the space of the exhibit for useful knowledge, and expelling the wayward frivolity of mere "idle curiosity" (True 335).

A similar aura surrounds "the modern vertical file"—the latest information technology; that central artifact, as Allan Sekula calls it (16)—which, here, merits two full-plate illustrations and detailed description. As an instrument for organizing and handling the Survey archive, the vertical file is said to constitute "as near an approach to the ideal as can reasonably be expected" (Gower, Jast, and Topley 85), and even its cost does not weigh against it. Like the paradigm in Saussure's linguistics, it is the structure of the filing cabinet and the decimal system of classification it supports that organize the system of substitutions and equivalences within which the photographic signs are disposed. But, as in the Saussurean model, the construction of meaning across this structure of differences also radically conflicts with the notion of meaning as a fullness interior to the sign. The primacy of the camera and the indexical realism of the print are therefore displaced, suggesting that Gower, Jast, and Topley—formalists in their hearts—might better have titled their work: *The Filing Cabinet as Historian.*

It could be only in the bureaucratic imagination, however, that the "modern vertical file" could be seen as functioning like an ideal language system. From Foucault, we have learned to see its ideal architecture as a disciplinary machine: an apparatus for individuation and comparative categorization; an instrument for regulating territory and knowledge, rendering them the object of technocratic ad-

judication.[4] Yet, as a *technology of history*, the filing cabinet has also to accommodate two further, paradoxical, concerns: a concern for the time history takes to function and the labor it expends (which, in the logic of Capital, amount in the end to the same thing); and a concern for the durability of history, for its duration and hardness, for the survival of history against the erosions of time. And, at the point where these two concerns coincide, there is the question of the expenditure of history as a machine that is used up in the very process of the efficient production of knowledge. On the one hand, the soundly constructed cabinet is a means to prolong the shelf life of history. On the other, at least in the imaginary of empiricism and the economy of information handling, its rigid structure holds out the promise of closing the circuit of reading-sign-referent, which is here hardly separable from the circuit production-consumption-profit. Already, in this cumbersome wood-and-cardboard computer, far short of the "real-time" technologies of CNN, the time of history is imagined as approaching the ideal zero time of disciplinary knowledge and the cycle of capital: "exchange in the least possible time ('real' time) for the greatest possible time ('abstract' or lost time)" (Lyotard sec. 251, 177).

These are, then, the banalities with which the model techno-historians Gower, Jast, and Topley concern themselves: with the "small techniques [as Foucault describes them] of notation, of registration, of constituting files, of arranging facts in columns and tables" (*Discipline* 190–91) that are so familiar to historians; with the modest techniques of knowledge that present themselves as procedural aids, but inscribe the Photographic Record and Survey in a new modality of power for which the workings of the camera give us little explanation. As Allan Sekula has said of the development of immense police archives in the same period, for all the epistemological stakes in the optical model of the camera, it is, in effect, able to secure little on its own behalf, outside its insertion into this much more extensive, and entirely non-mimetic, clerical, bureaucratic apparatus.[5] And the operation of this apparatus has, of course, its own discursive conditions, whose institutional negotiation and effects of power and knowledge I have been concerned to stress elsewhere (see Tagg, *Burden* and "Discontinuous"). This—need I add?—is not to suggest that historical record photography was the transparent reflection of a power outside itself. It is, rather, to insist that the record photograph's compelling weight was never *phenomenological*—to use Barthes's later term—but always *discursive*, and that the status of the document and the power effects of its evidence were produced only in the field of an institutional, discursive, and political articulation.

From this point of view, it would seem to be both true and untrue to say, as Jonathan Crary sometimes appears to, that photography came too late, seeming to reincarnate a model of the observer and a set of relations that had already been overthrown.[6] Within the workings of the archival apparatus, the linear, optical system of the camera obscura, with its rigid positions and inflexible distinctions of subject and object, inside and outside, could both retain its useful fixity and be articulated into a more pragmatic, adaptable system, capable of responding both to new, productive uses of bodies and spaces, and to the proliferating exchange of im-

ages and signs. The look of the camera remains a crucial moment in the machinery of the archival gaze. The absolutes of realism prove readily adaptable to a new pragmatics of performance. It is this articulation that produces the evidential effect, on which certain practices not only of photography but also of history remain dependent. But let us be clear about this system and what it would mean to depart from it.

The photograph, like the name in Lyotard's sense, pins the system to the ostensible fixity of an absolute singularity. But this singularity is an empty referent answering to a name that, by itself, cannot be "a designator of reality" (Lyotard sec. 75, 47). For that to occur, we must situate this name "in relation to other names by means of phrases" (sec. 68, 44). This is a process, however, that cannot be seen through to an end, because "the inflation of senses that can be attached to [the name] is not bounded by the 'real' properties of its referent" (sec. 75, 47). The name is, therefore, as Lyotard says, "both strongly determined in terms of its location among the networks of names and of relations between names (worlds) and feebly determined in terms of its sense by dint of the large number and of the heterogeneity of phrase universes in which it can take place as an instance" (sec. 81, 50).

What is crucial here—not least for the regimen of the instrumental archive and the practices of history that cannot detach themselves from it—is that the phrases that come to be attached to a name (in Lyotard's words) "not only describe different senses for it (this can still be debated in dialogue), and not only place the name on different instances, but . . . also obey heterogeneous regimens and/or genres" (sec. 92, 55). Whereas "essentialism conceives the referent of the name as if it were the referent of a definition" (sec. 88, 53), "the assignment of a definition . . . necessarily does wrong to the nondefinitional phrases relating to [the name], which this definition, for a while at least, disregards or betrays" (sec. 92, 56). For lack of a common idiom, there can be no consensus on the meaning of the name—or the meaning of the photograph—historical or not. "Reality entails the differend" (sec. 92, 55): the name does not designate "reality" so much as mark reality as the locus of radically incommensurable "differends," which summon humans "to situate themselves in unknown phrase universes" (sec. 263, 181; see also Lyotard 32–58 and Readings, esp. 86–139). To respond to this summons, the historian would have to "break with the monopoly over history granted to the cognitive regimen of phrases, and . . . venture forth by lending his or her ear to what is not presentable under the rules of knowledge" (sec. 93, 57). To the camera as historian, Lyotard would have this reply: "Reality is not a matter of the absolute eyewitness, but a matter of the future" (sec. 88, 53).

III

This might give us pause. But it is not quite the place at which we can stop. There is still the quotation with which I began, but whose argument I have avoided confronting directly. Perhaps it is not what we expect.

"The same century invented History and Photography." Yet, for the Roland Barthes of *Camera Lucida*, this is "a paradox" (93). "History is a memory fabricated according to positive formulas, a pure intellectual discourse which abolishes mythic Time" (93). Photography, however, is not an intellectual datum. It is "a certain but fugitive testimony" (93): "in Photography I can never deny that *the thing has been there*" (76); "every photograph is a certificate of presence" (87); photography "*authenticates* the existence of a certain being" (107); "it does not invent; it is authentication itself" (87).

History, then, lacks the authentication on which it would seem to depend, though it should be noted that "History" has to figure twice in this argument—I resist the temptation to say, "the first time as tragedy, the second as farce" (Marx 103)—but rather, once as writing and again as "the past." Barthes wants to suggest that "[p]erhaps we have an invincible resistance to believing in the past, in History, except in the form of myth. The Photograph, for the first time, puts an end to this resistance: henceforth the past [Should we now say 'History'?] is as certain as the present" (*Camera* 87–88). By contrast, "no writing can give me this certainty" (85), because "language is, by nature, fictional" (87). The Photograph, however, "possesses an evidential force," though "its testimony bears not on the object but on time" (88–89). While "the photograph is literally an emanation of the referent" (80), it is not a copy of a present reality but "an emanation of *past reality*" (88): the "pure representation" of the ostensive "*that-has-been*" (96)—which, from the beginning, has to become the truth of a human existence, a "*she-has-been*" (compare 73, 79, 85, and esp. 113).

The contrast with Barthes's 1967 essay "The Discourse of History" is immediately apparent, though in a striking continuity of the field of questions. Barthes, in 1967, seemed to celebrate openly the fact that "Historical narration is dying because the sign of History from now on is no longer the real, but the intelligible" (18). From the point of view of the structural linguistic analysis he was then practicing, the myth of the distinction of historical discourse from other forms of narration was "an *imaginary* elaboration" (16). The "objectivity" of historical discourse turns on a double suppression. In the first place, this is a suppression of the signs of the utterer—the signs of the "I" in historical discourse—whose absence marks a particular, telling form of imaginary projection: the "referential illusion," whose effects, Barthes says, are not exclusive to historical writing (11). Such a suppression amounts to "a radical censorship of the act of uttering," which links the historian's discourse to the discourse of the schizophrenic, in that both seek to effect "a massive flowing back of discourse in the direction of the utterance and even (in the historian's case) in the direction of the referent," so that "no one is there to take responsibility for the utterance" (14).

In the second place, and as an inseparable consequence, it is the signified itself that is forced out: "As with any discourse which lays claim to 'realism,' historical discourse only admits to knowing a semantic schema with two terms, the referent

and the signifier" (17). These are posited in a direct relation that dispenses with "the fundamental term in imaginary structures, which is the signified" (17). "In other words," Barthes writes, "in 'objective' history, the 'real' is never more than an unformulated signified, sheltering behind the apparently all-powerful referent. This situation characterizes what we might call the *realistic effect*" ("Discourse" 17). And, from this, Barthes concludes that "[h]istorical discourse does not follow the real, it can do no more than signify the real, constantly repeating that *it happened*, without this assertion amounting to anything but the signified 'other side' of the whole process of historical narration" (17–18).

Yet, what is important, Barthes suggests at the end of his essay, is the prestige that has attached to this "*it happened*," to this "*realistic effect*," for which our culture has such an appetite, as can be seen in:

> the development of specific genres like the realist novel, the private diary, documentary literature, news items, historical museums, exhibitions of old objects and especially in the massive development of photography, whose sole distinctive trait (by comparison with drawing) is precisely that it signifies that the event represented has *really* taken place. ("Discourse" 18)

Here, we may note that, for all the footnoted reference to "Rhetoric of the Image" ("Discourse" 20n13; compare "Rhetoric"), the "*it happened*" of the photograph is marked as an effect of signification. And this is in the context of an argument in which, against the refusal to assume the real as signified and in enthusiastic pursuit of the Red Guards of Mao's "Cultural Revolution," Barthes seems to call for "a destruction of the real itself," which "is never more than a meaning, which can be revoked when history requires it" ("Discourse" 18; see also 20n14). So "history" has to make its double appearance again, even though the "destruction of the real" spells the end of the secular survival of "that very sacredness which is attached to the enigma of what has been, is no longer, and yet offers itself for reading as the present sign of a dead thing" (18).

The constant repeating of the "it happened." "The present sign of a dead thing." These return us uncomfortably to the second part of *Camera Lucida* and to "the pure representation" of "that-has-been": the "evidential force" of the photograph. Yet, we should not miss the paradoxical point that it is because of its very power as evidence that "the Photograph [and, here, Barthes is thinking of his mother] cannot be penetrated" (106). The photographic image is both full—"no room, nothing can be added to it" (89)—and finite. It offers "nothing but the *exorbitant thing*" (91), "in it nothing can be refused or transformed" (91). This is "its unendurable plenitude" (90). The presence it discloses is entirely finished—complete and gone—and no displacement to a register of cultural meaning can allay or give voice to the "suffering" Barthes now experiences "entirely on the level of the image's finitude" (90). If the photograph dispels disbelief and bestows a certainty on History as "the past," then it does so with the "*irony*" (93) that there is

nothing to say about it, just as there is nothing to say about the flat fact of Death. If the Photograph is unarguable, it nevertheless, like the name, teaches us nothing.

There is another irony to add to this. As a memorial to the past, the photograph is frangible and fleeting:

> Earlier societies managed so that memory, the substitute for life, was eternal and that at least the thing which spoke Death should itself be immortal: this was the Monument. But by making the (mortal) Photograph the general and somehow natural witness of "what has been," modern society has renounced the Monument. (93)

It is at this point in the text that Barthes invokes the "paradox" of the nineteenth century's double legacy: its invention of History (let us say historiography) and Photography—the one fabricated, the other fugitive—together ushering in the double death of Memory, the death of the endurable, the death of the ripe and even, eventually, of the astonishment of "*that-has-been*," witness to which seers into the Photograph, and even into History as Michelet conceived it, love's protest against this loss (*Camera* 94).

The argument begins to fold against itself, knowingly perhaps, like the fall of a shroud that hides from view yet remains translucent, as in the curtains that hang at the entrance to Barthes's book. The fugitiveness of the photograph and the intellectual formulas of historiography have expelled redemptive ritual and displaced the continuity of memory. Yet they have also given us what remain our only fragile testimonies against the facts of Death and loss. Without being able to conceive duration, however, the fullness they offer can never ripen, but only be replete. It can only be the fullness of the formula and the fullness of the photograph that, like Death itself, precludes all transactions and is therefore closed to meaning—irrefutable, yet telling us nothing. The certainty without meaning of "what has been" threatens to induce stupefaction, but still its prick is felt, spurring Barthes to the revelation that "such evidence can be a sibling of madness" (*Camera* 115; see also 116).

Madness proliferates in these texts on History and Photography. Whereas, formerly, the discourse of the historian was shunned as too close to that of the schizophrenic, now it is the semiology and structural linguistics of the late 1960s that have been shaken off as the period of a "little scientific delirium" (compare Bann, "Introduction" 4); while the closeness of the discourses of history and photography to the discourse of the psychotic is now embraced as a madness, or "ecstasy" (Barthes, *Camera* 119), in which untamed affect (love, grief, enthusiasm, pity) is an absolute guarantee of Being (compare *Camera* 113). In the midst of "the civilized code of perfect illusions," madness drives crazily into the piteous spectacle of the photograph and wakens there "intractable reality" (119; see also 117).

"A sibling of madness": what has been taken as Barthes's belated reiteration and vindication of a realist position hardly yields evidence that would stand up in

court. The evidence that is without discursive conditions is the evidence of the ecstatic, of Nietzsche on his knees in the gutter, with his arms round the neck of a dying horse. There can be little joy for Leftist documentarism or social history in joining him there.

One could follow much more closely the vicissitudes of "History" and "Photography" in Barthes's writing: now as complicit in the imaginary elaboration of the realist effect; now as paradoxical inventions of the same epoch—intellectual formula set against the "message without a code"; now, again, as substitutes for memory in a society without monuments. But whether one reads here a continuity or a change of mind, it is clear that Barthes's final ecstatic embrace of the evidential power of the photograph is far removed from Gower, Jast, and Topley's dream of its efficient handling. This can hardly give satisfaction to "the connoisseurship of documentary evidence." But, on the question of History at least, surely these texts are more resolved: History for certain cannot claim to be a discourse without a code (compare Lévi-Strauss 258). Yet, as the analyses unfold, history keeps doubling, and the double keeps retreating, always to another space, another domain of existence, which the analyses exclude only to reinvoke.

In "The Discourse of History," Barthes frames the possibility of an analysis of the narrative structures of history only by closing those structures, thereby recreating, from what that closure expels, an *external* space of history "in" which, as Geoff Bennington and Robert Young point out, discursive structures—and, indeed, structural analyses of history—have to work their effects (4). So, too, in *Camera Lucida*—a book in which Barthes says his conception of photographic realism obliges him "to return to the very letter of Time" (119)—History is writing, formula, "a pure intellectual discourse." But History and Photography belong to the same century, to the same chronology, in which "the age of the Photograph" is also "the age of revolutions" (93), and the world of the "universalized image" (119) brings an end to belief, rendering "archaic" what Barthes lovingly treasures, leaving him to survive as one of the "last witnesses"[7] of the astonishment of a "that-has-been." History and Photography belong in history, of whose "past" existence photography offers certain evidence. And while, beyond "the civilized code of perfect illusions," the intractable evidence of photography is terrifying and ecstatic, bordering on madness, this device of madness is located within a historical frame and, like History itself, is said to have been historically invented.

So Barthes releases madness only to arrest it again. And, at this very moment, History escapes. One is reminded of Derrida's remark, in another context, that "philosophy . . . lives only by emprisoning madness" and "it is only by virtue of this oppression of madness that finite-thought, that is to say, history, can reign."[8] History, on the other hand, never does time; it is always over the wall and it remains at large even in Barthes's most structuralist text. It makes no sense, then, to demand that history be "added" to structuralist analysis: that is only to repeat the action of the carceral logic—the logic of the limit, the logic of the frame—that

constitutes inside and outside, work and context, structure and history. It makes no sense, then, to choose sides. Metaphorical or not, this penitentiary works its effects on both sides of its perimeter wall: the space of the structural interior—about which we know something from Barthes—and the space of "empiricisms of the extrinsic" (Derrida, "Parergon" 61)—about which we know something from Gower, Jast, and Topley—are kept apart only by a "thin blue line." This is the issue: the institution in question. And, to echo Derrida again, we can only "avoid the reconstitution of a new archivism or of a new documentalism" ("Statements" 93) by engagement with "the problematic of the border and of framing" ("Statements" 92). We come back to the question of the obliquity of the line. How else, outside appeals to the real, will we ever be able to show that the police or the Pentagon have once more overstepped the mark?

NOTES

1. Compare Foucault, "Discourse": "History, as it is practiced today, does not turn its back on events; on the contrary, it is continually enlarging the field of events" (230).

2. Bann, *Clothing* 138. The problem is that, whereas Bann is concerned to reveal the morphology of nineteenth-century rhetorics of historical representation, he wants to insist on "the fundamental difference between historical discourse, on the one hand, and the photograph" (135). The difference, for Bann, following Barthes and Berger and others, is rooted in the indexicality of the photograph as a guarantee of meaning outside the morphology of narrative and rhetorical structures he analyzes. Photography, therefore, comes to take on the "unique function of representing the past, of making manifest to the spectator what Roland Barthes has called the 'having-been-there . . . the always stupefying evidence of *this is how it was*' " (134). This leads Bann even to propose the possibility of identifying Ranke's "wie es eigentlich gewesen" with the "having-been-there" that, for Barthes, inhabits the photograph.

Elsewhere, Bann writes of the photograph as "not simply an automatic, and to that extent a more efficient, means of reproduction," but as "a reproduction with a signature in time" (*Clothing* 134). And, in the context of discussing "the succession of technical developments, beyond the sphere of language, which offered a temporary or more long-lasting effect of illusory recreation"—an illusory recreation central to "the new historical sensibility, striving to annihilate the gap between the model and the copy, and offering the Utopian possibility of a restoration of the past in the context of the present"—he suggests that "only the photograph, with its capacity to record and perpetuate light rays on a chemically-prepared surface, was able to achieve this effect with complete success" (138).

3. Gower, Jast, and Topley 96–97. It is worth noting that, of the authors, L. Stanley Jast was Deputy Chief Librarian of Manchester Public Libraries and Hon. Secretary of the Library Association, while W. W. Topley was a member of the Croydon Libraries Committee. For the influence of bibliographical science on photographic archive organization, see Sekula 56–57.

4. Gower, Jast, and Topley's manual is quite clear about the addressee of the Survey archive:

To the historian and the scientist the value of exact records, indisputably authentic, can hardly be overrated. Such are the primary requirements of their work, the raw materials necessary for their labours. (3)

The architect, and especially the student of architecture, will find there is no index to what has been accomplished so instructive as a series of photographs, comprehensively recording both broad outlines and details, compactly arranged and classified in such manner as to facilitate reference and comparison. (3)

The politician, in his efforts for the betterment of our social structure, must, if his constructive work is to stand the test of actual trial, take for his starting point the existing conditions of his time, and must duly weigh the evolutionary forces which have brought those conditions into being. For both purposes exact records of material conditions, chronologically arranged for purposes of comparison, furnish a valuable, indeed a necessary, basis for generalization. (3–4)

Nor is the work without value in a commercial and legal sense. Questions relative to property, and mutual rights therein, often arise, the solution of which requires evidence based on a state of things which has passed away. (4)

The value of adequate photographic records, kept as the common heritage of all, in fostering the civic spirit, is not to be overlooked. A healthy corporate consciousness constitutes a quality in our civic and national life which cannot be too highly valued or too sedulously fostered. . . . And in the fostering of such a consciousness exact records of fact, by reference to which misunderstandings and misapprehensions can be dispelled, have their fitting place. (4)

5. Sekula 16. For the development in the nineteenth century of non-mimetic strategies of historical representation, see Bann, *Clothing* 138ff.

6. Crary, "Modernizing Vision" 43. See also Crary, *Techniques of the Observer*, where he argues, somewhat differently, though still in terms of an epochal visuality, that:

the camera obscura and the photographic camera, as assemblages, practices, and social objects, belong to two fundamentally different organizations of representation and the observer, as well as of the observer's relation to the visible. By the beginning of the nineteenth century the camera obscura is no longer synonymous with the production of truth and with an observer positioned to see truthfully. The regularity of such statements ends abruptly; the assemblage constituted by the camera breaks down and the photographic camera becomes an essentially dissimilar object, lodged amidst a radically different network of statements and practices. (32)

7. Barthes, *Camera Lucida* 94. Compare 65: "impossible for me to believe in 'witnesses'; impossible at least, to be one."

8. Derrida, "Cogito" 61. For Derrida's reading of Barthes's *Camera Lucida*, see Derrida, "Deaths"; and Plissart and Derrida, esp. 90–92.

WORKS CITED

Attridge, Derek, Geoff Bennington, and Robert Young, eds. *Poststructuralism and the Question of History*. Cambridge: Cambridge UP, 1987.

Bann, Stephen. *The Clothing of Clio: A Study of the Representation of History in Nineteenth-Century Britain and France*. Cambridge: Cambridge UP, 1984.

———. Introduction. Barthes, "The Discourse of History" 3–6.

Barthes, Roland. *Camera Lucida: Reflections on Photography.* Trans. Richard Howard. London: Cape, 1982.

——. "The Discourse of History." Trans. Stephen Bann. *Comparative Criticism: A Yearbook.* No. 3. Ed. E. S. Shaffer. Cambridge: Cambridge UP, 1981. 7–20.

——. "Rhetoric of the Image." Trans. Stephen Heath. *Image-Music-Text.* Glasgow: Fontana/Collins, 1977. 32–51.

Bennington, Geoff, and Robert Young. "Introduction: Posing the Question." Attridge, Bennington, and Young 1–11.

Carroll, David, ed. *The States of "Theory": History, Art, and Critical Discourses.* New York: Columbia UP, 1990.

Cousins, Mark. "The Practice of Historical Investigation." Attridge, Bennington, and Young 126–36.

Crary, Jonathan. "Modernizing Vision." *Vision and Visuality.* Ed. Hal Foster. Seattle: Bay, 1988. 29–49.

——. *Techniques of the Observer: On Vision and Modernity in the Nineteenth Century.* Cambridge: MIT P, 1990.

Derrida, Jacques. "Cogito and the History of Madness." *Writing and Difference.* Trans. Alan Bass. Chicago: U of Chicago P, 1978. 31–63.

——. "The Deaths of Roland Barthes." Trans. Pascale-Anne Brault and Michael Naas. *Philosophy and Non-Philosophy Since Merleau-Ponty.* Ed. Hugh J. Silverman. New York: Routledge, 1988. 259–96.

——. "Parergon." *The Truth in Painting.* Trans. Geoff Bennington and Ian McLeod. Chicago: U of Chicago P, 1987. 15–147.

——. "Some Statements and Truisms about Neologisms, Newisms, Postisms, Parasitisms, and Other Small Seisisms." Trans. Anne Tomiche. Carroll 63–94.

Foucault, Michel. *Discipline and Punish: The Birth of the Prison.* Trans. Alan Sheridan. New York: Vintage, 1979.

——. "The Discourse on Language." *The Archaeology of Knowledge.* Trans. A. M. Sheridan Smith. New York: Pantheon, 1972. 215–37.

Goode, George Brown. "Report of the Assistant Secretary." *Report of the National Museum.* Washington: National Museum, 1893.

Gower, H. D., L. Stanley Jast, and W. W. Topley. *The Camera as Historian.* London: Sampson, Low, Marston, 1916.

Hunt, Lynn. "History beyond Social Theory." Carroll 95–111.

Lévi-Strauss, Claude. *The Savage Mind.* Chicago: U of Chicago P, 1966.

Lyotard, Jean-François. *The Differend: Phrases in Dispute.* Trans. Georges Van Den Abbeele. Minneapolis: U of Minnesota P, 1988.

Marx, Karl. "The Eighteenth Brumaire of Louis Bonaparte." Vol. 11 of *Collected Works.* Karl Marx and Frederick Engels. London: Lawrence, 1979. 99–197.

Milligan, Harry. "The Manchester Photographic Survey Record." *Manchester Review* 7 (1958): 193–204.

Plissart, Marie-Françoise, and Jacques Derrida. "Right of Inspection." Trans. David Wills. *Art & Text* 32 (1989): 20–97.

Pugin, A., and A. W. Pugin. *Examples of Gothic Architecture: Selected from Various Ancient Edifices in England.* 3 Vols. London: Bohn, 1850.

Readings, Bill. *Introducing Lyotard: Art and Politics.* New York: Routledge, 1991.

Sekula, Allan. "The Body and the Archive." *October* 39 (1986): 3–64.

Stothard, Charles Alfred. *The Monumental Effigies of Great Britain, selected from our cathedrals and churches, for the purpose of bringing together, and preserving correct representations of the best historical illustrations extant, from the Norman Conquest to the reign of Henry the Eighth.* London: 1811–33.

Tagg, John. *The Burden of Representation: Essays on Photographies and Histories.* London: Macmillan, 1988.

——. "The Discontinuous City: Picturing and the Discursive Field." *Grounds of Dispute: Art History, Cultural Politics and the Discursive Field.* London: Macmillan, 1992. 134–56.

Talbot, William Henry Fox. *The Pencil of Nature.* 1844. New York: Da Capo, 1968.

True, Frederick William. "The United States National Museum." *The Smithsonian Institution 1846–1896: The History of Its First Half Century.* Ed. George Brown Goode. City of Washington: De Vinne, 1897. 303–66.

Notes on Contributors

Herbert Blau is Distinguished Professor of English and Comparative Literature at the University of Wisconsin–Milwaukee. He is the author of five books that explore the relationships among theater, theory, and culture: *Take Up the Bodies: Theater at the Vanishing Point*; *Blooded Thought: Occasions of Theater*; *The Eye of Prey*; *The Audience*; and *To All Appearances: Ideology and Performance*.

Edward Buscombe is Head of Trade Publishing at the British Film Institute. He is the editor of *The BFI Companion to the Western* and has recently completed a volume on *Stagecoach* for the BFI Film Classics series. His essays have appeared in *Cinema Journal, Quarterly Review of Film Studies*, and *The Velvet Light Trap*.

Eduardo Cadava is Assistant Professor of English at Princeton University. His translations of the work of Jacques Derrida, Maurice Blanchot, Vincent Decombes, and others have appeared in *MLN, Topoi*, and various anthologies.

Philippe Dubois is Professor at the Université de Paris III (Sorbonne Nouvelle) and the Université de Liège, Belgium, where he is also codirector of the Centre de Recherches sur les Arts de la Communication. He is the author of *L'Acte photographique et autres amis* and *L'Acte photographique* and coauthor (with Yves Winkin) of *Rhétoriques du corps*.

Régis Durand, Professor of American Cultural Studies at the University of Lille, is contributing editor to *Art Press*. He has curated many exhibitions of contemporary photography and is the author of two books on photography, *Le Regard pensif* and *La Part de l'ombre*.

Tom Gunning is Associate Professor of Radio, Television, and Film at Northwestern University. A member of the editorial advisory board of *The Velvet Light Trap*, he is the author of *D. W. Griffith and the Origins of American Narrative Film*. His essays have appeared in *American Film, Cinema Journal, Film Quarterly, Camera Obscura, Discourse*, and *Wide Angle*.

Lynne Kirby is with Independent Television Service in St. Paul, Minnesota. She is the author of a forthcoming book on early American cinema and of essays in *Quarterly Review of Film and Video, Camera Obscura, Discourse*, and *Wide Angle*.

Patricia Mellencamp is Professor of Art History and Film Studies at the University of Wisconsin–Milwaukee. She is the author of *Indiscretions: Avant-Garde Film, Video, and Feminism* and *High Anxiety: Catastrophe, Scandal, Age, and Comedy*. She has coedited four books, including *Logics of Television: Essays in Cultural Criticism*.

Áine O'Brien is an Uihlein Fellow in the Modern Studies concentration in the Department of English and Comparative Literature at the University of Wisconsin–Milwaukee. She is completing her dissertation, "Gender, Space, and the Imagined Community: Dismantling the Foundational Fictions of Nation."

Patrice Petro is Associate Professor of English, Comparative Literature, and Film Studies at the University of Wisconsin–Milwaukee. She is the author of *Joyless Streets: Women and Melodramatic Representation in Weimar Germany* and of essays in *New German Critique, Discourse, Camera Obscura*, and *Wide Angle*.

John Tagg is Associate Professor of Art History at the State University of New York, Binghamton. He is the author of *Grounds of Dispute: Art History, Cultural Politics and the Discursive Field* and *The Burden of Representation: Essays on Photographies and Histories*. He is the editor of *The Cultural Politics of "Postmodernism"* and *Proudhon, Marx, Picasso: Three Studies in the Sociology of Art*.

Linda Williams, Professor of Film Studies at the University of California, Irvine, is the author of *Hard Core: Power, Pleasure and the "Frenzy of the Visible"* and *Figures of Desire: A Theory and Analysis of Surrealist Film*, and coeditor of *Re-Vision: Essays in Feminist Film Criticism*. Her essays have appeared in *Screen, Ciné-tracts, Semiotica*, and *Quarterly Review of Film and Video*.

Charles Wolfe, Associate Professor in the Film Studies Program at the University of California, Santa Barbara, is the author of *Frank Capra: A Guide to References and Resources* and editor of *Meet John Doe*. His essays have appeared in *Wide Angle, Quarterly Review of Film Studies, Journal of Film and Video*, and *Literature/Film Quarterly*.

Index

Abbas, Ackbar, 192

Agee, James, and Walker Evans: *Let Us Now Praise Famous Men*, xii, 196-208; and voice, 200; and self-critique, 206, 211-13

AIDS: and photography, 74

Akerman, Chantal: *Jeanne Dielman, 23 Quai du Commerce—1080 Bruxelles* and boredom, 276

Alpert, Jon, 75

Anderson, Robert, 88

Anthony, Susan B.: and Spiritualism, 42

Antonioni, Michelangelo: *Blow Up,* 153, 170

Arcade E, 34-35

Arendt, Hannah: and death of Walter Benjamin, 239

Arnett, Peter: and Gulf War, 82

Assimilation: and mimicry, 190

Atget, Eugène: critique by Walter Benjamin, 223; direction of attention in work of, 253; politics and aesthetics of, 254; and spirit, 254; and aura, 259-60

Aura (Walter Benjamin): and reproducibility, 3, 75, 98, 155, 165-68, 221-22, 227-30, 247; and early photography, 226-28; and authenticity, 227; and "shock," 237; and Eugène Atget, 259-60; and filing cabinet, 293

Autobiography: and film, xii, 152-70, 173-93. *See also* Depardon, Raymond; Frampton, Hollis; Frank, Robert; Jayamanne, Laleen; Marker, Chris; Moffatt, Tracey; Varda, Agnès

Avant-garde: and film, 152-70; and photography, 245-63

Avedon, Richard, 259

Bakhtin, Mikhail, 175-76

Baldessari, John: and allegory, 253; and captioning, 259

Balzac, Honoré de: *Cousin Pons* and daguerreotypes, 43; on photography, 45-46, 66, 67; and effect of picture-taking, 249

Banal: and Siegfried Giedion, 265; and survey photography, 288. *See also* Boredom

Bann, Stephen: *The Clothing of Clio* and historical imagination, 287; and accumulation of detail, 290; and narration, 290

Barnes, Djuna: *Nightwood,* 245, 261

Barthes, Roland: and photography, vii-xiv *passim,* 248, 261; and film, viii, 141-51; and photography, history, and death, 135n7, 224, 250-54, 290, 297-300; and historical photograph, 136nn10,12; and temporality in film, 141; and perception of film, 143-44; and punctum-effect, 150, 252; photograph and effect of truth, 170; *Winter Garden,* 170, 257; and bliss and boredom, 174; messages without codes, 245; association of photography and theater, 250-52; and pleasure, 278-79; and the co-emergence of history and photography, 252, 286-87, 296-300; and the photographic document, 294

Baudelaire, Charles: and obscenity, 3-4, 13; and stereoscope, 8, 11; and images, 12; as *flâneur,* 20; and women as viewers, 21; and index, 239

Baudrillard, Jean: and ecstasy, 37; and authenticity, 66; and visual obscenity, 247-48

Baudry, Jean-Louis: representations *vs.* perceptions, 5; patriarchal ideology, 8

Bayard, Hippolyte: autoportrait of death, 250

Bazin, André: film theory, viii; and obscenity, 3; and "sur-Western," 90; and movement in film, 144; and avant-garde of 1970s, 173; and "spatial realism," 176; and photos as index, 181

Beckett, Samuel: *Endgame,* 249; *Footfalls* and photography as theater, 250; *Waiting for Godot* and waiting, 276; and politics, 258

Benetton: advertisements for and photography, xi, 7

Benjamin, Walter: and film theory, viii; and knowledge, xiii; and authenticity, 66; and aura, 155, 166-68, 226-28, 227, 247, 259-60; and "Messi-